Into the Spotlight
Art at Baloise

Stephan Balkenhol, Untitled, 2000

Into the Spotlight
Art at Baloise

Edited by Martin Schwander
on behalf of Baloise

HATJE
CANTZ

Contents

The architectural firm of Diener & Diener designed the company headquarters at Baloise Park, which was inaugurated in 2020, as a light-filled cube. This not only offers potential for new workplace structures, but also provides the ideal framework for the presentation of our art collection. The entrance hall alone is an architectural gem; a visibly uninterrupted wall stretching from ground level into the first floor allows visitors to be welcomed by nine portraits of children by Canadian artist Jeff Wall.

The presentation of Jeff Wall's work *Children* is an excellent example of our guiding principles. Our collection is meant to be accessible not only to our employees, but also to the general public. Diener & Diener took this fully into account in their plans for the new building: on the ground floor, the Kunstforum Baloise presents monographic and thematic exhibitions of works from our collection, while the upper floors have meeting and assembly spaces that can accommodate further displays of art.

It was the initial acquisitions in the late 1940s that paved the way for an art collection that now comprises some 1,500 works. Back then, as now, groups of works were acquired in order to depict, as it were, a comprehensive portrait of each individual artist. Even the very first acquisitions of works by Basel-based artists were of high artistic quality that set them apart both in terms of their inner wealth of meaning, and also in terms of their visual language, which was unusual and even revolutionary at the time.

Our company has a tradition of collecting art. It has become an integral part of our identity. Art enriches our lives. The very fact that individual employees can choose original artworks for their own workspaces bears witness to the core value of the collection. This inclusive approach is also reflected in the process of acquisition, whereby the Art Committee responsible is made up of employees from different departments who have a personal appreciation for art, while the specialist knowledge is delivered by art consultant Martin Schwander. Once a year Baloise employees can also present their own handicrafts and artworks.

On the whole, we can look back on a long history of supporting emerging talent. For many years now, our training and development programs have provided a solid base for a sustainably successful future. This same emphasis on supporting and promoting talent is also the key concept behind the Baloise Art Prize. Since 1999, we have awarded the Baloise Art Prize annually during Art Basel to two young artists, helping to promote their emerging creative career.

Baloise Park marks a new departure in the history of our company. This latest chapter offers a wonderful opportunity to present our engagement with art to the public for the first time, as a book to be read. We are delighted to turn over this new page and we very much hope that you will enjoy reading it too.

Andreas Burckhardt President of the Board of Bâloise Holding AG
Isabelle Guggenheim Arts and Culture Management

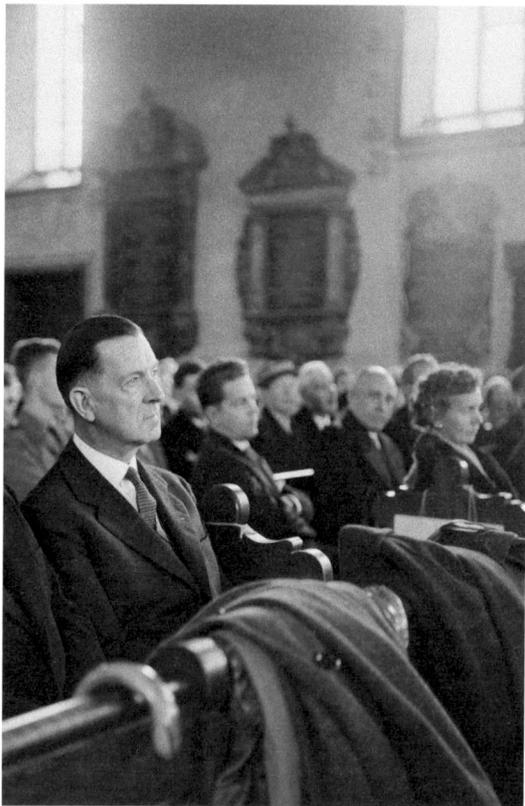

Josef Remigius Belmont at the ceremony during which he received an
honorary doctorate from the University of Basel at the Church of St Martin,
Basel, November 18, 1960

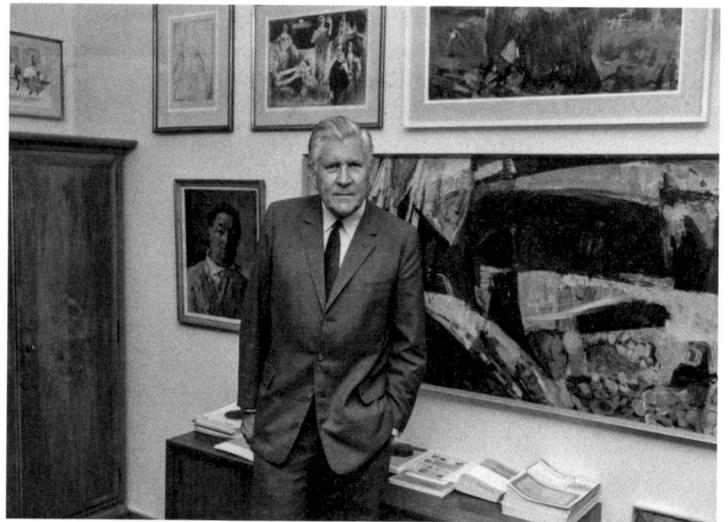

Hans Göhner in his office, Basler Versicherungen, 1977

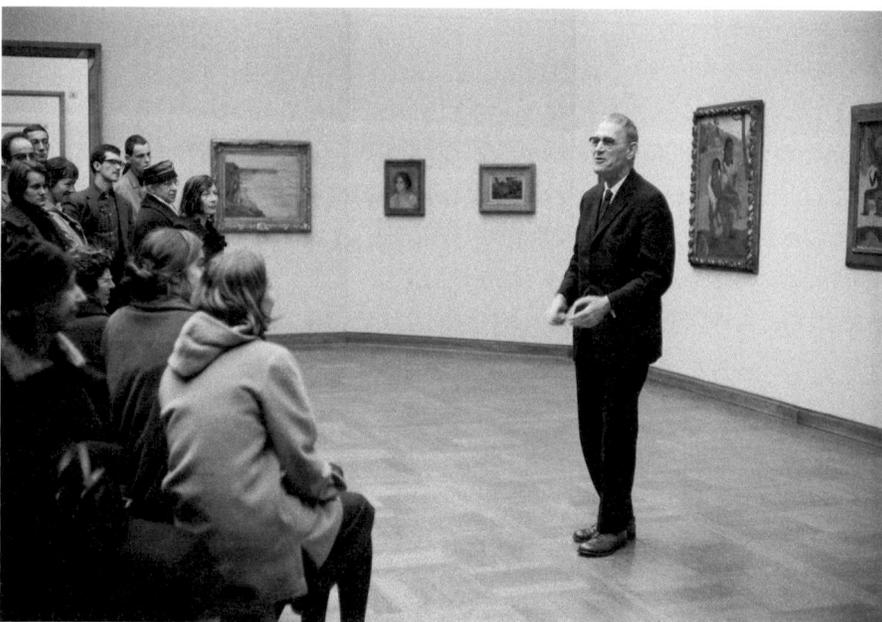

Director of the Kunstmuseum Basel Georg Schmidt introducing
paintings by Paul Gauguin, 1962. Photo: Maria Netter

Into the Spotlight
On the History of the Baloise
Art Collections

Martin Schwander

Basel Art Hub

Since it was founded in 1863, the insurance group Basler Versicherungs-Gesellschaften has played an important role in the economic and social life of the city of Basel and its urban fabric, setting important architectural landmarks throughout.[1] To this day, Baloise is known as a creative patron of the arts. The Baloise art collection is one of Switzerland's first corporate art collections. However, this private-sector involvement in art and culture has to be seen within the context of Basel's rise to prominence as a hub of the European art world during the course of the 20th century.

Up until the 1960s, two institutions in particular drove this trajectory: the Kunsthalle Basel with its program of exhibitions focusing almost exclusively on contemporary and emerging art,[2] and the Kunstmuseum Basel with its outstanding collection of Old Masters and works of the 20th and 21st centuries.[3] With the appointment of Georg Schmidt (1896–1965) as director of the Kunstmuseum Basel in 1939, the institution placed at its helm an art historian with a clear view of the developments in avant-garde art from the turn of the century onward. In his very first year in office, Schmidt set an important milestone. A specially allocated budget from the city council allowed him to acquire a dozen works of so-called "degenerate art" that had been confiscated from German museums by the Nazi regime.[4] In the postwar era, Schmidt systematically built up the collection of modern and contemporary art with the support of generous patrons, including the Emanuel Hoffmann Foundation, founded in 1933.[5] During this time, the Kunstmuseum Basel blazed a trail in Europe, becoming a point of reference for many war-damaged museums seeking to rebuild their collections of modern and contemporary art.

From the 1960s onward, some new and innovative players came onto the scene in the Basel art world. The Progressive Museum, for instance, which operated from 1968 to 1974, was launched by a group of individuals from the fields of commerce and culture. And in 1970, three Basel gallerists founded Art Basel, an art fair that has since burgeoned into a worldwide enterprise with satellites in Miami and Hong Kong.[6] Then, in 1980, the Museum für Gegenwartskunst (now Kunstmuseum Basel – Gegenwart) opened its doors, thanks to a joint undertaking between the Christoph Merian Foundation, the Emanuel Hoffmann Foundation,

1 On the history of the Basler Versicherungs-Gesellschaften insurance group, see Markus von Escher and Karl Lüönd, *Sicherheit als Prinzip. 150 Jahre und eine Zukunft für die Basler*, Bâloise Holding AG, Basel 2013.

2 On the history of Kunsthalle Basel, see Lukas Gloor, *Die Geschichte des Basler Kunstvereins und der Kunsthalle Basel: 1839–1988. 150 Jahre zwischen vaterländischer Kunstpflege und modernen Ausstellungen*, Basel 1989.

3 On the history of Kunstmuseum Basel, see Christian Geelhaar, *Kunstmuseum Basel. The History of the Paintings Collection and a Selection of 250 Masterworks*, Basel 1993; Bernhard Mendes Bürgi and Nina Zimmer (eds.), *Kunstmuseum Basel. Contemporary Modern Old Masters: A Guidebook with Selected Works*, Basel 2016.

4 On the acquisition of "degenerate art" by the Kunstmuseum Basel, see Georg Kreis, *Einstehen für "entartete Kunst". Die Basler Ankäufe von 1939/40*, Zurich 2017.

5 On the history of the Emanuel Hoffmann Foundation, see Laurenz Stiftung, Schaulager Basel (eds.), *Future Present. The Collection of the Emanuel Hoffmann Foundation*, Basel 2015.

6 Art Basel was founded in 1970 by Ernst Beyeler, Trudl Bruckner, and Balz Hilt. On the history of Art Basel, see Lukas Gloor, "Die Art Basel – von der internationalen Kunstmesse zum globalen Kunstforum," in Patrick Kury and Esther Baur (eds.), *Im Takt der Zeit. Von der Schweizer Mustermesse zur MCH Group*, Basel 2016, pp. 257–272.

and Kunstmuseum Basel. It was, at the time, the world's first new, custom-built museum designed specifically for the presentation of contemporary art. Two highly regarded international exhibitions of sculpture took place in 1980 at Wenkenpark in Riehen and in 1984 at Merian-Park in Basel.[7] Moreover, since the 1990s, institutions such as the Vitra Design Museum in Weil am Rhein, the Museum Tinguely in Basel, the Fondation Beyeler in Riehen, and the Schaulager in Münchenstein have contributed substantially to Basel's international reputation as an art center.

Portrayals of the city's cultural life never fail to mention the generous patronage of its private citizens and commercial enterprises alike. In this context, the cultural engagement of the business sector is generally measured in purely financial terms. What is rarely mentioned, however, is the contribution that some of them have made, through their art collections, to Basel's reputation as an art nexus. That is all the more surprising given the sheer quality of the art collections built up in recent decades by a number of firms throughout the Basel region, from middle-sized, family-owned companies such as Ricola AG in Laufen,[8] to multinationals such as Novartis and Roche.

Among the first firms in the Basel region to have begun and still continue collecting art are two insurance companies. In 1942, Hans Theler (1904–1998), who took the helm of the Schweizerische National-Versicherungs-Gesellschaft (now known as Helvetia Versicherungen) in 1939, acquired the landscape painting *Blick von der Mohrhalde* (1899) by Hans Sandreuter (1850–1901), a student of Arnold Böcklin, through an exchange with the Gemäldegalerie Dresden.[9] In doing so, Theler laid the foundations for an important collection of 20th-century art from Basel and wider Switzerland. Initially he relied on the advice of Kunstmuseum director Georg Schmidt, and the charismatic head of the Kunsthalle, Arnold Rüdlinger (1919–1967), whose avant-garde program of exhibitions created waves throughout Europe from 1955.[10]

Basler Versicherungs-Gesellschaften
and their Art Collections

Right from their inception, the insurance group known respectively as Basler Versicherungs-Gesellschaft gegen Feuerschaden, Basler Leben, and Basler Transport-Versicherungs-Gesellschaft (this last known as BATRA) operated as three virtually independent enterprises. Each of the companies made an impact on the urban environment from the late 19th century onward by constructing distinctive new office buildings. However, their architectural forays did not go hand in hand with any particularly noteworthy contribution to the wider art world. The facades of these commissioned buildings bore the typical decorative sculptural ornamentation of the day. Within their walls, there was little sign of

7 See *Skulptur im 20. Jahrhundert*, exh. cat. Wenkenpark, Riehen/Basel 1980; *Skulptur im 20. Jahrhundert*, exh. cat. Merian-Park, Basel 1984.
8 On the Ricola collection, see Roman Kurzmeyer and Lukas Richterich, *Sammlung Ricola*, Laufen 2016.
9 Matthias Frehner, "Kein Platz für Kompromisse. Die Kunstsammlung der National Versicherung," in Schweizerische National-Vericherungs-Gesellschaft, Basel, in collaboration with the Swiss Institute for Art Research (SIK-ISEA), Zurich and Lausanne (eds.), *Schweizer Kunst des 20. Jahrhunderts. Die Sammlung der National Versicherung*, Basel, Zurich, and Lausanne 2005, pp. 13–31, here p. 18.
10 On Arnold Rüdlinger and his work at the Kunsthalle Basel, see Bettina von Meyenburg-Campell, *Arnold Rüdlinger. Vision und Leidenschaft eines Kunstvermittlers*, Zurich 1999.

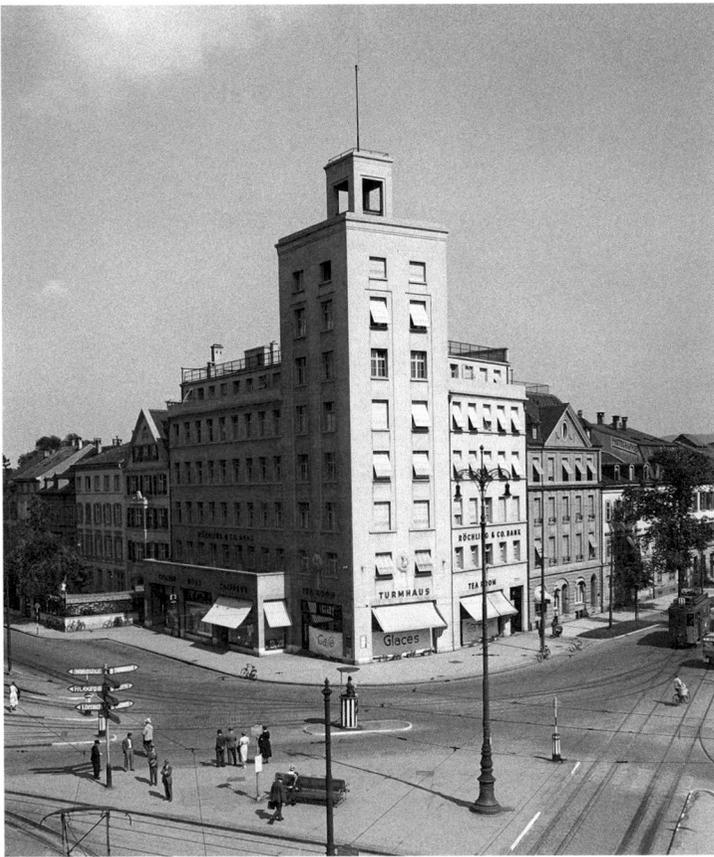

View from the west across Aeschenplatz toward the Turmhaus high-rise, built 1928–29
by Basler Versicherungen, Basel 1939. Architects: Ernst Benedikt and Paul Vischer

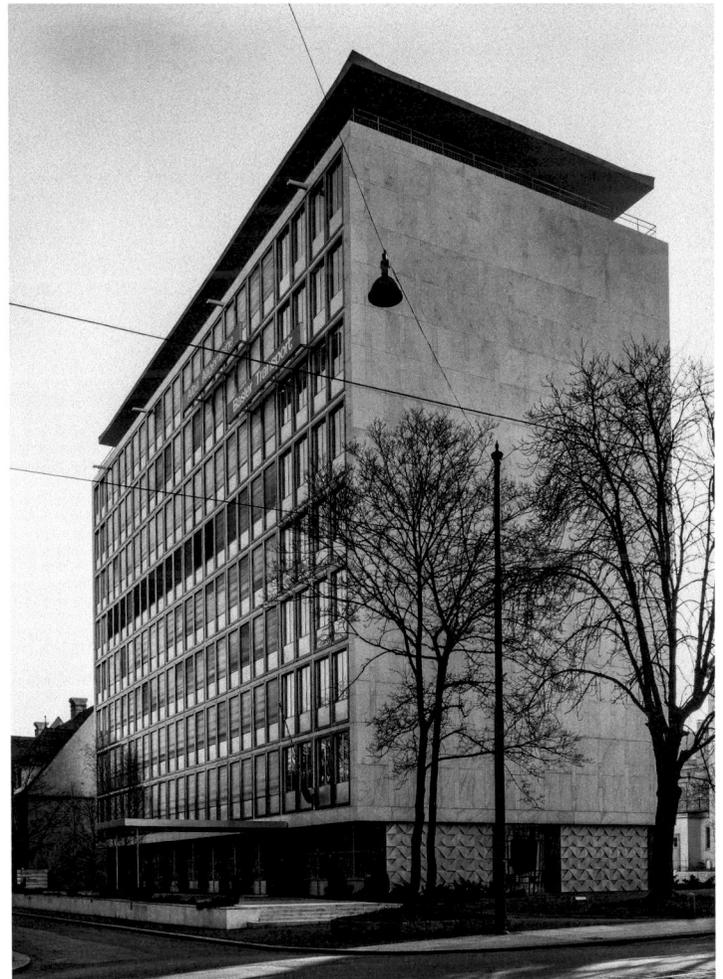

Basler Transport-Versicherungs-Gesellschaft, Aeschengraben 25, Basel, 1956.
Architect: Hermann Baur

On the History of the Baloise Art Collections

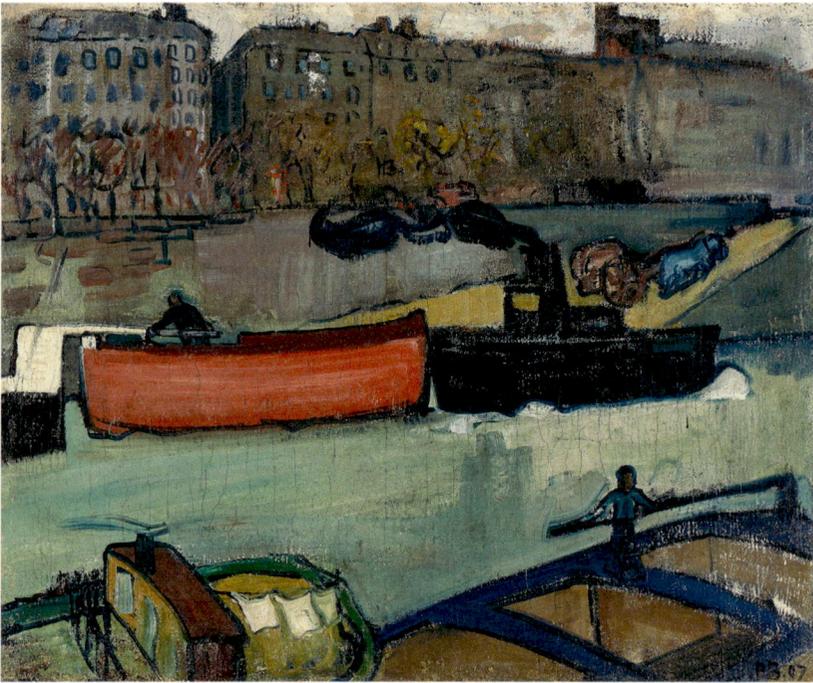

Paul Basilius Barth, *An der Seine*, 1907

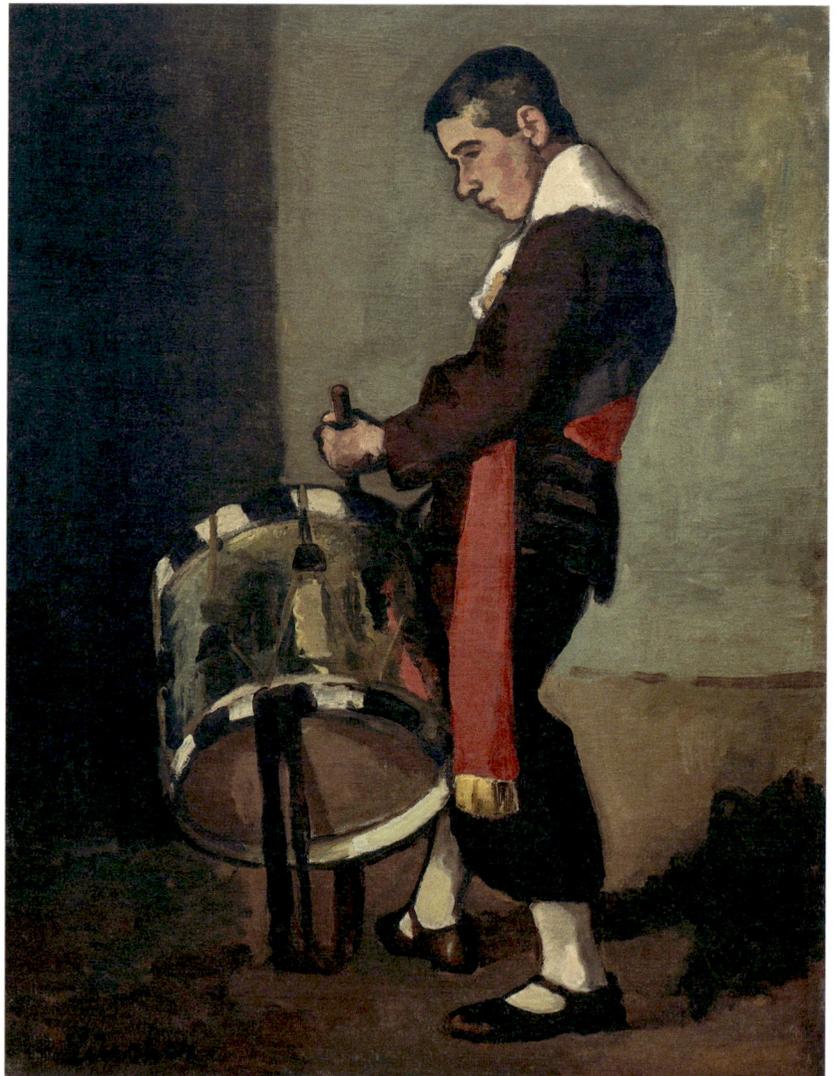

Jean-Jacques Lüscher, *Der Trommler (Waisenbube)*, 1911

any discreet artworks. The few paintings to grace their prestigious boardrooms were, for the most part, portraits of their own board directors.

Just after the end of WW2, the Basler Transport-Versicherungs-Gesellschaft decided, for the first time, to acquire artworks for the embellishment of their finest rooms. This move was initiated by Josef Remigius Belmont (1896–1981), who had been Director General of BATRA since 1940. Prior to that, Belmont had spent 20 years in Bombay (now Mumbai) working in the insurance department of the Winterthur trading company Volkart Brothers. Globally active since the second half of the 19th century, Volkart Brothers was headed by the Reinhart family from 1912 onward. Given that members of the Reinhart family counted among Switzerland's leading art collectors and patrons, it is quite likely that, during his time in Bombay, the young Belmont, whose interests were wide-ranging, may have regarded their cultural engagement in Winterthur as an example to follow.

On moving to Basel, by which time he had become a connoisseur of Indian art, Belmont took a keen and active interest in the city's cultural life. In 1947, he was appointed to the board of the Museum of Ethnology and Swiss Museum of Folklore, and was its chairman from 1950 to 1960.[11] At the same time, his newfound appreciation of Swiss art led him to build up a collection of his own at his home in Binningen. Although there is little in the way of documentation that might give a definitive insight into the thinking behind Belmont's creation of the BATRA art collection, what is certain is that the focus, right from the start, was on collecting paintings and drawings by contemporary Basel artists. The first known acquisitions, in 1946, were four landscape paintings. In addition to works by Paul Burckhardt (1880–1961) and Numa Donzé (1885–1952), both established figures of the older generation, works by two younger painters, Martin Christ (1900–1979) and Coghuf (Ernst Stocker, 1905–1976), were also acquired. This dual approach was to shape the trajectory of the collection over the following two decades. Alongside paintings and drawings by artists who had already become part of the city's recent art historical canon, funds were always available for the acquisition of works by younger, as yet unknown artists. This is particularly striking in the period around 1960, when the enthusiasm sparked by Arnold Rüdlinger for what he called "dark horses" also made its mark on the Basler Versicherungs-Gesellschaften.[12] Between 1958 and 1963, paintings by five innovative young artists—Lenz Klotz (1925–2017), Bruno Müller (1929–1989), Marcel Schaffner (1931–2012), Samuel Buri (b. 1935), and Bernd Völkle (b. 1940)—entered the collection. Each of these rising stars had developed their own personal variations on gestural abstraction, inspired by the exhibitions of leading American Abstract Expressionists hosted by Rüdlinger at the Kunsthalle Basel.[13] What is even more remarkable about these acquisitions is the fact that they were the first non-figurative works to grace the BATRA collection.

11 In 1960, the University of Basel awarded an honorary doctorate to Josef Belmont in recognition of his research into Indian art. For more information on Josef Belmont, see Miriam Baumeister, "Josef Belmont," in *Personenlexikon des Kanton Basel-Landschaft*, https://personenlexikon.bl.ch/Josef_Belmont (last accessed November 2019).
12 *DU* magazine's August 1959 edition was dedicated to the "dark horses," naming 42 Swiss architects, artists, and writers under the age of 35, nine of whom had Basel connections: Samuel Buri, Jürg Federspiel, Markus Kutter, William Phillips, Marcel Schaffner, Karl Gerstner, Wolf Barth, Bruno Müller, and Jean Tinguely.
13 On Rüdlinger's "dark horses," see Meyenburg-Campell, *Arnold Rüdlinger*, pp. 88–114.

To advise on building up the BATRA collection, Josef Belmont brought in Georg Schmidt, who had worked closely with many Basel artists during his time as museum director.[14] In addition to acquiring works by contemporary artists, Schmidt aimed to anchor the BATRA collection historically with groups of works by pioneers of modernism in Basel. Of particular note, in this context, was the purchase of nine paintings and works on paper from the estate of Walter Kurt Wiemken (1907–1940), who in his short life became one of the most important Swiss artists of the first half of the 20th century.[15] When the heirs of Carl Burckhardt (1878–1923) organized a major retrospective of Burkhardt's work at the Galerie Stadelhofen in Zurich in 1963, BATRA purchased a group of ten drawings and watercolors.[16] Georg Schmidt had already championed this outstanding sculptor and painter back in the 1920s.[17]

By the early 1950s, the head office at Elisabethenstrasse 51 had become increasingly unfit for purpose, prompting BATRA to announce an architectural design competition for a new building at Aeschengraben 25. Planning dispensation was granted to allow the construction of the nine-story building, which was the highest in the city at that time. The jury, whose members included the Chairman of the Board of Directors Felix Iselin (1884–1968), and Josef Belmont as representatives of the client, selected the proposal by Hermann Baur (1894–1980), a leading proponent of the Neues Bauen movement in Switzerland. The elegant high-rise, inaugurated in 1956, was undoubtedly one of the most important examples of postwar modernist architecture in Basel.[18] Paul Stöckli (1906–1991) was commissioned to create a floor-to-ceiling glass window for the entrance hall.[19] The monumental bronze sculpture *Christophorus* (1955) by Alexander Zschokke (1894–1981) marked the entrance.[20]

From 1957, Josef Belmont served a three-year term as Chairman of the Board of Friends of the Kunstmuseum Basel. This honorary appointment provided him an opportunity of support Georg Schmidt in his work for the museum. During his brief chairmanship, the Friends purchased an early work by Josef Albers, and a 1958 still life by Giorgio Morandi.[21] The close ties between the Basler Versicherungs-Gesellschaften and the Kunstmuseum Basel were maintained after Schmidt stepped down. In 1964, the company marked its centenary with the publication of a "jubilee edition for staff and business partners and as a gift to the city of Basel and its public collection."[22] Under the title *Kunstmuseum Basel. 150 Gemälde, 12.–20. Jahrhundert*, this lavishly illustrated publication, with many color plates, was authored by Georg Schmidt, who had retired in 1961.

14 Hans Göhner described Georg Schmidt's advisory role in building the BATRA collection in a letter to the author dated October 27, 1999.

15 In 1942, Georg Schmidt published the first monographic study of Walter Kurt Wiemken's oeuvre as well as a catalogue raisonné; see Georg Schmidt, *Walter Kurt Wiemken 1907–1940*, Basel 1942. Several works were acquired at an exhibition of his estate; see *Walter Kurt Wiemken, 1907–1940. Aquarelle, Zeichnungen*, exh. cat., Galerie am Stadelhofen, Zurich 1963.

16 See *Carl Burckhardt, 1878–1923. Plastiken, Aquarelle, Zeichnungen*, exh. cat., Galerie am Stadelhofen, Zurich 1963.

17 On Georg Schmidt's support for Carl Burckhardt's oeuvre, see Lukas Gloor, *Venus. Carl Burckhardt und das Kunsthaus Zürich*, exh. cat., Kunsthaus Zürich, Zurich 2013; *Carl Burckhardt 1878–1923. Ein Bildhauer zwischen Basel, Rom und Ligornetto*, ed. Gianna A. Mina and Tomas Lochman, exh. cat., Museo Vincenzo Vela, Ligornetto, Basel 2018.

18 On Hermann Baur and the BATRA building, see Dorothee Huber, *Architekturführer Basel. Die Baugeschichte der Stadt und ihrer Umgebung*, Basel 2014, p. 353.

19 The BATRA high-rise had to make way for the new Baloise Park development in 2016. Paul Stöckli's 1955 glass window was mounted in an aluminum relief. Baloise had the window restored and gifted it to the Nidwaldner Museum in Stans in 2018. For more about the aluminum relief, see also Manuela Ammer's essay on Jenni Tischer in this publication, pp. 182–184.

20 The Zschokke sculpture now stands on Gartenstrasse, where it marks the entrance to Baloise.

21 See *Die Sammlung des Vereins der Freunde des Kunstmuseums Basel*, exh. cat., Kunstmuseum Basel, Basel 1983, p. 51.

22 See Georg Schmidt, *Kunstmuseum Basel. 150 Paintings. 12th–20th Century*, Basel 1964, unpaginated. It was not until 1992 that Georg Schmidt's book about the collection was superseded by a new publication by the then director Christian Geelhaar, *Kunstmuseum Basel. The History of the Paintings Collection and a Selection of 250 Masterworks*. Geelhaar's publication was also substantially funded by Baloise.

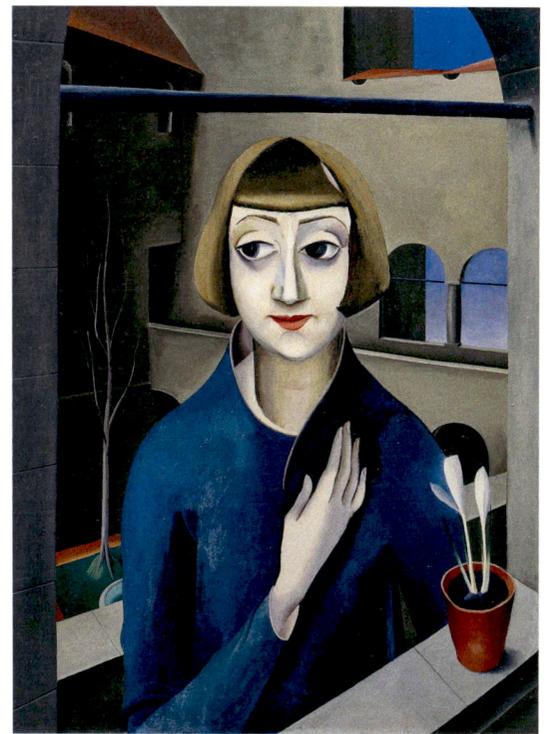

Niklaus Stoecklin, *Meine Schwester Franziska*, 1919

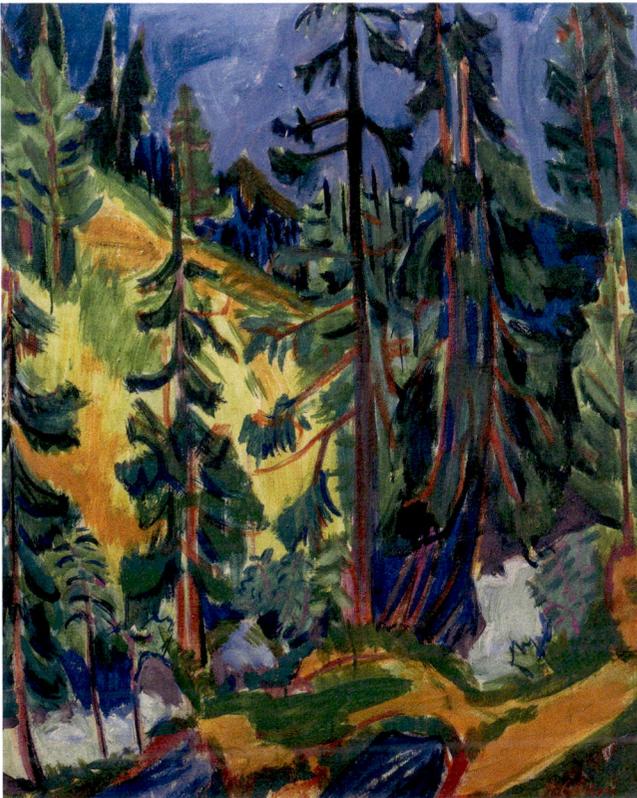

Hermann Scherer, *Bergwald bei Davos*, 1924

Walter Kurt Wiemken, *Artistenzimmer*, 1932

On the History of the Baloise Art Collections

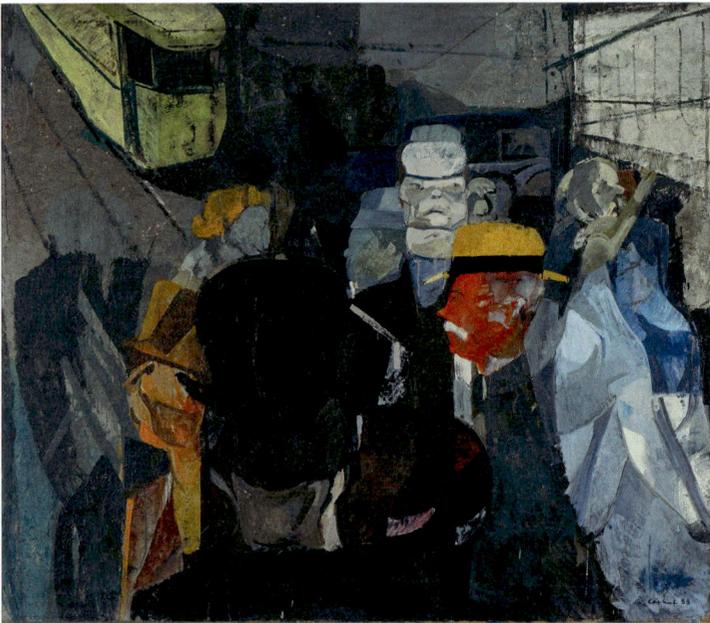
Coghuf (Ernst Stocker), *Marseille*, 1933

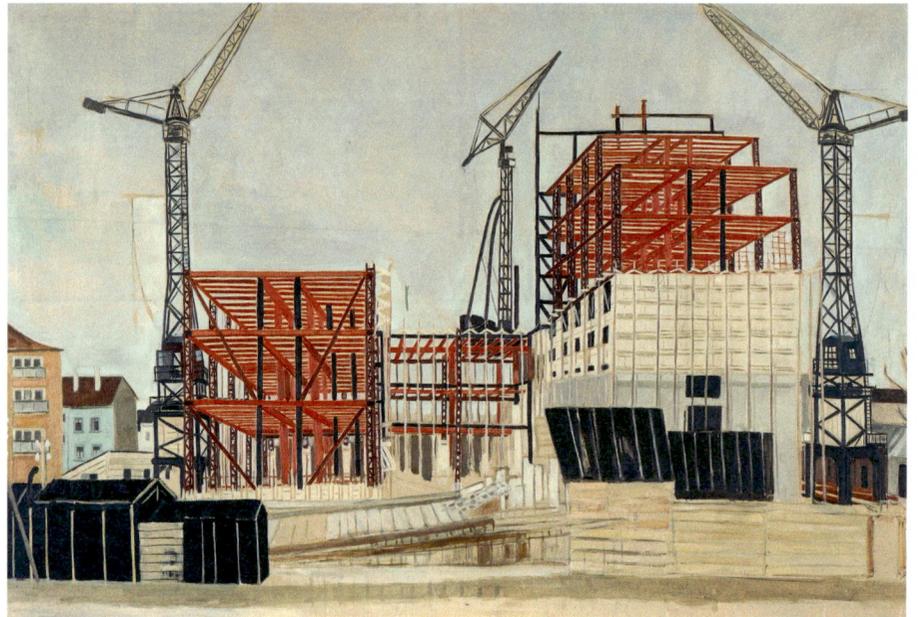
Rudolf Maeglin, *Skelettbau*, 1938

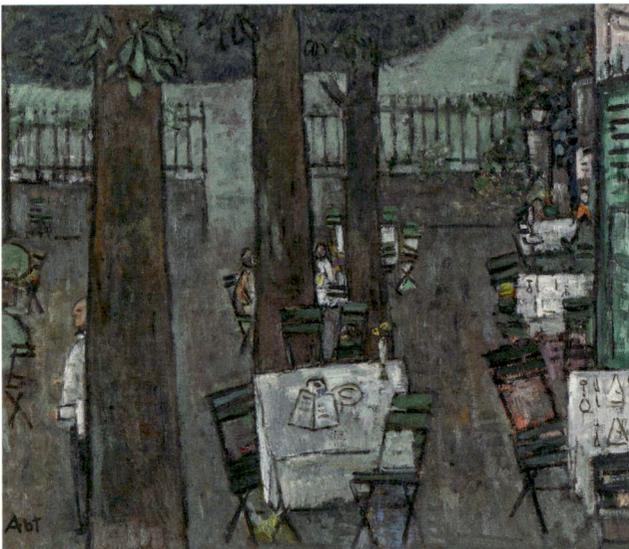
Otto Abt, *Jardin d'été*, 1952

Just a few months before his death, Schmidt once again outlined his Marxist-based view of the evolution of art. Described as "Schmidt's canon of the Basel Public Art Collection,"[23] the text met with considerable acclaim. The Friends of the Kunstmuseum Basel published the second edition of the book in 1970. The seventh and latest edition was published in 1994. Schmidt's introductory text has inspired generations of (Basel) art lovers and students of art history to view the masterpieces on display in the Painting Gallery—from Konrad Witz to Mark Rothko—through fresh eyes.

Two years after Josef Belmont had begun the task of building up the BATRA collection with the support of Georg Schmidt, Hans Göhner (1916–2003) started making sporadic acquisitions for the Basler Versicherungs-Gesellschaft gegen Feuerschaden. In 1948, in his capacity as secretary to the director, he purchased *Heisser Sommer (bei Augst)*, painted the previous year by Ernst Baumann (1909–1992).[24] Göhner, who was promoted to Deputy Director in 1957, was not allocated a regular budget for art acquisitions until 1960, and it was not on a par with that of BATRA.[25] He noted in hindsight, speaking of the remarkable circumstance of two independent insurance companies in Basel being involved in the same field of collecting at the same time, that, "up until 1964, both the Basler Transport-Versicherungs-Gesellschaft and the Basler Versicherungs-Gesellschaft gegen Feuerschaden had been collecting contemporary Basel art. Without any close-knit cooperation, two separate collections were built up independently of one another, and turned out to complement each other absolutely perfectly when they were merged in 1965."[26]

The decision, in 1962, to merge the largely independently operating insurance companies into Bâloise Holding AG, took effect on January 1, 1965. On this same date, Hans Göhner was promoted to the role of Director General for International Insurance and Counterinsurance.[27] On Josef Belmont's retirement at the end of 1964, Göhner was also put in charge of the fusion of the two art collections. From this point onward, and for the following 20 years, Hans Göhner had sole responsibility for the care, curatorship, and expansion of the Baloise art collection.

Göhner's personal preference was for artists of his own generation. He would regularly visit painters such as Coghuf, Ernst Baumann, Max Kämpf (1912–1982), Karl Moor (1904–1991), Gustav Stettler (1913–2005), and Walter Schüpfer (1903–1972) in their studios. When he did so, he would at times take the opportunity to purchase paintings for the Baloise collection. His "fundamental premise was to present the work of important Basel artists in all phases of their careers; which is how the collection came to hold substantial groups of works by individual artists."[28]

23 Roger Fayet, "Georg Schmidt und die Frage der künstlerischen Werte," in *RIHA Journal*, 0097, September 26, 2014, https://www.riha-journal.org/articles/2014/2014-jul-sep/fayet-georg-schmidt (last accessed November 2019).
24 See Paul Imhof, "Kunst am Arbeitsplatz (1). Die Basler Versicherung," in *Basler Magazin*, 26, June 29, 1985, p. 8.
25 The art acquisition budget for 1960 amounted to 10,000 Swiss Francs; letter from Hans Göhner dated October 27, 1999. The annual acquisition budget was adjusted according to requirements and rising prices and was capped at a maximum of 30,000 Swiss Francs; cf. Imhof, "Kunst am Arbeitsplatz (1)."
26 Hans Göhner, "Zum künstlerischen Schmuck des Ausbildungszentrums in Arlesheim der Basler Versicherungs-Gesellschaften," in *Basler Hauszeitung*, 3, 1979, supplement, unpaginated.
27 On the inception of Bâloise Holding AG, see von Escher and Lüönd, *Sicherheit als Prinzip*, pp. 152–157.
28 Göhner, "Zum künstlerischen Schmuck des Ausbildungszentrums in Arlesheim der Basler Versicherungs-Gesellschaften," 1979.

By bringing together the two collections, Baloise has taken on the stewardship of a broad range of Basel artworks—from turn-of-the-century paintings to avant-garde works of the 1960s. The first major focal point of the collection can be found in the dark-toned paintings of Paul Basilius Barth (1881–1955), Numa Donzé, and Jean-Jacques Lüscher (1884–1955), redolent of French Postimpressionism. The expressive painting of the 1920s is strikingly represented in works by Hermann Scherer (1893–1927) and Coghuf. During the 1930s and 1940s, the art scene in Basel was largely shaped by the circle of avant-garde young artists known as Gruppe 33. Among the leading exponents of this group in the Baloise collection are Otto Abt (1903–1982), Walter Bodmer (1903–1973), Theo Eble (1899–1974), Rudolf Maeglin (1892–1971), and Walter Kurt Wiemken. Early paintings by Samuel Buri, Lenz Klotz, and Marcel Schaffner convey an idea of how vibrant the Basel art scene was in the period around 1960. Notwithstanding, the Baloise collection also includes striking individuals such as Niklaus Stoecklin (1896–1982), who was a pioneer of the Neue Sachlichkeit movement, as well as important groups of works by Ernst Baumann and Max Kämpf.

When the prospect of building a new administrative headquarters near the BATRA high-rise was touted in the late 1970s, Hans Göhner made the case for an architectural design that would be sympathetic to the presentation of the collection in all its changing aspects. He invited a number of artists to put forward their proposals for the open square in front of the office building at Aeschengraben 21, designed by the firm of Burckhardt+Partner. Of the five proposals submitted by Swiss artists, it was the multi-part Baveno granite sculpture *Steinerne Landschaft* (1982/83) by Basel artist René Küng (b. 1934) that was finally chosen.

When he retired from his duties as administrator of the collection, Göhner described his underlying tenets as follows: "When companies buy artworks, they do not do so as a capital investment … The 'participatory' aspect of the acquisitions is mainly about the fact that these acquisitions are intended for a collection worthy of its name, and are therefore to be regarded as individual, rather than collective, choices. When it comes to the allocation of existing works within the collection, individual wishes can often be taken into account. Worthwhile art can be a very serious, though often unpopular, matter … Art that may be 'problematic' for the layperson can be hung to great advantage in the more widely accessible areas of the business premises … There, that kind of art can, over time, prove culturally edifying in its own subtle way."[29]

Göhner's engagement with the artists he admired went well beyond the bounds of merely purchasing artworks for the Baloise collection. For instance, within a period of 20 years, he published no fewer than seven monographic studies of Basel artists.[30] One remarkable achievement was the series of leaflets relating to contemporary works by Basel artists that Göhner issued between

29 Hans Göhner, "'Sammeln von Kunst' oder 'die Kunst des Sammelns,'" in *Der Monat in Wirtschaft und Finanz*, Schweizerischer Bankverein, June 6, 1986, pp. 10 f., here p. 10.
30 *Der Maler Fritz Ryser: Skizzen und Bilder aus seinem Leben und Werk*, with texts by Margarete Pfister-Burkhalter, Hans Göhner and Werner Gfeller, Basel 1965. *Karl Dick 1884–1967*, with texts by Wolfgang Bessenich, Wilhelm Barth, and Wilhelm Altwegg, Basel and Stuttgart, 1967. *Schüpfer*, with a text by Hans Göhner, Kunsthalle Basel, 1974. *Jacques Düblin. Leben und Werk*, with texts by Werner Schupp, Hans Göhner, and Leo Lejeune, Basel 1975. *Ernst Baumann: ein Schweizer Maler*, with a text by Dorothea Christ, Basel and Stuttgart 1981. *Gustav Stettler*, with texts by Heinrich Wiesner and Hans Göhner, Basel, 1983. *Max Kämpf*, with texts by Helmi Gasser, Annemarie Monteil, Jean-Christophe Ammann, and Hans Weidmann, Basel, Boston, and Stuttgart, 1984.

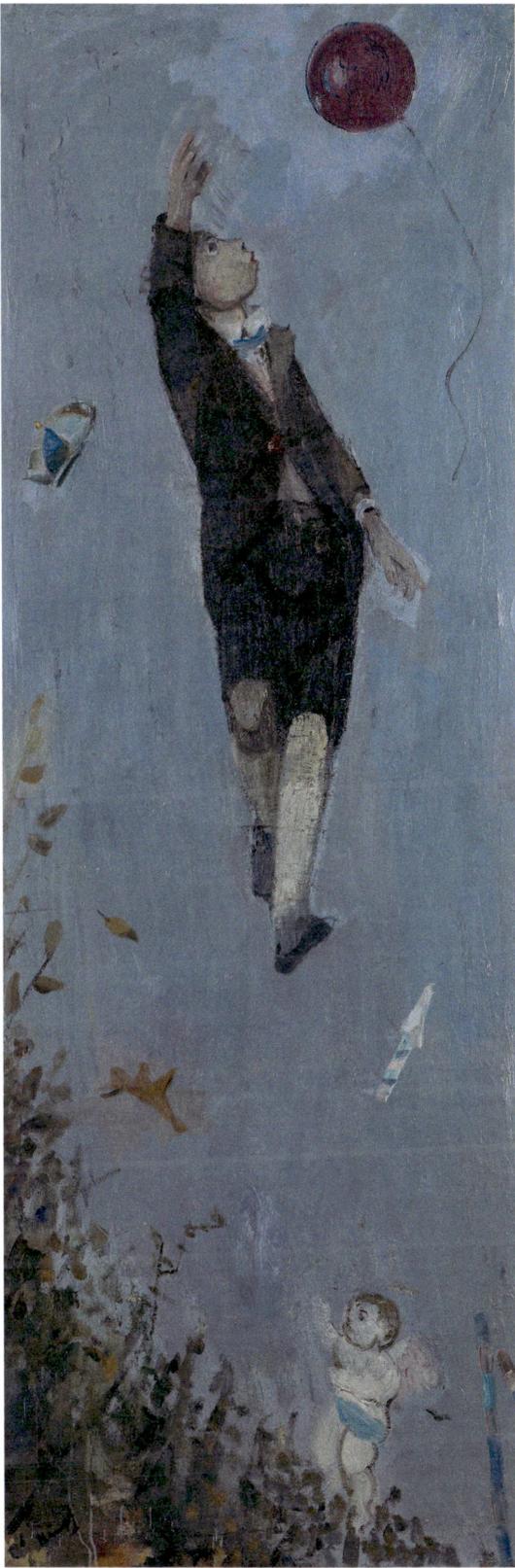

Max Kämpf, *Bube mit Ballon*, 1941–42

Ernst Baumann, *Heisser Sommer (bei Augst)*, 1947

Walter Bodmer, *Improvisation*, 1953

Samuel Buri, *Rot in Rot*, 1958

Lenz Klotz, *Struppig*, 1958

20

1954 and 1978 at the beginning of every year, and which were sent to business partners all over the world.[31] The photolithographic prints of drawings by artists such as Paul Basilius Barth, Niklaus Stoecklin, Karl Moor, and Walter Kurt Wiemken gave Göhner an opportunity to pen factually informative texts about each artist. Even the very first dispatch, in 1954, was printed in three languages (German, French, English). In retrospect, art critic Annemarie Monteil wrote of this "unusually insightful documentation … systematically zeroing in on a region (Basel), a generation (born between 1880 and 1914), and a medium (drawing)."[32]

The exhibition *Basler Kunst im 20. Jahrhundert – in Ausschnitten aus dem Besitz von Basler Unternehmen*[33] was undoubtedly the highpoint of Göhner's cultural engagement. Opening in August 1986 in the Theaterturnhalle at Theaterstrasse 12, it signaled a month-long celebration of Basel's modern art, coinciding with the centenary of the Christoph Merian Foundation (CMS). Rolf Gutmann (1926–2002), the architect who had designed the recently-built adjacent theater, was in charge of scenography, while Armin Hofmann (b. 1920) took charge of the graphic design for an exhibition that attracted more than 10,000 art lovers. Göhner had trawled the collections of various Basel companies to compile a presentation of more than 300 pictures and sculptures by some 160 artists. This ambitiously condensed and highly challenging art parcours included works by artists from Alfred Heinrich Pellegrini (1881–1958), Paul Camenisch (1893–1970), and Irène Zurkinden (1909–1987), to Hannah Villiger (1951–1997), Anselm Stalder (b. 1956), and Silvia Bächli (b. 1956). The catalogue lists 40 companies as lenders, though the owners of individual artworks were not specifically identified in either the exhibition or the catalogue. As Wolfgang Bessenich, longstanding art critic for the *Basler Zeitung,* noted: "Only this much can be discerned: almost half of the works on display come from three major collections, to wit, Basler Versicherungsgesellschaft, Schweizerische National-Versicherungsgesellschaft, and Schweizerischer Bankverein."[34]

The exhibition marked a previously unknown outpouring of public interest in the cultural endeavors of business enterprises in the Basel region. At the same time, however, it highlighted a similar trend among many of the other lenders. In the mid-1980s, the focus of many firms was on the Rot-Blau and Gruppe 33 circles. Although there was also a smattering of other contemporary and emerging artists, the danger of there being a certain uniformity and interchangeability between many of these collections was undeniable. It is in this context that we can gauge the title "Is Basel Provincial, or Is it Not?" chosen by Wolfgang Bessenich for his discussion of the exhibition, referring not only to the works on display, but also to the framework of the company collections involved.

31 1954 Karl Dick (1884–1967), 1955 Paul Basilius Barth (1881–1955), 1956 Paul Burckhardt (1880–1961), 1957 Alfred Heinrich Pellegrini (1881–1958), 1958 Niklaus Stoecklin (1896–1982), 1959 Jean-Jacques Lüscher (1884–1955), 1960 Otto Roos (1887–1945), 1961 Otto Staiger (1894–1967), 1962 Max Kämpf (1912–1982), 1963 Hans Stocker (1896–1983), 1964 Ernst Baumann (1909–1992), 1965 Gustav Stettler (1913–2005), 1966 Fritz Ryser (1910–1990), 1967 Karl Moor (1904–1991), 1968 Martin Christ (1900–1979), 1969 Walter Schneider (1903–1968), 1970 Jacques Düblin (1901–1978), 1971 Walter Schüpfer (1903–1972), 1972 Max Birrer (1905–1937), 1973 Walter Bodmer (1903–1973), 1974 Coghuf (Ernst Stocker, 1905–1976), 1975 Otto Abt (1903–1982), 1976 Walter Kurt Wiemken (1907–1940), 1977 Irène Zurkinden (1909–1987), 1978 Theo Eble (1899–1974).
32 Annemarie Monteil, "'Baloise'-Jahresblätter. Basler Kunst dokumentiert," in *Basler Zeitung*, 4, January 5, 1979, p. 38.
33 See *Basler Kunst im 20. Jahrhundert – in Ausschnitten, aus dem Besitz von Basler Unternehmen. 100 Jahre Christoph Merian Stiftung*, exh. cat., Basel 1986; cf. also Siegmar Gassert, "Ein Jahrhundert Basler Kunst," in *Basler Magazin*, 31, August 2, 1986, pp. 1–5.
34 Wolfgang Bessenich, "Ist Basel Provinz, oder ist es dies doch nicht?" in *Basler Zeitung*, 179, August 4, 1986, p. 19. The Baloise collection provided some 80 works on loan to the exhibition.

On the History of the Baloise Art Collections

Baloise and its Collection of Contemporary Art

The Baloise art collection comprised some 500 works when Hans Göhner stepped down from his role as keeper of the collection in 1985—four years after regular retirement age. The company directors took his retirement from the post as an opportunity to review their position both in terms of content and organization. Eventually they decided to set up an art committee with an art historian as an external advisor.[35] This panel, which meets several times a year for consultations and exhibition visits, is tasked with determining an annual budget framework for all art-related activities by the Baloise group. The committee is responsible for the care and expansion of the collection and, since the late 1990s, for the award of the Baloise Art Prize during the Art Basel fair, as well as for organizing the exhibitions at the Kunstforum Baloise.

For the past 35 years or so, the strategy has been focused on building up a collection of works on paper by contemporary artists, including drawings, gouaches, watercolors, and collages. Baloise chose this approach in the knowledge that the sensual yet unpretentious medium of paper, which constantly opens up new and different possibilities, is one of the most essential forms of artistic expression in our time.

In the early 1990s, the expanding collection took a new decisive direction toward the acquisition of photographic works. Since then, photography has become as important a part of the Baloise collection as the works on paper. In both of these mediums, groups of works by leading contemporary artists lend the collection its own distinctive profile.

This new direction went hand in hand with the collection's internationalization. Today, the Baloise collection of contemporary art comprises some 1,000 works by some 100 artists from 21 different countries. The veteran of the new collection is American conceptual artist Sol LeWitt (1928–2007), while Sara Cwynar and John Skoog (both b. 1985) are, at the time of publication, the youngest artists to enter the Baloise collection.

A primary focus of the collection is on Minimal and Conceptual art, as practiced in the 1960s and 1970s by American artists such as Sol LeWitt, Bruce Nauman (b. 1941), and Richard Serra (b. 1938). Their European counterpart in the Baloise collection is the German artist Franz Erhard Walther (b. 1939), one of the pioneers of participative art.

Another focal point is art of the 1980s—a decade in which expressive figuration, under the name of Neue Wilde or Transavanguardia, became a dominant and controversial force in European art. That generation of energetic, rebellious young artists is represented and documented in the Baloise collection through groups of works by the likes of Miriam Cahn (b. 1949), Martin Disler (1949–1996), Walter Dahn (b. 1954), Francesco Clemente (b. 1952), and Enzo Cucchi (b. 1949). At the same time, contrasting conceptual approaches by artists such as Helmut Federle (b. 1944), and poetically introspective mavericks such as Jonathan Borofsky (b. 1942), have also found a place in the collection.

35 See "Baloise Kunstsammlung neu orientiert," in *Basler Information*, 2, 1987, p. 1–8. The art committee is headed by a president—to date, Oliviero Tarolli (1986–2005), Philipp Senn (2006–2013), and Isabelle Guggenheim (since 2014). The author has acted as an external advisor to the committee since 1986.

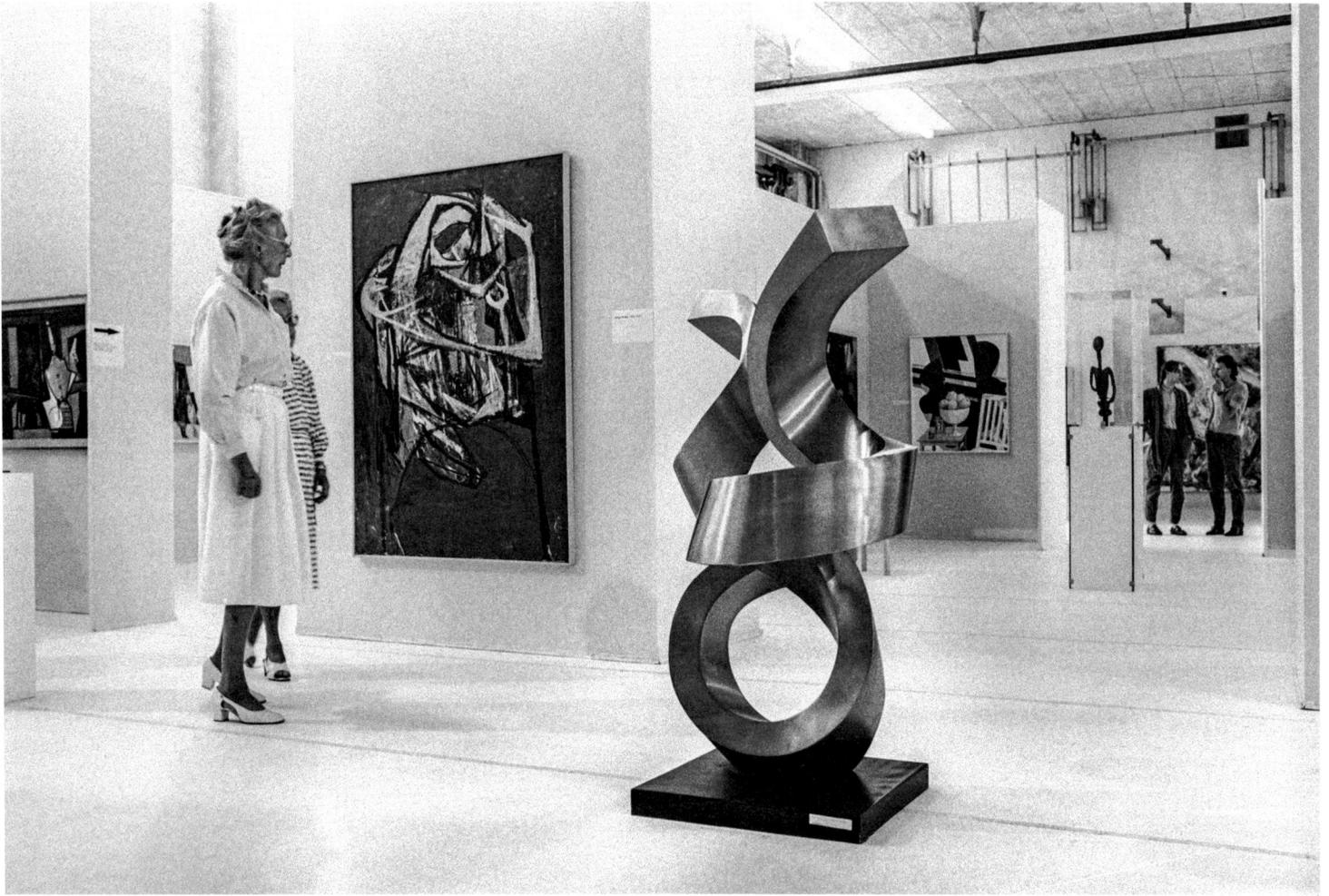

Basler Kunst im 20. Jahrhundert in Ausschnitten, exhibition view, Christoph Merian Stiftung,
Theaterstrasse 12, Basel, August 2–31, 1986

On the History of the Baloise Art Collections

Marcel Schaffner, *Maschine*, 1958

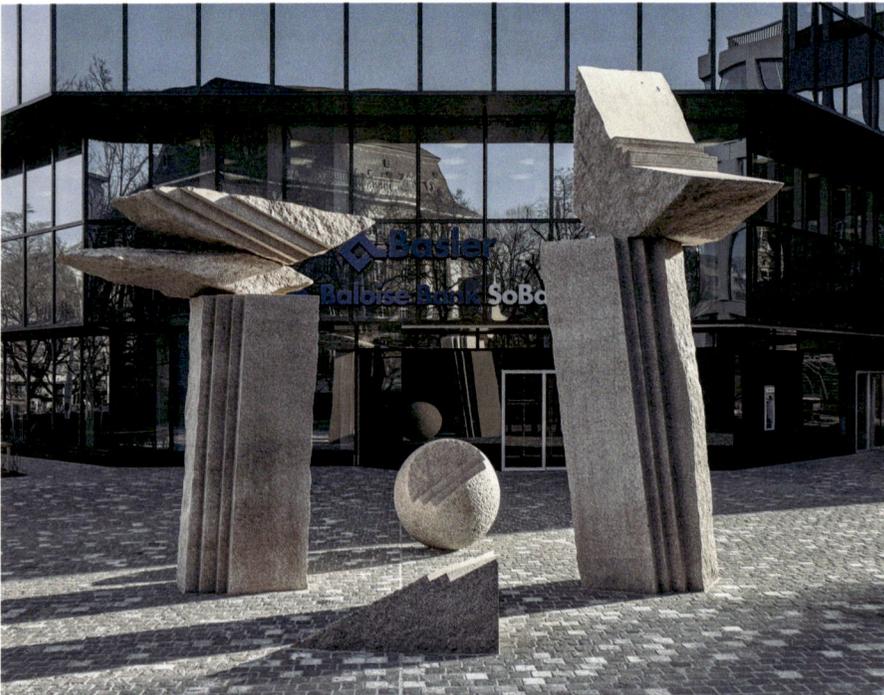

René Küng, *Steinerne Landschaft*, 1982–83

24

Since the turn of the millennium, there has been a huge expansion in the spectrum of expressive forms using the medium of paper: works on paper can range from preliminary sketches outlining some idea that has yet to be fully explored, to fully-fledged and carefully calibrated visual compositions. They may result from the exploration of some visual potential inherent within the medium itself, just as they might reflect the everyday culture shaped by media images. This latest, forward-looking aspect of the collection, which is being continually updated and expanded through new acquisitions, includes works by Silvia Bächli (b. 1956), Stephan Balkenhol (b. 1957), Ulla von Brandenburg (b. 1974), Marlene Dumas (b. 1953), Marcel van Eeden (b. 1965), Joanne Greenbaum (b. 1953), Zilla Leutenegger (b. 1968), Thomas Schütte (b. 1954), Lucy Skaer (b. 1975), Luc Tuymans (b. 1958), Amelie von Wulffen (b. 1966), and Heimo Zobernig (b. 1958).

The medium of photography first entered the Baloise collection in 1992 with the acquisition of two works by Jeff Wall—*Children* (1988) and *Adrian Walker* (1992). Since 2020, this Canadian artist's portraits of children—nine large-format transparencies—are an eye-catching feature of the entrance hall in the company's new Baloise Park headquarters designed by Diener & Diener Architekten.[36] Today the collection of visual photography and computer-generated images comprises, among others, works by Mathieu Kleyebe Abonnenc (b. 1977), Elger Esser (b. 1967), Karsten Födinger (b. 1978), Luke Fowler (b. 1978), Naoya Hatakeyama (b. 1958), Candida Höfer (b. 1944), Teresa Hubbard (b. 1965) and Alexander Birchler (b. 1962), Susanne Kriemann (b. 1972), Peter Piller (b. 1968), Thomas Ruff (b. 1958), John Skoog (b. 1985), Monica Studer (b. 1960) and Christoph van den Berg (b. 1962) as well as Stephen Waddell (b. 1968).

1999 marked the inaugural year of the Baloise Art Prize, awarded during the Art Basel fair. It is an award intended to support and promote two young and as yet little-known artists. Over the course of the past two decades, the prize has also become an important catalyst for prospective art acquisitions. Often coinciding with the awards, the acquisitions of works on paper and in photography means that important groups of works by the artists in question have entered the Baloise collection at an early stage in their careers. Today the collection includes works by laureates such as Laura Owens (b. 1970), Annika Larsson (b. 1972), Cathy Wilkes (b. 1966), Monika Sosnowska (b. 1972), Ryan Gander (b. 1976), Keren Cytter (b. 1977), Andreas Eriksson (b. 1975), Simon Denny (b. 1982), Jenni Tischer (b. 1979), Kemang Wa Lehulere (b. 1984), Mary Reid Kelley (b. 1979), and Sara Cwynar (b. 1985).

The art committee has twice contributed its expertise to important new building projects in Basel. In the early 1990s, Baloise commissioned Luciano Fabro (1936–2007), one of the leading lights of the Arte Povera generation, to shape the surroundings of the office building on Picassoplatz design by Diener & Diener Architekten. With his *Giardino all'italiana* the Milan-based artist created "an energy-laden place" (Fabro, 1994) that gives people the opportunity for "quiet, calm, and introspective contemplation."[37]

36 Jeff Wall's *Children* (1988) was previously installed in the entrance hall of the NAPA company building, inaugurated in 1994. This office building, designed by Burckhardt+Partner, gave way in 2016 to the Baloise Park development.
37 Martin Schwander, "Giardino all'italiana," in *Artmagazin. Die Kunstsammlung der Basler*, 1999, pp. 24–25, here p. 25.

Completed in the spring of 2020, Baloise Park consists of an urban square delineated by three distinctive buildings. It is here, on this new and prominent site—in view of the Centralbahnplatz, the SBB railway station, and the Strasbourg Monument (unveiled in 1895), by Frédéric-Auguste Bartholdi who also created the Statue of Liberty in New York—that Baloise has installed Thomas Schütte's monumental bronze *Drittes Tier* (2017). This amiable mythical creature, unconcernedly snorting and expelling steam through its nostrils, has the potential to become a favorite of passersby.

Schütte's sculpture lies within view of the entrance to the company headquarters. On the ground floor of the glass office building by Diener & Diener Architekten, the Kunstforum Baloise—150 square meters of exhibition space open to the public—invites visitors to come and see its changing exhibitions. In the middle of the building, on every floor, there are square rooms that the architects have dubbed "étagères," where works from the collection are presented. Accordingly, the art at Baloise Park opens up a panoply of promising perspectives.

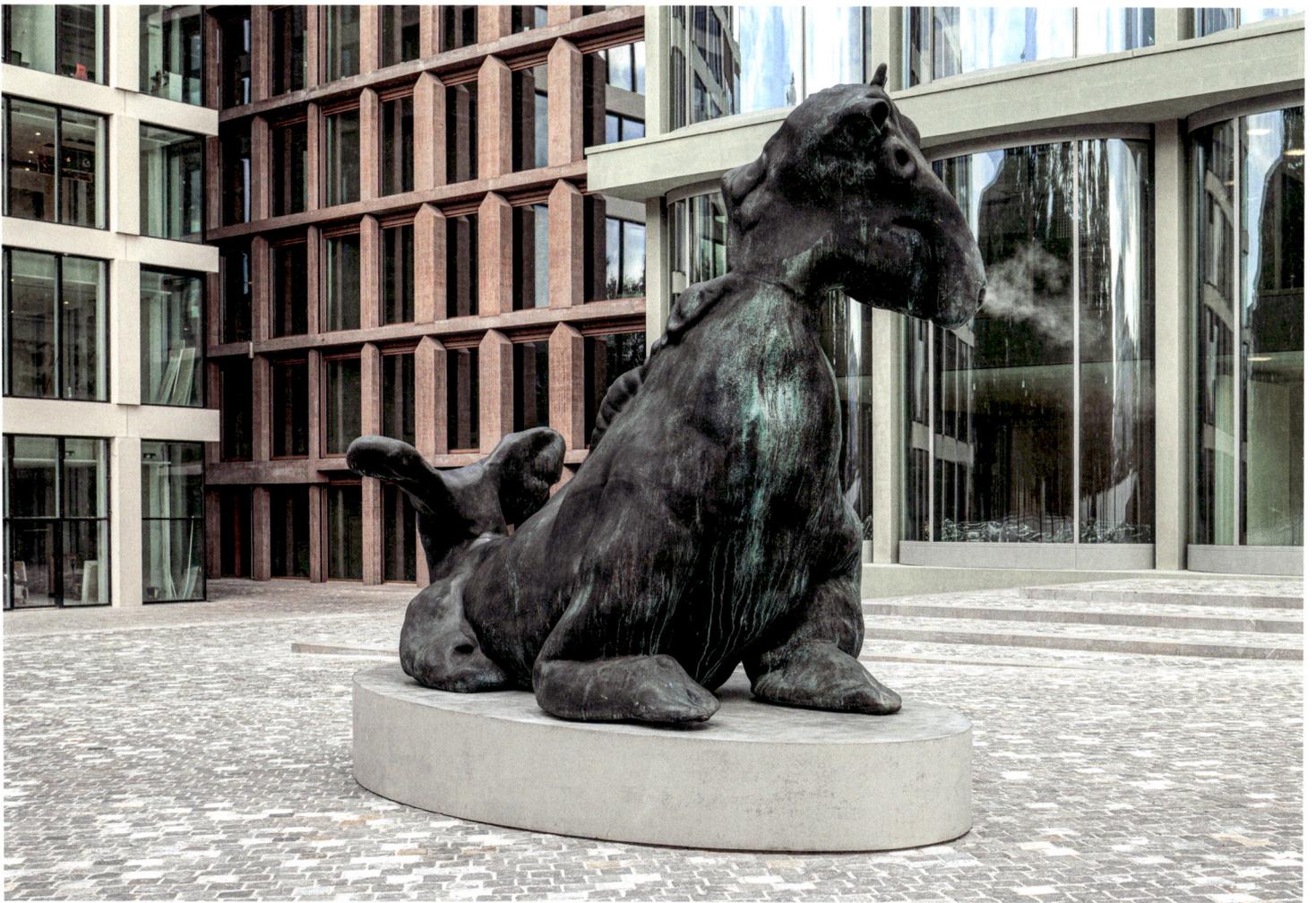

Thomas Schütte, *Drittes Tier*, 2017

On the History of the Baloise Art Collections

Artists from the Collection

The following pages provide a condensed insight into the Baloise art collection, featuring a range of works on paper, and photographs by international artist from the 1960s onward. Right from the start, Baloise has pursued a strategy of following the progress of individual artists over a lengthy period of time and acquiring entire groups of works by each of them. Here you will find a selection of these artists, with a presentation of some or all of their respective groups of artworks. For a more comprehensive insight into the Baloise art collection, visit the company website at www.baloiseart.com.

Mathieu Kleyebe Abonnenc, Silvia Bächli, Stephan Balkenhol, Jonathan Borofsky, Miriam Cahn, Francesco Clemente, Enzo Cucchi, Sara Cwynar, Keren Cytter, Walter Dahn, Simon Denny, Martin Disler, Christoph Draeger, Marlene Dumas, Marcel Dzama, Andreas Eriksson, Elger Esser, Luciano Fabro, Helmut Federle, Karsten Födinger, Luke Fowler, Pia Fries, Katharina Fritsch, Simon Fujiwara, Ryan Gander, Geert Goiris, Joanne Greenbaum, Naoya Hatakeyama, Candida Höfer, Teresa Hubbard/Alexander Birchler, Thomas Huber, Alain Huck, Susanne Kriemann, Annika Larsson, Zilla Leutenegger, Sol LeWitt, Aleksandra Mir, Tracey Moffatt, Mrzyk & Moriceau, Claudia & Julia Müller, Bruce Nauman, Saskia Olde Wolbers, Peter Piller, Mary Reid Kelley, Thomas Ruff, Thomas Schütte, Richard Serra, Ross Sinclair, Lucy Skaer, John Skoog, Monika Sosnowska, Anselm Stalder, Monica Studer/Christoph van den Berg, Jenni Tischer, Luc Tuymans, Marcel van Eeden, Inez van Lamsweerde, Ulla von Brandenburg, Amelie von Wulffen, Kemang Wa Lehulere, Stephen Waddell, Jeff Wall, Franz Erhard Walther, Cathy Wilkes, Erwin Wurm, Heimo Zobernig

Mathieu Kleyebe Abonnenc

Born 1977 in Paris, lives in Sète

Mathieu Kleyebe Abonnenc, *Vieux-Wacapou. La maison de M. Bernes*, 2017–18

Since 2017 French artist Mathieu Kleyebe Abonnenc has been working on a series of large-format color photographs under the title *Vieux-Wacapou*. The photographs were taken in French Guiana, an overseas department and region of France on the north-eastern coast of South America, where the artist spent his childhood. The title of the series refers to the Maroni river, which is the destination of Abonnenc's journeys into the interior.

Already in the early 20th century, this was a settlement that attracted newcomers from the English-speaking island country of Saint Lucia and the French-speaking neighboring islands of the Antilles. Most of the settlers were people of African descent whose ancestors had been slaves in the Antilles. Over the course of time, Wacapou developed into a prosperous village that was supported primarily by gold panning. In the mid-1980s, the artist's mother decided to buy a house there, which had previously been occupied by a former gold panner named Joseph Bernes. However, her plans for her family to sometimes stay in this modest wooden house on stilts were thwarted by the postcolonial civil war that broke out in neighboring Suriname in the summer of 1986, making it dangerous to remain in such a volatile border area.

1 "Où que je me tourne, d'autant plus en Amérique du Sud, les questions avec lesquelles j'aimerais m'avancer s'avèrent productives : A qui est cette terre ? De qui la tenez-vous ? Où est votre maison ? Ces trois récits orientent la lecture des lieux que j'aimerais traverser pour tenter de donner une image au souvenir fragile de cette maison." Quoted from the unpublished project description of Abonnenc's film *Maraudeur*, 2017, p 7.

It was not until 30 years after the violent upheaval in Suriname that Abonnenc took the decision to travel to Wacapou. The photographic series *Vieux-Wacapou* documents the artist's quest for the place of his childhood. Today, the remains of the abandoned settlement are buried beneath a dense layer of vegetation. Abonnenc had to apply himself as an archaeologist in order to uncover the secrets of the jungle. Just as our eyes adjust only gradually to the darkness, so too do we recognize, in time, the traces of the former village and its history: the stilts of the houses, the gas bottles, the crosses in the graveyard, the concrete steps of the jetty. Abonnenc's photographs of the abandoned village of Wacapou are a complex amalgam of European colonial history, the march of time, and family history. At the same time, Abonnenc's exploration of the history of his mother's house confronts him with questions that go far beyond his immediate quest. As he puts it: "Wherever I turn, especially in South America, the questions I want to pose, for my own edification, prove to be productive: Whose land is this? Who did you get it from? Where is your house? These three narrative strands direct the way I interpret the places that I would like to visit in my bid to capture an image portraying the fragile memory of this home."[1]

Martin Schwander

Mathieu Kleyebe Abonnenc, *Vieux-Wacapou. Le dégrad*, 2017–18

Silvia Bächli

Born 1956 in Baden, lives in Basel

In the mid-1980s Silvia Bächli became known for her striking presentations of variously sized drawings—unframed, directly on the wall or elsewhere in the exhibition space. In her displays the gallery wall has a similar role to that of the areas of visible white picture ground in individual drawings, where motifs are seen in a reduced tonality ranging from pale gray to pitch black. This unpretentious pictorial language is in keeping with her subjects, whether simple objects or observations the artist makes in her own environment or about aspects of herself, from her head to her body language to gymnastic contortions. Bächli's drawings are made individually, not as part of a larger composition or pictorial narrative. It is only after the event that she puts together groups or ensembles from her fund of drawings, taking individual sheets and creating connections between them that could perhaps better be described as constellations rather than compositions. This means that while there is no linear story for the observing eye to read, there is an open-ended narrative of sorts, albeit only a potential narrative in which the unsaid, things between the lines, vague glimpses of memory, and the climate that nurtures things of that kind are just as important as individual pictorial motifs.

In 1998, a good ten years after the nine-part ensemble of drawings *Feldstecher – Leiter – böses Gesicht*, Bächli painted *Floréal Nr. 2*, a dynamic, large-format linear composition, which marked the beginning of an extensive series of gouaches. Even if this almost Baroque group of works appears to be the polar opposite of her work as a whole, which generally tends toward reduction, the wonderfully light,

1 See Silvia Bächli, *Lidschlag. How It Looks*, Baden 2004, unpaginated.

Silvia Bächli, *Feldstecher – Leiter – böses Gesicht*, 1986–87
Installation view at the Kunsthalle Basel, 1987

Silvia Bächli, Untitled, 2003

"flowery" clusters do in a sense indicate the direction that her drawings and linear art have taken since then. Her pictorial means have remained sparse, yet there is room for calligraphic elements; masterful ease is perfectly balanced with extreme concentration.

Bächli's work has become ever denser, like an inward spiral. Whereas there were hints and touches of narration in her early works, autonomous abstraction has increasingly taken precedence over figuration. Meaning is distilled in concentrated contents and looms into view with poetic concision. But there is also an outward spiral: within the close confines of her work—"drawing and painting on paper is my sole artistic activity"[1]—and for all the restraint of her pictorial means and the absolute priority given to the line, Bächli has laid claim to an extensive terrain that goes far beyond the bounds of conventional drawing. The fact that color suddenly appeared in her work over ten years ago—which previously had seemed barely possible—attests to the great freedom she allows herself in those close confines. And another thing still holds true: these days when Bächli is able to fill an entire room with her works, the outcome is always a multipart, full-scale mise-en-scène: a realm of drawing for visitors to stroll through as they please, with no immediate goal.

Beat Wismer

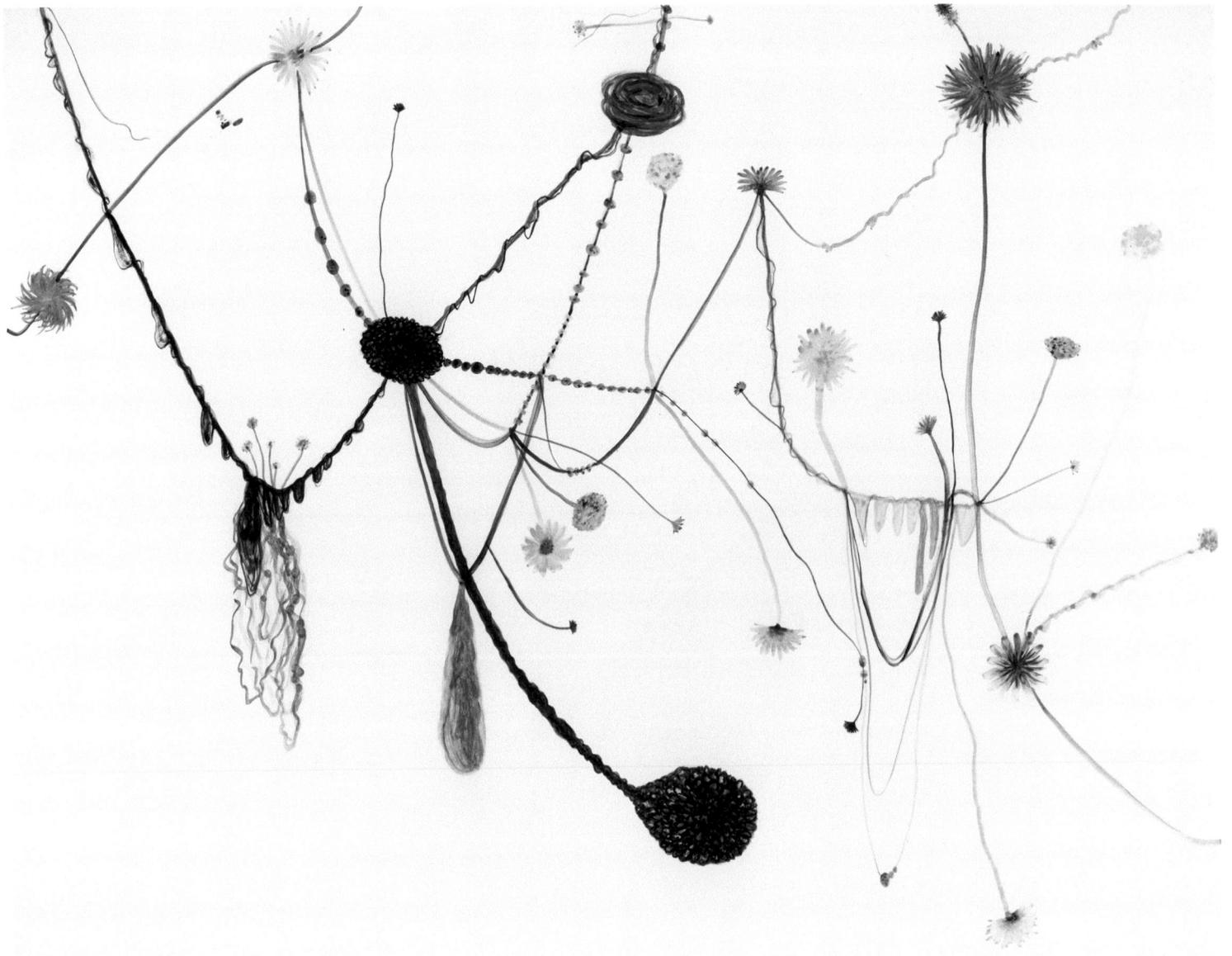

Silvia Bächli, *Floréal Nr. 2*, 1998

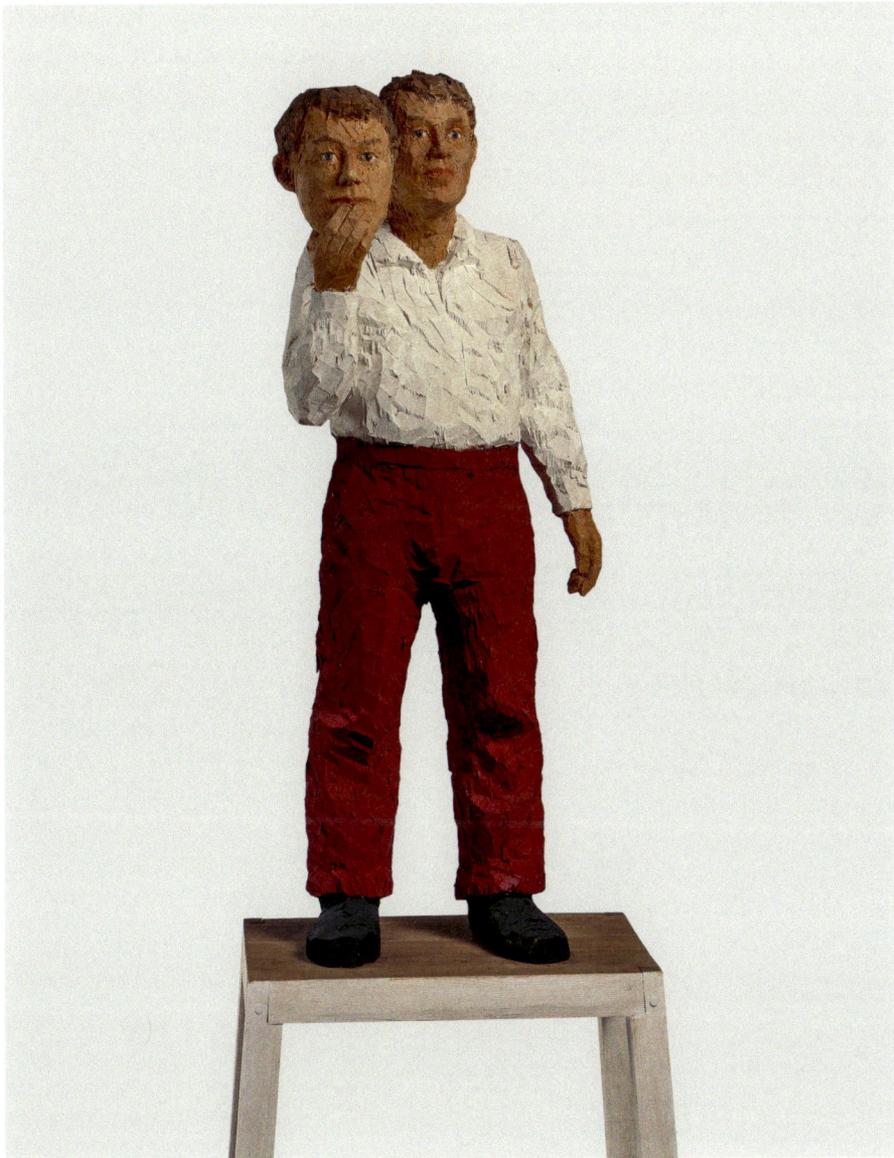

Stephan Balkenhol, *Mann mit Maske*, 1995

Stephan Balkenhol

Born 1957 in Fritzlar, Germany, lives in Kassel, Karlsruhe, Berlin, and Meisenthal, France

Human beings are at the heart of Stephan Balkenhol's work. Usually they are alone, but now and then they may be accompanied by animals or architectural elements. The figures we encounter in his delicate drawings or in roughly hewn wooden sculptures with painted finishes are anonymous, reserved, even emotionless. A man leans against a table, a dancing woman swirls her skirt, another woman gazes directly at us clutching her arm, a man draws a stick figure—Balkenhol captures unremarkable moments. The people he pictures are entirely absorbed in themselves. They look composed, impartial, aloof. Their gaze, despite being directed toward us, often seems vacant. This further heightens their intriguingly puzzling air: "So far I've always wanted to keep the figures' characters and demeanor as open as possible and not pin them down with some telling expression," Balkenhol explained in an interview in 1992, the same year that he became a professor at the Staatliche Akademie der Bildenden Künste Karlsruhe.[1]

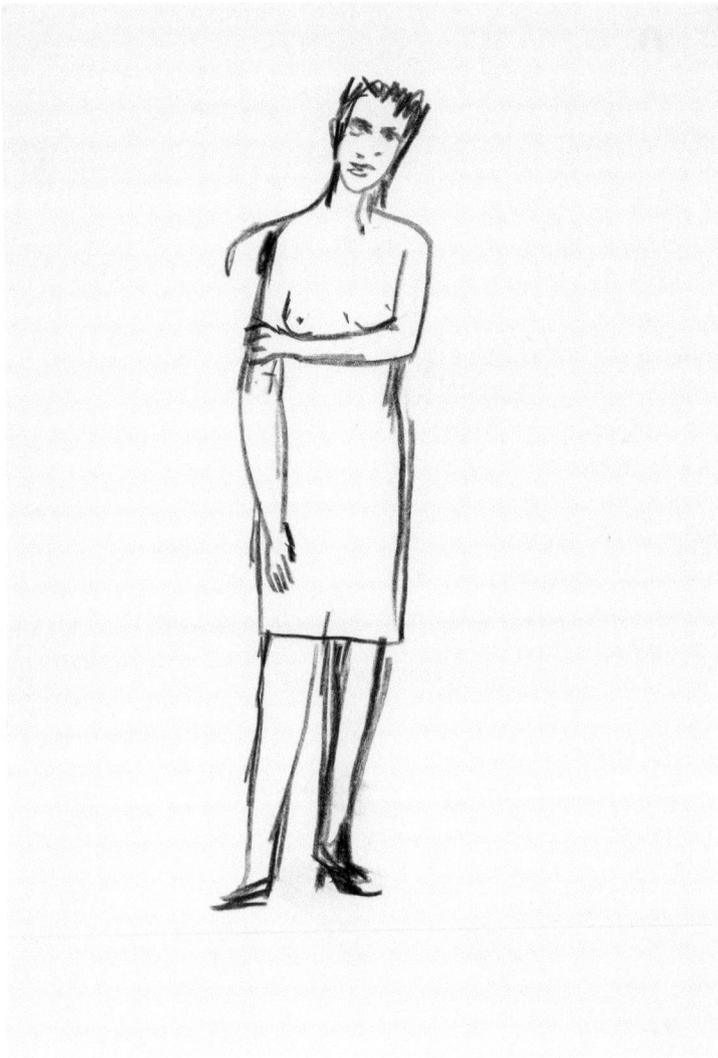

Stephan Balkenhol, Untitled, undated

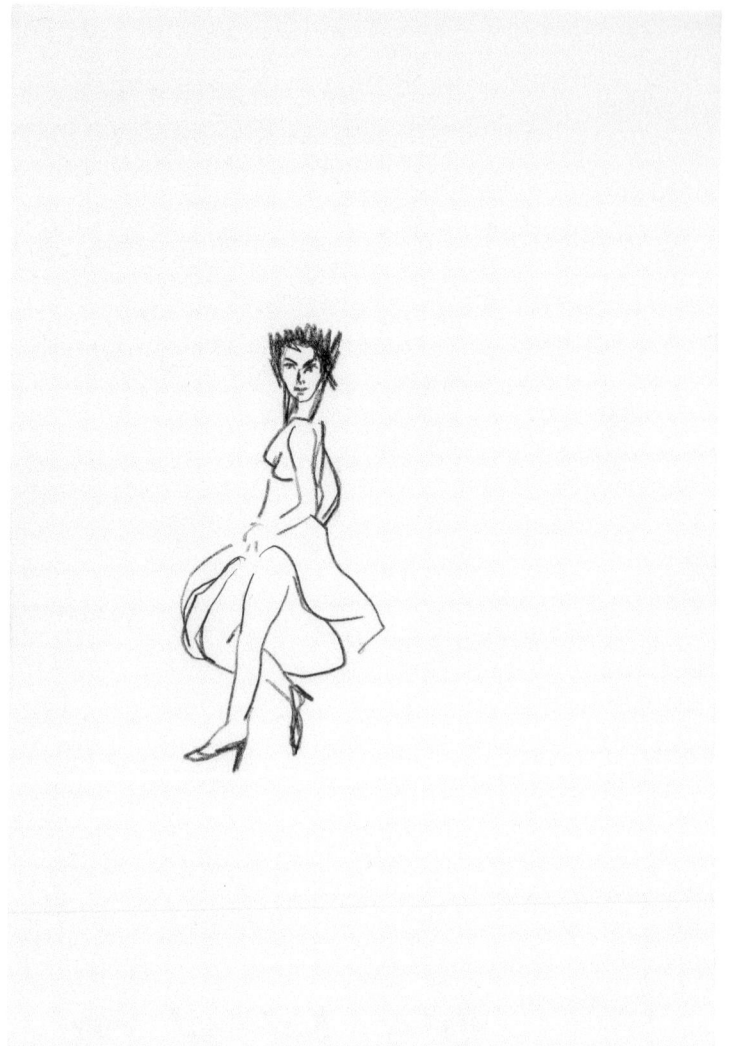

Stephan Balkenhol, Untitled, 1984

When Balkenhol studied under Ulrich Rückriem and Sigmar Polke at the Hochschule für bildende Künste Hamburg, his figurative compositions went against the grain of the prevailing abstract art and conceptual art: "My works aren't portraits in the concrete sense: they don't portray anyone in particular, nor are they signs or symbols of human beings."[2]

Balkenhol's small-format drawings should not be seen as preparatory studies for his sculptures, however closely related they may be thematically. In a few deft lines Balkenhol secures his observations of both the external and the internal world. Succinct yet hesitant, almost awkwardly rendered, these images are telling examples of thinking through drawing.

Brigitte Kölle

1 Stephan Balkenhol in conversation with Thomas Schütte, in *Stephan Balkenhol. Über Menschen und Skulpturen/About Men and Sculpture*, Stuttgart 1992, pp. 72–79, here p. 74.
2 Stephan Balkenhol in conversation with Marie Luise Syring and Christiane Vielhaber, in *BiNATIONALE. Deutsche Kunst der späten 80er Jahre/German Art of the Late 80s*, trans. William A. Mickens, Cologne 1988, pp. 68–77, here p. 69.

Stephan Balkenhol, Untitled, 1997

Stephan Balkenhol, Untitled, 1981

Jonathan Borofsky

Born 1942 in Boston, lives in Ogunquit, Maine

When Jonathan Borofsky arrived in New York in 1966, with his freshly minted postgraduate degree from Yale University, his interest was less in the practice of art, than in what leads us to think about the definition of art it suggests and its *raison d'être*. Couching philosophical concepts and aphorisms on paper, he thematizes the routine of "making" art, devoting himself daily to numerical notation in works that were later grouped under the title "Counting from 1 to 3227146." Over the years Borofsky developed a particular sensitivity for anodine materials that are a familiar presence in everyday life. His work takes shape naturally on paper, for example, a support that is both inexpensive and accessible to all. Meeting the artist Sol LeWitt and the theoretician Lucy Lippard at the start of his career encouraged him to deploy his drawings directly onto the walls of the exhibition venue. His first show at Paula Cooper Gallery in 1975 and a second one at MoMA in 1978 made clear his special affinity for designing the display and arrangement of his works as a single spatial installation.

The large Borofsky drawing 2,260,384 in the Baloise collection is a fine example of his monumental approach to both drawing and the legacy of minimal art. Here the artist limits his interventions as much as possible to allow the human figure to surge out of the white reserve of the sheet of paper. In this body, reduced as it is to a few lines, we can already make out the silhouette and artificial forms of the artist's large-scale sculptures that would later be installed in city spaces, such as the *Hammering Man* (1989) in Basel's Aeschenplatz.

Jonathan Borofsky, Untitled (2515729), undated

Jonathan Borofsky, Untitled (2,495,559), undated

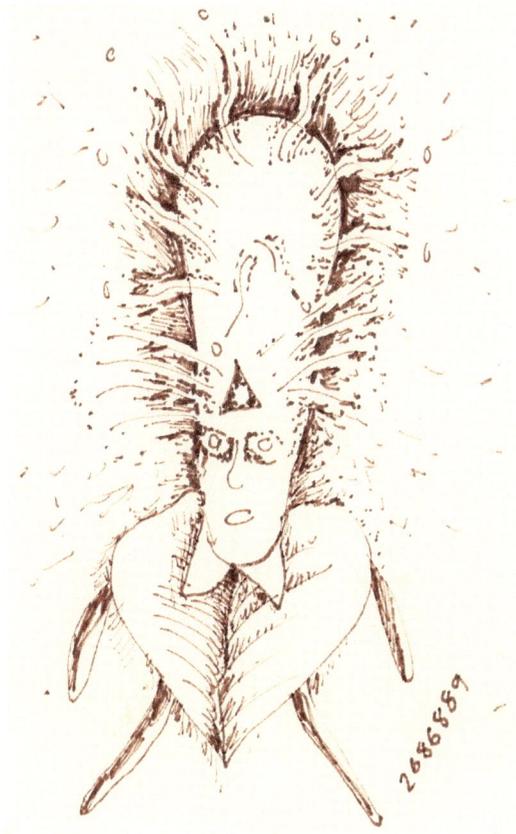

Jonathan Borofsky, Untitled (2686889), undated

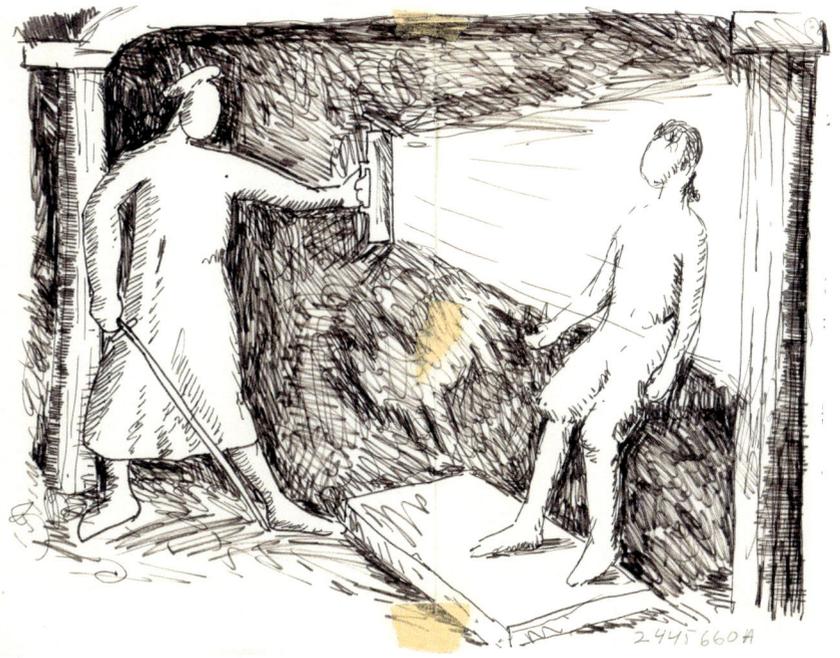

Jonathan Borofsky, Untitled (2445660A), 1977

But the great inspiration for Borofsky's drawings lies especially in the artist's dreams. That can be seen in the page from a small ring notebook 2445660A, where he has drawn a figure armed with a sword and shining a spotlight on a young man seated with his back to the wall in felt-tip pen. In a style that blends the legacy of Philip Guston, a certain influence from Robert Crumb, and a distant reminder of Renaissance classicism, Borofsky asserts his own idiom here. Combining the simplicity of forms with an access to the hermetic world of the unconscious, this idiom surfaces, for example, in the portrait of a character with a hairy hypertrophic head (drawing 2686889). A triangle on its forehead with a point at its center seems to form something like a third eye on this flabbergasted-looking figure. Its head, lacking a neck, rests on what appears to be a leaf with four stems that are akin to the legs of an insect. In this hybrid world where the kingdoms mix and melt into one another, Borofsky also finds animals, like the bird whose flight closely follows a spiral, while a giant fish with an expressive face takes on a barely outlined human form.

A subtle blend of the simplicity of its forms and a visual language that everyone can understand, drawing in Jonathan Borofsky's work reflects his universalist vision of art, which has taken shape on the fringes of the great urban centers, independent of contemporary trends.

Julie Enckell Julliard

Jonathan Borofsky, Untitled (2,260,384), 1975–76

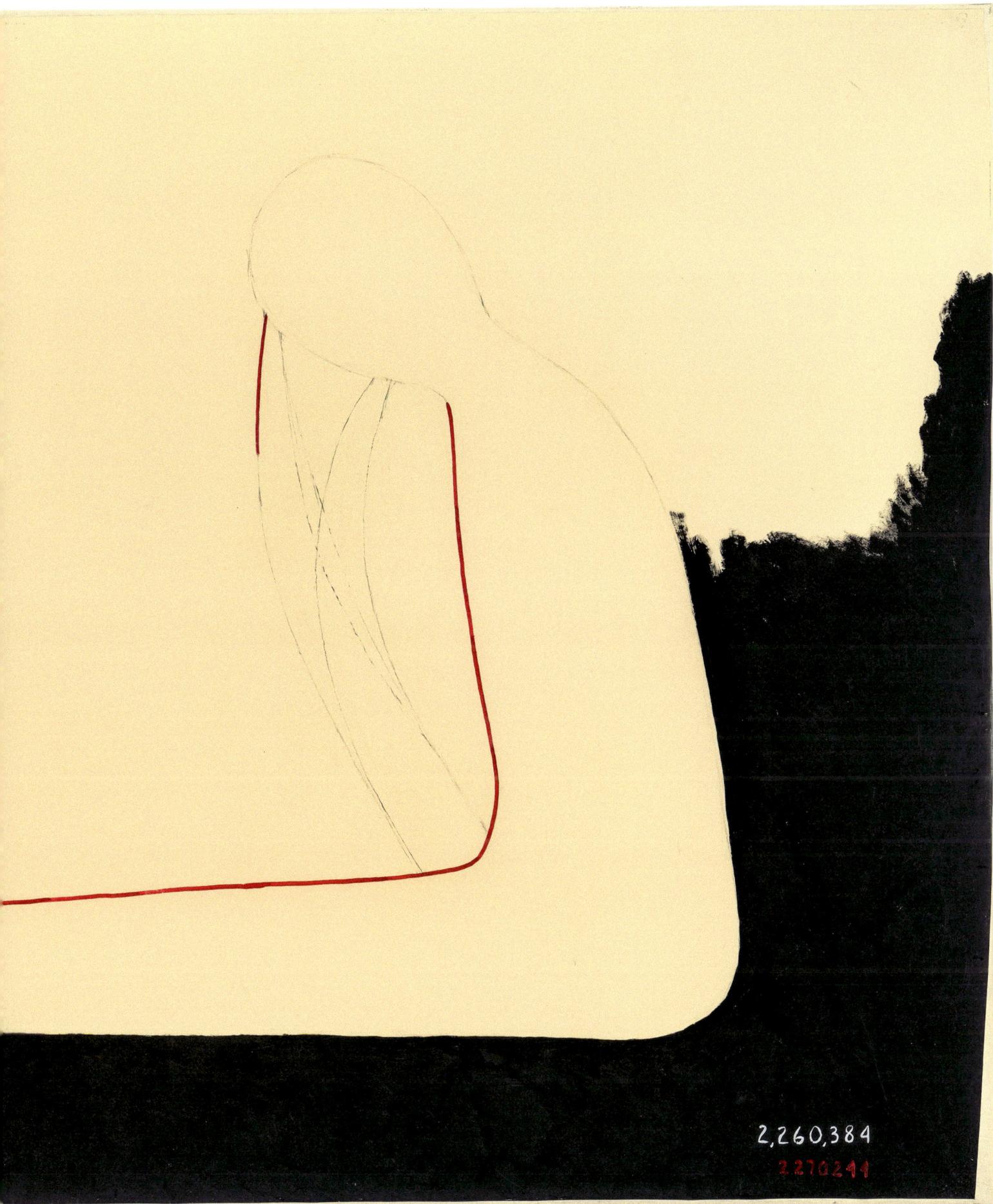

2,260,384
2270211

41

Miriam Cahn

Born 1949 in Basel, lives in Basel and Stampa

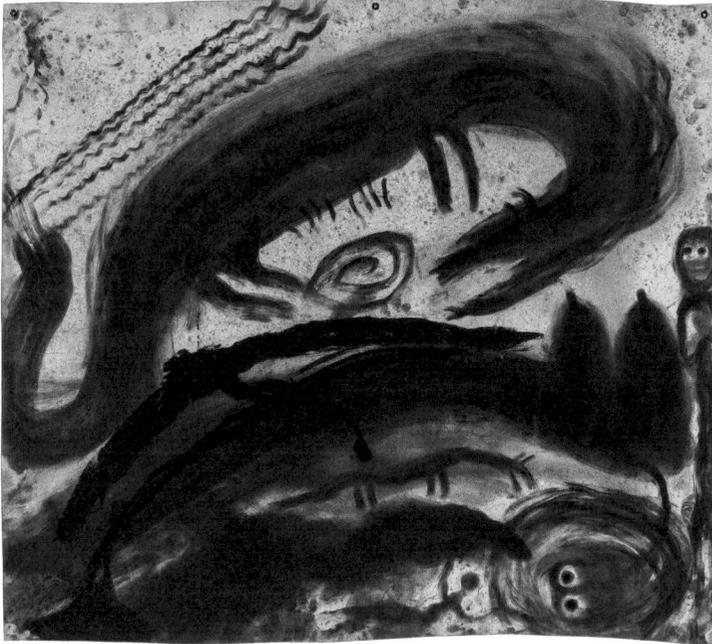

Miriam Cahn, *Frau mit 2 Körpern*, 1986

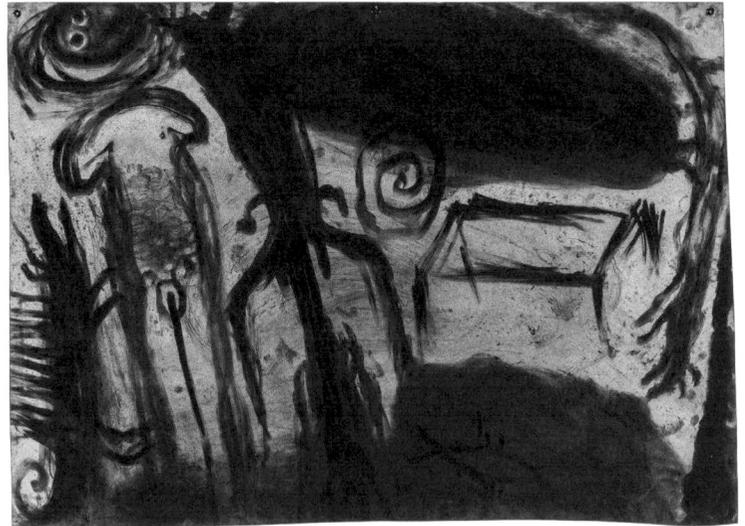

Miriam Cahn, *Frau mit 2 Körpern*, 1986

Miriam Cahn's decision in the late 1970s to draw in black and white was a carefully considered one. It marked a deliberate departure from traditional notions of art. Instead Cahn developed a performative praxis that allowed her to combine private and public motifs, personal and political issues. For these new drawings she used fragile paper, heavily charged with materials that peeled away from the paper ground, creating a naive, childlike language of forms. She turned her back on the male cult of genius, working in huge formats and no longer striving to retain an overview of her own artistic creativity, resolutely refraining from making adjustments in order to avoid paying homage to the fetish of the "masterpiece." Her aim was to create "womanly" works, in which—thanks to their intuitive making—unfiltered, innate knowledge would rise to the surface.

Having specifically explored the differences between the sexes in the late 1970s and early 1980s, in the mid-1980s Cahn started to work on series focused on the interrelationships between humans, animals, and plants. Nowadays this is a hotly debated topic in the philosophical discourse surrounding the Anthropocene (the age of human beings), but Cahn was already engaging with it at a time when Europe, more than ever before, was gripped by the fear that the Cold War could lead to a nuclear bomb being dropped, a time when the world suffered a number of terrible environmental disasters. Against this backdrop of unprecedented, manmade forces of destruction, Cahn created dreamlike inner images, but in her art she also warned against the political and ecological hazards facing humanity: the more tangible the threat posed by global politics, the more vulnerable and withdrawn the animals, children, and plants in her clouded, black charcoal drawings.

1 Miriam Cahn, *WHAT LOOKS AT ME.
 SURROUNDINGS*, trans. Claire Bonny,
 Darmstadt 1996, p. 21.

Since then she has taken her intentional loss of creative control a stage further by drawing with her eyes closed, or using her hands to conjure up figures from black chalk dust. She does this by activating her body memory, and as she concentrates on affinities between different beings, she herself temporarily becomes the fish, bird, horse, or tree that she is drawing. During the creative process her body recalls distant ages in the history of the natural world, and she associates the black dust that she rubs off blocks of chalk with the ancient strata of the Earth. Exploring relationships and affinities, Cahn also delves into the similarity between corporeal outgrowths and the energies that make plants grow. It is only chance that dictates whether this energy has a positive outcome in the spring-like burgeoning of shoots, leaves, and blossoms, or a negative outcome in a rampant ulcer. Cahn has written: "the work art as I understand it means relationship to nature rethinking, working and taking action what plant, animal, landscape is to me (i.e., everyone). my plant-being, my landscape-being, my stone-being, my animal-being are my political and public part, just as my woman-being is my political and public part."[1]

Kathleen Bühler

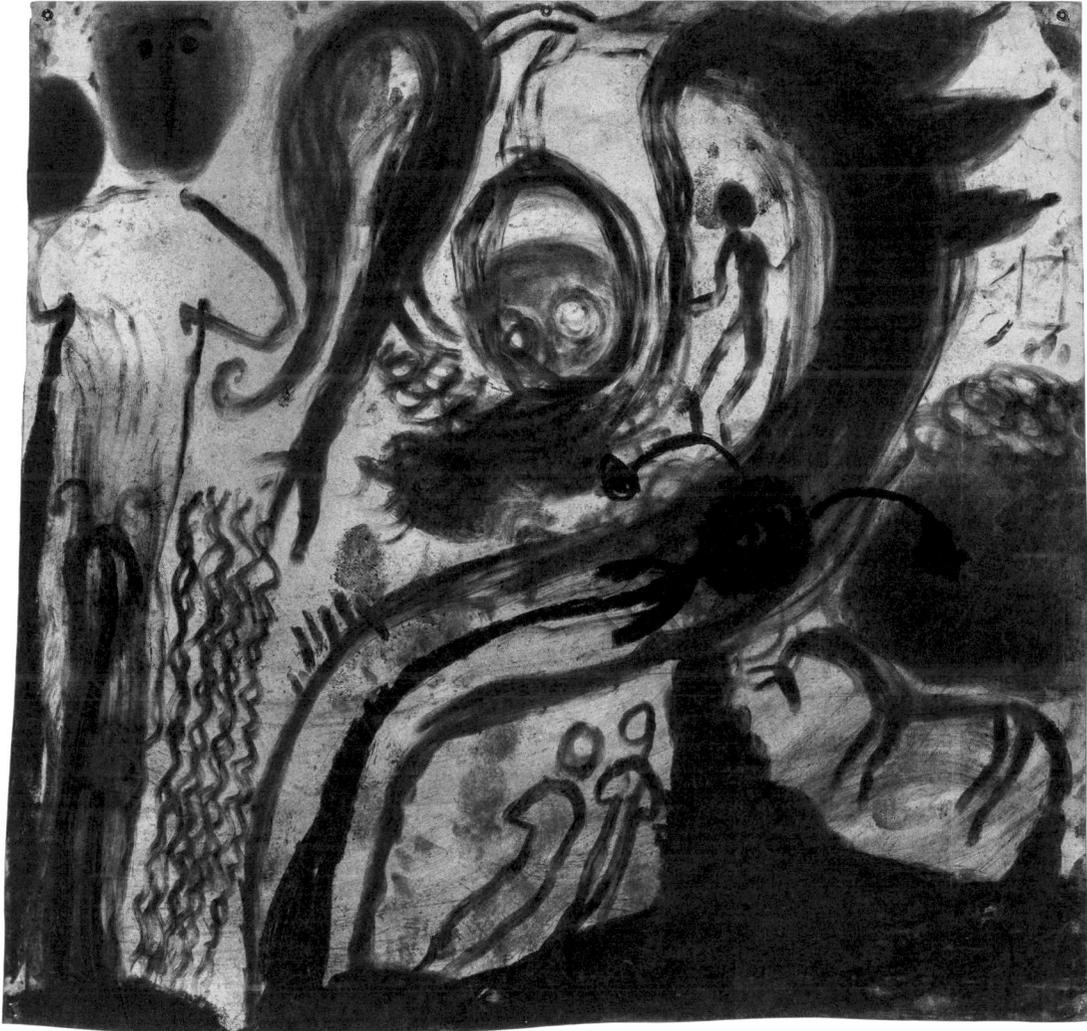

Miriam Cahn, *L.I.S./m.d.k.+t.*, 1986

Francesco Clemente

Born 1952 in Naples, based in New York

Born into a cultured and art-loving family, Francesco Clemente received a humanist education and, from an early age, traveled with his parents throughout Europe, getting to know many cities and their museums. Before devoting himself fully to a career as an artist, he spent several semesters studying architecture in Rome. It was during this time that he made his first visits to Asia. Since 1977 he has lived and worked in Madras (India). Then, in 1981, he took a studio in New York, and has divided his time ever since between Italy, America, and India.

These broad horizons have shaped Clemente's fundamentally multicultural view of life. He took an early interest in Europe's past and present-day roots in antiquity, as well as in the local traditions of southern Italy. In India he engaged intensively with Asian mythology and imagery. America then opened up a rewarding exploration of the New World and its changing focal points, as well as an insight into the Native American cultures that influenced avant-garde artists such as Jackson Pollock.

Through these many and varied influences, the artist gradually developed his own distinctive approach of combining diverse motifs, styles, and techniques, figural and figurative fragments, painterly gestures, and conceptual thinking. His visual syntax, clearly shaped by a free and graphic style, remains fluid and open to change, without ever calling into question the notion of the image itself. As Clemente puts it: "I have never thought in terms of abstraction or figuration. I have always thought in terms of fluidity and fracture. My work is born out of a proliferation of drawings. They were amulets, made to remember images that had for me a healing power. The continuity of the proliferation, on the one hand, and the fracture, the recognition of the fracture of identity, on the other. I was attempting to reflect this polarity of fluidity and fragmentation, and give witness to these two elements of experience. The continuity of the image and the interruptions of the self."[1]

Typical characteristics of his work include a playful fluidity and layering of different and often fragmentary motifs without reference to place. Elements from comic strips combine with mythological signs, and the surreal with the clearly defined, often within one and the same image. This ambiguity is evident in the works shown here, which do not attribute any unequivocal role to that which they portray, but which instead are infused with a playful underlying tone. In this context, Clemente has stressed the influence of his hometown of Naples and its self-identity: "There is a great amount of play." There is a "greater imagination in how many roles and how many parts are allowed to be interpreted in real life."[2]

In this, he names a factor that sets him apart from the Italian Transavanguardia, which, at the same time, he so distinctively represented.[3] His work is clearly oriented toward "disegno." Here it is not the expressive and vibrantly colorful style prevalent in northern Europe at the time that comes to the fore, but a more muted palette of painting and drawing. Nor is his focus on the immediate past, but on a retrospective contemplation of the mythical sources, and on the concern for beauty and balance that prevailed in classical art.

Carla Schulz-Hoffmann

1 Francesco Clemente in conversation with Danilo Eccher and Francesco Pellizi (New York, March 1999), in Danilo Eccher, *Francesco Clemente. Arbeiten auf Papier*, exh. cat. Galleria d'Arte Moderna – Bologna, Villa delle Rose; Kunstsammlung Nordrhein-Westfalen, Düsseldorf, Turin, and London 1999, pp. 91–166, here pp. 127–128.
2 Ibid., p. 96.
3 The term "Transavanguardia," coined by Achille Bonito Oliva, primarily describes the Italian variant of neo-expressionism in the late 1970s and 1980s. Achille Bonito Oliva, *La Transavanguardia Italiana*, Milan 1980.

Francesco Clemente, Untitled, 1971

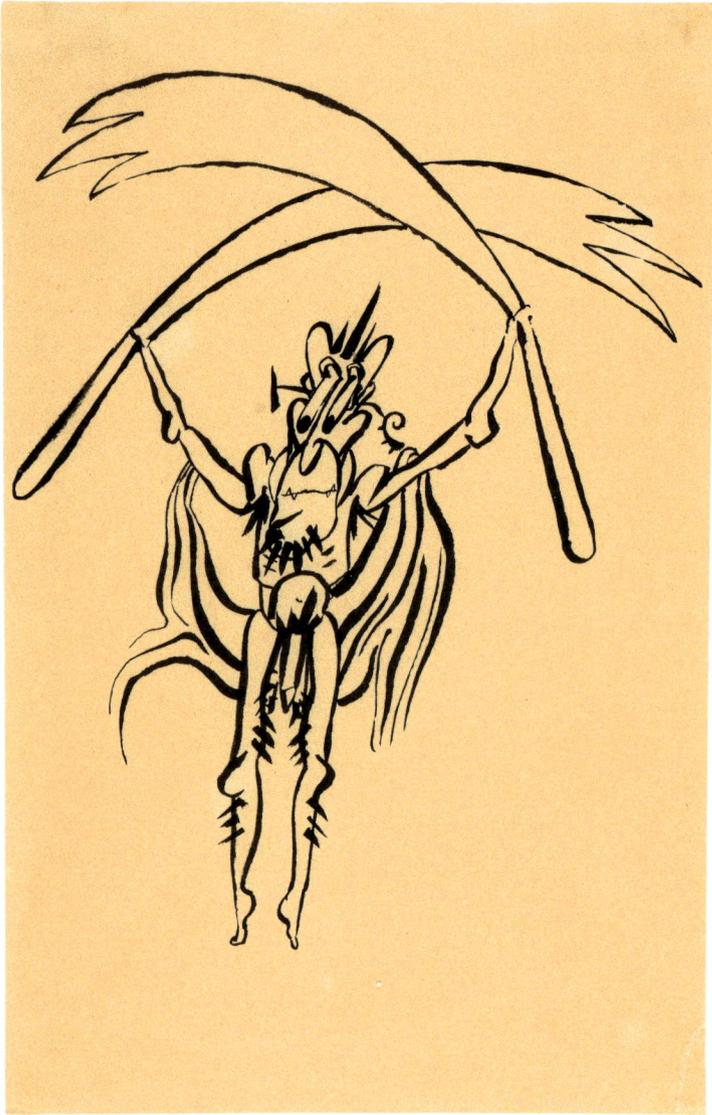

Francesco Clemente, Untitled, 1972

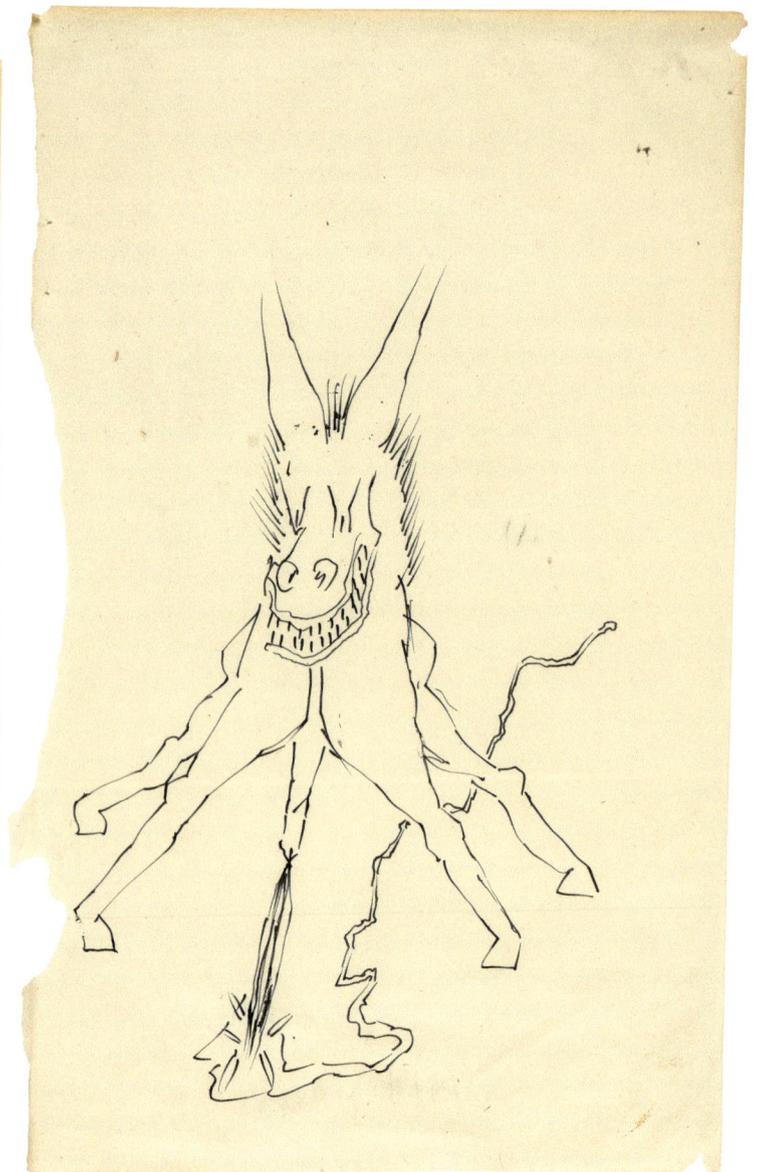

Francesco Clemente, Untitled, 1977

Enzo Cucchi

Born 1949 in Morro d'Alba, Italy, lives in Rome

Enzo Cucchi, a leading figure of the Italian neo-expressionist Trans-avanguardia group,[1] does not seek to persuade gradually, but instead to convey the truth he portrays like a bolt of lightning. In doing so, Cucchi eschews all that is irrelevant, and concentrates entirely on just a few important forms. These are gestures freed from temporary chance occurrences, reducing figurative painting to a minimum in order to underline the power of metaphor. Recurrent motifs trigger a wealth of associations linked to memories that we cannot quite define, for "painting is exclusively a painting of legends … Legends that have really taken place … "[2] Cucchi's belief in the authenticity of images is bound up with an understanding of reality that is based more on the reality of mythical ur-images than on the transient experiences of the present.

It is not a matter of finding the correct form, in the sense of an ideal form, but of finding an ideal image. Accordingly, the motifs are neither beautiful nor even realistic in relation to the natural forms on which they are based, but are measured solely in terms of how aptly they express what they are meant to convey. In this respect, Cucchi follows in the footsteps of a northern European tradition that is very much rooted in German idealism, and that has entered the world of visual art through various avant-garde movements. At their core lies a definition of beauty formulated by Friedrich Schlegel in the Romantic era.

Enzo Cucchi, Untitled, 1987

Schlegel makes a distinction between what is "beautiful" and what is "interesting." What is interesting becomes the criterion by which the quality of a contemporary aesthetic object is judged. The benchmark is no longer beauty as a timeless ideal, as formulated in classical antiquity, but the notion of a truth that can take different concrete forms. What is interesting thus becomes the contemporary equivalent of past beauty and, with that, comes to embody a new concept of beauty. Franz Marc, for instance, posits that, "beauty = truth, ugliness = untruth."[3] Elsewhere, he deduces that essence of things lies "only in purpose (the purpose of life) … the how being irrelevant, but rather, the consequence of purpose (of the emotion)."[4]

Cucchi would subscribe to such a statement, even though his own approach is a far remove from the religiously transfigurative approach of German Romanticism and its offshoots. He is more interested in the truth that is embedded in a mythical past, when images were not yet dependent on rational explanation. In his works, the absence of a specific time is striking by its very absence from a specific place. There is no living vegetation. Instead, there are boundless oceans, rugged landscapes, and arid deserts of sand. People are present only in archaic ideal images—as heroes or barbarians, as embryonic beings or as skulls. Cucchi grasps bygone, mythological time as a reality in the here and now, making it fruitful for the present day.

This attitude is shored up by the conviction with which the artist commits to his work, setting signs and signals that suggest a solution to the conflicts of our time. For Cucchi, the past does not clash with his own historical situation, but instead possesses an autonomous and eternal value, independent of real time frames.

Carla Schulz-Hoffmann

1 The term "Transavanguardia," coined by Achille Bonito Oliva, primarily describes the Italian variant of neo-expressionism in the late 1970s and 1980s. Achille Bonito Oliva, *La Transavanguardia Italiana*, Milan 1980.
2 "La pittura è solo quella delle leggende … Le leggende sono veramente accadute … " Enzo Cucchi, *La cerimonia delle cose/ The Ceremony of Things*, ed. Mario Diacono, New York 1985, p. 49.
3 Marc further emphasizes: "Why should we not speak of true and untrue images—you call them pure and impure, but you mean the same thing. And those who describe the beauty, purity, and ugliness in truth as untrue mean the same as well." Franz Marc, Schriften, ed. Klaus Lankheit, Cologne 1978, p. 178.
4 Franz Marc, *Briefe aus dem Feld*, Berlin 1940, p. 61.

Enzo Cucchi, Untitled, 1987 (detail)

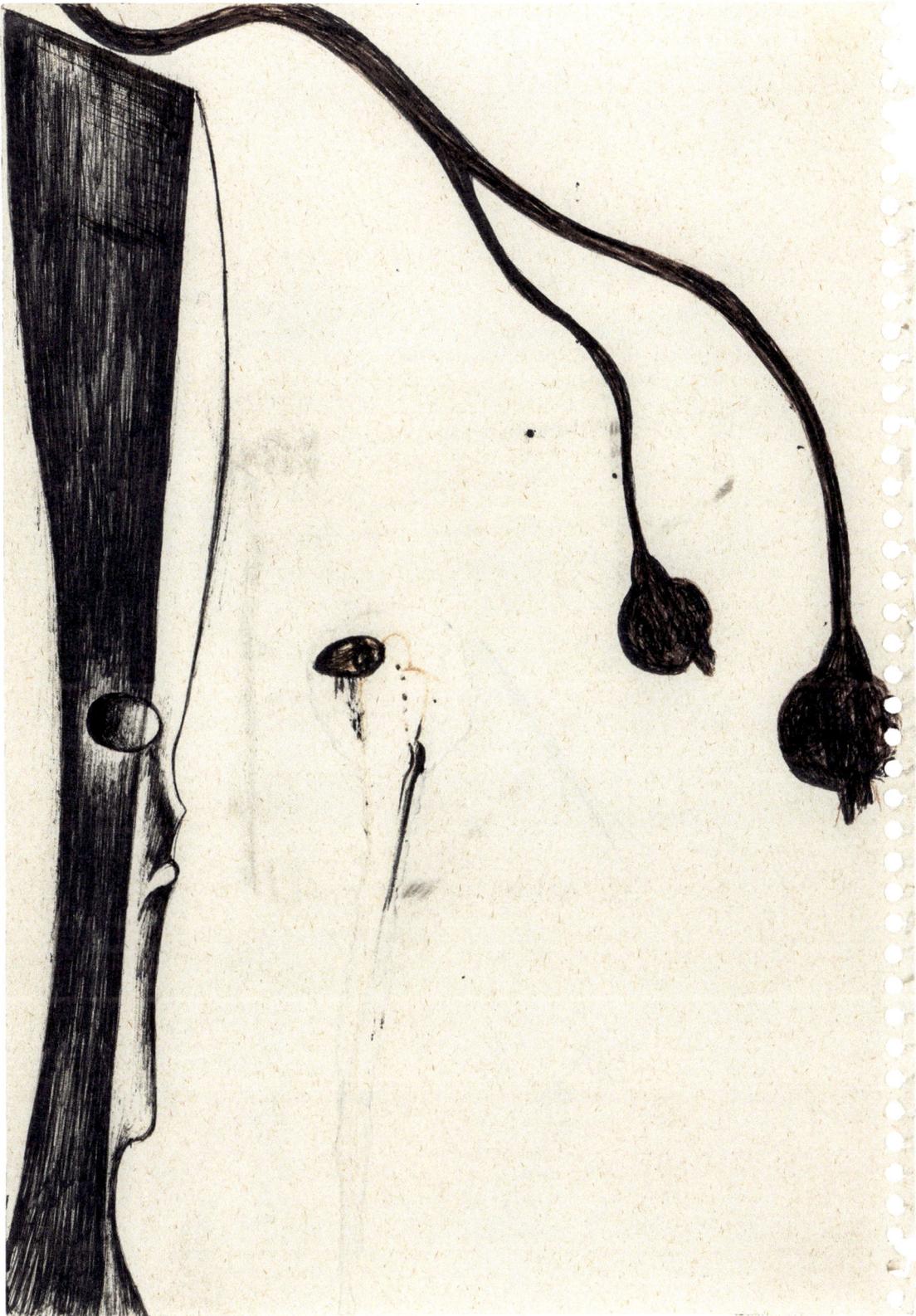

Enzo Cucchi, Untitled, 1987

Sara Cwynar, *Tracy (Cézanne)*, 2017

Sara Cwynar

Born 1985 in Vancouver, lives in New York

In 1964, the literary and cultural critic Roland Barthes published "The Rhetoric of the Image," a groundbreaking essay that examined in detail a typical advertising studio still life photograph (for Panzani, the French-made range of "Italian" food products). Each object in the photograph—fresh vegetables and tinned food spilling out of a net shopping bag—along with the lighting and composition, combined to produce an overall meaning aimed at making factory food appear rustic and traditional. Culture was being presented as nature, convention presented as normality. The same year, Jean Luc-Godard made the film *Une Femme Mariée*, in which a young woman reflects on the way "femininity" is constructed and commercialized in the mass media. Pop art was in full swing, and the Situationists were twisting the images and slogans of commercial culture until they revealed their contradictions. Soon, feminist artists and filmmakers such as Babette Mangolte, Chantal Akerman, and Agnés Varda began to make work that took mainstream culture as a set of signs that could be subverted, recombined, and turned upside down.

Sara Cwynar, *Tracy (Calvin)*, 2017

That mode of semiotic bricolage went on to inform much of the art that was labeled "postmodern," in which advertising, cinema, television, and art history were ice-boxes to be raided and remade. Canadian by birth and living in New York, Sara Cwynar makes work that can be understood in relation to this legacy of rhetorical play. She is interested in the ways commodities, cosmetics, color, advertising, industrial design, and synthetics shape the understanding of gender, gesture, sexuality, and desire. Where does the self come from? Where do commodities end and the self begin?

Tracy is a friend of Cwynar. They had known each other a decade when these pictures were made. Tracy had a background in design and art direction, so she understood constructed photography, the way elements can be choreographed as a set of proposals and counter-proposals. She dressed herself for the shoots, did her own makeup, and struck her own poses, although the whole notion of things being "one's own" is really the subject here. The props, arrangement, and lighting are Cwynar's choices, although "choice" is what is being called into question.

The whole ensemble of these images is playful but serious. The tone of precise awkwardness and calculated gaucheness has its own allure. There are nods to the 1980s. It is the decade in which Cwynar was born, but also the decade in which Barthes' theories were being stripped of their critical intent and turned into manuals for advertisers; the decade when irony began to look like hypocrisy with a sense of style, and progress appeared to be running out of steam. In Cwynar's images it is not just the signs of consumer culture that are reworked; she reworks the last 50 years of that reworking.

David Campany

Keren Cytter

Born 1977 in Tel Aviv, lives in New York

"Her drawings do not please me. Because she does not want to please me, or you. This is what makes them so good."
 Marlene Dumas[1]

Keren Cytter once said it was not being able to work on her videos during a power cut that had led her to develop a taste for drawing. That is typical of Cytter: she makes an untrue, drily humorous statement, which nevertheless reveals a deep truth about herself. She is constantly trying, by whatever means, to maintain contact with her surroundings and react to them.

Keren Cytter, *Face*, 2007

Keren Cytter, *Blue Aquarium*, 2007

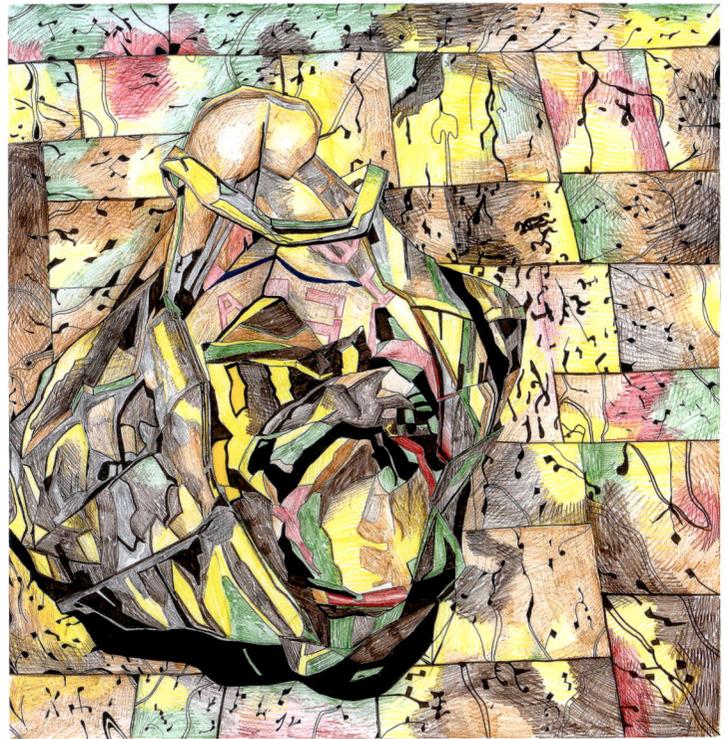

Keren Cytter, *A Bag on the Floor Camouflaged*, 2007

When she made her Baloise drawings (2006–2008), Instagram did not yet exist. But even then this artist—now Instagram dependent—already had an obsessive urge to incessantly observe her own milieu and to capture it in her own subjective way. The Israeli writer and curator Avi Pitchon has described this aspect of Cytter as her "high voltage level of attention."[2] Intriguingly, she generally devotes her (almost) neurotic attention to banal things: in the same way that her films are often shot in simple apartments—preferably in the kitchen—her ballpoint pen and felt-tip drawings are in effect snapshots of her daily life.

Her pen drawings on A4 paper were made in 2006, while she was shooting a film in Rotterdam. They depict fragments of newspapers, details of Cytter's rented apartment, and excerpts from advertisements, which—she says tongue-in-cheek—she drew in a burst of subconscious creativity. Cytter describes these as "doodles," the sort of things someone might find themselves doing on paper in a moment of boredom or distraction—for instance during a phone call.

The larger colored pencil and felt-tip drawings replicate images from a book of posters of Hitchcock movies. However, Cytter has replaced the titles with some of her favorite words—"Boredom!" for instance—and she has inserted portraits of actors from *Repulsion* (2006), the film inspired by Roman Polanski that she had recently shot.

Keren Cytter is often directly or indirectly present in her own works either in the form of items she owns, such as the camouflage-print bag, or in portraits—in the work here, in the multicolored, faceted image of her face in a black mirror.

Letizia Ragaglia

1 Marlene Dumas, "Improvise. On the drawings of Keren Cytter," in *Keren Cytter*, exh. cat. Museum Moderner Kunst Stiftung Ludwig Wien, Nuremberg 2007, pp. 78–81, here p. 81.
2 Keren Cytter in Conversation with Avi Pitchon, "Anyone Who is Not Mentally Ill Likes a Happy Ending," in *Keren Cytter. I Was the Good and He Was the Bad and the Ugly*, ed. Hila Peleg, exh. cat. Kunst-Werke Berlin, Frankfurt am Main 2006, pp. 72–101, here p. 82.

Keren Cytter, *Boredom*, 2006

Walter Dahn

Born 1954 in St. Tönis near Krefeld, lives in Cologne

Walter Dahn, Untitled, 1985

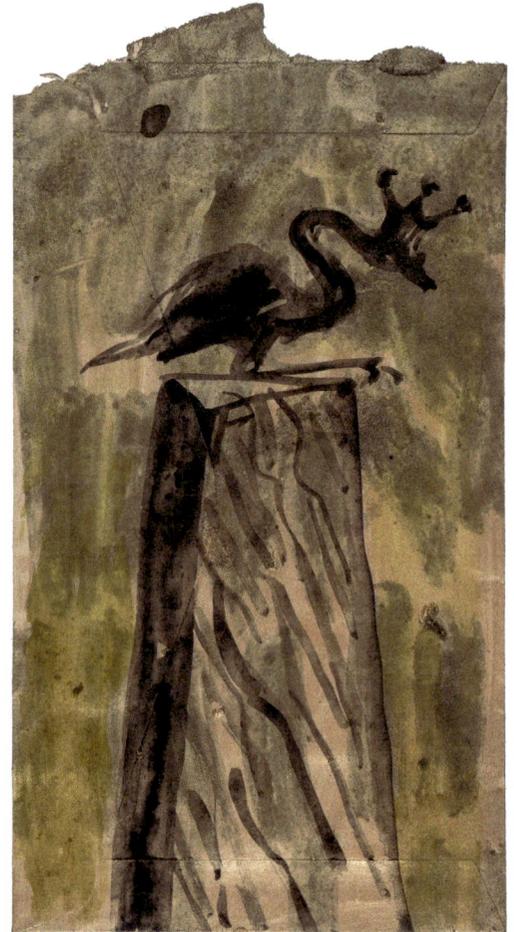

Walter Dahn, *König Schwan*, 1985

Untitled (*Selbstbildnis als Maler*), a watercolor painting done in 1985, depicts a painter boldly waving a paintbrush at the viewer. The deftly sketched figure of the artist, Walter Dahn, peers out from behind a dark square, probably a canvas—defying the physical limits of that medium. The blithely anarchic gesture of a painter's brush held high underlines Dahn's decision to turn his back on stylistic convention and standard motifs. He takes no interest in allegorical representation, virtuosity, pictorial depth, or luminous glazes. It seems that the artist pictured is stating that, "despite everything," he is still a painter. The small-format figure—in a watercolor painting—thus has a comically impudent air.

Walter Dahn was the main protagonist and cofounder of the artists' collective Mülheimer Freiheit (1980–82)—named after the street in Cologne where its studio was located. The group soon became known as one of the *Neue Wilde*. Dedicated specifically to painting, these artists developed a style that was perceived as "rough" and "wild," and introduced elements of punk into art. Their paintings—impulsive and lackadaisical—reflect their insistence on motifs that are not mere decoration, and exploit the extraordinary strength of the grotesque and the banal. However, following his participation in documenta 7 in 1982, Dahn struck out in a new direction, which is already hinted at in his *Selbstbildnis als Maler*. He started to work in other mediums, such as drawing and photography—which he had pursued concurrently from the outset—and screen printing.

All of Dahn's work impressively confronts the existential issues of our own time, as in the untitled ink drawing of 1985 depicting a naked male torso with a tree trunk and branches growing out of the neck instead of a head. The motif in brown, earthy tones is executed on repurposed paper, with still visible biographical details of German sculptor Andreas Bindl (1928–2010), who in some circles is less well known today than during his lifetime. The writing is upside down in relation to the painted motif. If the viewer turns the sheet the right way up to read the writing, the tree trunk and branches become a root system. While there is an internal affinity here between the human and arboreal parts of the human-tree-hybrid motif, there is also a tangible affinity between Dahn and Bindl; it seems that Dahn appreciated the latter's commitment to exploring fundamental existential factors such as relations between human beings and animals, and relations between human beings and nature.

After Dahn's break with "wild painting," more connections to "kindred spirits" appear in his work—including numerous musicians, writers, and fellow artists. The drawing *König Schwan*, for instance, depicts the creature that Dahn's teacher, Joseph Beuys, connected with transformation and sociopolitical issues. The gold-bronze glaze and the envelope suggest a Beuysian energy exchange—in both material and intellectual terms. The gold-bronze can be read both as the conduction of physical heat and as a symbol of spiritual transformation, with the letter, as a means of communication, representing an exchange of ideas within a protected domain. Dahn's compositions show that art can always be reconsidered in terms of its role as a means of communication and as a conduit for meaning.

Julika Bosch

Walter Dahn, Untitled (*Selbstbildnis als Maler*), 1985

Simon Denny

Born 1982 in Auckland, lives in Berlin

Simon Denny's multifaceted artistic practice reflects the reception of images, or, to put it more precisely, the production, distribution, and consumption of visual media in an age of growing technological obsolescence. He is specifically interested in the evolution of an increasingly mediatized society. His over-arching topic is information. How is it constructed, how does it circulate, and how is it generated in the first place?

As Nam June Paik did in the past, Simon Denny uses the television monitor as a sculptural element. In 2009 Denny's *Deep Sea Vaudeo* already reflected ongoing technological developments and the ensuing aesthetic transformation of television monitors from bulky cuboids with cathode-ray tubes to flat rectangles with LED screens. The hardware progressively slimmed down, which in turn led to the outer frame being reduced and the screen itself enlarged.

This is the backdrop to the two works by Simon Denny in the Baloise collection. In these, he overlays sculpture with digital prints. Samsung Smart TVs are placed inside Plexiglas and aluminum display cases. In each case a ghostly, translucent photograph—an elderly lady in one and a young couple in the other—obscures the screen, the remote control, and the 3D glasses that create digital illusions. The promise: state-of-the-art technology, easy to use for young and old alike. Denny borrowed both the visual language and the slogans (used as titles) from a Samsung advertising campaign—"Ich brauche keinen Computer. Ich habe Facebook auf dem Fernseher" (I don't

Simon Denny, *Ich brauche keinen Computer*, 2013

Simon Denny, *Vernetzt im Hier und Jetzt*, 2013

need a computer. I've got Facebook on my TV) and "Vernetzt im Hier und Jetzt" (Connected in the Here and Now). Both of these slogans are closely interconnected with the history of our broadcasting companies. They not only allude to the impact that technological change has on our daily lives as individuals, but also to the fact that the society we live in is increasingly dependent on various media. Let us not forget: in 1989 no one had any idea what surprises the Internet would have in store for us, and before 2004 no one had even heard of a future social-media giant called Facebook.

Both of these works by Denny were made at a time when digital TV technology was gaining the upper hand in Europe. Older forms of analog broadcasting were falling into disuse and people were compelled to make massive changes in the hardware they owned if they wanted to keep on watching their favorite series. In these works Simon Denny highlights a phenomenon of our time, as we shift from analog to digital, as television and the internet become ever more closely intertwined, as viewing figures for national public-service broadcasters decline, and streaming services like Netflix are in the ascendant.

Denny demonstrates how much our daily experience as consumers affects our wider aesthetic criteria, and how dramatically the media are taking ownership of "the medium."

Marianne Dobner

Martin Disler

Born 1949 in Seewen, Switzerland, died 1996 in Geneva

In the 1970s the young Martin Disler was initially much admired for his drawings. His charcoal and chalks—frenetically, furiously reducing and compressing his motifs into pithy, even crude pictorial marks—chased across ever larger sheets of paper. In 1976 he was not only one of the youngest artists invited to participate in the major exhibition *Mentalität: Zeichnung* at the Kunstmuseum Luzern,[1] he was also the most radical. Over the next few years Disler turned from drawing to painting. Following a number of spectacular presentations—from the installation *Invasion durch eine falsche Sprache* in 1980 (with paintings filling every room of the Kunsthalle Basel)[2] and the monumental, 140-meter panorama painting *Die Umgebung der Liebe* in Stuttgart,[3] to the gigantic, violently brutal paintings issuing highly charged

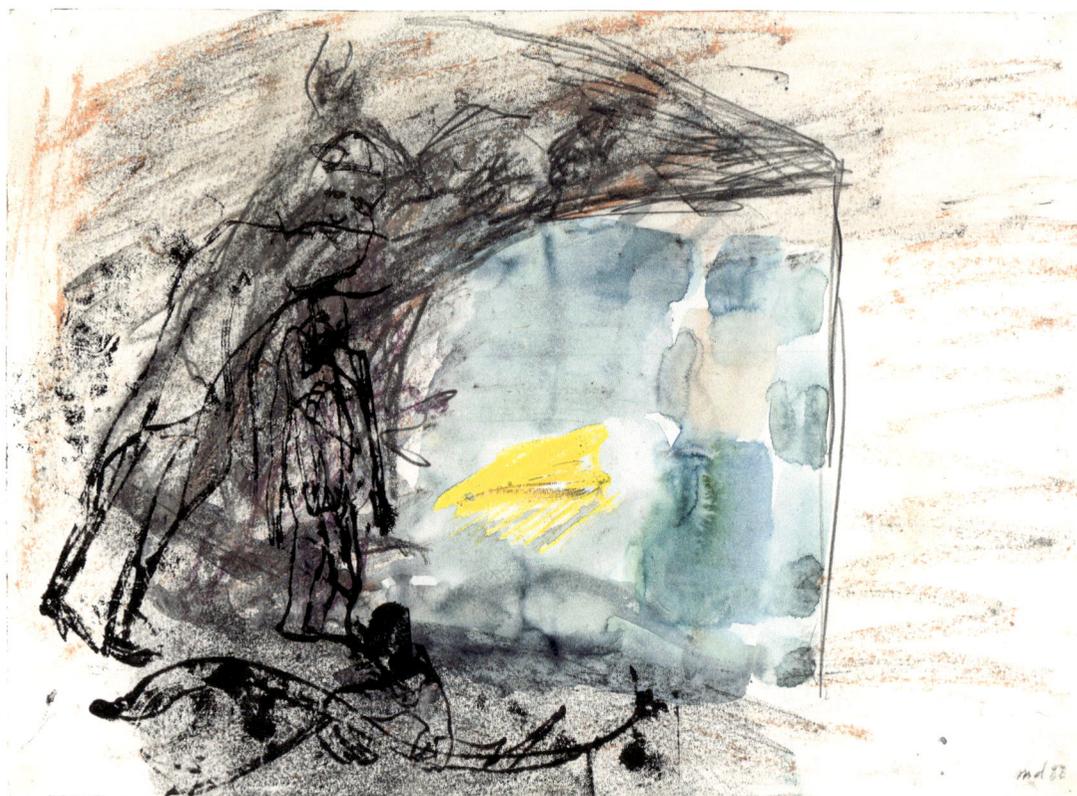

Martin Disler, Untitled, 1988

accusations at documenta 7 in 1982—for a few years Disler became an internationally celebrated star of the new *Wilde Malerei*. It was a red-hot career, marked by an intensity—arising both from Disler's excessively workaholic nature and from the inordinate pressures of the art business—that he compellingly described in *Bilder vom Maler*, the novel he dashed off in 1980.[4]

The large-format sheet from 1984 is a complex fusion of drawing and painting, with Disler taking a draughtsman's materials—charcoal, chalk, ink—and using them as a painter might; at the same time his monumental canvases from that period show how crucially and energetically aspects of drawing almost subcutaneously inform his paintings. 1984 was an important year for Disler the painter. Besides fast acting materials such as emulsion paints and acrylics, he now also started to use oil paints—slower moving, thick, and saturating. In terms of their content, the compositions on paper are closely

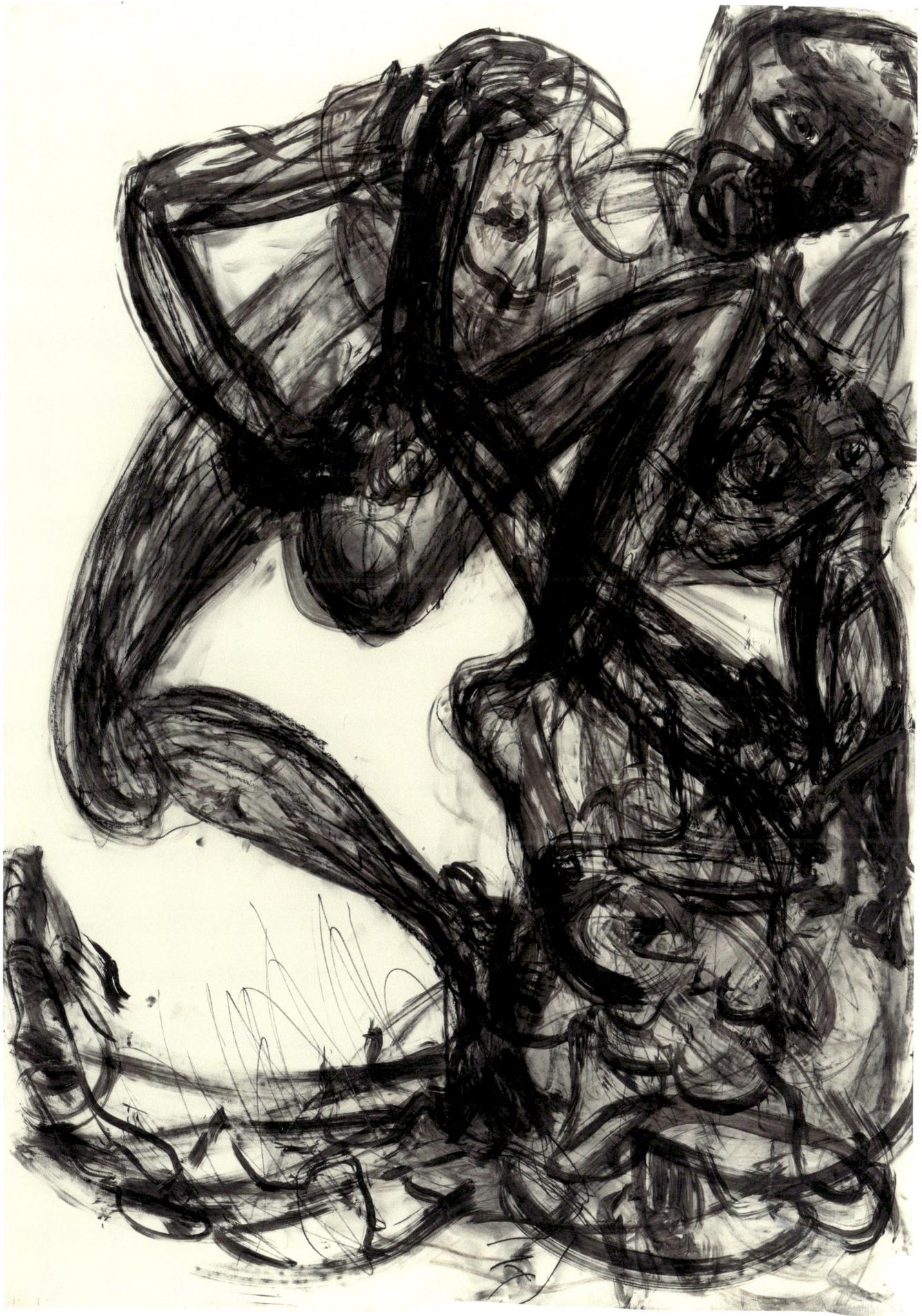

Martin Disler, Untitled, 1984

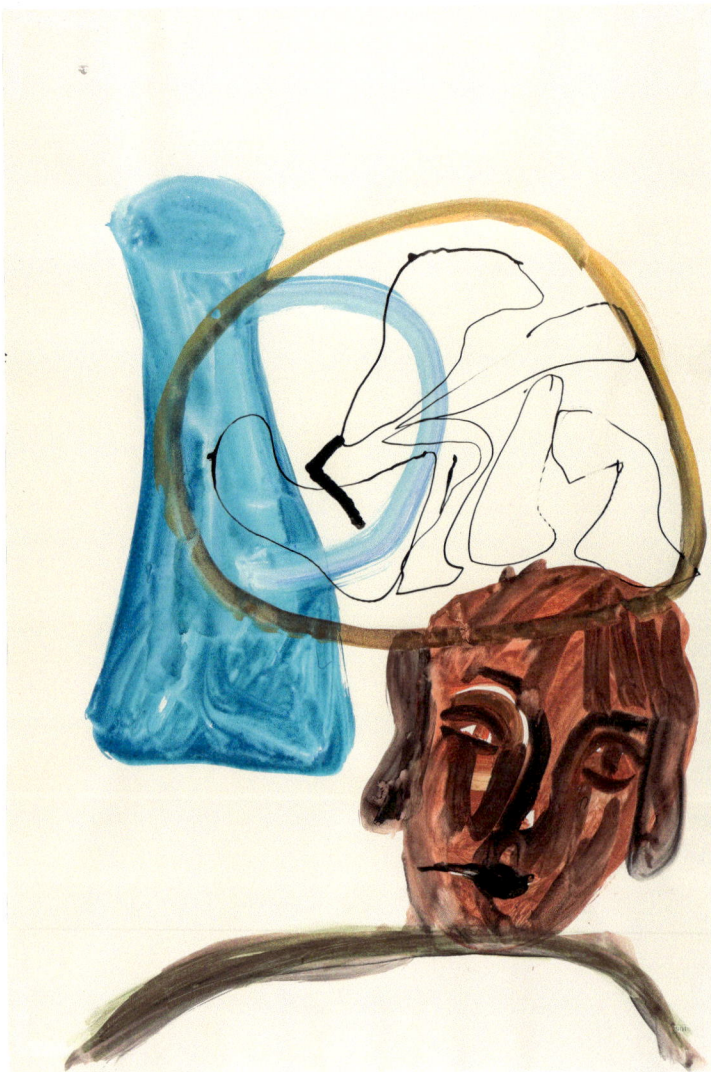

Martin Disler, Untitled, 1979

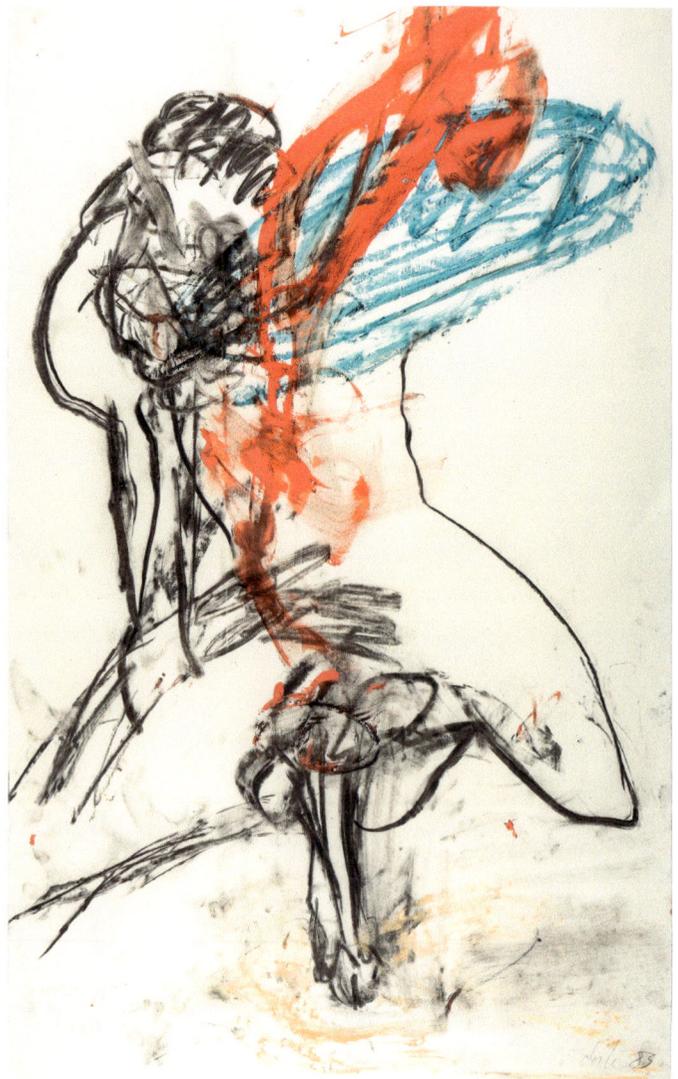

Martin Disler, Untitled, 1983

related to the works on canvas; they, too, address violence and sexuality, erotic and forceful contact, amorous struggles and the dance of death. Unlike the densely painted canvases, the manically dancing or fighting bodies and limbs in the large-format works on paper are mostly seen against an open, empty picture ground.

In 1986 Disler's career started to slow down; his paintings were less and less in demand. Nauseated by the art world's constant clamors for something new, Disler withdrew from public life in 1988. In a secluded farmhouse in the Jura mountains he explored a wide range of mediums—drawing, prints, and painting—and increasingly turned to modeling and sculpture. It was here, between 1988 and his early death in 1996, that Disler produced an extensive series of monotypes; the sheet illustrated here from 1988 may well be one of the first. The monotype allowed Disler to produce drawings in the most direct manner possible once again. These pictures were caressed into life from the back of the sheet, blindly. Disler himself described their making as a sensual, erotic pleasure: "This kind of monotype is made by placing a sheet of paper on an area of paint applied using a roller; the paper is touched tenderly, but with gentle pressure, in the same way that practiced lovers have learnt to use their hands to morse or telegraph long unencrypted messages into the beloved body." [5]

Beat Wismer

1 See *Mentalität: Zeichnung. Christian Ludwig Attersee, Anton Bruhin, Martin Disler, Markus Dulk, Helmut Federle, Heiner Kielholz, Claude Sandoz, Hugo Suter, David Weiss*, exh. cat. Kunstmuseum Luzern 1976.
2 See *Martin Disler. Invasion durch eine falsche Sprache*, exh. cat. Kunsthalle Basel 1980.
3 See *Martin Disler. Die Umgebung der Liebe*, exh. cat. Württembergischer Kunstverein, Stuttgart 1981, and on the occasion of the representation of *Die Umgebung der Liebe* at Bündner Kunstmuseum Chur, *Martin Disler. Die Umgebung der Liebe*, ed. Stephan Kunz, Zurich 2019.
4 Martin Disler, *Bilder vom Maler*, Dudweiler 1980.
5 Martin Disler, "Was ertastbar war. Gezeichnet auf der Rückseite," in Martin Disler, *Das Plateau. Die Zeitschrift im Radius-Verlag*, 34, April 1996, unpaginated.

Christoph Draeger

Born 1965 in Zurich, lives in Umeå, Sweden

Swiss artist Christoph Draeger is an obsessive collector, sampler, and manipulator of static and moving images. He gleans the raw material for his art from documentary and fictional portrayals of man-made and natural disasters. There are images of plane crashes, politically motivated attacks, oil spills at sea, nuclear power accidents, earthquakes, forest fires, and avalanches—images that confront us daily in the media.

Draeger transfers this visual cosmos to his photographs, video works, installations, and large-format jigsaw puzzles. In doing so, he uses "the recognizability and widespread distribution of these images as a highly charged field for his works, which cover the entire ambiguous spectrum of media images, from dulled familiarity to sensationalism and unease."[1]

A key feature of Draeger's often ludicrously overreaching visual narratives is the role that time plays in our perception of catastrophe. This is evident, for instance, in the jigsaw puzzles *The Most Beautiful Disasters in the World*, which are underpinned by an analogy between the subject matter and the medium through which it is conveyed. The photographs Draeger chooses to use portray sequences of events in which, within seconds, a firmly established structure descends into utter chaos. At the same time, the large-format and intrinsically fragile jigsaw puzzles, which require much patience, concentration, and manual dexterity, evoke a sense of just how suddenly a situation can be destroyed through carelessness or miscalculation.

The *Voyages apocalyptiques* constitute a further form of visual reflection on time and transience through the medium of visual art. This multi-part series comprises Draeger's photographs of places where sensational catastrophes once occurred. They include, for example, *Hiroshima, Japan, Aug 4 1995*, which shows an inconspicuous view of a sunset over a city that preserves the memory of more than 80,000 victims of the atomic bomb that claimed their lives on August 6, 1945. *Schweizerhalle – Basel, Switzerland, May 5 1995* recalls a chemicals incident that has been largely forgotten. An almost casual view across the railway tracks in an industrial area with storage ground and a Sandoz company building recalls the place where a fire raged on November 1, 1986, sending clouds of toxic fumes into the air, polluting the Rhine as the flames were extinguished, and causing turmoil in the local population.

The discrepancy between what we see—photographs of quiet, unspectacular, and even idyllic locations—and the names of places where catastrophe has struck, whether forgotten or repressed, or with long-term effects, brings to the fore just how rapidly and irrevocably time deletes discernible traces and memories, not only in the mind of the individual, but also in the physical world.

Martin Schwander

1 Beatrix Ruf, "Christoph Draeger," in *Kunst bei Ringier 1995–1998*, ed. Beatrix Ruf, Zurich 1999, p. 56.

Hiroshima, Japan, Aug 4 1995

Christoph Draeger, *Voyages apocalyptiques. Hiroshima, Japan, Aug 4 1995*, 1995

Schweizerhalle - Basel, Switzerland, May 5 1995

Christoph Draeger, *Voyages apocalyptiques. Schweizerhalle – Basel, Switzerland, May 5 1995*, 1995

Christoph Draeger, *The Most Beautiful Disasters in the World. Challenger*, 1999

Marlene Dumas

Born 1953 in Cape Town, lives in Amsterdam

"I make a distinction between drawings which I regard as autonomous works of art and drawings which are 'just drawings.'"[1]

The works by Marlene Dumas in the Baloise collection, all from around 1990, are "just drawings." While they should be viewed without imagining how they might be transposed into another medium or dimension, compared to Dumas's extensive cycles of ink paintings and large-format washes from the 1990s, these are nevertheless clearly notes, intense and fleeting, channeling and interrupting a stream of ideas.

The artistic medium in these drawings is impure, in the sense that watercolor, ink, chalk, pencil, and more are all used together. But above all it is impure because Dumas combines a figurative idea with a physical, scarcely targeted and not wholly controlled method of color and paint distribution—"hand and head in relaxed partnership."[2] Dumas painted these pieces after the birth of her daughter Helena. They are part of a larger group of drawings and paintings in which she addresses the disconcerting transition between one's own body and that of another person: "The Next Generation."[3]

1 Marlene Dumas, "The Meaning of Drawing," in Dumas, *Sweet Nothings. Notes and Texts*, ed. Mariska van den Berg, Amsterdam 1998, pp. 34 f., here p. 34.
2 Ibid.
3 Marlene Dumas, "The Next Generation," in Dumas, *Sweet Nothings*, p. 93.

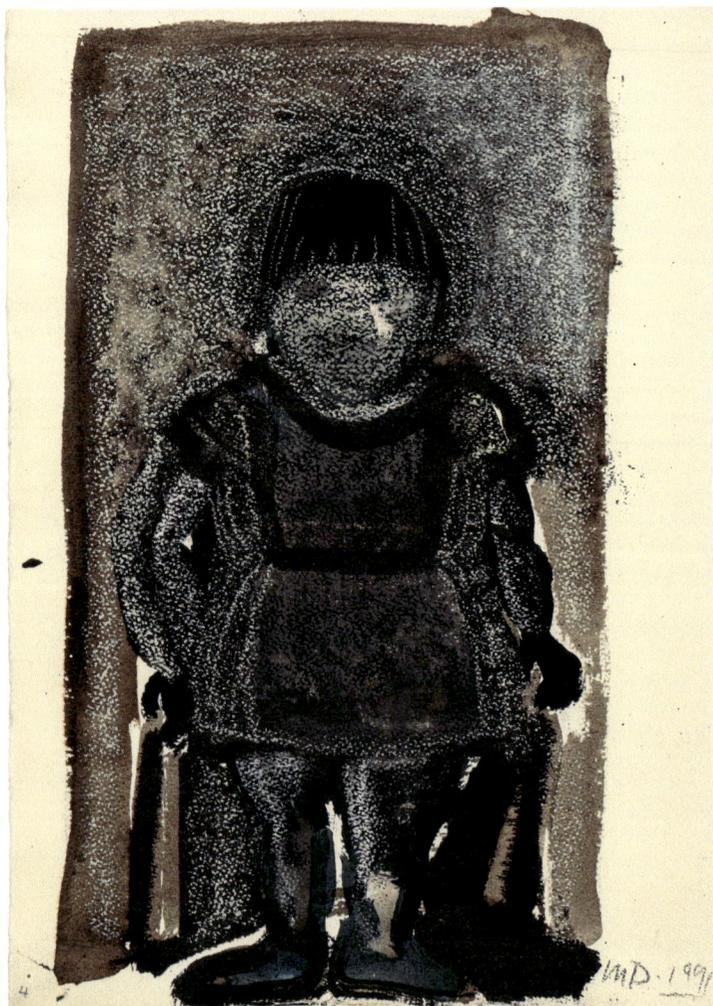

Marlene Dumas, *The Riddle*, 1991

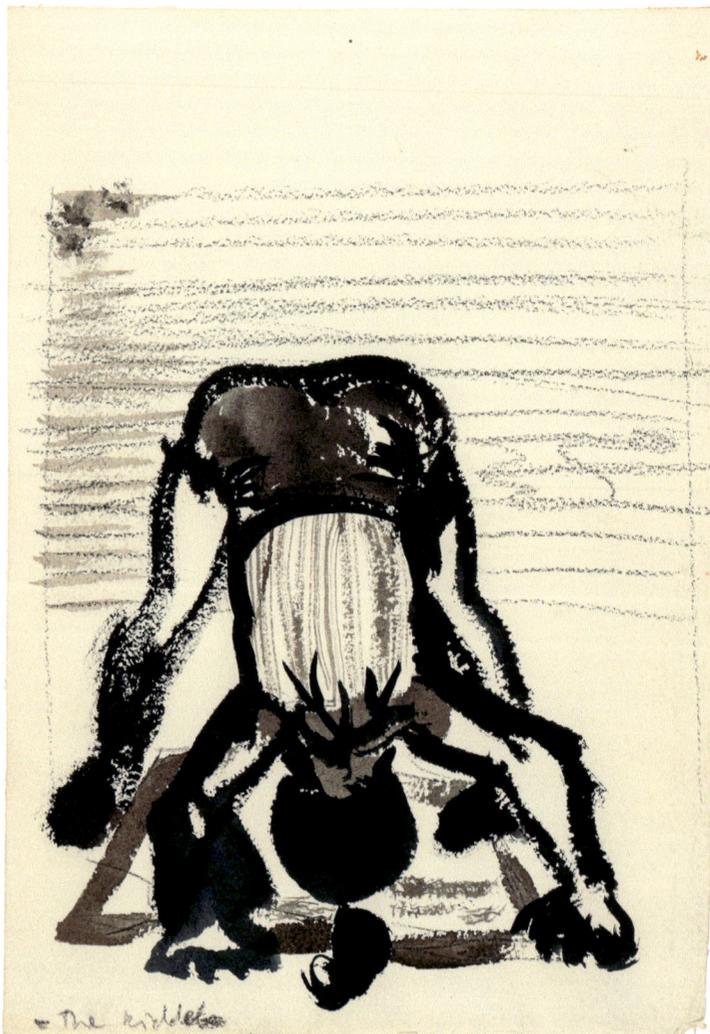

These works look as if they had been painted in a moment of absentmindedness. The paint application is raw, but not coarse, neither falsely nor naively clumsy, concise without being obvious. The drawings are the outcome of a striving for proximity to bodies and things. The latter are not primarily objects to be represented as pictorial likenesses; rather they kindle a desire for real physical contact. Expanding, merging pools of paint form a picture of a pregnant woman, whose thin arms and legs give her body the look of a newborn child. The title links the newborn, sketchily depicted in a few brushstrokes, with the notion of a headache. The oddly compressed figure of a child-adult, of a child's body turning into a beetle, constitutes a riddle. For a long time nude male figures were absent from Dumas's paintings until, in *Vader + Baby* the naked father—by dint of complicated associations—takes on the role of the omnipresent Mother of God.

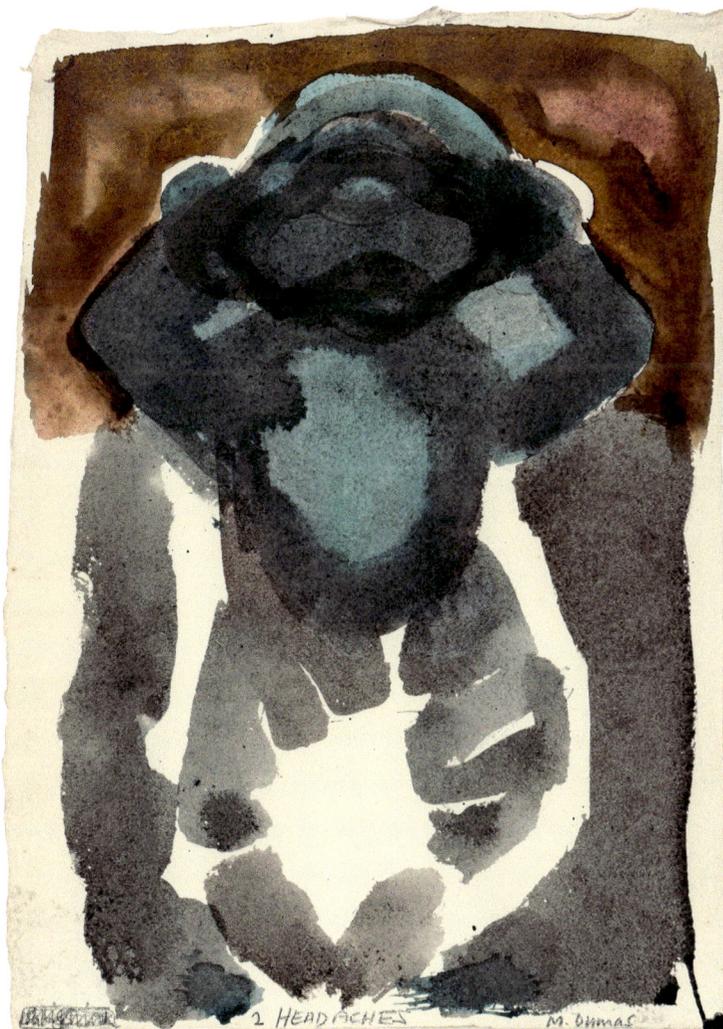

Marlene Dumas, *2 Headaches*, 1991

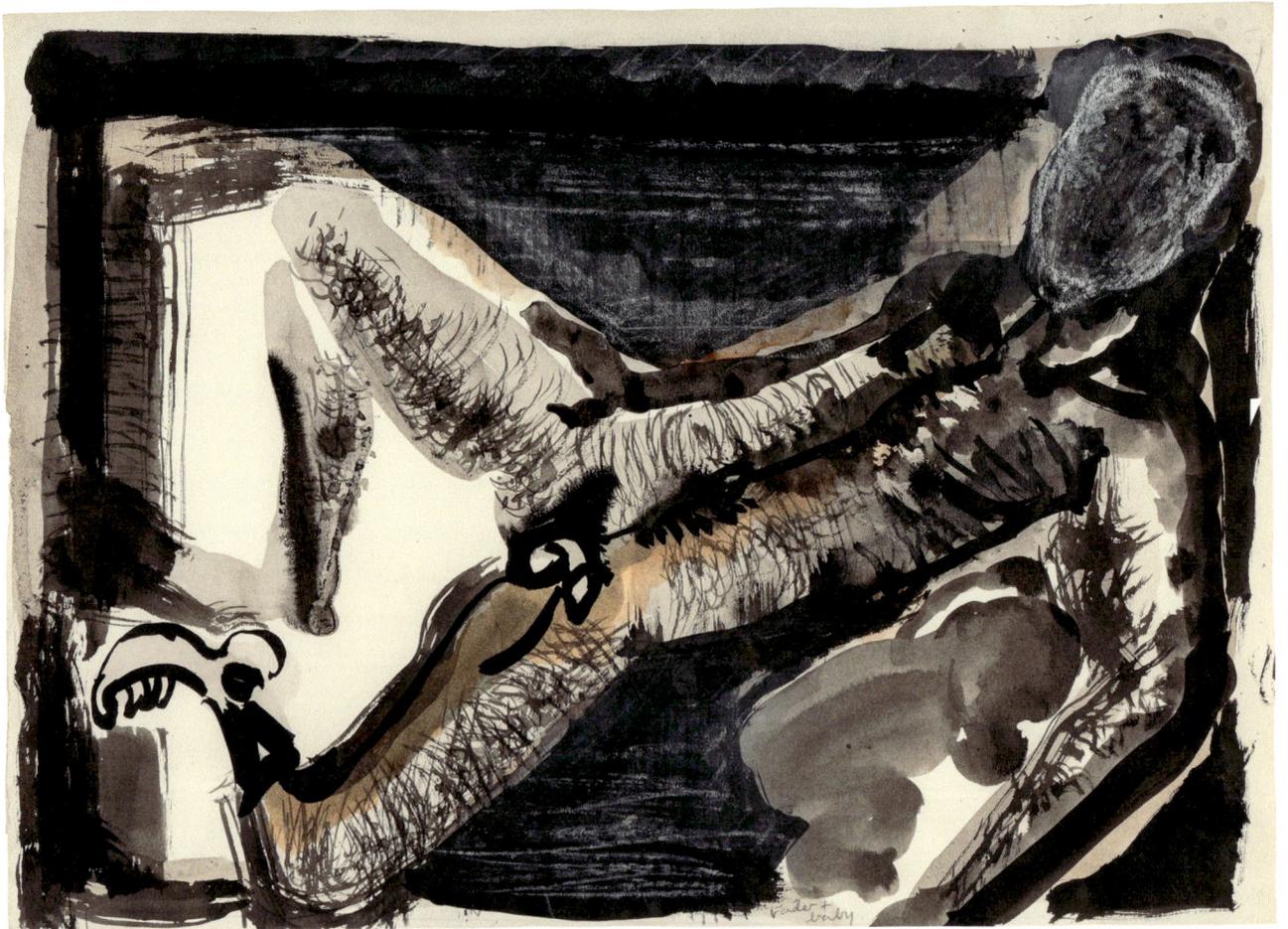

Marlene Dumas, *Vader + Baby*, 1992

Dumas has the ability to evoke far-reaching connections in simple compositions and to avoid allegorical generalizations in the process. She concentrates almost exclusively on painting people: isolated figures—figures in isolation—embody major themes, from love, eroticism, sexuality, gender identity, racism, and oppression, to grief, death, and art, all areas in which people negotiate relationships between one individual and another, and, more generally, the formation of the subject as such.

There is something especially disconcerting about the metaphorical comparability (or incomparability) of artistic production and the birth of a child, and these drawings—"just drawings"—that address the next generation, fundamentally challenge the notion of artistic creation.

Ulrich Loock

Marcel Dzama

Born 1974 in Winnipeg, lives in Brooklyn

Mostly known for his pen-and-ink drawings, Marcel Dzama started broadening his practice in the 2010s to include film (*Une danse des bouffons*, 2013), photography, collage, painting, and even slideshows. A keen music fan, and inspired by the Dada movement and the Surrealists, the artist has created many important album covers, and contributed to the art direction of Arcade Fire's short film *Scenes from the Suburbs* (2011). Fairly early on, Dzama developed his own visual language, easily recognizable thanks to motifs borrowed from vernacular culture and children's stories. In elliptical compositions in which dream elements rub shoulders with carnival monsters in a combination of tenderness and cruelty, the artist profoundly questions human behavior. In the space where the border between reality and the unconscious is blurred, each sheet of paper forms an enigma that the artist submits for our consideration.

On blank A4 sheets of paper—left that way as an allusion to the whiteness of the Canadian winter—Dzama traces delicately outlined images in pen and ink that create a stark contrast with the page, on which the context or background is never specified. The dominant shades of ochre, red, and brown are often achieved using natural pigments like root beer, for instance, from which the Canadian artist derives the blood red of his drawings. In this way popular culture is embedded in the very materiality of the drawing, along the lines of

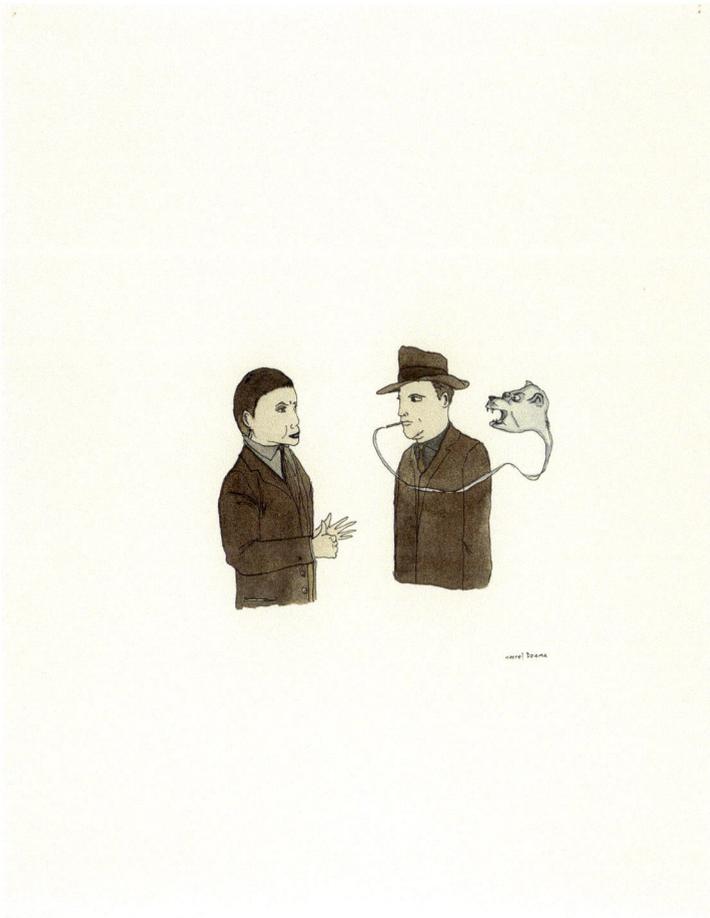

Marcel Dzama, Untitled, 2000

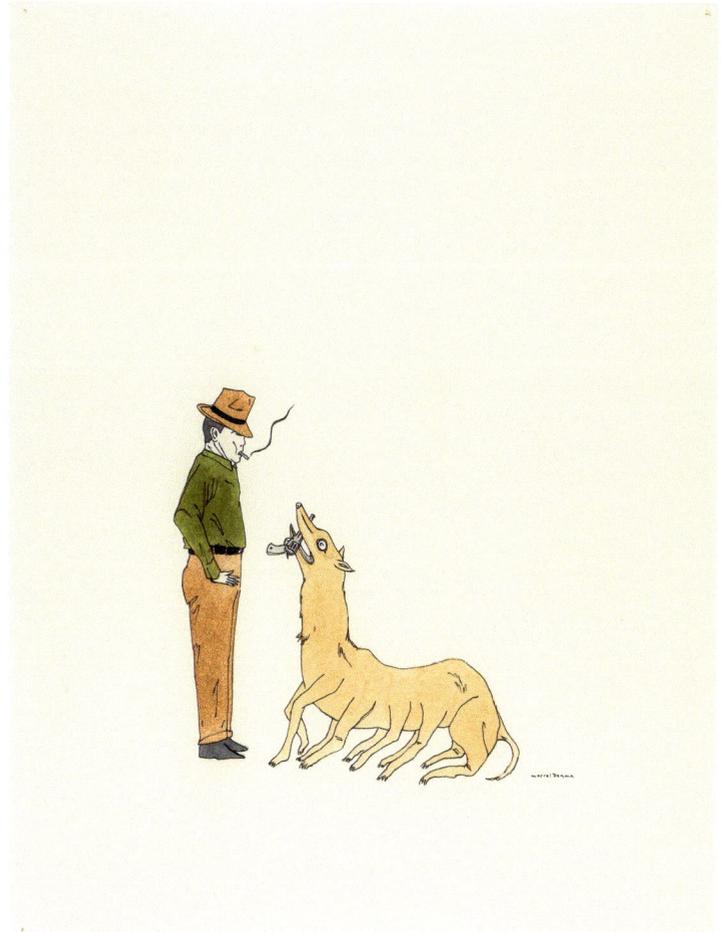

Marcel Dzama, Untitled, 2000

Andy Warhol and Ed Ruscha. Dzama's compositions are isolated fragments of a personal mythology or unfinished dreams, and seem like so many little scenes staged by a Surrealist, in which our childhood fears and our most primitive impulses play out, reflecting the failures and flaws of the contemporary world.

In the series of drawings for Baloise, Dzama uses the relationship between humans and animals to address our connection to violence, whether this is inflicted on humans, on their bodies, or on animals. Cigarette smoke, for instance, takes the form of a small sanctimonious dog barking in the guilty party's ear, while another dog, sporting ten legs, brings a handgun instead of a stick to his master. Elsewhere, a man instructs a bear to get to work if it wants to eat, and a crocodile threatens to pull the plug on a television showing a Western. In this universe and its deliberately offbeat timeframe—one of the drawings features a cassette tape changing into a cat, while others picture men whose style harks back to the 1960s—Dzama concisely revisits the significant themes of the contemporary world, through a play of relational tensions and transgressions of roles, which point up both the latent violence and the connections of domination that govern our society.

Julie Enckell Julliard

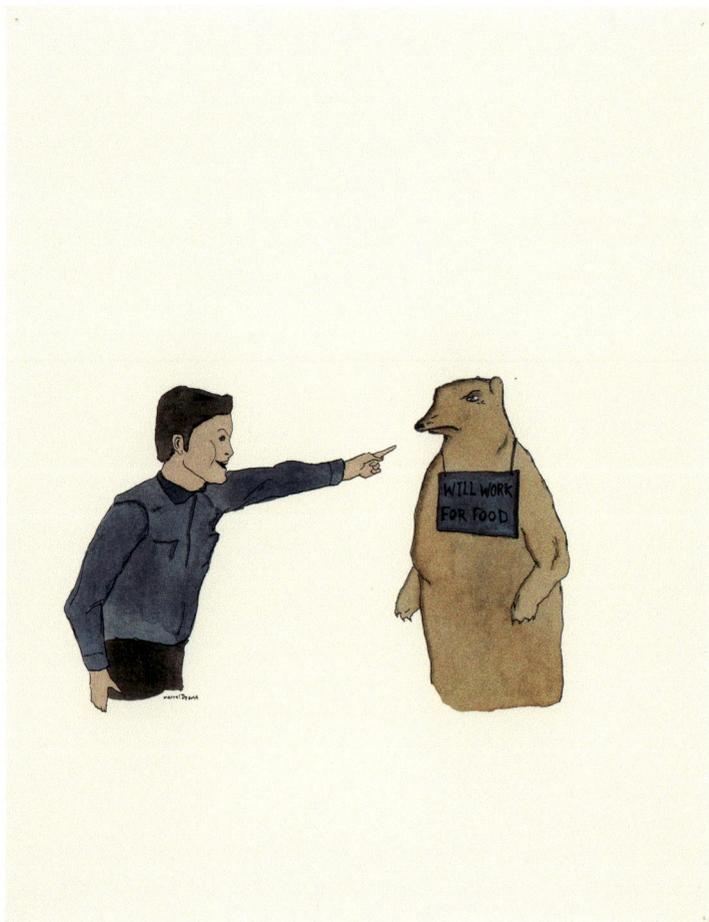

Marcel Dzama, Untitled, 2000

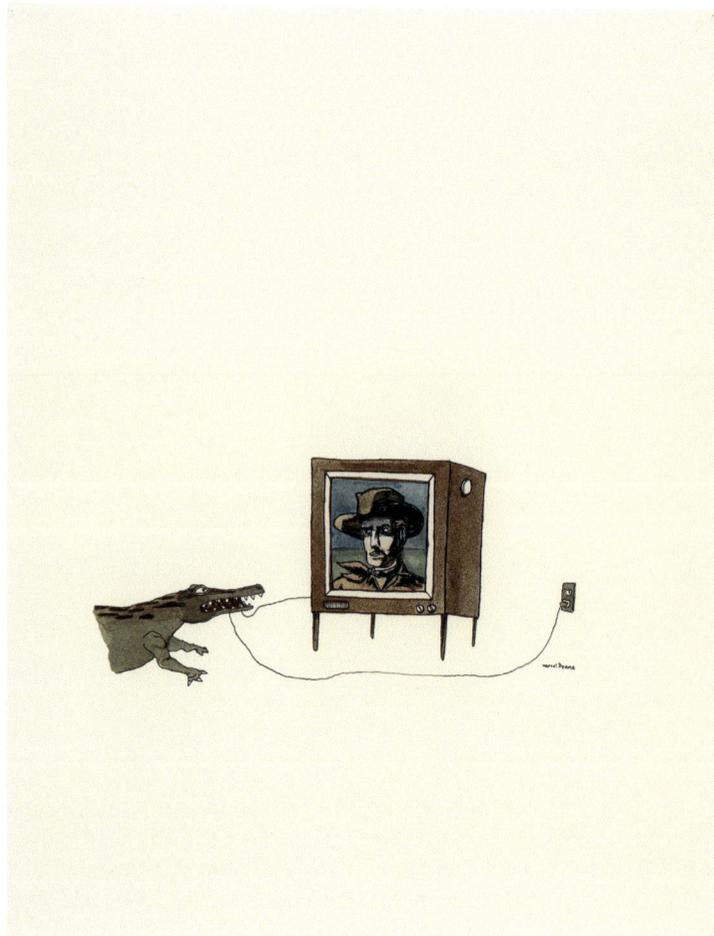

Marcel Dzama, Untitled, 2000

70

Andreas Eriksson

Born 1975 in Björsäter, Sweden, lives in Medelplana, Sweden

Andreas Eriksson, *Erosion 4/1/3/5/6/9/16/24/34*, 2015

Swedish artist Andreas Eriksson chose *Erosion* as the title for an extensive series of small-format watercolors, painted in 2015, which were first shown that same year in his exhibition at the Baloise Kunstforum. *Erosion*, plus a sequential number, signifies individual paintings, and it was also the title of the exhibition. Eriksson lives in some seclusion in a small, rural settlement, where he works in a wide

range of mediums; besides painting in oils and watercolors, he also makes prints, photographs, and videos, sculptural figures and reliefs. First and foremost, however, he is a painter, more precisely a painter of landscapes—sometimes in extremely large formats.

Describing his paintings, including his small watercolors, as landscapes requires a more differentiated understanding of the term. While these paintings are contemporary and abstract, and truly modern, the artist is in fact very deliberately aligning his work with a particular tradition of representations of the landscape; we might more properly talk here of appropriations of the landscape. Eriksson borrowed the title *Erosion* from geology; as a concept it has less to do with the representation or depiction of the landscape than with the process of its formation under the influence of such elemental forces as water, wind, and the weather. Eriksson's aim is not to paint a picture of the landscape, but to create an image that reflects its evolution; accordingly, the 39 small-format watercolors in his *Erosion* series combine to form a large-scale, multi-faceted, composite picture of the landscape.

Eriksson's landscapes have aptly been described with reference to Paul Cézanne's concept of the harmony of art "parallel to nature."[1] Like that founding father of modernism, but also like Picasso and other modern painters, Eriksson might well cite nature and the art museum as his mentors. He has an extensive knowledge of landscape painting since Romanticism and even in his abstract paintings he never attempts to disavow his engagement with that formative background. Eriksson is equally discerning in the way that he deals with nature, on the one hand, and art-historical tradition, on the other. As such his approach is reminiscent of that of the Danish painter—and geologist— Per Kirkeby, particularly in his explicit recourse to geological factors and phenomena. Although there is a full generation between these two painters, in their wholly individual yet kindred attitudes to painting— alive to the past yet explicitly contemporary and progressive—they occupy similar positions in Nordic landscape art, which has had its own, very particular atmosphere ever since the mid-19th century. Eriksson could also be said to be similarly located in the traditions of watercolor painting as it has developed since its emancipation around 1800, and its first absolute high point in the watercolor paintings of land- scapes, seascapes, clouds, and skies by J. M. W. Turner.

Beat Wismer

1 See Martin Schwander, *Andreas Eriksson. Erosion*, exh. folder, Kunstforum Baloise, Basel 2015.

Elger Esser
Born 1967 in Stuttgart, lives in Düsseldorf

Unlike many German photographic artists of his generation, Elger Esser is no "painter of modern life."[1] In his *Combray* series, created between 2005 and 2016 using analog black and white photography, Esser has compiled a visual atlas of places in France that appear to have remained untouched by the technological changes wrought elsewhere in the course of industrialization from the mid-19th century onward. His classically composed images of "la France profonde" portray a deeply rural and provincial world where time seems to have stood still, and where man's presence does not appear to have disturbed the tranquility of the idyllic backwater.

Esser transposed his black and white negatives into heliogravures —a photographic printing process that was widely used in the late 19th century. This elaborate and intricate intaglio technique not only

1 Charles Baudelaire, "Le peintre de la vie moderne" (1863), in Baudelaire, *Oeuvres completes*, vol. 3, L'Art romantique, Paris 1868, p. 51–114.
2 Marcel Proust, *À la recherche du temps perdu*, 7 vols., Paris 1913–1927.

produces high-resolution images of extraordinarily fine tonal definition, but also represents a close connection between artisanal printmaking and photographic reproduction. In Esser's oeuvre, this combination has produced images of places that seem to radiate the presence of a time gone by, at the apogee of heliogravure.

The ambiguity of his visual compositions fuels the viewer's own reminiscences. Indeed, Esser taps into this by choosing *Combray* as the title of the series, in reference to Marcel Proust's iconic *À la recherche du temps perdu* and the happy childhood days spent by the first-person narrator in the fictional village of Combray.[2] For Proust, this primordial scene of innocent young contentment can be revisited only through writing—for us, born later, it can also be found in the contemplation of Esser's images.

Martin Schwander

Elger Esser, *Combray (Douville-sur-Andelle), Frankreich (Haute-Normandie, 27 Eure)*, 2010

73

Elger Esser, Combray (Echaney II), Frankreich (Bourgogne, 21 Côte-d'Or), 2008

Elger Esser, *Combray (Fontaines-en-Duesmois), Frankreich (Bourgogne, 21 Côte-d'Or)*, 2008

Luciano Fabro

Born 1936 in Turin, died 2007 in Milan

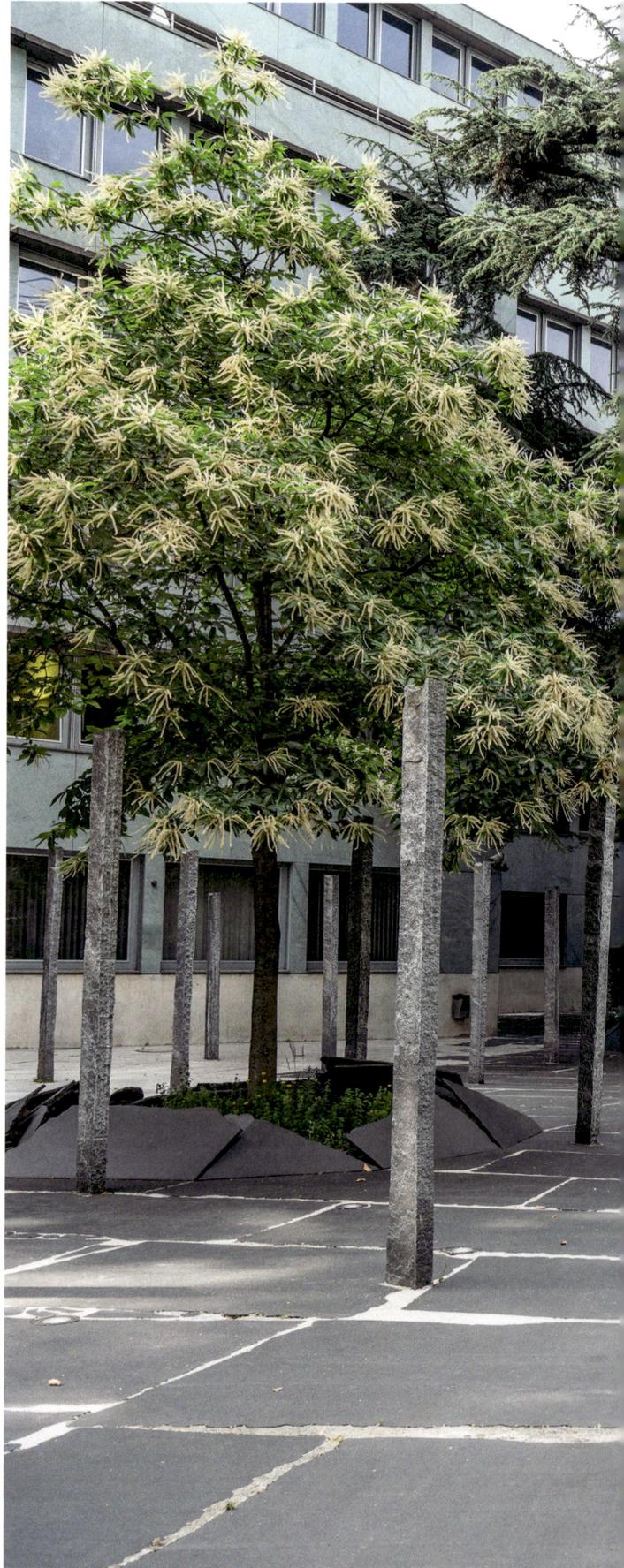

Luciano Fabro, *Giardino all'italiana*, 1994

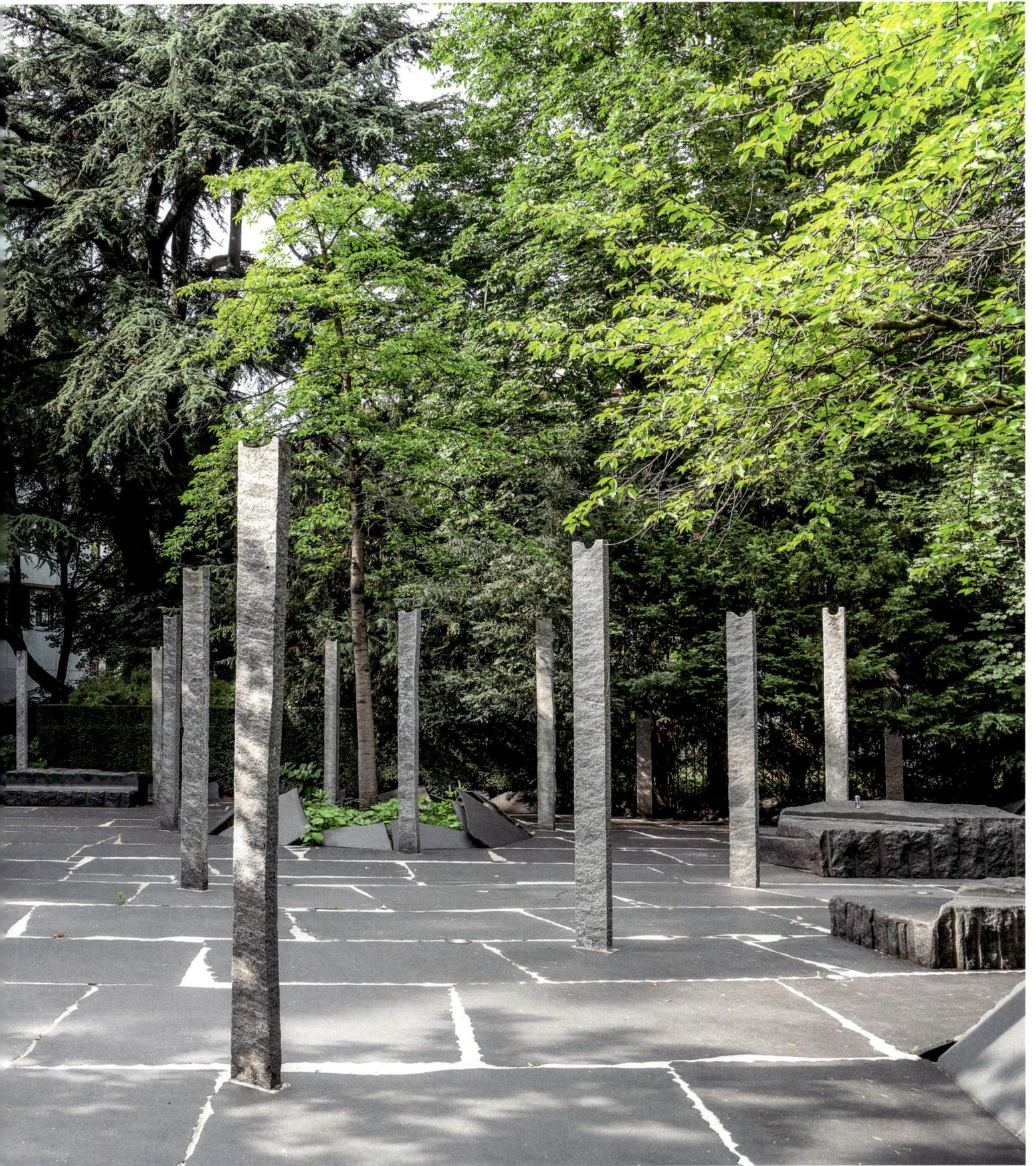

"Nature has *fantasia*."

A casual visitor strolling across Luciano Fabro's Italianate "garden" in Basel's Picassoplatz initially notes a rhythmic series of vertical poles set at regular intervals. Every so often, one of these poles unexpectedly becomes a fruit tree sprouting from a verdant tuft. These trees seem to erupt violently from below the ground, breaking apart the large slabs of black granite that compose the otherwise orderly pavement.

According to Fabro's description of the work, we discover that we are not just traversing a square in Basel, but rather an image of a giant lake that reflects the stars. We are walking between two spheres: the starry constellation of the Southern Hemisphere, and the sky above. "I wanted to make the earth transparent, as if it didn't exist anymore," the artist explained.[1]

Star-like electric lights set into the dark pavement, and pale granite slabs trace a path through the Milky Way, taking us back to an age when the only manner in which primitive man could orient himself in the universe at night was by the stars. Fabro's star-studded quest is as much physical as it is metaphysical: all three of Dante's canticles in *The Divine Comedy* end with the word "stars," the point of arrival of his spiritual journey. The earth has broken through the sky. Macrocosm and microcosm become interdependent and a dialogue between the two is sought.

The poles and trees in the plaza have a dual function. Fabro wanted to "show how nature is worked by man," and as a symbol of this he chose viticulture. This thought led him to realize that in the old areas of viticulture, for example in Ticino, archetypal elements of construction in the form of pergolas were used, elements that joined together symbolic meanings and functional elements. He thus created a system of rhythms symbolized by the poles of the vines inserted into architecture. The orthogonal grid that underlies these poles and trees leads us back to the Renaissance, the vanishing point of perspective, the architectural treatises of Alberti and Bramante, and further back to Vitruvius' accounts of the origin myths of architecture—for instance, the idea that people lived in huts formed from pergolas made of trees. Nature is tamed into architecture. Another form of synthesis is created between two opposites: tangible stone and the ageless principles of mathematics.

1 "Ich wollte die Erde transparent machen, wie wenn sie nicht mehr existieren würde," "Luciano Fabro über Plätze, Natur, Architektur und Mensch" [Interview with Sabine Lubow], in *Artmagazin. Die Kunstsammlung der Basler*, Basler Versicherungen, Basel 1999, p. 26–27, here p. 26.

2 "Denn die Natur hat Phantasie," in "Luciano Fabro über Plätze, Natur, Architektur und Mensch" [Interview with Sabine Lubow], in *Artmagazin*, p. 26–27, here p. 27.

Leonardo da Vinci, detail of monochrome preparatory drawing on wall, ca. 1498, Sala delle Asse, Castello Sforzesco, Milan

Luciano Fabro, *Basilea: il cielo sotto la pioggia*, 1992

Although not apparent to the casual passerby, Fabro's ideas for this plaza connect back to the humanist tradition. In Raphael's *School of Athens* (1509–1511), Plato pointed up to the heavens and Aristotle down to the earth, searching for and seeking to reconcile a mean point between the two extremes. Raphael paints himself near geometers and mathematicians, and the entire fresco intimates the shared principles of harmony that govern art, music, geometry, and architecture.

The trees erupting from the pavement in Fabro's plaza are reminiscent of another Renaissance master, Leonardo da Vinci, and his drawings on the wall of the *Sala delle Asse* in the Castello Sforzesco in Milan. Da Vinci depicts enormous tree roots penetrating strata of giant rocks and stones that represent the castle walls. For Leonardo, as for Fabro, nature and culture are intertwined in two primordial antithetical forces. In both cases, the formidable tree roots erupt, erode, and break up the stones. Leonardo and Fabro give us a phenomenal sense of the instability of creation. "Nature has *fantasia*," wrote Fabro.[2]

A young couple crosses the plaza with a baby stroller and in a flicker, our mind transitions back from these lofty universal musings to the realities of the here and now: a plaza made for human pleasure, a moment bracketed out of our rushed daily lives, a place for temporary respite, casual thoughts, and relaxed conversation.

Sharon Hecker

Helmut Federle

Born 1944 in Solothurn, lives in Vienna

Helmut Federle, *Relation of All Possibilities. Cold Nov. NY*, 1980

The dates of these three works on paper, 1979 to November 1980, mark the end of a decisive watershed in the evolution of the work of painter Helmut Federle. That crucial change of direction dated back to 1977 when he began work on his extensive *Nullbilder* series, which was shown at Kunsthalle Basel in early 1979.[1] These were Federle's first purely geometric-abstract paintings and also his first distinctly large-format works. Both aspects—geometric abstraction in muted, "impure" colors and often very sizable formats—were to become the main hallmarks of Federle's much admired work in the next decades.

Before that Federle had primarily produced drawings, which had established his reputation. In 1976 he was represented at the legendary exhibition *Mentalität: Zeichnung* at Kunstmuseum Luzern with works on paper—abstract, freely imagined mountainscapes— some of which were aptly titled *Hommage à Ferdinand Hodler*.[2] The artists represented in the exhibition also included Martin Disler (five years younger than Federle); the two had a joint exhibition at the Kunstmuseum Solothurn that same year.[3] Subsequently the two friends' works developed in very different directions. Disler became an internationally celebrated star of expressive painting in the early 1980s, while Federle's paintings met with great acclaim in the new field of geometric abstraction.

1 See *Helmut M. Federle. Bilder 1977–78*, exh. cat., Kunsthalle Basel 1979.
2 See *Mentalität: Zeichnung. Christian Ludwig Attersee, Anton Bruhin, Martin Disler, Markus Dulk, Helmut Federle, Heiner Kielholz, Claude Sandoz, Hugo Suter, David Weiss*, exh. cat., Kunstmuseum Luzern 1976.
3 See *Helmut M. Federle*, exh. cat., Museum der Stadt Solothurn 1976.
4 See *Helmut Federle. Black Series I + II und Nachbarschaft der Farben*, ed. Beat Wismer, exh. cat., Aargauer Kunsthaus Aarau; Staatliche Kunsthalle Karlsruhe; Kunstverein Braunschweig, Haus Salves Hoppe, Baden 1998.

Helmut Federle, *Disaster Drawing mit untergehender Sonne for V.*, 1979

Helmut Federle, *Familienbaum 19. Aug. 1980, NYC*, 1980

There are two main strands to Federle's works on paper. On the one hand there are not only the extensive cycles with quasi-systematic pictorial investigations, as in the various *Black Series* (1977 onward for two decades), which accompanied the development and progress of Federle's geometric paintings, but also the much later, extended series, *Nachbarschaft der Farben*, executed in colored oil crayons on paper from 1994 to 1997.[4] On the other hand he still draws individual sheets that are not part of any systematic series; sheets that in some ways are more like notes and—on a deeper level, rarely explicitly— relate to his painterly work.

In two of the titles of drawings there are references to New York, where Federle mainly lived and worked from 1979 to 1983, and where he was also involved in various musical circles. These sheets, like the bulk of this strand of Federle's drawings, have a striking, pathos-free openness. For all their exploratory qualities, they also seem to embody something akin to plans or maps. While the geometric subdivision of the picture ground in *Familienbaum 19. Aug. 1980, NYC* prefigures certain features that still characterize some of Federle's later paintings, *Relation of All Possibilities. Cold Nov. NY* demonstrates Federle's powerful, creative determination to achieve maximum concentration: an aim that runs through all his work, be it on canvas or paper. As is sometimes the case, the unpretentious medium of drawing casts a revealing light on the essence and motivation of his work as a whole.

Beat Wismer

Karsten Födinger

Born 1978 in Mönchengladbach, lives in Berlin

Karsten Födinger takes resilient materials and static structures and tests them in constructions designed to demonstrate the passage of time and the intensity of various forces. His sculptures counter the precariousness of different forms of equilibrium—be it in built constructions or human relationships.

Gravity is the indivisible force that can cause the materials selected by the artist to crash to the ground, determining their final form. It impacts on plinths, pillars, and wedges made from reinforced concrete, steel, or wood. To give them a chance of withstanding gravity, Födinger combines them as figures with self-reinforcing structures and—by the very nature of their montage—underlines the urgency of reacting to imminent catastrophe. He always derives the specific characteristics of his sculptures from the nature of the place for which they are made.

In 2009, in his native city of Mönchengladbach, Födinger was struck by the sight of three supporting struts between two buildings, which illustrated the hidden, internal forces that are at play in constructions, in spaces, in architecture, and in the very society that has brought forth these edifices.

From that moment onward the camera became a crucial tool for Födinger as a means to record different ways of reinforcing and supporting buildings in danger of collapse. This has left its mark on his artistic work as a series of prints, which can even be read as an autobiographical description of existence in time. For long exposures Födinger generally places the camera on a tripod, so that no moving figures appear in the photograph. Sometimes he returns time and again to the same place in order to capture a photograph in particular conditions, for instance to avoid vegetation or other features (depending on the time of year) that would detract from the sculptural qualities of the target object. The struts and braces photographed in Mönchengladbach for this series—all selected by Födinger for their geometric forms and emotional overtones—highlight the fragility that is hidden by the seeming strength of the walls in question.

In the same way that the wood used as molds for Födinger's sculptures reacts to the pressure of moist cement as it dries, the structures he photographs demonstrate the forces that affect walls and supports. They may even look like beings in heroic attitudes. In some ways they seem like the mighty arms of a modern Laocoon, fighting an invisible, destructive force. Their presence and tensions invigorate their locations as they raise questions concerning the very ephemeral nature of human existence.

Roberto Gargiani and Anna Rosellini

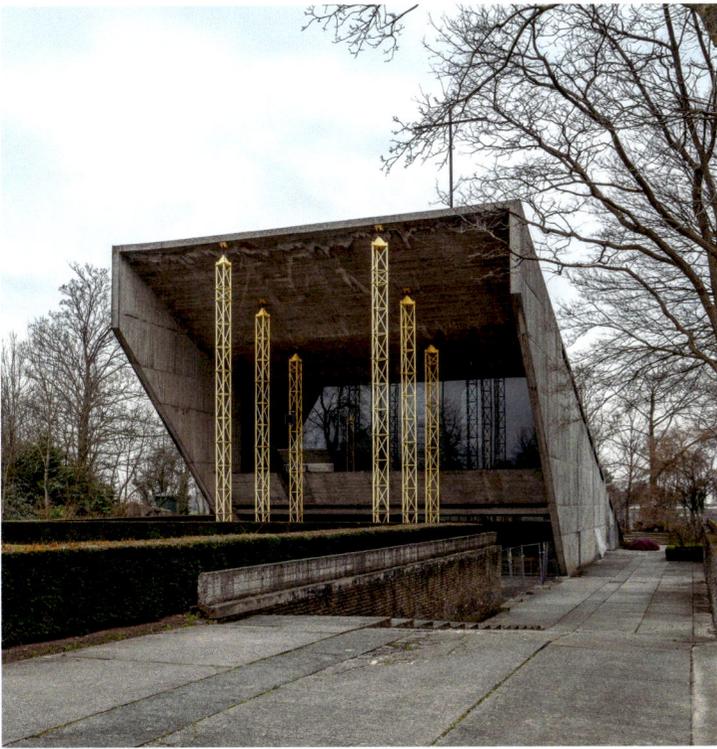
Karsten Födinger, Untitled, 2018

Karsten Födinger, Untitled, 2009

Karsten Födinger, Untitled, 2010

83

Karsten Födinger, Untitled, 2016

Karsten Födinger, Untitled, 2016

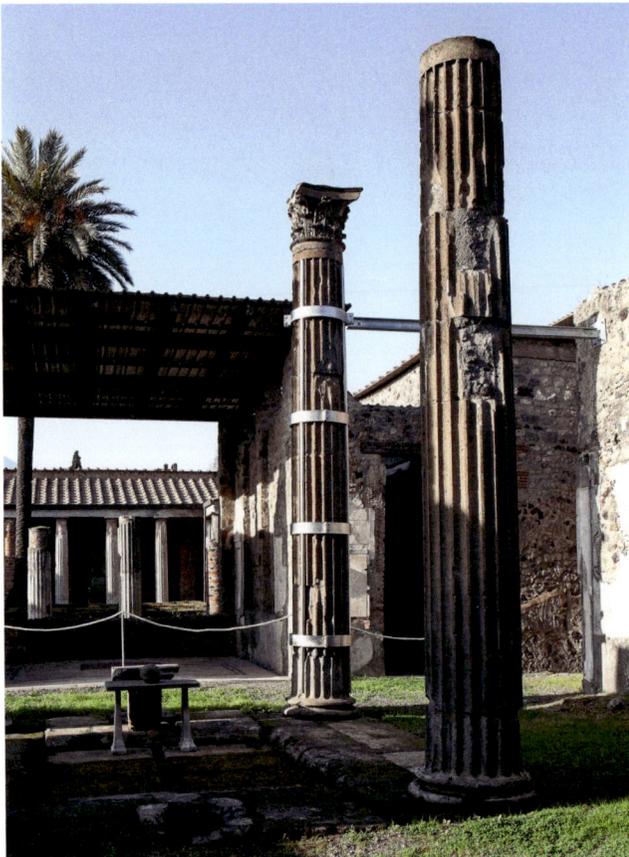

Karsten Födinger, Untitled, 2017

Karsten Födinger, Untitled, 2017

Luke Fowler

Born 1978 in Glasgow, lives in Glasgow

In his films, Scottish artist, filmmaker, and musician Luke Fowler explores the conventions and boundaries of biographical and documentary genres. Little-known or forgotten material from audiovisual archives forms the basis for his portraits of fascinating and often scintillating personalities from alternative cultural scenes, including, for example, the Scottish psychiatrist R. D. Laing (1927–1989) and the English composer Cornelius Cardew (1936–1981).

What lies behind Fowler's photographic output is his approach to analog techniques. Light reflexes, underexposure, overexposure form, among other photographic flaws and a certain amateurishness, part of the artistic strategy by which Fowler counteracts the seductive appeal of consumerist high-gloss aesthetics. *Perfect Lives* consists of 20 analog color photographs shot between 2013 and 2015. These photographs show images that Fowler took while strolling around the urban environment, waiting to deliver a talk, drinking in a bar, visiting a church, a travel agent, or a park.

Luke Fowler describes his approach as follows: "The images I photographed were taken by amateurs and professionals to represent a variety of commercial, architectural, or social uses of photography (I refer to the photograph here as an image in physical space rather than in the digital realm)—they function as acts of surveillance, shaming, as simulation, or politically projected space, as reproduction etc. I extended my criteria to include the use of the photograph or other graphical representations of space as a source for art (e. g. the map, the photo-realist painting). On my travels I noted how photography is used around the city as a banner of longevity—archival images on corporate or municipal buildings consecrate the agency as good, honest, and reliable (not to mention a nostalgia for simpler, pre-global times). The photograph as simulacrum in these instances completely obscures current transnational capitalist operations—not to mention an understanding of the historic."[1]

This seemingly plan-less creative process contrasts with the artist's prescribed arrangement of 20 photographs illuminating minimal narrative strands. In his eschewal of conventional narrative structures, Fowler sensitizes the viewer to the quotidian and the purposeless, to the alienated and the ephemeral. For it is along these fault lines that, for Fowler, the history of everyday things and our approach to them unfolds.

Martin Schwander

1 Luke Fowler, email to the author, October 16, 2019.

Luke Fowler, *Perfect Lives*, 2015

Luke Fowler, *Perfect Lives*, 2015, sheet 8 of 20

Luke Fowler, *Perfect Lives*, 2015, sheet 18 of 20

Pia Fries

Born 1955 in Beromünster, Switzerland, lives in Düsseldorf and Munich

Ever since Pia Fries showed her paintings on paper at a 1995 exhibition in Meggen, the artist has revisited the medium many times. So her interest in creating works on paper in particular was strengthened when she began enriching the white of the underlying primer with printed images, thereby creating figurative focal points for her painterly interventions. These include, as in her work No. 8, screen prints of twisted fabric that create an illusory aspect in the image. The power of illusion in her photographic reproductions is shattered in several ways by nonfigurative color markings. In another group of works, No. 53, Fries used leftover copies of the cover of one of her own catalogues as a visual element. There is an encounter in the picture between the white ground of the paper, the gray printed paper, the painting reproduced on it, and the actual painting—all converging and overlapping, supporting and negating each other's reality.

Fries was a student of Gerhard Richter, so her approach is hardly surprising. She had a somewhat divided attitude to painting right from the start: attracted to the sensual beauty of the paint and color that she applied in the creation of figures, only to turn her attention soon afterward to treating the paint as an object in its own right. Yet, because this was not enough for her, she integrated mechanically reproduced images into the purely painterly.

Pia Fries, Untitled (No. 53), 2000

Pia Fries, Untitled (No. 8), 2001–02

When Fries paints, she does not do so on impulse. She approaches the matter with thought and deliberation, carefully choosing the color, the place where she will apply it, and the choice of instrument. Instead of paintbrush and palette knife, she uses a wide variety of found and self-made tools to apply the paint, whether in thick clumps or as a fine glaze, in ways that shape its appearance. In doing so, she does not stand in front of the vertical image; instead the paper lies horizontal on the floor. She walks around it, observing this island of white from various angles, bending over it, crouching, kneeling—always ensuring that a certain balance is maintained. Her way of seeing is never frontal and from a distance, but ensuing from movement, it is directly involved and thus partial. This is an artist who perceives the parts rather than the whole, and who moves from one patch of color to another, pulling the center of the image outward toward the edges.

Improvisation takes the place of self-contained composition; lines are flexed and forms are stacked, there is no taking pause nor seeking a firm hold. Here, painting is not so much a question of projecting an idea onto a surface, but rather of physical work driven by the reach of the artist's gestures, her shifting focus, both reaching out and shoring up. This is evident in the distinctive tectonics of the composition, and reflected in the buoyancy of the individual parts within the image. For Fries, the use of paint and color is not about outlining and contouring figures, but about shaping the material into tactile forms and making them glide over the surface in order to assert their very existence against the printed images.

Dieter Schwarz

90

Katharina Fritsch

Born 1956 in Essen, lives in Düsseldorf

It is not by chance that Katharina Fritsch's lexicon drawings call to mind illustrations in books from a past era. The inspiration for these screen prints was in fact an old, illustrated encyclopedia—published by Duden in the 1930s—that had fascinated the artist as a child, because words and concepts were explained there not only in words but also in images.

In Fritsch's screen prints there are no words, but the copied scenes retain the somewhat old-fashioned style of illustration used in the encyclopedia. The figures are reduced to outlines as they were in the Duden pictures, where maximum clarity and legibility were always the aim. Fritsch's interest here was in the fundamentals of drawing: "I was interested in this kind of standard drawing. What is a drawing? For me a drawing is first of all a sheet of white paper with black lines on it that represents something, and a frame."[1]

1 "Matthias Winzen in Conversation with Katharina Fritsch," in *Katharina Fritsch*, exh. cat., San Francisco Museum of Modern Art, Museum für Gegenwartskunst, Öffentliche Kunstsammlung Basel 1996, pp. 68–84, here p. 72.

Katharina Fritsch, *Lexikonzeichnungen, 4. Serie. Aberglaube, Geisselerzug*, 1996

Katharina Fritsch, *Lexikonzeichnungen, 4. Serie. Aberglaube, Geisterbeschwörung*, 1996

Katharina Fritsch, *Lexikonzeichnungen, 4. Serie. Aberglaube, Hexentanz*, 1996

Katharina Fritsch, *Lexikonzeichnungen, 4. Serie. Aberglaube, Wahrsagerin*, 1996

In fact, without accompanying texts these scenes appear all the more concise: it seems they have no need of explanation. Obviously the naked young woman on a broom is a witch flying to a witches' Sabbath. There is also something witchlike about the older woman reading another woman's hand. And of course this interior would not be complete without the skull and the cat with its arched back. In another picture the warlock has drawn a magic circle in order to strengthen his spell. In short, ideas are pictured here that we all know from the fairytales we were told as children.

The situations appear realistic, but the scenarios are fictitious and ahistorical, and the style of the drawings could hardly be definitively ascribed to any particular era. The subjects call to mind the Middle Ages, albeit a romanticized Middle Ages that was invented in the 19th century. In some respects the outline drawings are reminiscent of a style that was in fashion in the early 1920s—as testified by the slim figures, and the elegant footwear of the woman seeking advice from the fortune-teller.

92

Both in their form and content these lexicon drawings highlight central themes in the work of Katharina Fritsch. She focuses on familiar, popular motifs—monks, Madonnas, and fairytale figures, but also rats, octopuses, and cockerels—motifs that we know and recognize from stories and pictures, but that also arouse a wide range of associations and emotions. The familiar often comes up against the uncanny. But even when Fritsch's figures are charged with numerous personal and collective memories, they are always presented in a state of undercooled perfection. Fritsch often works with series, because she also has a particular interest in the reproducibility of motifs—whether as sculptures that are meticulously replicated or in the lexicon drawings that shaped the imaginations of many thousands of little readers.

Dora Imhof

Simon Fujiwara

Born 1982 in London, lives in Berlin

Simon Fujiwara is a storyteller. His objects and spatial installations, his performances and artifacts take us into a world where reality and fiction, autobiographical elements and historical events, his own experiences and wider cultural connections are inextricably intertwined. The point of departure for his *Letters from Mexico* were the five letters written by the Spanish conquistador Hernán Cortés between 1519 and 1526, in which he reported to King Charles I of Spain (the future Emperor Charles V) on his military exploits in Mexico.

Simon Fujiwara started writing his own *Letters from Mexico*—very likely not by chance—at exactly the time when Mexico was celebrating 200 years of independence and the 100th anniversary of the Mexican Revolution. Fujiwara's letters are addressed to Europe and start with the words "dier Europ." In them he reports on his own experiences and observations as a European tourist in Mexico—a modern-day conqueror—and reflects on the beauty, violence, and poverty he found in that country. Drawing on real and fictitious biographies, the letter-writer fantasizes about a sexual revolution that would unite all the different strata in society.

The three typewritten letters were not typed by Fujiwara himself. He dictated them, between December 2010 and January 2011, to Mexican scribes working in the Plaza de Santo Domingo in Mexico City. However, given that the scribes spoke no English, the letters are purely phonetic transcriptions of the spoken words. As it were "lost in translation," the letters symbolize the enduring misunderstandings between Mexico and Europe, and the difficulty of finding a common language.

Fujiwara has framed each letter individually with mementos of his journey (photographs, ribbons, and medals) but also with objects that originally came from Europe (sunglasses, coins, and so on). The fabric lining the box frames echoes the colors of the Mexican flag (green, white, and red).

Letters from Mexico lay trails and play with allusions, connections, and associations. They invite viewers to engage with the course of colonialism, to reflect on present-day relationships between Europe and Mexico, and—as they do so—not to lose sight of the political power structures and economic dependencies. But there is nothing didactic in this invitation. Conceptual calculation and a love of storytelling come together vibrantly in the work of Simon Fujiwara.

Brigitte Kölle

Simon Fujiwara, *Letters from Mexico (Triptych)*, 2011

Ryan Gander

Born 1976 in Chester, England, lives in Suffolk

Ryan Gander, *Portrait of Spencer Anthony Somewhere Between 1970 and 1973*, 2003

"Motivation instruments"[1]—that's what British conceptual artist Ryan Gander calls the fictional characters he creates, who have turned from synonyms into the core and substance of his work. For a decade these different characters—originally consisting of five personas: Spencer Anthony, Abbé Faria, Murray Jay Siskin, Jan Martin, and Ryan Gander himself—pervaded his work in various configurations and formats.

The fact that the idea of a "group show" with the aforementioned, markedly distinct alter egos adopted by Gander did not inspire the response he wished for—visitors focused on the fictive, overall concept, rather than on individual works—did not discourage him from continuing to engage with these figures. Work by work he developed a narrative that created ever stronger connections between the characters, and in effect provided them with a past, a present, and a future. Thus Gander's trilogy *Spencer, Forget About Good* (2001), *Mary Aurory Sorry* (2002), and *The Death of Abbé Faria* (2003) is not just a tale of loss, guilt, and death, it also invites viewers to speculate on the complex interrelationships between the figures.

1 Stuart Bailey, "Character Building, Monster Consequences etc.," in Ryan Gander, *Appendix*, ed. Stuart Bailey et al., Amsterdam 2003, pp. 97–100, here p. 97.
2 Ibid., p. 100.

Ryan Gander, *Portrait of Mary Aurory 1972*, 2003

In his artistic praxis Gander confronts us with numerous veiled references; at the same time he encourages us to decode them and form our own associations. Party to just a few facts and scraps of information, we have to fill in the gaps ourselves. The full story only exists in our minds; fiction and reality proceed hand in hand. The extent to which the narrative is dependent on the individual viewer is illustrated by Gander in a comparison between his working process and a well-known dinner party game: "You know, someone draws a head on a piece of paper and folds it over, and so on until you get the whole body. That's not as entertaining because you always end up with a gorilla-duck hybrid in suspenders, though it shows how drastically stories adapt and change when they travel through people. It's human nature to elaborate and exaggerate … There has to be a way of formulating these things in your head before they can actually be executed in the world."[2]

The black-and-white photographs of Spencer Anthony and Mary Aurory in the Baloise collection fit perfectly into the overall narrative of Gander's work. In fact they depict the artist's parents: in the landscape format *Portrait of Spencer Anthony Somewhere Between 1970 and 1973* we see Gander's father, smoking at the seaside. In *Portrait of Mary Aurory 1972* his mother, also at the seaside and wearing sunglasses, looks directly into the camera. The fictitious narrative involving these two "characters" tells of a secret on-off affair. There is no hint as to whether that corresponds to the real-life history of Gander's parents. It is up to the viewer to decide.

Marianne Dobner

Geert Goiris

Born 1971 in Bornem, Belgium, lives in Antwerp

Whiteout is the title of a series of photographs by Belgian artist Geert Goiris, who captured these images during two visits, each several weeks long, to the Antarctic in 2008 and 2009. The analog color transparencies document the lives of people working at the research stations there under extreme climatic and material conditions. However, the main protagonist here is the endless expanse of the icy wilderness, filled with crystal-clear light.

Geert Goiris, *Whiteout 1*, 2008–09

Goiris chose the title *Whiteout* in reference to an experience that had a lasting impact on him. During one of his two visits, on a journey to the coast, he found that the diffuse reflection of low sunlight considerably lessened his perception of the surrounding contrasts. The light differences suddenly seemed almost non-existent. The horizon line had disappeared, with the sky and ice-sheathed earth converging seamlessly. Goiris had the impression of moving within an infinite void. Such a borderline experience can lead to psychological pressures that give rise to feelings of unease and anxiety. Often such feelings may be compounded by disorientation and an impaired sense of balance. The resulting shift in perception, both of the self and of the surrounding reality, is suggested by Goiris' use of the term "confabulation," which he chose as the title for a 2009 exhibition of his *Whiteout* photographs at Kunstforum Baloise. It is a medical term that is used to describe a distortion of memory in individuals who perceive their incorrect recall of incidents as true.

Geert Goiris, *Whiteout 2*, 2008–09

For the most part, the photographs are based on a simple and conventional compositional approach, with no discernibly seductive or manipulative artifice. The *Whiteout* images look like documentary or journalistic photographs. On closer inspection, however, they reveal a thought-provoking complexity.

Bleak and lonely landscapes on the edge of civilization, where humans, animals, and vegetation survive under extreme conditions—these are Goiris' chosen subjects. He describes the artistic fruits of his endeavors on all continents as "traumatic realism," whereby photography is the medium that reveals the unfamiliar and the uncanny of the quotidian.

Martin Schwander

Geert Goiris, *Whiteout 3*, 2008–09

Geert Goiris, *Lion*, 2005

Joanne Greenbaum

Born 1953 in New York, lives in New York

When Joanne Greenbaum's distinctive paintings started to gain recognition in the mid-1990s, she was no longer a "young" artist. Although the large-format paintings from that first phase (covering the period up until 2004/05—what went before is her own business) were executed in oil on canvas, they look a lot like drawings and are clearly related to the two early watercolors from 2001 and 2003 that are illustrated here. In 2005 her oils started to take on a much more painterly air, even if they also contain a drawn, under- or overlaid armature that often remains visible. This trajectory in Greenbaum's oils—from quasi-drawing to painting in the usual sense—is also apparent in the extensive group of around 30 watercolors in the Baloise art collection; it is even seen in the difference between the two earlier watercolors and the three later watercolors (from 2008) shown here.

Three of the first exhibitions in New York that Greenbaum participated in had titles that perfectly befitted her position as a painter: *New York, Abstract Painting* (1994), *Exploiting the Abstract*, and *Painting Now and Forever* (both 1997). Joanne Greenbaum was always at home in abstract painting—she never had to deliberately pursue the path to abstraction. It was already part of her skill set and the full panoply of its potential was at her disposal—that might be one way of reading the title *Exploiting the Abstract*. At the same time, despite having cut her teeth on Minimal and Conceptual art in an era that was openly skeptical of painting, Greenbaum always believed in painting's right to exist—today and in the future. Painting, for her, is and always will be an adventure. As she herself put it in a conversation in 2008: "When I start a painting, I have no idea of what I am going to do or where I want to go. I like working in the territory of the unknown which fascinates me and exposes as false the prevalent idea that everything has already been done in painting."[1]

1 Joanne Greenbaum in conversation with Bob Nickas, "Often the Mistakes Become My Best Works," in *Joanne Greenbaum. Painting*, ed. Dorothea Strauss and Susanne Titz, exh. cat. Haus Konstruktiv, Zurich; Städtisches Museum Abteiberg, Mönchengladbach, Ostfildern 2008, pp. 98–102, here p. 99.
2 Ibid., p. 101.
3 Ibid., p. 101.

Joanne Greenbaum, Untitled, 2001

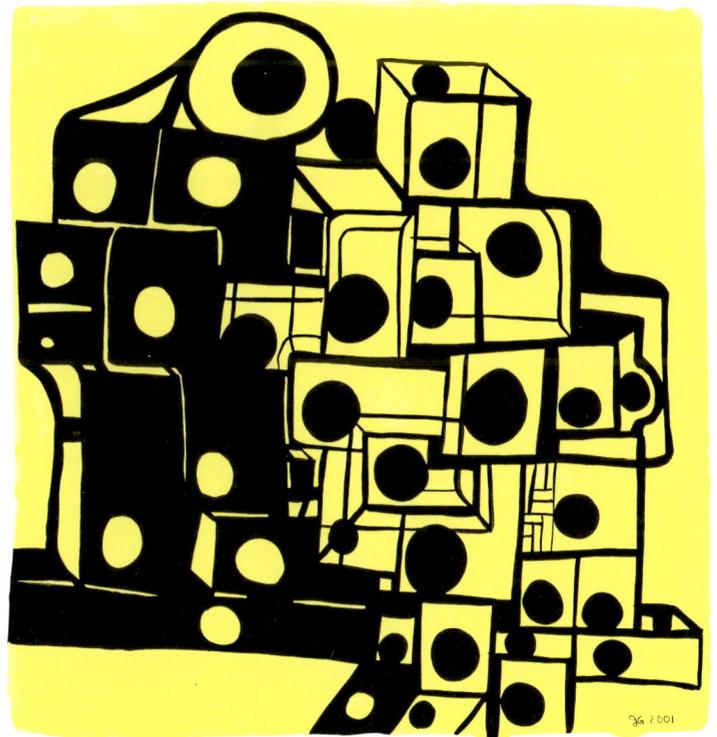

Joanne Greenbaum, Untitled, 2001

Joanne Greenbaum always draws, as she says, in order "to stay connected to [her]self."[2] She produces countless swift, so to speak unthinking, doodles and "scribbles" in ballpoint pen. But, to quote her again, "painting is another kind of energy … "[3] Whereas those drawings are a law unto themselves, there is a close affinity between the watercolors and the large-format oil paintings. In both cases forces that tend toward conceptual order, planning, structures, and patterns come up against energies that are sooner likely to bring about disorder and chaos. There are hints of rudimentary architectures, forms are built upon other forms or organically combined, small-scale motifs proliferate across the picture plane in a more or less structured manner; often numbers distributed around the composition entice the eye into seeking out the progressive emergence of a particular figure. Since 2003 Greenbaum has also created ceramic sculptures: it may well be that the development of her painting so far has in part been influenced by her experience of working in three dimensions.

Beat Wismer

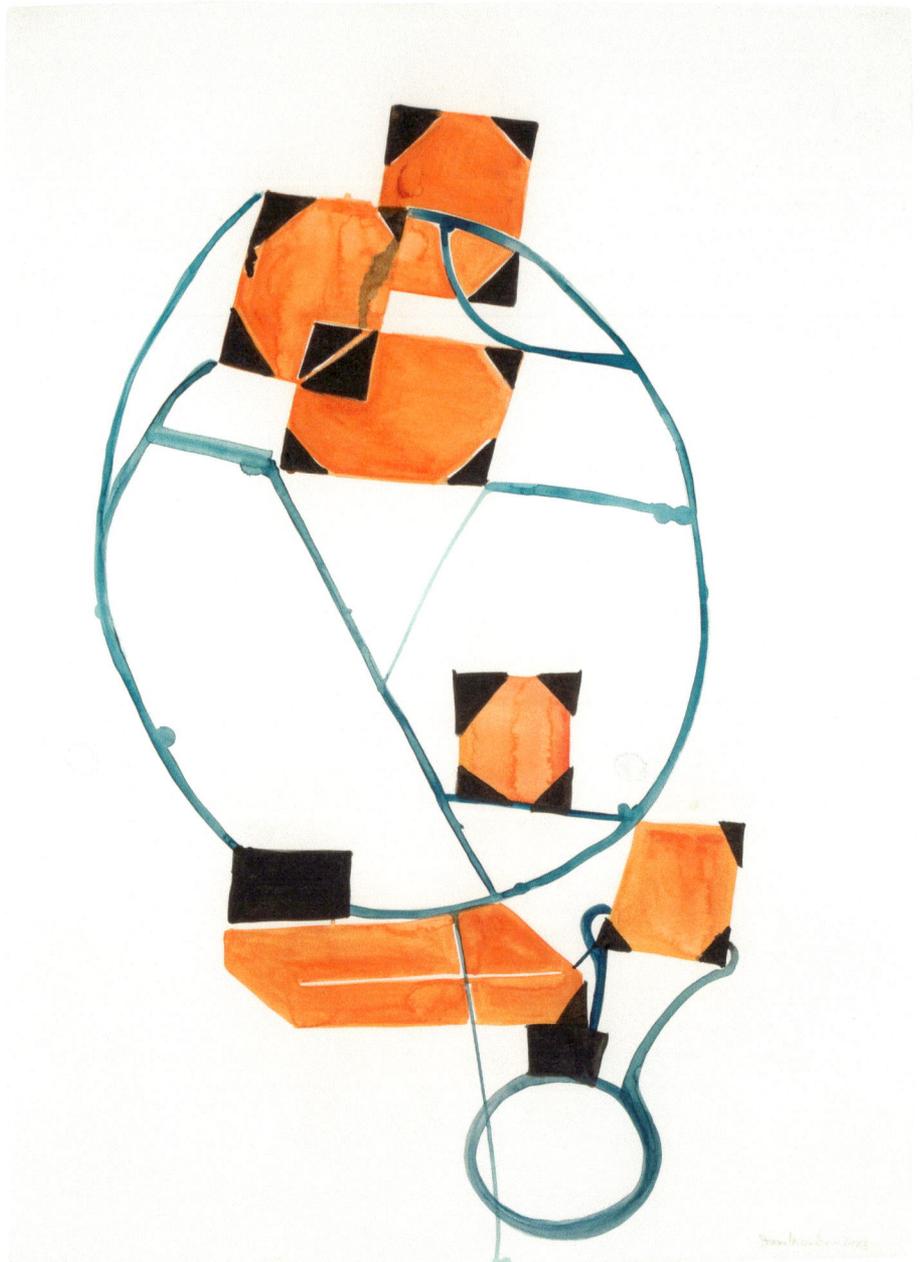

Joanne Greenbaum, Untitled, 2003

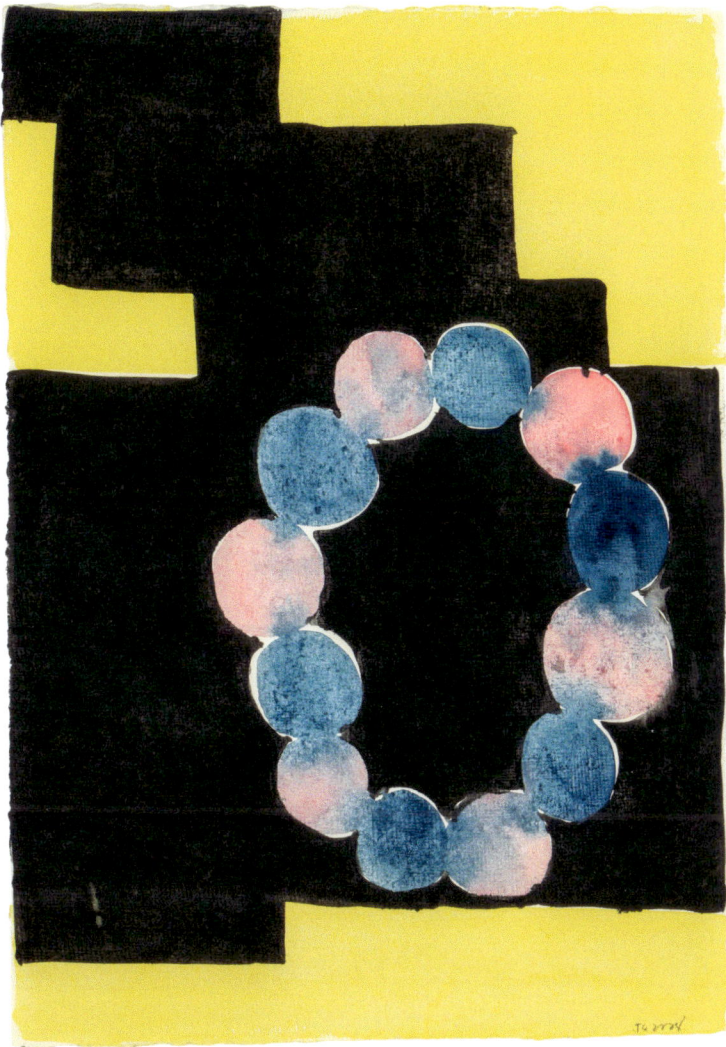

Joanne Greenbaum, Untitled, 2008

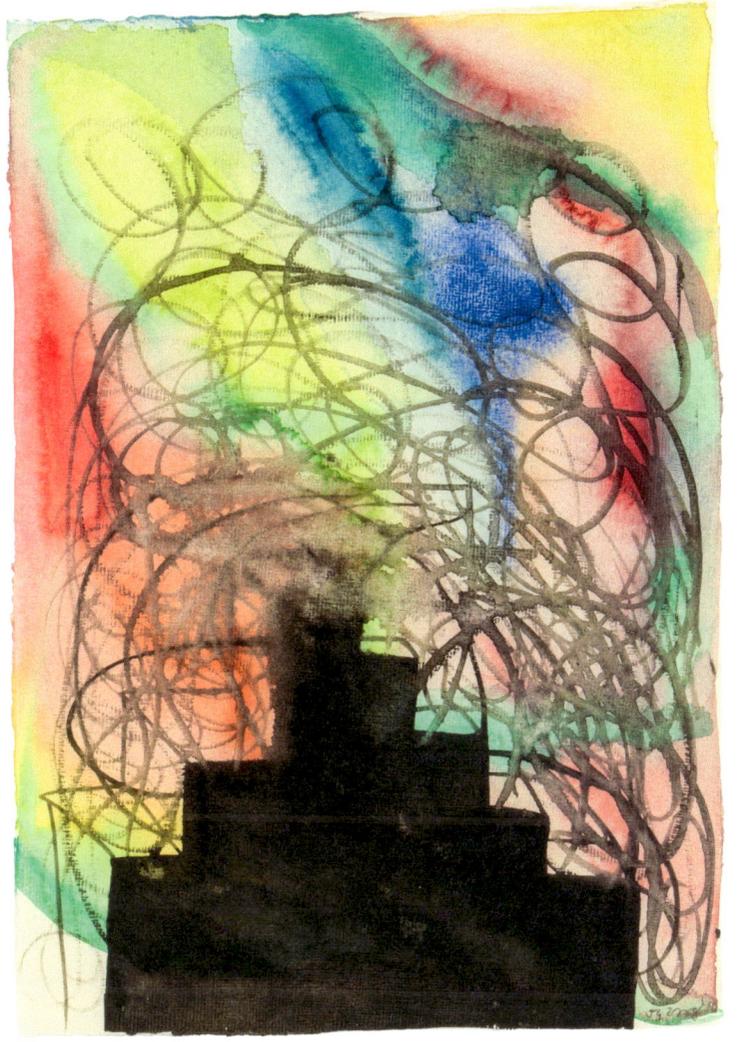

Joanne Greenbaum, Untitled, 2008

Naoya Hatakeyama

Born 1958 in Iwate, Japan, lives in Tokyo

Naoya Hatakeyama, *Still Life*, 2001

Milton Keynes is a large urban development 50 miles northwest of London. It is the flagship of the UK's postwar New Towns: settlements built to relieve the housing pressure in London. Designed in the early 1960s to a master plan, Milton Keynes was utopian in its conviction that modern architecture and bold urban design could embody and foster a good society. Very few towns in the UK have been planned in this way. Most have grown in an ad hoc manner, lacking any grand oversight. Indeed, Milton Keynes soon became synonymous with the whole idea of the planned town. By the 1970s however, much of that faith in modernism had evaporated in Britain, and Milton Keynes began to symbolize all that was bland, sterile, rigid, and boring about postwar urbanism.

As the reputation of modernism rises and falls, so does the reputation of Milton Keynes. While new civic buildings still hold to modernist ideals, British domestic architecture has reverted almost entirely to pseudo-traditional red-brick buildings with pitched roofs. In 2001 the Japanese photographer Naoya Hatakeyama had a four-month residency in Milton Keynes. Hatakeyama works in series, each time with a specific subject matter and photographic approach. His projects have the simplified quality of visual archetypes. Strong and distinctive subject matter is given sympathetic but confident and graphic form as a set of photographs. All the images in each set follow the same pictorial conventions, cohering them as a unified visual statement.

Naoya Hatakeyama, *Still Life*, 2001

Naoya Hatakeyama, *Still Life*, 2001

Naoya Hatakeyama, *Still Life*, 2001

Naoya Hatakeyama, *Still Life*, 2001

Still Life is the provocative title Hatakeyama gave to his suite of photographs of red brick new-build houses in the expanded Milton Keynes. They are photographed carefully, but with a feeling for the generic nature of the subject matter, and the conventional way it is often represented for functional town planning purposes or basic publicity. However, working with a camera positioned slightly above human height, Hatakeyama's rectilinear views make the buildings and streets look a little like models of themselves. They are bathed in picturesque low sunlight—near dawn or dusk—or else in the almost shadow-less light of overcast skies. Both are typically English or at least typical of the way English towns and landscapes are represented in art, television, and cinema.

New but old-fashioned houses, toy-like depiction, clichés of light; all these elements combine to give a sense of suspended time. The forward-looking ambition of modernism, which was the great promise of Milton Keynes, has ground to a halt. The mute stillness of photography has not interrupted anything. Rather it emphasizes the enervation, and the feeling that history, or progress, might be at an end. What kind of people live here? What are their expectations? What kind of community is suggested by this arrangement? Several of Hatakeyama's photographs are views down cul-de-sacs; this French word that the English use in everyday speech describes scenarios in which there are no choices left, no chance to move forward. The only option is to reverse and try something else.

David Campany

110

Candida Höfer

Born 1944 in Eberswalde, Germany, lives in Cologne

Taking no heed of the latest technical possibilities or digital worlds, German artist Candida Höfer adheres to an analog photographic concept of the image which has—precisely because it is so straightforward and timeless—lost nothing of its persuasive quality. Höfer has been photographing interior spaces, devoid of human presence, with an unerring compositional approach since the 1980s.

In their objectivity Höfer's photographs bear witness to a critical and detached viewpoint that bears comparison with that of a scientist focused entirely on her research subject. What piques Höfer's interest is the semi-public sphere. Her approach is like that of a sociologist analyzing a test run of cultural devices that condition and regulate the way people interact in our society. Höfer is interested in the spaces that have been created for people to both learn and enjoy themselves in (such as theaters and opera houses) as well as the spaces where people nurture and expand their knowledge about themselves, their history, and their culture (such as libraries and museums).

Candida Höfer, *Allgemeine Lesegesellschaft Basel III*, 1999

Candida Höfer, *Anatomisches Institut der Universität Basel I*, 2002

Höfer had already worked in Basel in the 1990s. In March 2002, with a view to her forthcoming exhibition at Kunstforum Baloise in the summer, she launched a new "test run" in Basel. The outcome was a series of 25 photographs created in nine places. They show, for example, the Painting Gallery of the Kunstmuseum Basel, but they also feature interior spaces that are less well known, such as the library of the Frey-Grynaeisches Institut of the University of Basel, as well as other spaces that tend to be on the outer fringes of collective awareness, such as the Anatomical Institute of the University of Basel. In the Baloise buildings Höfer honed in, for instance, on the staff restaurant that had been designed in the early 1980s. Her photographs document the space in its original state, shortly before its refurbishment in 2006.

Martin Schwander

Candida Höfer, *Baloise Basel II*, 2002

Teresa Hubbard / Alexander Birchler

Born 1965 in Dublin and 1962 in Baden, Switzerland, live in Austin and Berlin

Ever since Teresa Hubbard and Alexander Birchler started working together as an artistic duo in the mediums of sculpture, photography, and film, they have had a particular interest in giving their art a narrative dimension. Yet their narrations are almost always fragmentary, in suspended animation as it were, like the objects in the multipart photographic series *Falling Down* (1996). Bank notes, ladies' shoes, a coffee cup, and a book all slipping from people's grasp attest to the loss of control by male and female protagonists. It is as if, by means of meticulous stage direction, Henri Cartier-Bresson's "decisive moment"—the moment captured in a photograph that usually remains hidden from the naked eye—were here being shown to be a myth. Hubbard/Birchler's staged scenarios are first and foremost analog images constructed for the camera; utilizing an explicitly cinematographic language they evoke specific mini-dramas—as in the case of the young man who has just alighted from a Greyhound Bus with all his worldly goods, seemingly ready to embark on a new life.

Hubbard/Birchler's interest in an affirmative language of pop culture is seen again in *Stripping* (1998), their next, large-format photographic series, in which it seems we are given glimpses of the female protagonist in a private, ambivalent moment. The artificiality of the film set along with the vertical and horizontal bands dividing particular images inevitably activate the potential for illusion associated with cinema and moving pictures. Thus it hardly comes as a surprise that not long afterward Hubbard/Birchler turned their attention to cinema facades in their *Filmstills* (2002), and started to work on video and film projects.

In so doing Hubbard/Birchler neither altered their pictorial language, nor did they abandon their practice of staging images. Right from the outset, through their photographs and films, their works have always served them as a means to engage in an analytic exploration of the limits of the medium in question. Hubbard/Birchler have always been fascinated by the margins of photography, by the lack of focus of this medium, which both produces meaning and instigates a narrative moment, as do the objects suspended in mid-air in *Falling Down*. Hubbard/Birchler use the medium's autonomy to reinforce the suggestive powers of their cinematic language and, in so doing, create mysterious, poetic images.

Philipp Kaiser

114

Teresa Hubbard / Alexander Birchler, *Falling Down*, 1996

Teresa Hubbard / Alexander Birchler, *Falling Down*, 1996

Teresa Hubbard/Alexander Birchler, *Filmstills. Tinseltown South*, 2002

Teresa Hubbard/Alexander Birchler, *Filmstills. Tinseltown Twenty*, 2002

Thomas Huber

Born 1955 in Zurich, lives in Berlin

Painter Thomas Huber clearly demarcated the beginning of his signifi-
cant work. Toward the end of his time as a student at the Kunstakademie
in Düsseldorf he delivered programmatic speeches introducing
three of his own paintings—*Sintflut* and *Schöpfung* in 1982, *Schule* in
1983—at the Kunstakademie. These compositionally complex yet very
legible paintings are in some ways reminiscent of the educational
posters that many will remember from their school days. Huber's
extensive creative output falls naturally into a chronological sequence
of distinctive yet related groups of works on different themes. His
focus is always on the painting as such, on the pictorial space within
the painting and its architecture, on the relationship of figure and
ground, language and image. From the outset Huber's pursuit of a
picture within a picture was a key tactic and stylistic device. Over the
decades the form of painting that is the vehicle for his pictures—
painting in the sense of "peinture"—has barely changed.

 Huber's imagery bears the stamp of his original ambition to
become an architect, and of his active interest in architecture and urban
planning. This also comes across in the watercolors that he painted
in 2002 in connection with a commission to design the interior of
the art library for the newly extended Aargauer Kunsthaus in Aarau.[1]
The art museum wanted a space reserved for those wishing to engage
with art through words and texts. Huber had taken on several library
projects since 1990, which led to the invitation. Accordingly, in 2003
he created four large-format paintings for Aarau, in which the reservoirs

1 See Thomas Huber, *Die Bibliothek in
 Aarau (Schriften zur Aargauischen
 Kunstsammlung*, vol. 4), Aarau 2003.
2 Thomas Huber, "Wolken," in Huber,
 Die Bibliothek in Aarau, p. 3–6, here p. 6.
3 *Thomas Huber. Die Bibliothek*, exh. cat.,
 Kunstraum München 1990, p. 90. This
 statement was reused by Huber as a
 commentary on the painting *Ein Bild kommt,*
 in *Thomas Huber. Das Kabinett der Bilder*,
 ed. Beat Wismer, Baden 2004, p. 161.

Thomas Huber, *Bildreservoir*, 2002

117

Thomas Huber, *Réservoir*, 2002

and repositories first seen in the watercolors make a reappearance. *Huberville* is the name Huber has given to his urban project, which in many ways calls to mind designs for ideal cities created by Italian artists during the Renaissance. In the library in Aarau visitors find themselves facing a horizontal townscape, with a building directly on the water in the foreground; it is divided into three barrel-vaulted sections, with the painted facades reflected in the water. This is a variant on Huber's earlier *Bildreservoir*, although in the watercolor it stands alone in an Alpine landscape and has only two barrel-vaulted sections.

When Huber reworked *Bilderlager 1* as an oil painting for the library in 2003, the vertical format became an expansive horizontal format. Aside from the wider perspective and the different color scheme, this is in effect the same painting, although the title—*Wolken*—now makes reference to the way the walls are painted. A similar transformation is seen in the pictorial space of the watercolor *Réservoir*, which becomes *Lesesaal* in the oil painting. Once again the walls are decorated with amphora-like vases, but now a man is seen wading in a round pool with numerous sheets of paper floating on its surface. The painter explained this image: "The water has collected together all of this world's pictures in its reflections, preserving them since the beginning of time."[2] Long before that—as someone who has extensively engaged in words and images not only with alchemy but also with the "ideal pictorial temperature" and with the aggregate states of a picture—he had already stated that, "The clouds in the sky are latent pictures, picture chambers, an indescribable [literally: unpaintable] wealth of pictures."[3]

Beat Wismer

118

Thomas Huber, *Bilderlager 1*, 2002

Alain Huck

Born 1957 in Vevey, Switzerland, lives in Lausanne

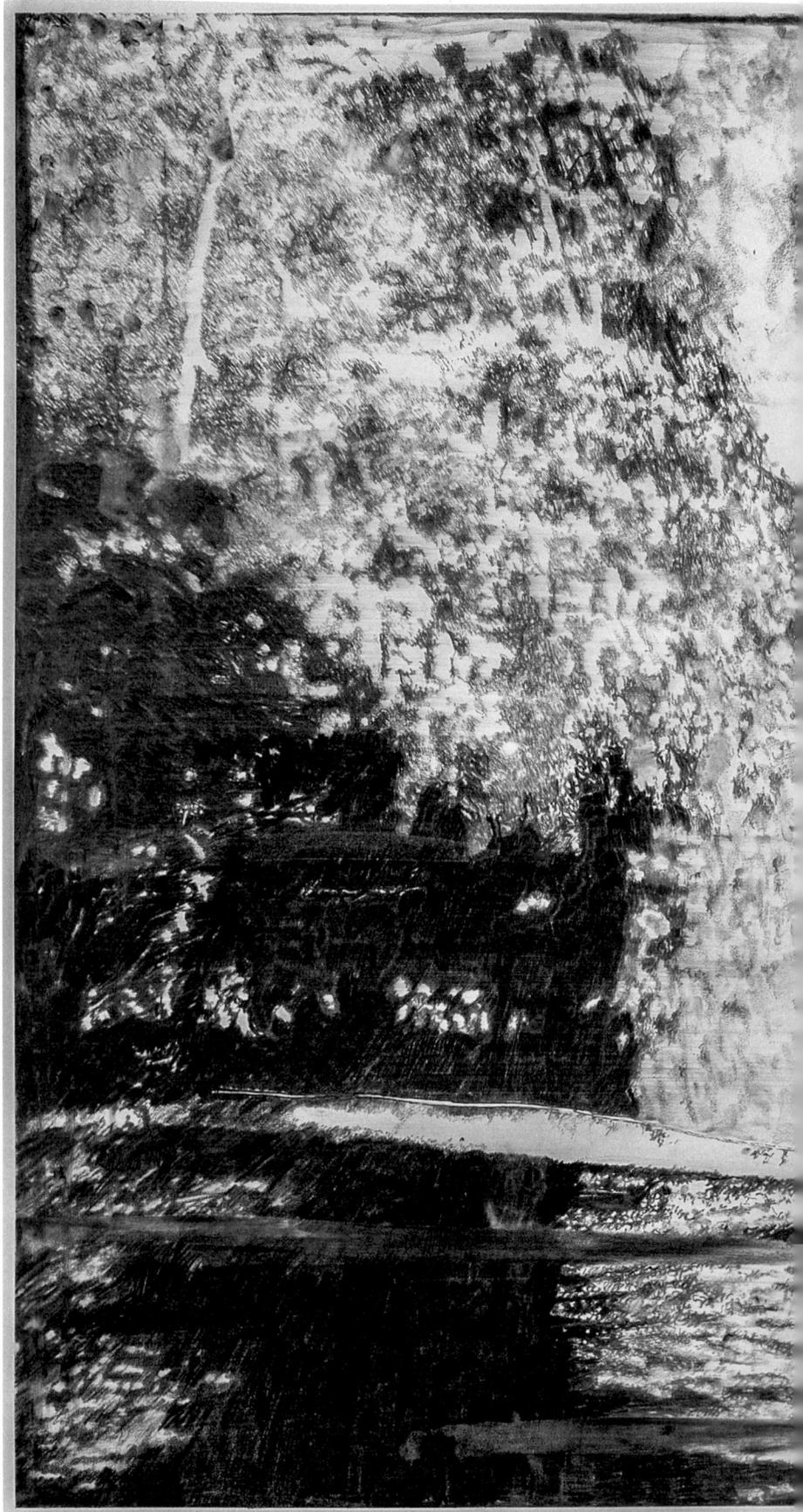

Alain Huck, *Affection*, 2010

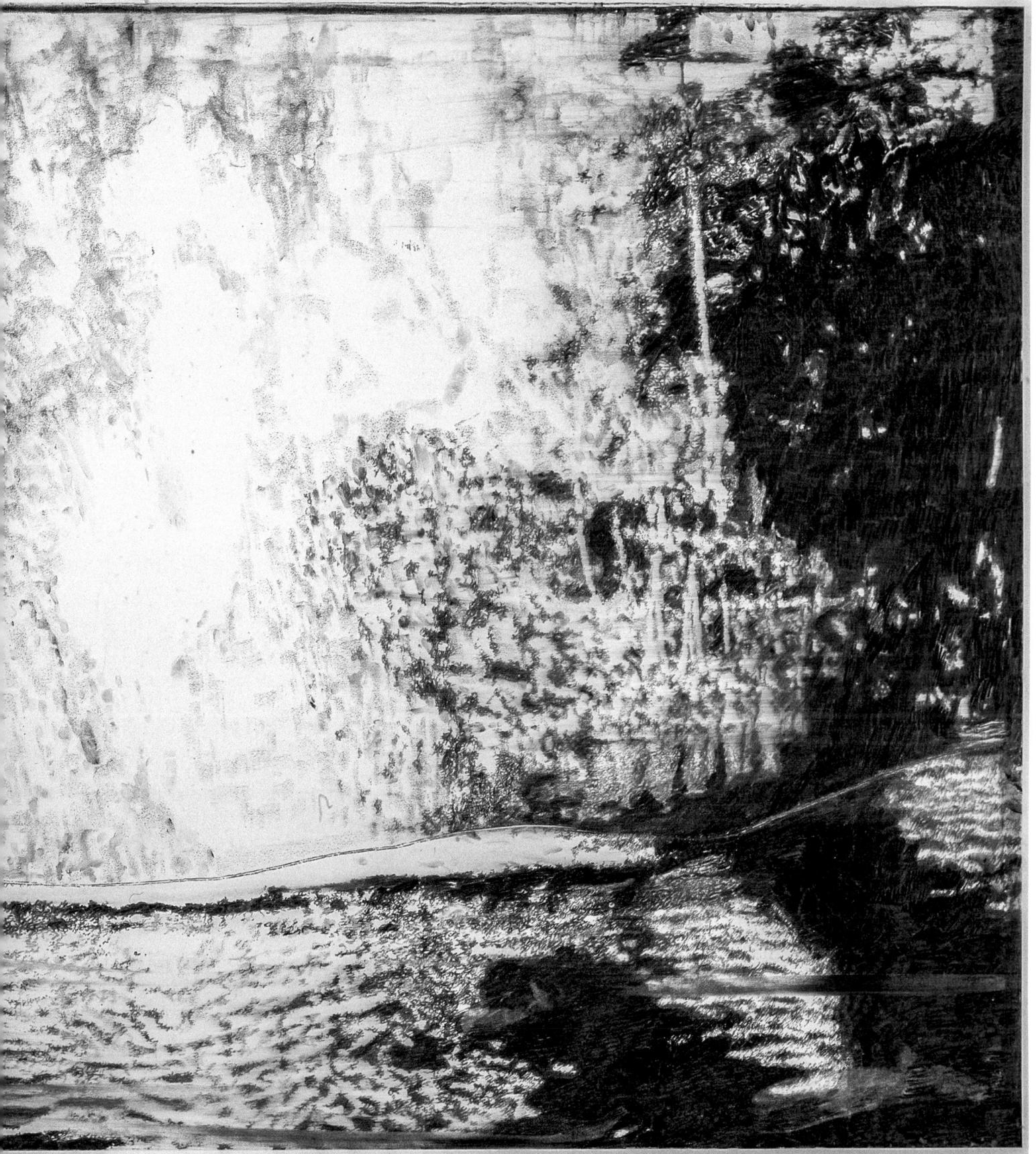

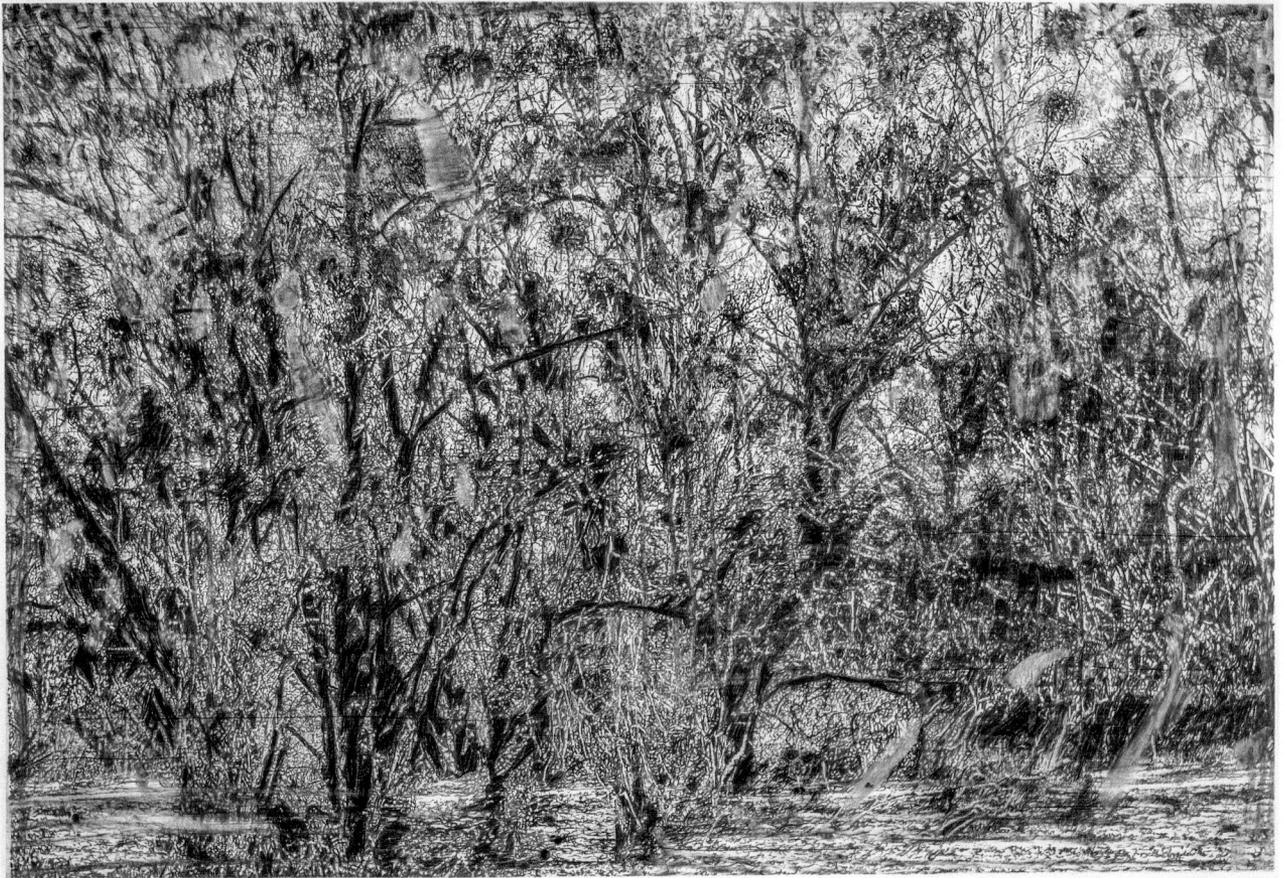

Alain Huck, *Le souffle*, 2010

Alain Huck created the visually striking drawings *Affection* and
Le souffle in the summer of 2010 for his exhibition at the Kunstforum
Baloise. Both drawings share the same format and technique. They
also bear similarities in the choice of motif and style of drawing. Both
works are based on photographs that the artist painstakingly trans-
lated into the medium of drawing with charcoal over a period of
several weeks. *Affection* portrays the spectacular panoramic closing
scene from Werner Herzog's film *Aguirre. Wrath of God* (1972). For
Le souffle, Huck based his drawing on a photograph he took of an
ordinary and unassuming spot near Lausanne. The drawing sets viewers
"barking up the wrong tree" by pulling them into a densely grown
coppice that confounds their orientation and confronts them with an
unfamiliar and impenetrable reality that suggests something as
enigmatic as it is uncanny.

 The uncanny and the unfamiliar are also inscribed into the draw-
ings themselves. Viewed from a distance, the photorealistic precision
of this detailed rendering has an astonishingly impact. Seen close up,
however, both drawings dissolve into a dense and formless com-
mingling. This is the result of rapid and impulsive interventions by which
the artist partially "destroys" the drawings. Huck has used the ball of
his hand, his fingers, and even his arm to blur the finely detailed
elements of his drawings. The charcoal that remains on the surface of
the paper reverts to its original dust-like state. This residual matter
lies like a melancholy veil over the images, both of which are also meta-
phorical images of natural elements: *Affection* stands for fire, and
Le souffle for air.

Martin Schwander

122

Susanne Kriemann

Born 1972 in Erlangen, lives in Berlin

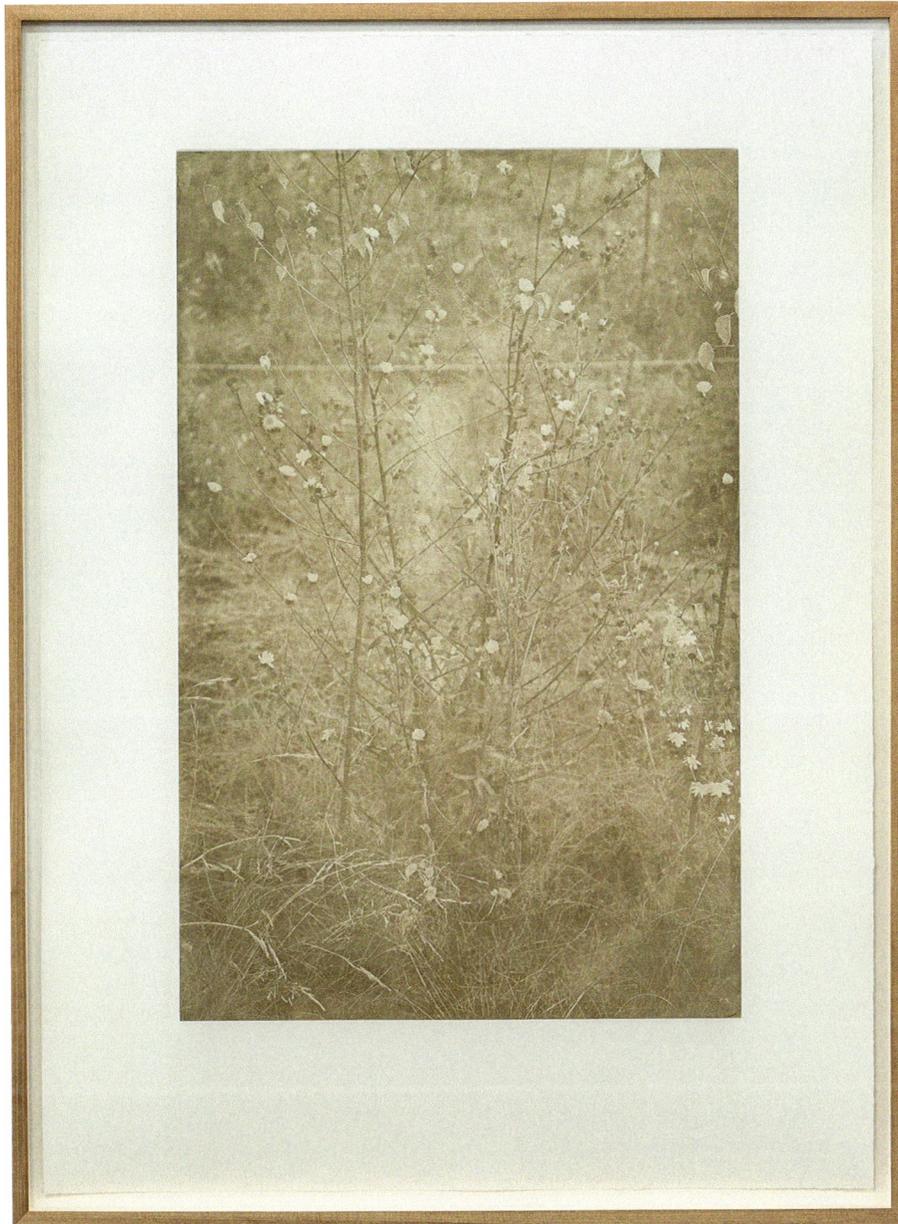

Susanne Kriemann, *Bitterkraut aus: Falsche Kamille, Wilde Möhre, Bitterkraut (Zyklus 2)*, 2017

For her 2017 exhibition at the Kunstforum Baloise, Susanne Kriemann created a series of heliogravures showing plants and herbs. In these prints, the German artist combines the artistic with the scientific. In recent years, Kriemann's field research has taken her to Schlema (in the Erzgebirge region of Saxony), where the highly radioactive mineral pitchblende (also known as uraninite) was mined from 1946 to 1991 and contributed substantially during the East German communist era to the Soviet build-up of nuclear armaments.

A major program has been launched to renature the area around Schlema by 2045. For this purpose, scientists are undertaking research on local test plots to determine the growth rates and accumulation of radioactivity in plants and herbs there. Kriemann photographed

1 Reference to Charles Baudelaire, *Les fleurs du mal*, Paris 1857.

123

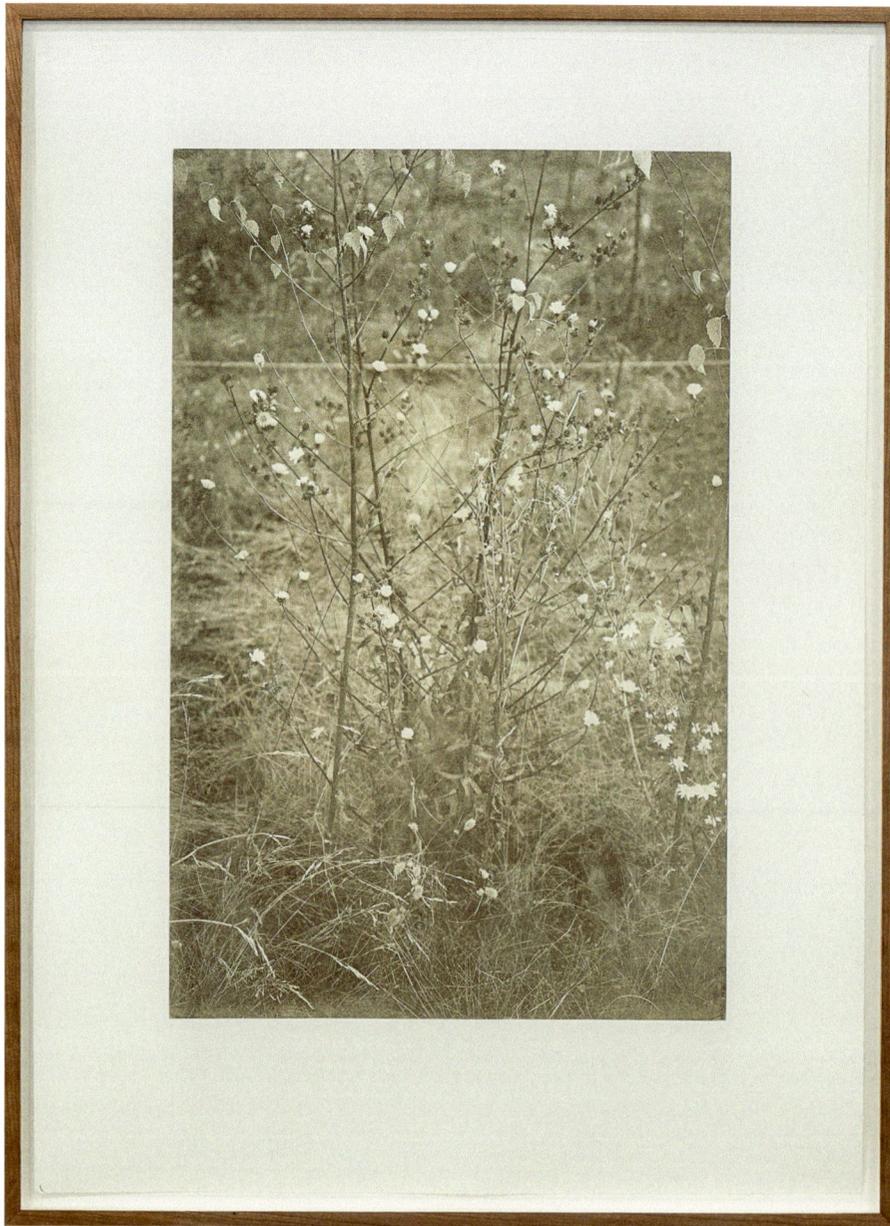

Susanne Kriemann, *Bitterkraut aus: Falsche Kamille, Wilde Möhre, Bitterkraut (Zyklus 2)*, 2017

the plants and herbs on the contaminated test plots over an extended period, painstakingly documenting the timescales of the renaturing program.

At the same time, her photographs formed the basis for her heliogravures, which involve a photomechanical printmaking process used primarily in the late 19th century. This complex intaglio printmaking process results in a very finely detailed rendering of the varying tones in the photograph, and, as such, represents a close connection between artisanal printing techniques and photographic reproduction processes.

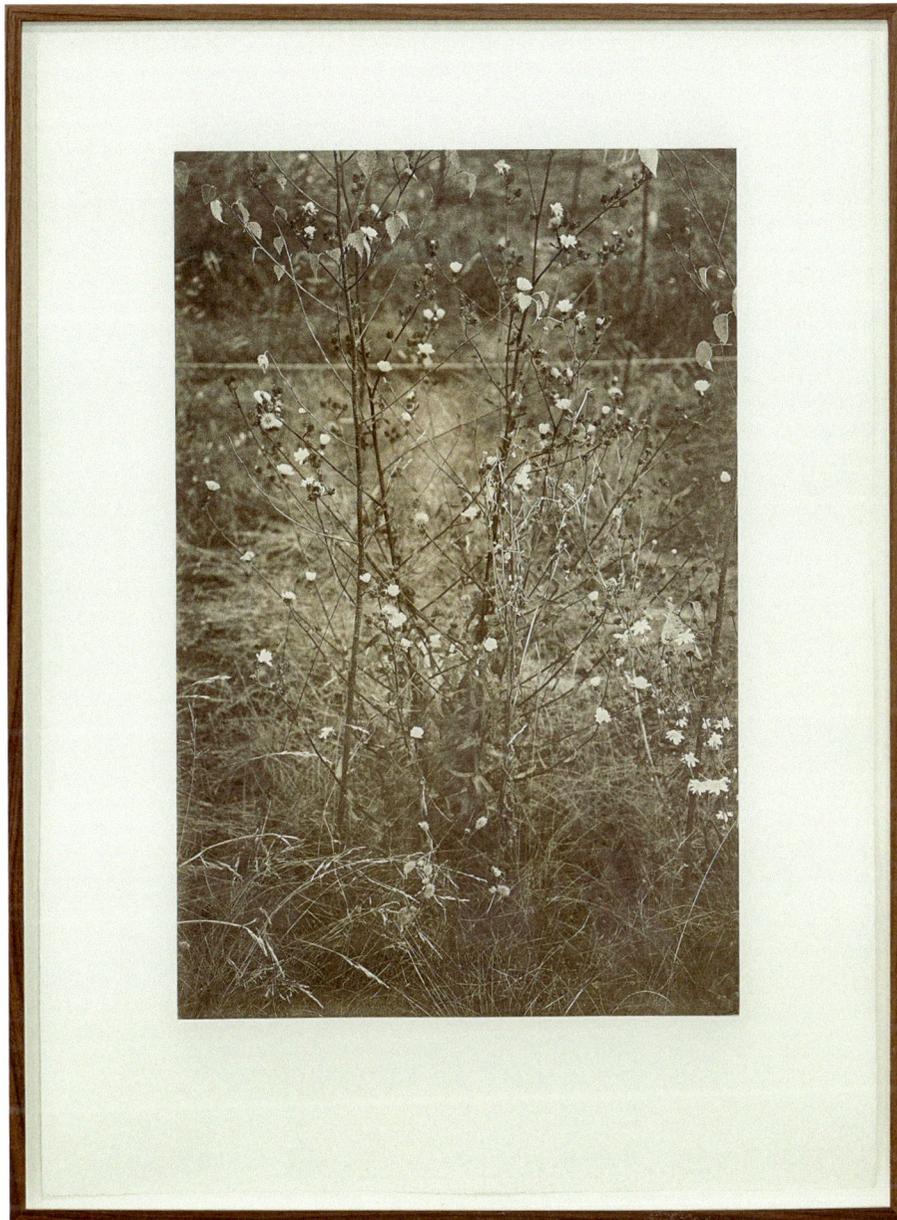

Susanne Kriemann, *Bitterkraut aus: Falsche Kamille, Wilde Möhre, Bitterkraut (Zyklus 2)*, 2017

The images that Kriemann has created in this way portray en-
chanted places from some distant time, even though the photographs
on which the prints are based are entirely contemporary. She height-
ens the ambiguity of the visual composition by individually coloring
each printing plate with uranium-rich pigments she has made by
drying and grinding specimens of the plants and herbs they portray.
"The Flowers of Evil"[1] in Kriemann's heliogravures prompt the viewer
to dwell on the ambiguous relationship between man and nature.

Martin Schwander

125

Annika Larsson

Born 1972 in Stockholm, lives in Berlin

The man in the suit is the epitome of professionalism. His body is
hidden from sight by his perfectly fitting jacket, white shirt, and tie. Like
a figure in uniform, his individuality also recedes into the background.
Among male suit-wearers there can be a very fine dividing line
between power and powerlessness: a suit can demonstrate a man's
superior status, but it can also turn him into a gray mouse who disap-
pears in the crowd.

In her videos and photographs Swedish artist Annika Larsson
meticulously observes the rituals and gestures of masculinity and
power. The men in her images are mostly young, smooth, and de-
individualized. Their immaculate, over-perfect looks and clothing recall
advertising and simulations. Her protagonists often exude a latent
erotic tension or aggression.

The surfaces of these three images are similarly smooth and
gleaming. They are in fact stills from Larsson's video Untitled (*Bend II*)
(2001), which portrays an uncanny interplay between a human and a
computer. A blond, besuited man sits at his laptop using a mouse, but
he has a counterpart—a dark-haired, computer-animated man on the

Annika Larsson, Untitled (*Bend II*), 2002

Annika Larsson, Untitled (*Bend II*), 2002

screen. Both move slowly. As if transfixed, the blond man stares at the screen where the animated figure is bending down in an ever more bizarrely distorted manner; at one point the latter's fingers are bent backward at an anatomically impossible angle that is painful to behold.

The video image switches abruptly to and fro between the men—one in front of, the other on, the screen. By definition they appear to be connected and there is more than a passing similarity in their outward appearance. The situation is puzzling: is this a work or a game? Is the blond man controlling the animated figure in the computer, or is it the digital figure that is mysteriously in control of the blond man? Is the computer-generated figure an alter ego of the man at the laptop? Neither seems able to act of his own free will; it appears they are both being manipulated by an invisible, external force or order.

Larsson's evocative photographs and videos kindle a multitude of associations. They can be read as reflections on alienation and stereotypical masculinity, on the strictures of an anonymous business world, or on the subtle influences exerted by the mass media and digital images—or on the convergence of all three.

Dora Imhof

Annika Larsson, Untitled (*Bend II*), 2002

Zilla Leutenegger

Born 1968 in Zurich, lives in Zurich

The young, girlish woman who is the protagonist in most of Zilla Leutenegger's compositions should not be mistaken for the artist herself, but she may be seen as an alter ego and referred to as "Zilla." The compositions with this fictive figure are not self-portraits in the traditional sense; if anything they are portraits of a younger self in the 2000s when Leutenegger first showed her work in public. "I work with myself as the figure, partly because it is simplest to give stage directions to myself, and partly because it is the most authentic method."[1] The image and the characterization of the figure are crucially dependent on the setting within which the figure is seen. However, as Leutenegger puts it: "I design the set, but I don't create the plot."[2] That is how she herself describes her own intentions, whether in drawings, in videos, or in combinations of the two, that is to say, in animated, projected drawings or in a video installation with integrated drawings.

However, the props in these pictorial spaces are only one aspect of the work, and not as important as the uniquely elusive atmosphere—perhaps best described as melancholic—that pervades these drawings, an atmosphere that may well remind an older generation of the song *Lazy Sunday Afternoon*. These are bare-bones snapshots, presented by the artist as the briefest of chamber plays. Stories are not told here using narrative devices. It may be that these images are

Zilla Leutenegger, *New York*, 2010

in fact the concentrated essence of stories, or maybe they only contain the seeds of possible stories, which—were they told in full—would report, briefly and succinctly, on people's responses to their memories. Leutenegger once commented on this in conversation: "The figures in my drawings and works are always alone—alone but not lonely."[3] And, elsewhere in the same conversation: "I regard the figure, which is mostly my own, as an exemplar for humankind,"[4] as "a figure you can see yourself in."[5] Meanwhile, her ideal exhibition goers are those "who stop of their own accord, reflect, and feel solidarity with the figure and its existence."[6]

Leutenegger's visual language, which in some senses calls to mind children's drawings, looks distinctly unpretentious in what are often very large-format compositions. Her figures and objects are rendered as line drawings with just a few zones in the motifs marked out by patches of concentrated color. These drawings thus have an almost collage-like air. They are easy to read, the visual language is pared back, props and furniture are kept to a minimum in these stage sets where a figure engages in certain actions, often gazing into space as if sleepwalking. Using the simplest motifs and formal means, Zilla Leutenegger evokes a very particular atmosphere in the realms of her art.

Beat Wismer

1 Inka Graeve Ingelmann in conversation with Zilla Leutenegger, "Ring My Bell," in *Z – Zilla Leutenegger*, exh. cat. Pinakothek der Moderne, Munich 2015, p. 61–73, here p. 69.
2 As cited in Ralph Melcher, "Poesie des Raumes," in *Zilla Leutenegger. Wichtiger Besuch*, exh. cat. Saarlandmuseum, Moderne Galerie, Saarbrücken, Ostfildern 2006, p. 67–73, here p. 69.
3 Graeve Ingelmann and Leutenegger, "Ring My Bell," p. 64.
4 Ibid., p. 70.
5 Zilla Leutenegger in conversation with Dorothee Messmer, "Versuche, das Unmögliche möglich zu machen," in *Zilla und das 7. Zimmer*, exh. cat. Kunstmuseum Thurgau, Warth, Zurich 2008, p. 101–109, here p. 103.
6 Graeve Ingelmann and Leutenegger, "Ring My Bell," p. 67.

Zilla Leutenegger, *Zahnweh*, 2005

Zilla Leutenegger, *Telefon (Mia Farrow)*, 2005

Sol LeWitt

Born 1928 in Hartford, Connecticut, died 2007 in New York

Having explored multiple permutations of lines of different colors and directions in his drawings for several years, from straight lines to curved arcs with changing midpoints, Sol LeWitt then looked into the possibilities of contrasting these systematic arrangements with others that might seem chaotic by comparison. Choosing a random given as the starting point for the parameters of a structure and continuing from there, opens up a realm of unexpected potential. In 1973 LeWitt began creating works that focused on the position of points and lines on the plane, describing these in words and also incorporating the words into the drawing. As so often in his oeuvre, the idea brought forth surprising visual results. LeWitt expanded this new concept to other areas of his work and published several artist's books in which he demonstrated this placement of points, lines, and geometric figures. He was fascinated by the paradox that a detailed and consistently formulated description, and one of ever-increasing exactitude, culminated in absurdity, just as he had noted in literary texts. As he put it, "I was very involved in writers like Samuel Beckett who were also interested in the idea of absurdity as a way out of intellectuality. Even a simple idea taken to a logical end can become chaos."[1] About the *Location Drawings* LeWitt added that, "The more information that you give, the crazier it gets, until to construct a very simple form or figure such as a circle you could have three pages of text. In a way it was an extension of the idea that prolixity created simplicity and unity."[2]

In *Drawing for Four Pages*, created for an as yet unidentified publication, we find a structure of various types of lines interacting with one another—lines that radiate from the end or the center of other lines, lines that lead from specific points to other points, and even the positioning of a straight, curved, and broken line respectively. LeWitt set the text along the constructed lines so that it underpins its trajectory on the plane as an equal visual element. No matter how precisely the respective position might be described, it does not really justify or explain the run of the lines, which remains arbitrary. The fact that the premise and the result are proportionally at odds to one another can also be seen as a subtle jibe at European modernism's functionalist aesthetic of "less is more," and its promise of a recon-ciliation between the ideal and reality.

Dieter Schwarz

1 Sol LeWitt interviewed by Andrew Wilson, "To Avoid a Rational Step, Intuition Is Important" (1993), in Patricia Bickers and Andrew Wilson (eds.), *Talking Art. Interviews with Artists since 1976*, London 2007, pp. 414–421, here p. 416.
2 Ibid., p. 417.

Sol LeWitt, *Drawing for Four Pages*, 1974

Aleksandra Mir

Born 1967 in Lubin, Poland, lives in London

Aleksandra Mir, *The Big Umbrella. Copenhagen*, 2004

At the 2004 Art Basel fair, Aleksandra Mir gave an insight into her project *The Big Umbrella*. This multi-part installation, full of humor and melancholy, persuaded the Baloise Art Prize jury to single her out for one of their two awards.

The central element of *The Big Umbrella* project is an oversized black umbrella. The largest umbrellas available commercially have space for four people beneath them. Mir's umbrella is more than twice that size and offers shelter for as many as 16 people. It was custom-made by specialists with meticulous craftsmanship. The result is a fully-functioning umbrella that looks much the same as any other—the difference being that its sheer size makes it, depending on the situation, either an object of admiration or of astonishment.

The artist went walking with the umbrella in six different places: first in Paris, "where it often rains."[1] The following year, she did the same in London, Dresden, and Copenhagen, Martinique and New York. The photographs document each of these performative urban excursions.

In each of the places visited by the artist, *The Big Umbrella* acted as a catalyst "to inspect how the elements of weather and community interact with each other and differ."[2] The umbrella is thus both

1 www.aleksandramir.info/projects/
 bigumbrella/bigumbrella.html
 (August 2006).
2 Ibid.
3 https://www.aleksandramir.info/projects/
 the-big-umbrella/ (last accessed
 November 2019).

Aleksandra Mir, *The Big Umbrella. London*, 2004

sculptural performance prop and functional everyday object that anyone can relate to. But its dimensions alter that relationship, making the familiar seem fantastical, while the fantastical shows the familiar in a new light.

In retrospect Mir sums it up as follows: "*The Big Umbrella* was designed to shield up to 16 people from the rain. It was a cheerful and simply idyllic structure, but did 16 people want to crowd together to avoid getting wet? Does bad weather affect people differently in different parts of the world? To find out, I took my big umbrella on the road between 2003 and 2004, visiting six cities in as many countries. Traveling the world with a familiar object of uncanny proportions can have some unexpected effects. While *The Big Umbrella* proved useful as a tool for plucking down stray balls from trees, its unwieldy size on busy streets turned altruistic motives into harassment. Providing a shelter, it brought some strangers momentarily together while alienating others, and in its most salient moments, simply amplified the solitude of the bearer."[3]

Martin Schwander

Aleksandra Mir, *The Big Umbrella. London*, 2004

Tracey Moffatt

Born 1960 in Brisbane, Australia, lives in Sydney and New York

Childhood and youth are central to the work of Australian artist Tracey Moffatt. These crucial years are often far from idyllic, but a time of hurt and trauma. Tracey Moffatt's ten-part photographic series *Scarred for Life II* tells of everyday humiliations that can be indelibly burnt into a person's memory: the boy who is baited because he has home-knitted sportswear (*Homemade Hand-Knit, 1958*); the sisters, punished out of all proportion to their misdemeanor, who have to cut the grass with scissors (*Scissor Cut, 1980*); the boy, small for his age, who always has to be the sheep in school plays (*Always the Sheep, 1987*). Most of the scenes depicted in Moffatt's photographs relate to minor or major events at school or in the family, but they frequently also point to greater grievances in society: to injustices, to prejudices based on gender, social affiliations, skin color, or body weight.

The fact that Moffatt's works are highly complex—never merely one-dimensional indictments—is due to their form. Each sheet has an image, a title, and a text. While the explanatory comments are extremely short and pithy, the images are filled with details that open up

Homemade Hand-knit, 1958

He knew his team mates were chuckling over his mother's hand-knitted rugby uniform.

Tracey Moffatt

Tracey Moffatt, *Scarred for Life II. Homemade Hand-Knit, 1958*, 1999

Tracey Moffatt

Tracey Moffatt, *Scarred for Life II. Scissor Cut, 1980*, 1999

an entire narrative panorama. Although the photographs look almost
like snapshots, they are carefully staged by Moffatt, who also often
works with film. The muted colors in the photographs, and the thin,
cream-colored paper create the impression that these are reproduc-
tions of the kind that were seen in illustrated magazines in the 1960s—
in publications such as *LIFE* magazine in the United States. Thus the
private, unspectacular nature of the scenarios contrasts with their
form, which calls to mind what is now an iconic visual language from
the world of publishing.

Many of the scenes in *Scarred for Life II* are based on the artist's
own experience or on tragi-comic stories told by her friends. In her
photographs and films Tracey Moffatt consistently addresses gender
issues, minorities, and the situation of the native peoples of Australia.
She made the earlier series, *Scarred for Life I*, which explores a
related theme, in 1994. But even in her very first film, *Nice Coloured
Girls* (1987), Moffatt already juxtaposed the reality of life for young
Aborigine women with historic images of their female ancestors'
oppression by white men. Moffatt's discomfiting works demonstrate
the power of images and the power of clichés and prejudices. They
show how crucial these have been not only in the colonial history of
Australia, but also in her own life, right up to the present day.

Dora Imhof

Piss Bags, 1978
Locked in the van while their mothers continued their affair,
the boys were forced to piss into their chip bags.

Tracey Moffatt

Tracey Moffatt

Always the Sheep, 1987
The smallest boy in class had to be the sheep
every night in the production of Waltzing Matilda.

Tracey Moffatt, *Scarred for Life II. Piss Bags, 1978*, 1999

Tracey Moffatt, *Scarred for Life II. Always the Sheep, 1987*, 1999

Mrzyk & Moriceau

Born 1973 in Nuremberg and 1974 in Saint-Nazaire, live in Montjean-sur-Loire

Since 1998 Petra Mrzyk and Jean-François Moriceau have worked as
a French artist duo whose *ligne claire* drawings, gracefully snaking
their way through animated films, or else couched on paper or drawn
on the surface of a wall, immediately identifies the two. They met at
the fine art school in Quimper and since then have been developing a
two-handed graphic approach that has yielded a prolific output
characterized by the concision of their line and the playful exploration
of forms and motifs. The pair has also collaborated with musicians,
creating video clips for Philippe Katerine, Air, and Sébastien Tellier.
 Mrzyk & Moriceau have adopted an intuitive take on drawing that
sees motifs springing from one another and responding to each
other with a humor that is often tinged with cruelty. In elaborating their
drawings, the artists like to borrow their subjects from popular

Mrzyk & Moriceau, Untitled, 2001

140

Mrzyk & Moriceau, Untitled, 2003

culture—you may run into Tintin as well as icons of art history and film, but also logos from the world of advertising. They decontextualize, transpose, and reappropriate these, producing new meanings. The forms and images that fill our daily lives are thus a chance to present a rereading of them that is endlessly renewed, one that views the subjects and motifs that are dealt with as so much noise, whose multiple meanings and wealth of harmonies are brought out and put on display. Mrzyk & Moriceau work to render these effects of meaning immediately visible through the optimal use of a minimum of resources.

The *ligne claire* of their black-and-white drawings is deliberately unexpressive, and the generically drawn figures are universal in character. Pencil and paper are characters in their own right and regularly appear at the heart of the artists' imagery, offering them a way to provide a self-deprecating running commentary on their own work. The page is thus a place meant to be explored over and over without end, tautologically. One drawing in the collection shows pencils as

standing characters ready to disappear into a book that is opening its pages to them, welcoming them into its folds. Elsewhere a stack of pages becomes the pretext for an undulating line or a play of waves. Like some absurd farce, one sheet of paper shows a pencil tracing a line followed by the eraser that is rubbing it out just as quickly, as if to recall the fleeting character of every artistic gesture.

A universal language that is accessible to one and all, drawing is for Mrzyk & Moriceau first and foremost a means to take a tender and poetic look at our culture. The pair engage in a form of 21st-century pop art, where archetypal figures drawn in *ligne claire* humorously defuse the creative gesture in favor of an art that is akin to our day-to-day world.

Julie Enckell Julliard

Mrzyk & Moriceau, Untitled, 2004

Mrzyk & Moriceau, Untitled, 2004

Claudia & Julia Müller

Born 1964 in Basel, lives in Basel; born 1965 in Basel, lives in Berlin

Claudia & Julia Müller, *Groups and Spots (Apes)*, 2003

The first retrospective catalogue of the work of sisters Claudia and Julia Müller was published just over a decade after they started working together as an artists' duo.[1] Set out as a comprehensive, chronological catalogue raisonné, it covers all their work from 1992 to 2004—everything from drawings to wall paintings to large-scale installations, video works, and computer animations. At that time the series *Groups and Spots* (2003) had only recently been completed. It comprises 12 acrylic paintings on paper, six of which are now in the Baloise art collection. The title of each work is noted on it, as in "group (children)," "group (Tibetanian beauty queens)," "group (warriors)," "group (apes)." In their next retrospective catalogue, works from 2004 to 2014 are listed in alphabetic order, rather than chronologically.[2] This in itself is an indication of the pivotal part played by systems and collation in the Müller sisters' thinking—regarding anything ranging from simple shopping lists to encyclopedias and the many different kinds of private and public archives.

1 *Claudia & Julia Müller*, ed. Madeleine Schuppli, exh. cat. Kunstmuseum Thun and Grazer Kunstverein, Basel 2004.
2 *Claudia & Julia Müller*, Berlin 2015.
3 See "Popular Abstraction. Daniel Baumann talks to Claudia & Julia Müller," in *Claudia & Julia Müller*, 2004, p. 81–87, here p. 86 and 87.

Claudia & Julia Müller, *Groups and Spots (Warriors)*, 2003

Claudia & Julia Müller, *Groups and Spots (Children)*, 2003

Claudia & Julia Müller, *Groups and Spots (Tibetanian Beauty Queens)*, 2003

The people and animals that feature in works by the artists mainly derive from found images sourced from a wide variety of locations. Their fund of images is as diverse as the classification systems they work with. The images in the vast archive they have built up over the years come from family photograph albums, from magazines and newspapers, from advertisements and picture agencies. Their found protagonists become fluid, painted figures—mostly in somewhat muted colors—in images that have been rigorously cleared of inessentials and that are always about readability rather than sophisticated, "artistically brilliant" representation. Accordingly, it simply does not matter which of the two sisters happens to be holding the paintbrush. The entire focus of the artistic representation here is on analyzing and articulating not only patterns of behavior and strategies that are commonly used to depict figures and groups of figures, but also the ways that individuals and groups pose for the camera. However, the artists' interest is not only in the roles that individuals enact, but also in the roles that are ascribed to them. Prime examples of the interaction between deliberate poses and the expectations of a critical audience are of course seen at beauty contests, but the artists have also found telling material for their pictorial investigations in gardens where children are playing, and in primates' enclosures in zoos. The animals that feature in their work are mainly domesticated, or found in zoos (in habitats designated for them by human beings) where they have to exist and behave in a way that will meet the expectations of those gazing at them.

As for the children standing on either side of a snowman, could it be that they are deliberately, spontaneously defying that combination of audience and stage management, taking a stand against the idea of posing? It would in fact be perfectly possible to read the "spots" and blotches in *Children* as marks left by snowballs that the two children have been throwing at the window where their mother is watching from inside the house, taking snapshots of them at play.

145

In conversation around the time when *Groups and Spots* was completed, Claudia Müller commented on their treatment of source materials: "By drawing, we interpret the representation anew, introduce new codes which function as a reading aid for that particular depiction of the everyday." And Julia Müller explained the importance of "poses" in their work: "Yes, pose is culture. And we are interested in what representational forms emerge as a result. We want to list them and expose their foundation … When people pose, the camera interrogates a constellation. A politician's family poses more consciously than a crowd of soldiers who have been waiting for hours to be deployed. Here, laws emerge which make valid statements at a visual, psychological, and sociopolitical level. A central component of our work is to recognize and understand these."[3]

Beat Wismer

Bruce Nauman

Born 1941 in Fort Wayne, Indiana, lives in Galisteo, New Mexico

What is striking about Bruce Nauman's work is that it has always involved what was directly accessible to the artist—the space around him, his own body, and language. The language aspect, in particular, reveals how the subjectivity of the artist breaks with social convention. Nauman does not invent expressions or turns of phrase. He finds them in everyday speech and makes them his own. In this respect, he can be compared to Marcel Duchamp and Jasper Johns, who also used language, and, by way of minimal vocal changes, brought astonishing new meanings to the surface from the depths of the words themselves, without shying away from disturbing connotations. Nauman's approach is diametrically opposed to that of his contemporaries Carl Andre and Lawrence Weiner, for instance, who treat words as objectifiable material things.

In drawing, Nauman found a medium at an early stage of his career that could hold its own with his sculptural work, for it served him not only as way to project his ideas, but also as a field for exploring and evolving his propositions, and leaving their traces visible. Over time, he worked with sheets of paper of ever-larger dimensions, so that they commanded a presence of their own on the wall, thereby bringing the sensual appearance of objects to the fore. This is especially true of the drawing shown here, in which the relief of the letters has been highlighted in watercolor, while the background remains cursory. The three-pronged alignment seems to have been derived from the tunnel pieces that Nauman had worked on quite extensively in the years before. The writing, on the other hand, is redolent of the neon pieces that he was creating around the same time as this drawing. Such correlations can also be found in the wording itself. For instance, in a 1978 drawing of a five-part structure with the inscription "DRAIN 1 + DRAIN 2," we can actually discern a star-shaped configuration converging on a central point that could well be seen as a drainage system.[1] In the neon piece *Human Nature*, the words "HUMAN NATURE/ANIMAL NATURE" appear alternately.[2] These word

1 *Bruce Nauman. Zeichnungen 1965–1986*, exh. cat., Museum für Gegenwartskunst, Basel; Kunsthalle Tübingen; Städtisches Kunstmuseum Bonn, Basel 1986, no. 372.

2 *Bruce Nauman. Exhibition Catalogue and Catalogue Raisonné*, ed. Joan Simon, exh.cat., Museo Nacional Centro de Arte Reina Sofía, Madrid; Walker Art Center, Minneapolis; The Museum of Modern Art, New York; Basel 1994, no. 304.

3 The drain itself is the subject of Nauman's drypoint and aquatint print *Floor Drain* (1985). See *Bruce Nauman. Prints 1970–89. A Catalogue Raisonné*, ed. Christopher Cordes with Debbie Taylor, exh. cat., Castelli Graphics and Lorence-Monk Gallery, New York; Donald Young Gallery, Chicago; New York 1989, no. 49.

4 A related pair of opposites also appeared two years earlier in the lithograph *Human Companionship/Human Drain*, in which the words "HUMAN DRAIN" spiral into the depths. See *Bruce Nauman. Prints 1970–89*, no. 46.

Bruce Nauman, *Human Need Drain*, 1983

147

pairs are a mirror image of the pronged alignment in "HUMAN NEED/ DRAIN," suggesting nature as the common denominator between human and animal. Nonetheless, "HUMAN NEED/DRAIN" is not a pendant piece to this, for we suspect that the word "drain" may well be a corruption of the word "brain": the fundamental opposition of need and thought, of physical and intellectual existence, is dissolved by the replacement of a single letter, whereby the heights of the cognitive are replaced by the depths of all that is washed into the sewer. The idealistic notion that human existence is an equilibrium between two mutually balancing opposite poles is quite literally washed down the drain.[3] Nauman skeptically infers that the asymmetry of language overrides the visual symmetry of the construction.[4]

Dieter Schwarz

Saskia Olde Wolbers

Born 1971 in Breda, Netherlands, lives in London

A placebo is a form of medication that contains no pharmaceuticals, yet can still have a healing effect for patients simply because they believe it works. Placebos play an important part in medical testing, but ultimately—however beneficial they may be—their effect is based on an illusion.

Pictures can also be deceptive at times, as can words. This is the premise of Saskia Olde Wolbers's video *Placebo* (2002), from which this still is taken. Imagine you wake up from an anesthetic in intensive care. Slowly reality returns as you gaze around you. But what has happened? What is real? Who is that person standing by your bed?

In *Placebo* there are images that appear to show a deserted intensive care unit in a hospital. Everything is white. Beds, operating lights, partition walls—everything dissolves into droplets and molecular structures, like elusive memories. Then a female voice tells her story. Her lover is a married man who claimed he was a surgeon. At this precise moment she is returning to consciousness after a car accident "arranged" by her lover. But is her story really true? Is she not just confused—the surgeon, the accident—suffering the after-effects of an anesthetic? Is her mind playing tricks on her or is she deliberately lying?

The images show a hospital setting that looks more like a scene in a sci-fi movie. The shots do not illustrate the supposed sequence of events. Instead they create a bewildering atmosphere, a feeling of reality dissolving. Electronic sounds underpin the sense of unreality.

The story told here is about illusion or self-delusion; even the images that appear to connect are deceptive. One might imagine the video to be a simulation created using a computer program. And yet it is the outcome of the purest kind of craft skills. Olde Wolbers built all the items seen in the video—she created a miniature film set that she painted and then filmed underwater in real time.

Placebo, like any successful work of art, is ultimately deceptive. It creates a fictive world: images and a voice draw us into a scenario that we willingly go along with. Two hundred years ago the Romantic poet and philosopher Samuel Taylor Coleridge had already described our readiness to fully enter into a world created by an artist—whether reading a book or gazing at a painting—as the "willing suspension of disbelief."

Dora Imhof

Saskia Olde Wolbers, *Placebo*, 2002

Peter Piller

Born 1968 in Fritzlar, Germany, lives in Hamburg

With the transition from analog to digital photography in the early years of the 21st century, the number of photographs produced and archived on a daily basis throughout the world took on previously unimagined and boundless dimensions. For German artist Peter Piller, this was just one more reason to hold back from projecting himself, through his own pictures, into a world already brimming with images. On the contrary, Piller's artistic raison d'être (and cheeky indulgence) lies in viewing, organizing, and archiving found visual material. In doing so, he can fall back on a substantial reserve of found photographs from German regional newspapers. The images he has archived in his thoroughly idiosyncratic way are published by him in books with titles such as *Regionales Leuchten*, *Noch ist nichts zu sehen*, and *Auto berühren*.

Peter Piller, *nimmt Schaden*, 2007

Peter Piller, *nimmt Schaden*, 2007

In 2006 Piller was awarded the Baloise Art Prize at the Art Basel fair. The following year, Baloise gave him access to several hundred thousand digital images from the insurance company's claims archive. The photographic series he subsequently presented in the summer of 2007 at the Kunstforum Baloise under the title *nimmt Schaden* is the result of his trawl through these images.[1] *Nimmt Schaden* consists of 60 photographs, all with the same format and white border, and all taken out of their purely functional context as evidence for Baloise insurance claims. The series opens up a vast panorama of the imaginable and the unimaginable alike, from the sublime to the ridiculous, from the spectacular to the trivial, mostly photographed within the context of the aesthetic banality of Swiss suburban life. It is not the artist "who is telling a story here, but the observer who pieces it all together according to his/her own imaginings based on the images themselves."[2]

1 *Archiv Peter Piller. nimmt Schaden*, ed. Christoph Keller, Zurich 2007.
2 Simon Baur, "Gesucht, gezeigt: Schadens-bilder. Peter Piller zeigt im Kunstforum Baloise seine Arbeit, nimmt Schaden," in *Basler Zeitung*, July 12, 2007, p. 17.

Peter Piller, *nimmt Schaden*, 2007

Nimmt Schaden is also the result of an exemplary collaboration between artist and corporate culture. The insight into the procedures of an insurance company was, for Piller, the sine qua non in shaping his concept of *nimmt Schaden*—a work that trawled through the Baloise company's prosaic images, and recast them as witness to an aesthetic of everyday life and of social history, thus captivating the imagination of company staff and exhibition visitors alike. Nonetheless, it cannot be denied that there was a certain mischievous irony in the outcome of the collaboration between the artist and the company. After all, Baloise did indeed end up spending a substantial sum for the acquisition of photographs that were (albeit admittedly in somewhat different form) already in their possession.

Martin Schwander

Peter Piller, *nimmt Schaden*, 2007

153

Mary Reid Kelley

Born 1979 in Greenville, USA, lives in Olivebridge, USA

The American artist Mary Reid Kelley studied painting, but quickly took up video art, a medium with an inexhaustible narrative potential, and has since developed a singular visual universe. Executed in an expressionist vein, her black-and-white films recall cinema's early days. The expressive faces and stark contrasts of the German film director F. W. Murnau (1888–1931) immediately spring to mind. With the help of her partner Patrick Kelley, she creates her videos in their entirety, from writing the script to filming to editing, designing and making the accessories and costumes down to the last details. It is mainly Reid Kelley as well, in costume and skillfully made-up or disguised, who brings to life the various characters. She plays them within an historical or mythological framework, whether it is World War I, the French Revolution, or ancient Greece. While she treats a broad range of subjects, an interest in the place of women in history runs through her work, as well as a more general interest in the question of violence, power, and domination.

Her projects constitute a complete body of work that brings together film, theater, drawing, painting, and poetry; in each case they result from a long research process—historical, visual, and literary—that is bound up with the intense work that goes into the writing itself. Her ability to juggle words, her appetite for linguistic play, the poetic tone of the dialogues, and the attention paid to the scansion of the verses open multiple levels for reading her work, and pace the drama-turgy of her films. If the text forms an essential pivot in her work, she has also managed to invent a graphic language that is immediately recognizable, whether in her videos (her preferred form of expression) or in her photography. Deftly combining the falsely realist illusionism of her depictions with a form of exaggeration, the artist amplifies the features of her characters, who swing between tragedy and comedy.

Inventive, and displaying a consummate feel for the burlesque, over the years Mary Reid Kelley has built up a teeming gallery of characters that are largely fictional—even if they display numerous interconnections—but also very much from the real world, as can be seen with the portraits in the Baloise collection. These belong to a series of photographs shot in 2015 in which the artist depicts various personalities who have in one way or another influenced her relationship with language. Drawing on existing clichés, she repro-duced three-dimensional busts, which she then photographed in black and white. The photographic portrait here makes a detour by way of modeling clay and painting before returning to the image. The painted faces reflect the artist's formal vocabulary and her attrac-tion to expressive physiognomies. Viewers will recognize the writers Edgar Allan Poe, Mary Shelley, and T. S. Elliot, with their features heightened and wearing an engaging expression thanks especially to their intense gaze which is a result of their slightly enlarged eyes. Among these eminent literary figures, contemporary faces pop up unexpectedly, such as the American rap stars Lil' Kim and Nicki Minaj, whose virtuosity in rhyming is as much an inspiration for the artist as classic prose. This is one of the treasures found in the world created by Mary Reid Kelley. Drawing on both classical and popular cultures, she cheerfully shakes up codes, exercising great freedom along the way.

Marie-Noëlle Farcy

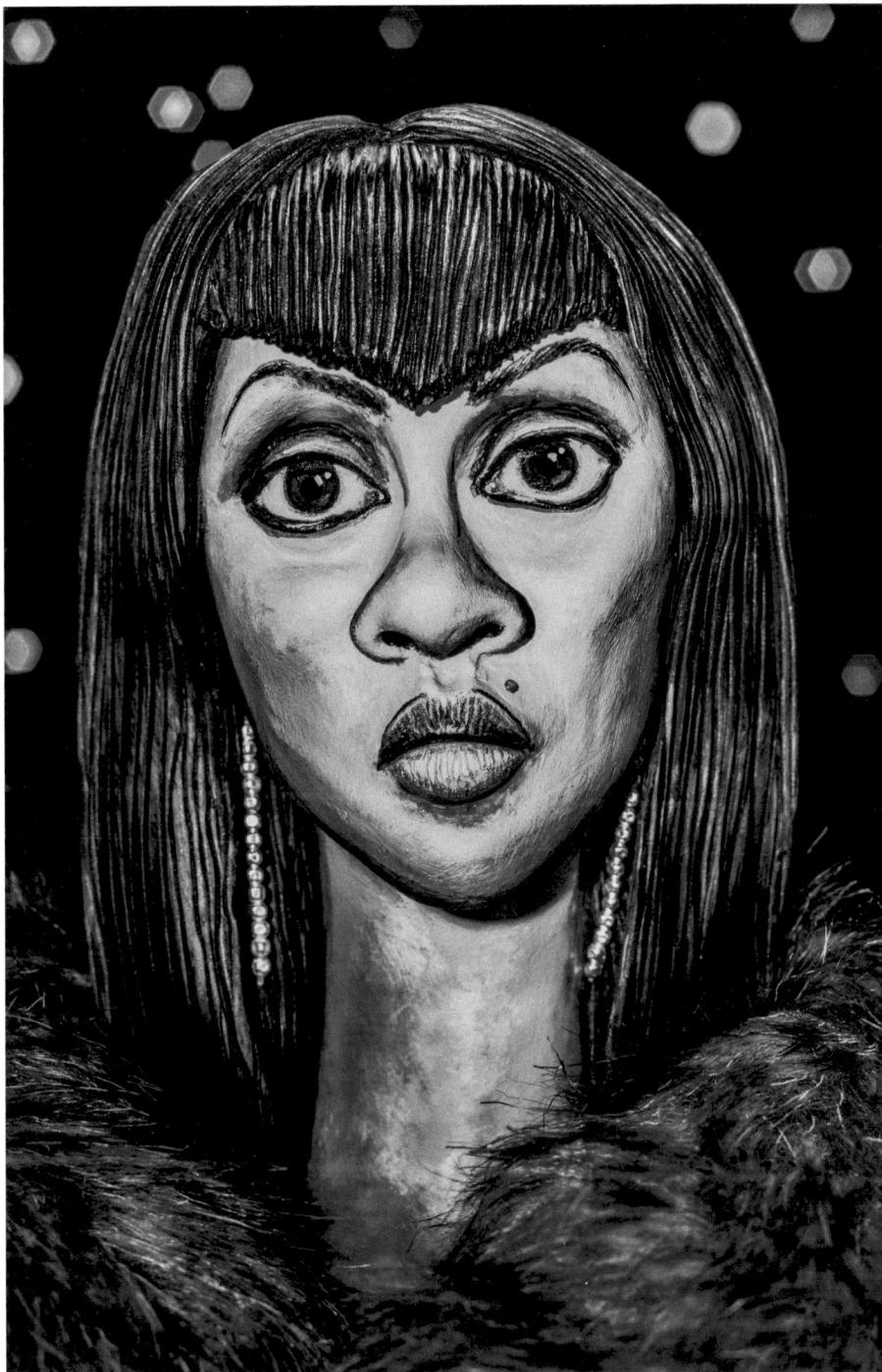

Mary Reid Kelley, *Lil' Kim*, 2015

Mary Reid Kelley, *Mary Shelley*, 2015

Mary Reid Kelley, *Edgar Allan Poe (Stella)*, 2015

Thomas Ruff

Born 1958 in Zell am Harmersbach, Germany, lives in Düsseldorf

Thomas Ruff, *Portrait*, 1987

Thomas Ruff, *Portrait*, 1987

At first glance, Thomas Ruff's engagement with the photographic image appears remarkably disparate. It runs from formal and carefully crafted photographs of domestic interiors, to the appropriation and re-presentation of old photographs; from highly detailed portraits made with a large format camera, to blow-ups of low resolution image files found online; from the slow and considered photography of urban buildings, to the manipulation of images beamed back from the surface of Mars; from resolutely analogue photographic practices to computer generated images that stretch the definition of photography to breaking point.

Ruff studied at the Staatliche Kunstakademie in Düsseldorf, under Bernd and Hilla Becher, the German photographers renowned for their typologies of anonymous industrial architecture (formal black and white photographs of water towers, gas tanks, blast furnaces, and the like). Ruff has retained the Bechers' analytical and systematic approach, but he is interested less in types of subject matter than types of image. Visual culture is structured by photographic conventions and standardized uses of camera technologies. Ruff selects different image types and makes his own versions of them. He relies on presentation in the space of art to set up a critical distance that allows viewers to consider his images in relation to the images that surround us daily.

In 1981 he began photographing his friends. In the *Portrait* series, all personal insight and psychological depth is put aside in favor of plain neutrality. The images appear to be more technically precise versions of the generic identity card or passport photograph. Calm, serious, and anonymous. They were made at a time of heightened paranoia in both West and East Germany. The Cold War was still a real source of fear, as were the national security services that kept a close eye on citizens. In 1986 Ruff began printing them big (160 × 120 cm), the shift in scale adding to the estranging effect.

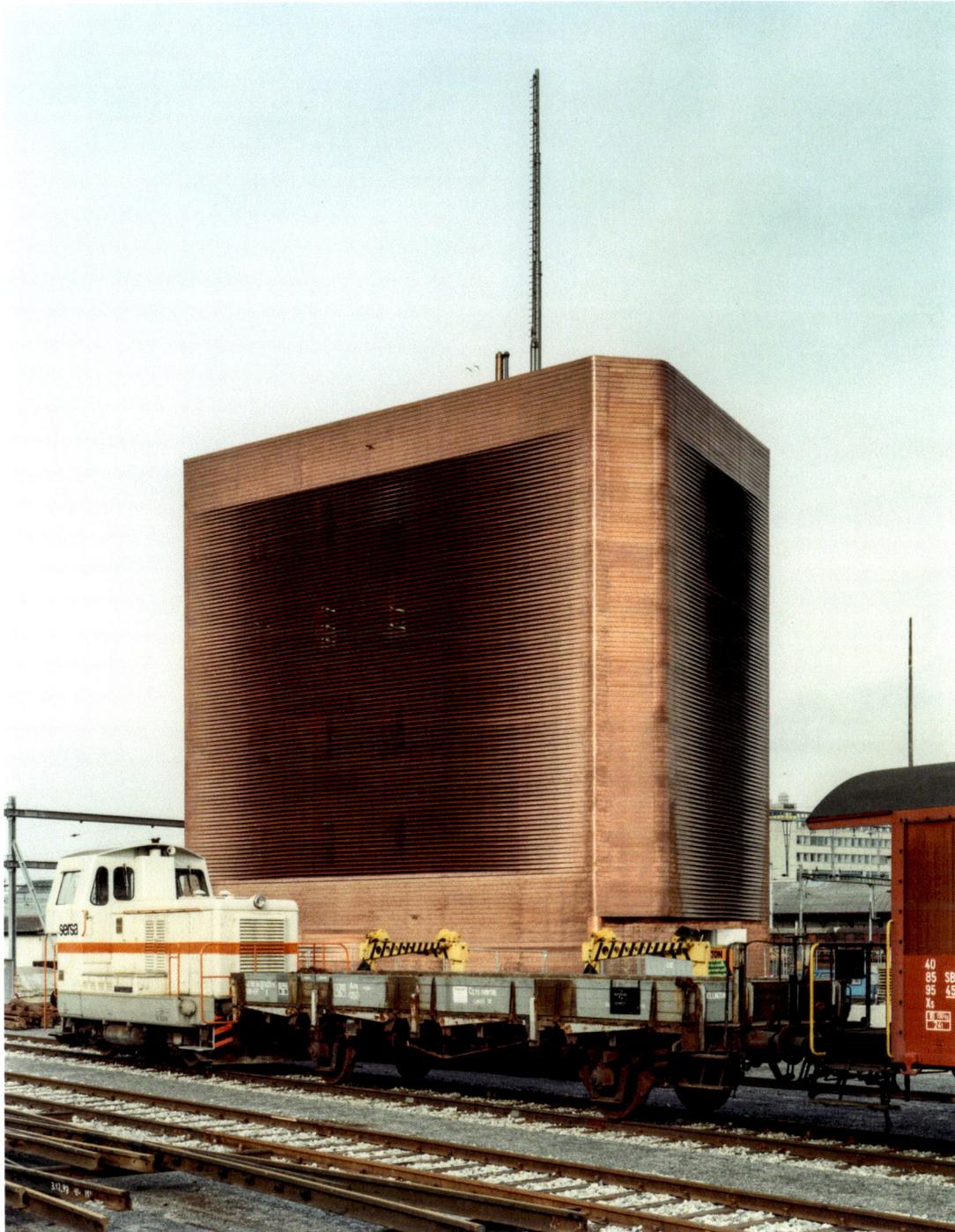

Thomas Ruff, *Stellwerk Basel*, 1994

Thomas Ruff, *Nacht 12 I*, 1992

In 1992, shortly after the end of the Gulf War, Ruff began his *Nacht* series. These images were made using a light-amplifying camera of the kind that was commonly found in tanks and military fighter aircraft, and used for missions after dark. Ruff used the camera to shoot banal city scenes, but the technological aesthetic renders them sinister, as if these places are under suspicion, being watched and monitored. The green comes from the phosphorescent screen. Very few photo-journalists were permitted to cover the Gulf War. Instead television and newspapers used images supplied by the Allied forces, made with specialized camera equipment.

Cameras record, and on that basic level they have a degree of objectivity. They are also prosthetic devices, extending and transform-ing vision. Whatever its artistic possibilities, most of photography's uses are highly functional, and it is largely scientific, industrial, and military imperatives that drive the advances in camera technology. Nevertheless, all images have an aesthetic dimension. Ruff accepts all this, and sees his artistic practice as a kind of parallel commentary on the status of the photographic image in general.

David Campany

Thomas Schütte

Born 1954 in Oldenburg, lives in Düsseldorf

Visually imagining something—by drawing or modeling—forms the basis of all that Thomas Schütte does. He starts with what is conceivable and representable, and, thus, with what is possible rather than what is real. Over the years Schütte has drawn personal motifs—flowers, vegetables, fruit, soft toys, portraits of women. For this, he has developed a representational approach using pen or brush that succinctly and elegantly notes the object. He outlines the contours, hints at the surroundings, and sometimes, before moving on to the next subject, adds a watercolor counterpoint. For these small-scale formats Schütte does not need a studio, but works instead in nocturnal solitude at his table at home.

Many of Schütte's drawings have been created in loosely-linked sequences that explore variations of the same motif, with occasional excursions into a narrative style, as in his series *Flucht*. While these ten numbered sheets are initially organized without commentary, the fifth, which acts as the title page, is captioned "Storyboard," indicating a cinematic process involving individual frames, close-ups, and long shots, which, together, form a narrative. Although neither the figures nor the circumstances are explained, connections may be guessed. The sequence begins with a hefty dispute, then a cut, followed by the image of a multi-story building that fits with the fortresses and castles found in variations in Schütte's works. Enter two figures in conversation, possibly about the young man of determined mien that we encounter in the next image, who could well be regarded as the hero. In the second part, following the title page, escape is clearly of the essence, for there is a mountain landscape with a hidden tunnel entrance, a view into the tunnel's depths, a train hurtling through the night, and a carriage with two slumbering passengers, evoking a trans-Alpine journey to some unknown place. At the end, there is a black-rimmed porthole—surely we are now on the high seas—revealing a glimpse of an island with the silhouettes of tall buildings. Is this a retreat to some distant isle where the fugitive feels safe? Is the fugitive en route to some nostalgic place where discord and surveillance might be avoided? There is no definitive answer to that, for the storyboard outlines only the dream, but not its interpretation. The associations that leap from image to image, the departure from a confined environment to venture into dreamt-of worlds are not just metaphors for the creation of fantasies, but the very inspiration for them. The romanticism of Schütte's vision lies in the way he sets his sights on something indeterminable on the horizon that prompts him to draw. The view through the porthole is a metaphor for the existence of the artist, framing Schütte's work in ever-new directions of flight.

Dieter Schwarz

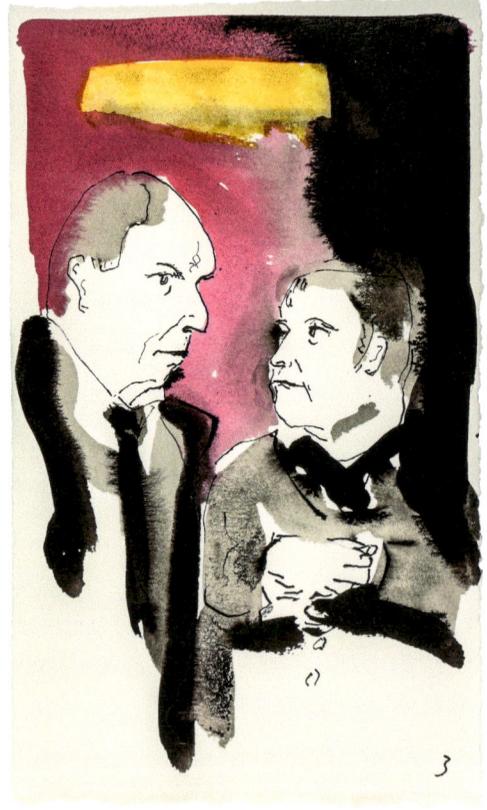

Thomas Schütte, *Flucht*, 1997

162

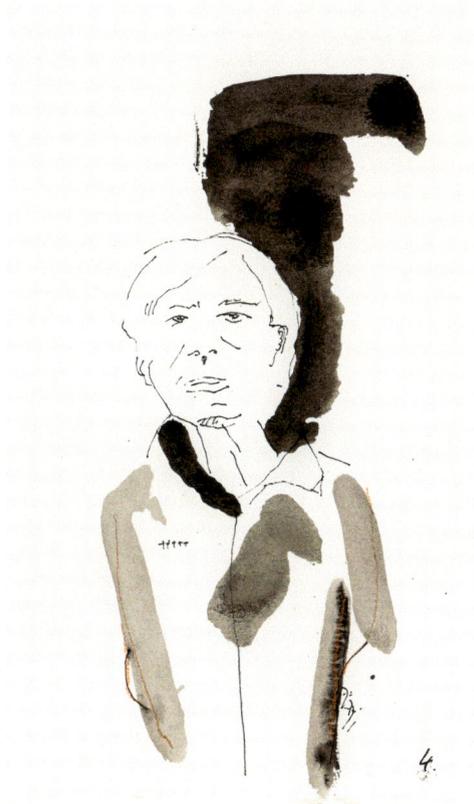

4.

FLUCHT

STORYBOARD

1	2	3	4	TI LE
6	7	8	9	10

13.3.97

Th. Schütte

5.

9.

10.

Richard Serra

Born 1938 in San Francisco, lives in New York

That a sculptor might use the medium of drawing as something analogous to sculpture, rather than as a preliminary study, is hardly to be taken for granted. Some sculptors, such as David Smith, have created painterly drawings, while others have developed and weighed up the contours and tectonics of their sculptures in linear ways. For a sculptor who does not regard sculpture in terms of a figure, but rather in terms of mass placed in space, and whose focus is therefore not on the perception of the pictorial aspect of the sculpture, but rather on the relationship between observer and work, and on the effect of the sculpture's mass on the perception of the surrounding space, a drawing has to encapsulate this experience in adequate form. That is the case with Richard Serra, who can look back on a substantial output of drawings. He was quick to move from his first works on paper, rendering sculptures or elements of sculpture, toward works in which he formulated a fundamentally new concept of drawing. That happened in the course of the 1970s, and this changing view of drawing went hand in hand with a transition from tabletop to wall-sized works: drawing meant covering a vast surface with black paintstick so densely that the resulting form took on a sculptural presence on the wall.

In this work, the genres of drawing and printmaking converge, with Serra developing an unconventional printing technique that closely resembles the execution and effect of his drawings, albeit with the difference that only a small edition of 15 was produced. What distinguishes this work, which is one of the very first of its kind, from conventional prints is primarily the oversized paper format. First, a screen print of the surface figure was printed in matte black. Serra then added two further layers of black by applying black paintstick over the black print to add both physical density and structural tactility. The end result is not so much a picture as a clearly outlined figure that gains its significance in the moment at which the observer views it on the wall, for it does not portray any representation, but is in itself part of the situation it creates. The viewer is overwhelmed by the work, because the figure is so huge that it can be perceived only in terms of its position and weighting. This effect is further compounded by the vast swathe of black, uninterrupted by any drawing, which appears as pure mass.

In Serra's oeuvre, the two drawings *Spine I* and *II*, both 1983, may play a role as precursors to *Robeson*; their titles indicate the vertical disposition of a human figure whose subtle sideways tilt is directly perceptible. *Robeson* alludes to the black singer, actor, and civil rights activist Paul LeRoy Robeson (1898–1976)—but this purely factual aspect of the work is merely a reference, rather than an illustration.

Dieter Schwarz

Richard Serra, *Robeson*, 1984

Ross Sinclair

Born 1966 in Glasgow, lives in Glasgow

In 1994 Scottish artist Ross Sinclair had the words "REAL LIFE" tattooed on his back in uppercase letters. This marked the beginning of a project that is still ongoing today, and that has become the trademark of his artistic practice.

First came photographic series in which Sinclair always presents his naked back to the camera—in fact the "REAL LIFE" motif soon recurred in all the mediums he was working with, from photography and film to installations and performance. Over the years the poses have changed, as have the haircuts and the environment, but the writing, the tartan shorts, and the face turned away from the camera have remained unaltered. Not unlike Caspar David Friedrich's famous figures painted only from the back, Sinclair becomes a figure of identification for the viewer.

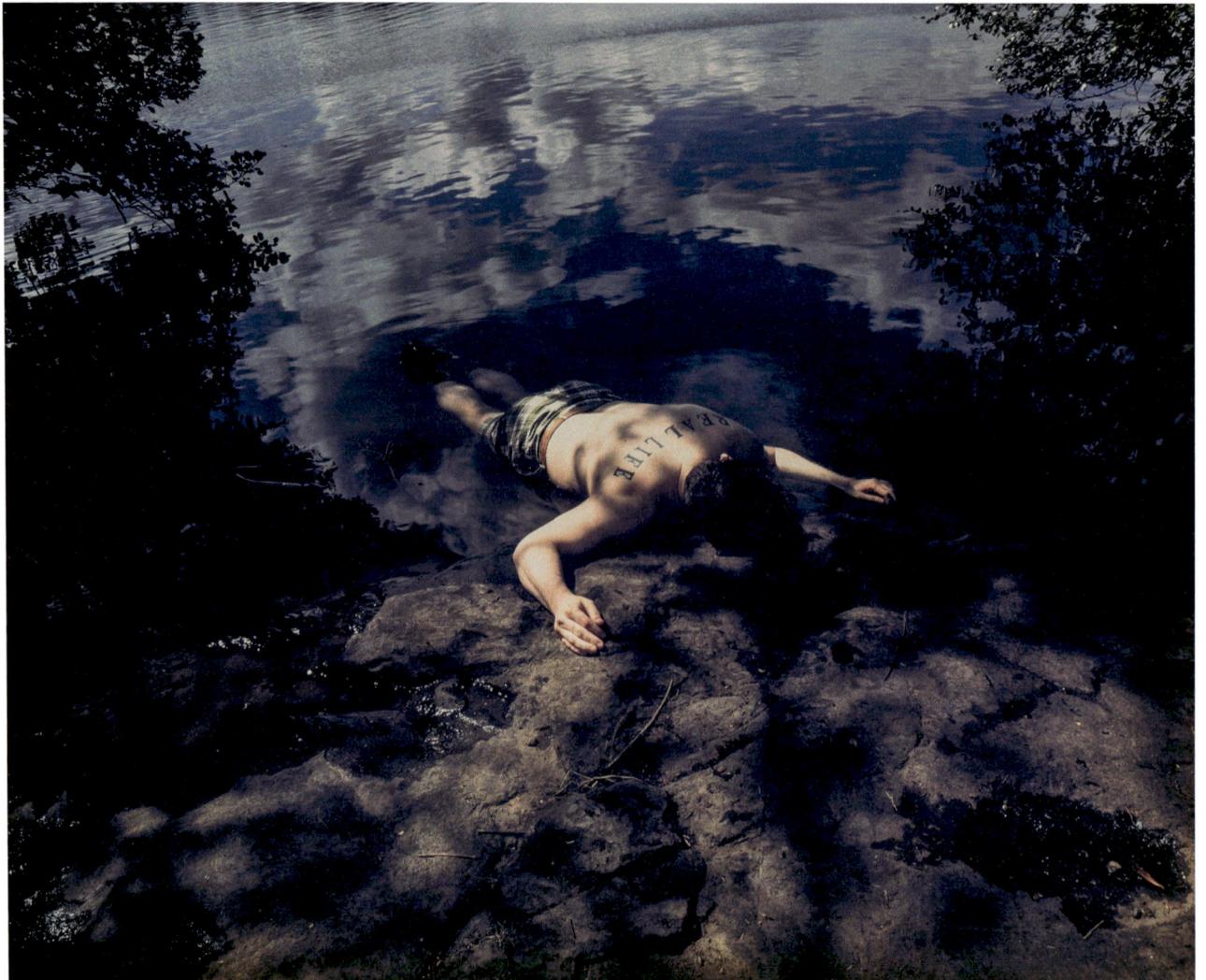

Ross Sinclair, *Decline and Fall, No. 7*, 1998

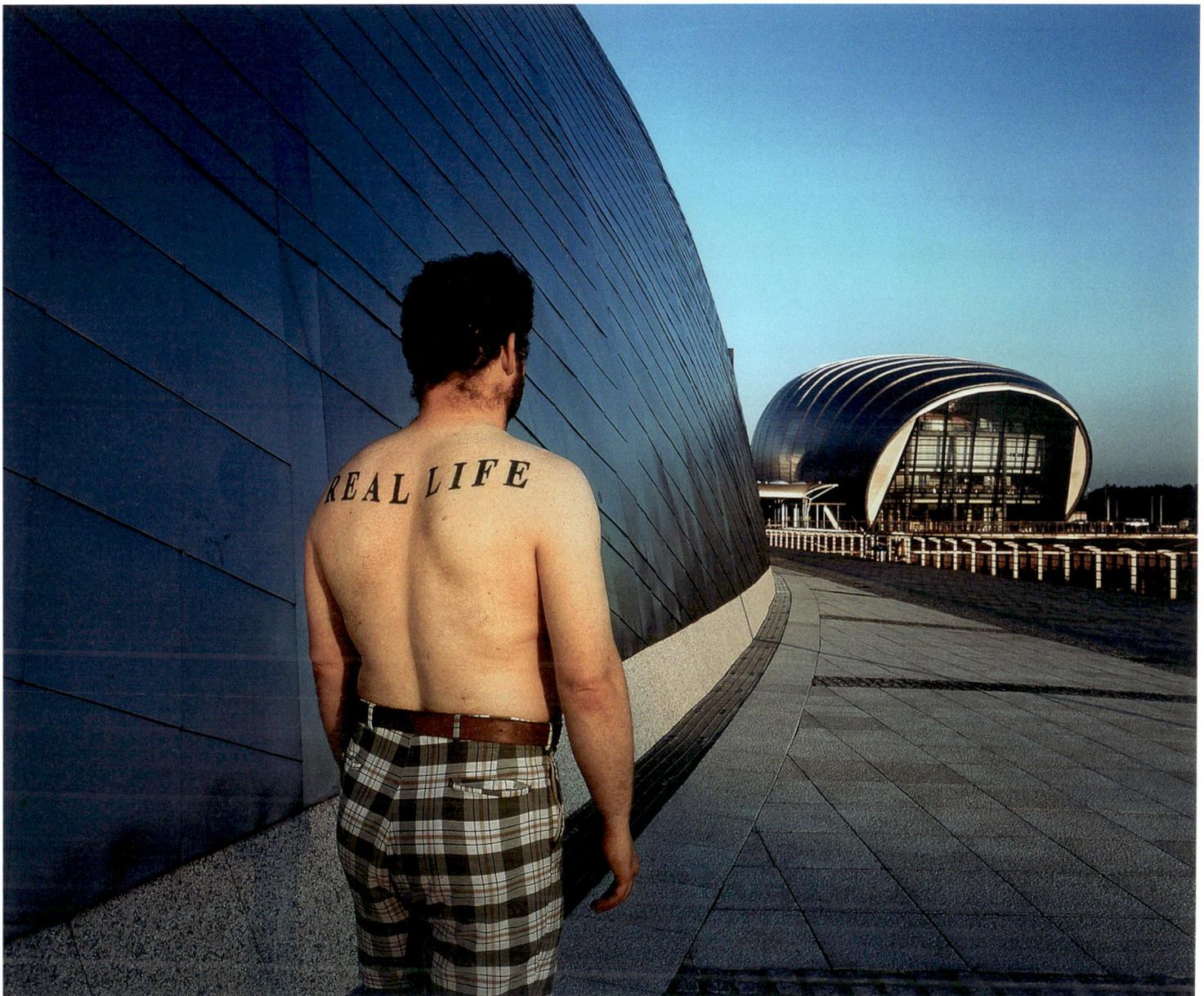

Ross Sinclair, *Glasgow II, No. 5*, 2001

But what does "real life" mean to Sinclair? Above all, Sinclair explores the relationship between the individual and society as a whole. He engages with individual, collective, and national identity. What makes us who we are? And, in this era swamped by digital images, are we still even capable of distinguishing real life from fiction? However, this is not to say that Sinclair is against events communicated by the media and in favor of "reality"; his aim is to investigate and better understand the way these two worlds relate to each other, questions that have become all the more urgent over the past decades. In *Decline and Fall*, for instance, we see the artist's body lying on a shore, but the circumstances are unclear: is this person dead, or merely unconscious? Maybe the notion of Sinclair being washed up by the water can be read as a national portrait with an as yet uncertain outcome, since the title alludes to the first novel by the English author Evelyn Waugh, in which he presents an ironic snapshot of British society. Outcome uncertain.

REAL LIFE
... and how to live it
GEOGRAPHY

1. BURN YOUR PASSPORT
2. IGNORE CONTINENTS
3. EMBRACE STATELESSNESS
4. RENOUNCE CITIZENSHIP
5. EXPLODE BORDERS
6. ANNIHILATE NATIONS
7. ABOLISH GEOGRAPHY
8. DISSOLVE CITIES
9. ABANDON REPUBLICS
10. SECEDE

Ross Sinclair, *Real Life. Geography*, 2001

Besides these self-portraits Sinclair has also created a number of text-based works on the notion of "real life." The ten points in *Real Life. Geography* recall the instructions pasted by Sinclair on the blank side-wall of the Riquet building in Leipzig during Expo 2000. Whereas passers-by there were still given a choice in the heading "DU SOLLST/ NICHT" [Thou shalt/not], in the Baloise collection there is no ambiguity: "1. Burn your passport 2. Ignore continents 3. Embrace statelessness 4. Renounce citizenship 5. Explode borders 6. Annihilate nations 7. Abolish geography 8. Dissolve cities 9. Abandon republics 10. Secede." The question as to whether borders and national identities still make any sense these days does not even come into it.

Marianne Dobner

Lucy Skaer

Born 1975 in Cambridge, England, lives in Glasgow and London

These two drawings by Lucy Skaer are from a group of works called *Solid Ground*. Yet, for all the promise of the title, as we view these large-format pieces we discover fragmented filigree structures: lines, cross hatchings, patterns, and ornamentation. Then there is the delicately applied gold leaf that gives these sheets a precious, fragile air. Hints of figuration loom into view. At the center of *Solid Ground. Carpal*, for instance, we can make out a human figure turning away. Meanwhile the golden shapes distributed across the sheet in *Solid Ground. Tarsal* could as easily be fragments of old buildings as parts of new walls under construction. And do the same two shadowy figures, facing each other, not appear several times in the center of this sheet? Three times as black silhouettes, once as a white void? In this drawing in particular, the white picture ground is more than just a setting for shapes and marks, it also forms figures.

While the figures and pictorial forms in these two drawings pull the viewer in, they are also puzzling. The eye roams across the sheets in search of figures, structures, and hints at their meaning. Yet even the titles explain very little. "Carpal" and "tarsal" are both anatomical terms, with carpal referring to the wrist bone, and tarsal to a cluster of foot bones. Thus, as we read the titles, contemplate the drawings, and compare titles and works, we are already actively engaged in a process of observation and analysis. And, as such, we are also in the middle of the work of Lucy Skaer.

Skaer, who trained at Glasgow School of Art, works with drawing, sculpture, and film. More often than not the point of departure for a new work is a photograph found in a magazine, a book, or online. During the process of drawing, or as she works on a sculpture, Skaer appropriates these found images, transforming and alienating them. Talking about her approach to her work, Skaer commented: "I'm interested in a state of between-ness, and that state you find if one thing transforms to another."[1] And this process of transformation is seen in the drawings in the Baloise Collection, when, for instance, a shape suddenly mutates into a figure. The relationship between abstraction and figuration is central to this group of works.

1 See https://www.theguardian.com/ artanddesign/2009/dec/04/lucy-skaer-turner-prize-profile (last accessed November 2019).

169

The same interest is also evident in Skaer's use of gold, both as a drawing medium and for its own sake. She is fascinated by gold, which is both an actual metal and an abstract value, and she has even found inspiration in the national gold reserves. This is specifically seen in the two figures in *Solid Ground. Tarsal*, who represent employees shifting the gold around.

However, the "between-ness" Skaer cites in the quote above can also refer to her work in a wider sense, specifically the artistic process whereby she appropriates images made by others. The viewer's active observation is part of this. It may even include the wrist bones and foot bones that crucially connect the arm and the hand, the leg and the foot—which are, in other words, essential factors in the act of grasping (both literally and metaphorically) and in walking. Against this backdrop the innate flexibility of seeing and observing appears to be the real—solid yet mutable—basis of her work.

Dora Imhof

Lucy Skaer, *Solid Ground. Tarsal*, 2006

Lucy Skaer, *Solid Ground. Carpal*, 2006

John Skoog

Born 1985 in Kvidinge, Sweden, lives in Copenhagen

John Skoog, *Movie Palaces Series. Community Theater, the Grand, Milwaukee, WI*, 2010–15

John Skoog, *Movie Palaces Series. Streamers, Westlake, Los Angeles, CA*, 2010–15

Swedish artist John Skoog was awared the Baloise Art Prize at Art Basel in 2014 for his film installation *Reduit (Redoubt)* of the same year. The jury was impressed by the "calm, cinematically composed images" of his 14-minute black and white film, which, in accordance with the defining trait of his oeuvre, focused on finding "traces of people and memories in ordinary places."[1]

Movie Palaces Series (2010–15), acquired by the Baloise art collection, bears close affinities to the 16mm black and white film *Shadowland*, also made in 2014, which conveys a subtle reflection on the medium of film and its American success story. Skoog filmed in places around Los Angeles that had been used as locations by Hollywood studios for scenes that were meant to take place in Afghanistan, the Sahara, or the French Alps. This is "a subtle reenactment of the topography and filmmaking in the American West. It lingers on the iconographic imagery and atmospheric resonance of places and their geographical meaning from earlier films."[2]

With its atmospherically-charged color images, the 26-part *Movie Palaces Series* documents the architecture of the picture palaces where, for decades, the premiers of lavish Hollywood

1 Jury report, Baloise Art Prize 2014.
2 *John Skoog: Slow Return*, Värn, exh. cat., MMK Museum für Moderne Kunst, Frankfurt am Main; mumok – Museum moderner Kunst Stiftung Ludwig Wien, Vienna 2015, p. 188.

productions were celebrated. For the most part, however, the ostentatiously historical decor of these bombastic movie theaters has not stood the test of time. Today, many of these rundown buildings are used as casinos, churches, or flea markets. In this respect, Skoog's *Movie Palaces Series* proves to be yet another piece in the mosaic of his quest to trace people and memories in everyday places.

Movie Palaces Series also identifies a shift in the way that the medium of film came to be perceived. In the first half of the 20th century, people flocked in their thousands to the glittering movie palaces to indulge in the latest elaborate film production. By the 1960s, the advent of television in private homes ushered in the demise of the big-screen extravaganza, not only in America.

Martin Schwander

John Skoog, *Movie Palaces Series. Toile, Al Ringling, Baraboo, WI*, 2010–15

John Skoog, *Movie Palaces Series. Women, the Orpheum, Madison, WI*, 2010–15

John Skoog, *Movie Palaces Series. Catedral de la Fe, the State, Los Angeles, CA*, 2010–15

John Skoog, *Movie Palaces Series. Red Carpet, the Lake, Oak Park, IL (with Nicholas Vargelis)*, 2010–15

John Skoog, *Movie Palaces Series. Lobby Orpheus, the Orpheum, Madison, WI*, 2010–15

Monika Sosnowska

Born 1972 in Ryki, Poland, lives in Warsaw

Monika Sosnowska, Untitled, 2003

In these small-format drawings on paper by Polish artist Monika Sosnowska, which look a lot like architectural sketches albeit without communicating any directional orientation or sense of scale, rigorously geometric, three-dimensional components are formed solely by means of outlines. Some lines are considerably thicker than others, introducing rhythm into the pictorial compositions. Atmospheric crosshatching and narrative details have no place here. Sosnowska's direct, uncontrived artistic approach has a certain affinity with the Minimal art of the 1960s and 1970s—her parents' generation of artists—which had a major influence on her work. One such artist is Sol LeWitt in the United States, who is also represented in the Baloise collection with a series of drawings, *Incomplete Open Cube*. He, too, "conjugates" a basic geometric figure, running through different combinations in a distinctly mathematical manner. However, unlike the modernist currents of Polish Constructivism in the 1930s, or Bauhaus design, or Minimal and Conceptual art in the 1960s, for all their geo-metric rigor, clarity, and sobriety Sosnowska's spatial forms appear strangely mysterious and inaccessible.

175

Sosnowska, who studied at the Art Academy in Poznan and at the Rijksakademie van beeldende kunsten in Amsterdam, is primarily a sculptor: she thinks spatially. Her drawings already convey a sense of what she does in three dimensions, namely the labyrinths she builds from familiar, clearly structured spatial units. She creates bewildering 3-dimensional constructions in which corporeal, as well as mental and emotional sensations and experiences unfold. Her installations, intended for visitors to enter, challenge our sense of orientation. They instigate a dizzying game with architecture, the most stable of all the arts. Inside one of Sosnowska's interlocking labyrinths, as we progress from one windowless room to the next, we feel trapped and claustrophobically coerced. Above all we are confronted by ourselves and our anxieties, our anger, our impatience. Sosnowska's architectural structures take the sobriety and aloofness of a modernist vocabulary of forms to such an extreme that they seem to develop a psychological, emotional potential. And that is exactly what she is aiming for.

Brigitte Kölle

Anselm Stalder

Born 1956 in Rheinfelden, Switzerland, lives in Basel

The hectic, breathless momentum of the Swiss art scene around 1980 marked a watershed in young and new Swiss art. In Basel the Kunsthalle, led by Jean-Christophe Ammann, specifically opened its doors to the latest currents; in Zurich, where young protesters set the agenda in the summer of 1980, the exhibition *Saus und Braus* captured the mood, with young art adding its voice to a highly charged situation.[1] Although the flamboyant painting of the Neue Wilde dominated the discourse, the art scene itself was very open-minded. Martin Disler and Miriam Cahn were as much part of it as Urs Lüthi, Fischli and Weiss, and Klaudia Schifferle, who was both a painter and a musician. Anselm Stalder, known as much for his drawings as his paintings, was one of the youngest protagonists. His work was shown alongside that of exponents of "new painting," but his compositions had little in common with the demonstrative immediacy and rapid spontaneity of that trend. While the latter was described as neo-expressionism, Stalder's work had more to do with objectivity.

In 1977, following two semesters as a student reading art history, ethnology, and philosophy at Basel University, Stalder embarked without further ado on a career as an artist. Soon he was producing sculptures as well as paintings, and in 1983 he commented on his own approach: "In the same way that I am not a painter, I am also not a sculptor. In the same way that I have to reflect on painting, I also have to reflect on sculpture, in order to be able to do my work."[2] Stalder was soon very successful. In 1984 at the age of 28, when he already had various gallery exhibitions and group shows behind him as well as solo exhibitions at the Kunsthaus Zürich and the Kunstmuseum Basel, Stalder played out his ideas in the Swiss Pavilion at the Venice Biennale.[3] The term "playing out" is used intentionally here, because Stalder's exhibitions are always through-composed zones with interconnected individual works or groups of works (often with very complex titles) and precise mise-en-scènes that the public can move around in—as if in an enclosed pictorial space.

1 *Saus und Braus. Stadtkunst*, ed. Bice Curiger, exh. cat. Städtische Galerie zum Strauhof, Zurich 1980. Anselm Stalder's work was not represented at this exhibition in Zurich.
2 Anselm Stalder, "Provisorisches zu meinen Plastiken und Bildern," in *Anselm Stalder. Der Baumeister und sein Begleiter, der Zauberlehrling (Eine Doppelfigur)*, ed. Elisabeth Kaufmann, with texts by Anselm Stalder and Patrick Frey, exh. cat. Galerie Konrad Fischer, Zurich 1983, unpaginated.
3 For more on this, see *Anselm Stalder. Der Bergbau*, exh. cat. Kunstmuseum Basel 1982; see also Toni Stoos, "Anselm Stalder. Das 5. Rad der Trilogie," in *Mitteilungsblatt der Zürcher Kunstgesellschaft* 5 (1982); *Anselm Stalder. Il ricevitore e le 5 gambe del disertore*, exh. cat. Swiss Pavilion, Venice Biennale, Bundesamt für Kulturpflege, Bern 1984.
4 See Barbara von Flüe, "Working on a Vibrating Horizon. On Anselm Stalder's *As if* Series," trans. Fiona Elliott, in *Anselm Stalder. Glimmende Peripherie*, exh. cat. Kunstmuseum Solothurn, Zurich 2012, p. 119–27.
5 Christoph Vögele, "Preface," in *Anselm Stalder. Glimmende Peripherie*, p. 49–53, here p. 49.

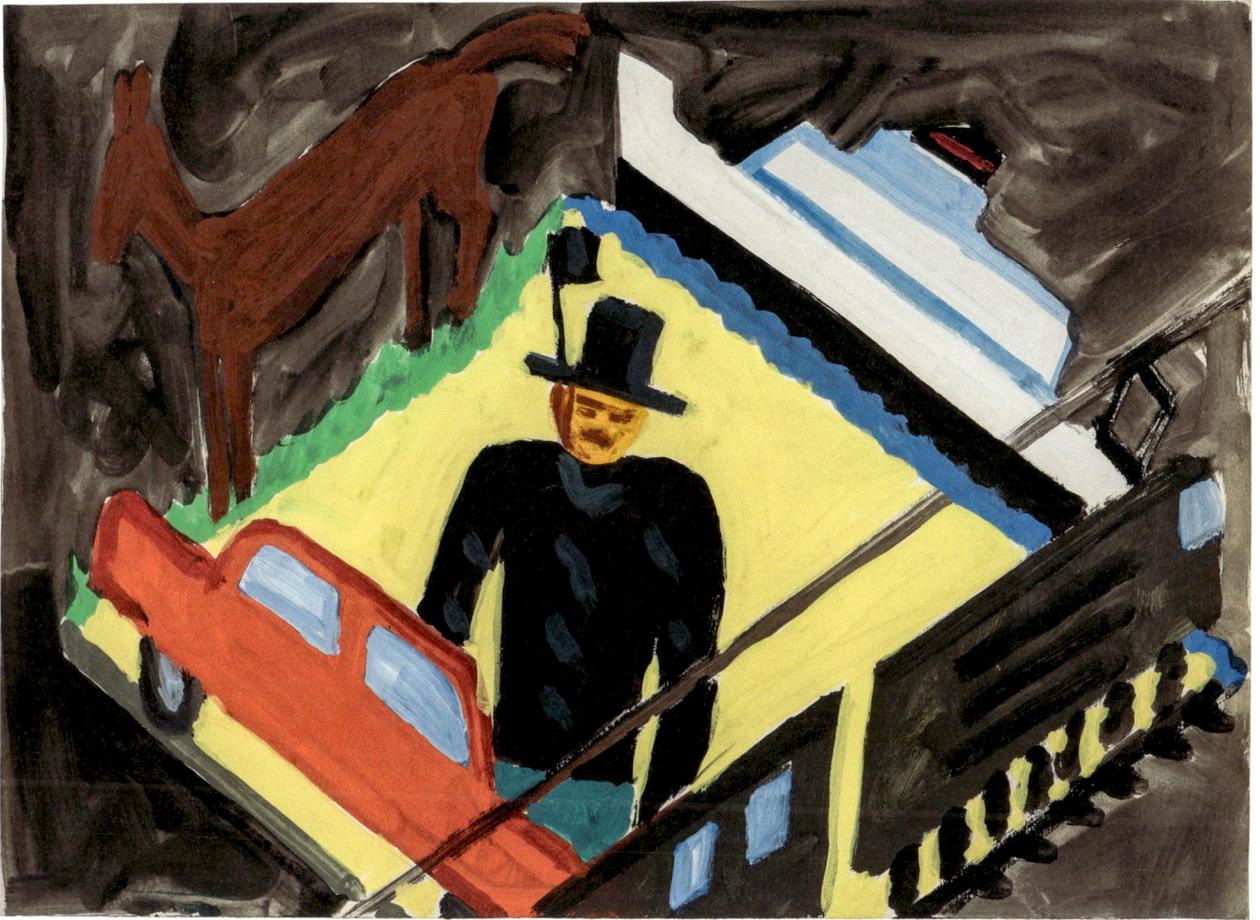

Anselm Stalder, Untitled, 1980

Stalder's oeuvre of drawings and works on paper is vast. In his most important early exhibition, *Der Bergbau* at the Kunstmuseum Basel in 1982, he showed six paintings and over three hundred works on paper. The gouaches in the Baloise art collection date from that period. They take us into a very specific world of things. Even if its pictorial vocabulary and the things themselves are easy to read—possibly even reminiscent of figures in a child's construction kit—this is by no means true of the "text" or the potential "texts" that arise from these constellations of figures. Much later on, Stalder chose the title *As if* for an extensive series of works (2000–12).[4] The individual works in this series are not merely executed using different techniques, the nature of their presentation is generally also a constitutive part of the work. Language, language theories, and specific semantics are key concepts in Stalder's myriad, multifariously reflective body of artistic work. The drawings from 1980 and 1982 marked the evolutionary beginning of an oeuvre that is as diverse as it is extensive. For over 40 years Stalder—as open to new ideas as ever—has comprehensively engaged not only with the conditionalities and meaning of art, painting, and language, but also with the artistic reception of the world in its widest sense. His work, which, for all its "apparent simplicity" is "concentrated and complex," revolves around "bodies and space, perception, and language,"[5] and in the context of recent Swiss art, poses a truly demanding challenge to the viewer.

Beat Wismer

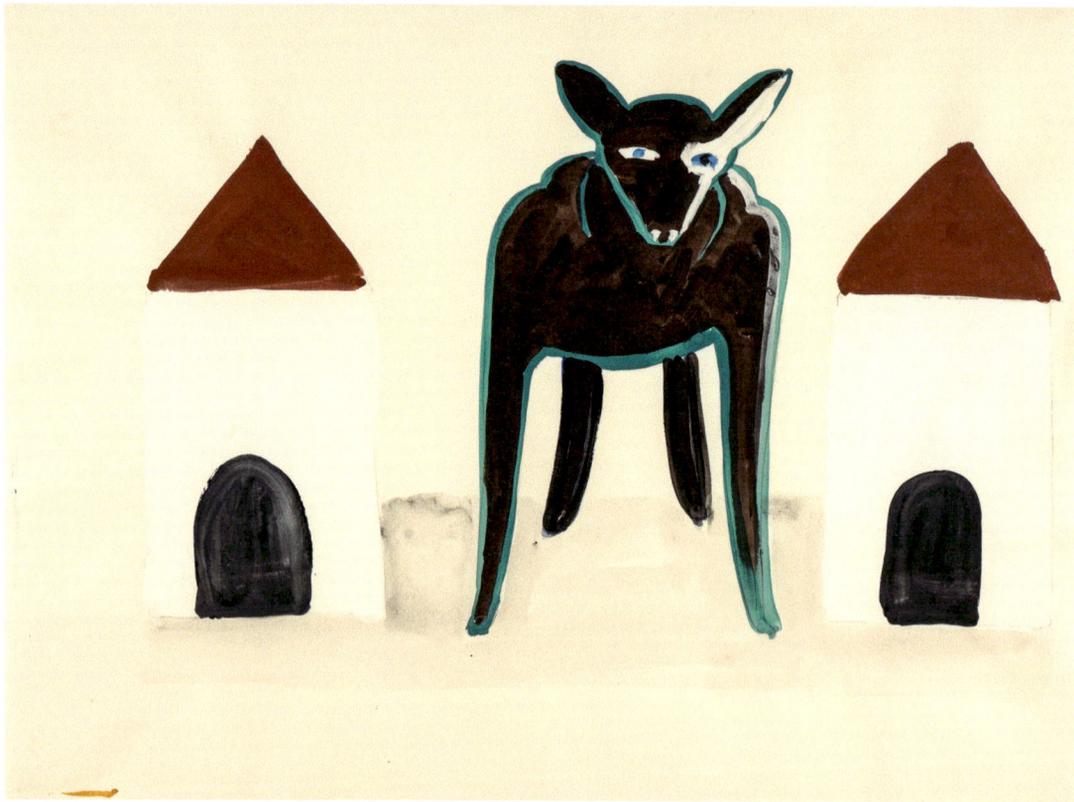

Anselm Stalder, Untitled, 1982

Anselm Stalder, Untitled, 1982

178

Monica Studer / Christoph van den Berg

Born 1960 in Zurich and 1962 in Basel, live in Basel

In *Hotel Vue des Alpes. Terrasse 4* a magnificent Alpine panorama unfolds in the background. On the horizon a snow-capped peak, and in the foreground a metal table with sunglasses, map, and drinking glass. Gradually, the scene takes on a strangely disconcerting air. There seem to be disruptions and inconsistencies—whether in the overall scene or in its countless details—that thwart our ability to grasp quite what it is we are looking at here.

The creators of this entirely computer-generated mountain world —artist duo Monica Studer and Christoph van den Berg—play wittily yet persuasively with the viewers of their work, which oscillates between an almost pedantically detailed photorealism and a supposedly cool abstract artificiality. Studer/van den Berg generate images without photographic prototypes, resulting in bizarrely synthetic surfaces and unnatural breaks both within and between the structural units that shape the environments.

The sequence of images held by the Baloise collection was created in connection with the sophisticated Internet project *Hotel Vue des Alpes* (2000–) using Cinema 4D and Bryce, as well as the artists' own programming to generate an environment of a virtual hotel complex and its surroundings on screen. Hotel guests can book a room on the website www.vuedesalpes.com for five days, and receive exclusive online access. They can take a virtual look around it whenever they want, follow the path to the lake, or take a pedal-boat trip.

Drawing on the nostalgic romanticization of 1960s aesthetics, Studer/van den Berg have lovingly created an over-crafted alpine realm so brimming with clichés that it can only be conceived as a construct—or perhaps as a fond memory of happy childhood holidays spent in mountain climes.

Martin Schwander

Monica Studer/Christoph van den Berg, *Hotel Vue des Alpes. Nr. 4 Speisesaal*, 2003

Monica Studer/Christoph van den Berg, *Hotel Vue des Alpes. Nr. 3 Zimmer*, 2003

Monica Studer/Christoph van den Berg, *Hotel Vue des Alpes. Terrasse 4*, 2003

Monica Studer / Christoph van den Berg, *Hotel Vue des Alpes. Alpenrose*, 2005

Jenni Tischer

Born 1979 in Heidelberg, lives in Berlin

Jenni Tischer's interest in patterns and patterning is a constant in her artistic work. The regularity and repetition that are intrinsic to patterning play an important part in the history and practice of working with textiles that Tischer so often turns to. Hints and indications of activities such as braiding, weaving, and embroidery abound in her works. But she also has a particular interest in the patterning that is crucial to digital processes—including the question of how identity can be coded and decoded. After all, it is only at first sight that there may seem to be a gulf between textiles and the digital world; in reality, when punch cards were first developed in the early 19th century, they were used to control a sequence of operations in power looms; in both fields the question is how data can be inscribed into materials and surfaces. And last but not least, there is a close connection between patterning and the decorative arts, which—notably in modern times— have often been seen as lesser forms of aesthetic praxis, particularly associated with "femininity." This is the minefield that Tischer probes in a series of works on paper that she made for her exhibition at Kunstforum Baloise in 2016. Their point of departure was a relief that adorned the erstwhile Baloise building at 25 Aeschengraben in Basel, designed by Hermann Baur, but now demolished. This relief, consisting of several horizontal strands of triangular aluminum plates laid out in a regular zigzag pattern, clung to the facade like a strip of cloth with multiple folds.[1] In her *Pattern Recognition* series, Tischer transforms

1 There are certain indications that this relief may have been by architect and artist Walter Förderer, who was working for Hermann Baur's practice at the time of the construction of the Baloise building. Information kindly supplied by architect Quintus Miller, Basel, April 30, 2019.

Jenni Tischer, *Pattern Recognition (Color) I*, 2016

Jenni Tischer, *Mood*, 2016

Jenni Tischer, Untitled (*Pattern Fragments*), 2016

Facade of the former Baloise building, 25 Aeschengraben, Basel, with ground-floor metal relief

Jenni Tischer, *Pattern Recognition (sw) II*, 2016

the pattern of this relief, and in a sense liberates it from its rigorous formatting: in a sequence of black-and-white drawings, basic geometric figures—trapezoids and rhombuses—combine in new configurations, some with hints of basket weaves, others calling to mind rays or starbursts, often flouting the "rules." In other drawings the pattern is colored (adding drama), snakes along the edges at speed, or is even transformed into a multiplicity of small origami figures that flutter against the blue ground like birds. And, lastly, in a collage titled *Mood*, Tischer has in fact integrated strips of folded paper into the facade pattern, thus underlining the ambivalent status of the relief, on the cusp between two and three dimensions. Between two strips of paper on a neon-pink ground, the word "mood" is written in pixilated letters, adding a human, emotional—but also eccentric—touch to this geometric composition. Tischer thus not only casts doubt on the dividing line that modernism drew between abstraction and decoration, but also points to those (human) dimensions that computer-generated patterns can never fully embrace.

Manuela Ammer

Luc Tuymans

Born 1958 in Mortsel, Belgium, lives in Antwerp

These six watercolors, dating from 1986 to 1991, mark the first important phase of Luc Tuymans' paintings. In works of this kind he formulated pictorial ideas that often derive from things he had seen, sometimes many years earlier; at this point he rarely used photographs as the basis for his paintings. Even the most modest of Tuymans' paintings on paper already demonstrate an essential aspect of his work as a whole: he detaches a particular image from a wider context. That image is often not instantly "readable" in isolation, but requires a verbal commentary.

The contents of these sheets are childhood memories, on the one hand, and moments in collective history on the other. What Tuymans said in 1992 applies here: "The picture is the negation of the picture. The statement it makes is like a loss, something that cannot be reconstituted, it has become an irreversible memory … the whole can only be seen in fragments."[1]

1 Luc Tuymans, "Disenchantment," in *Luc Tuymans*, ed. Ulrich Loock, exh. cat. Kunsthalle Bern 1992, p. 12.
2 Conversation with Ulrich Loock, March 29, 2019.

Luc Tuymans, Untitled, 1987

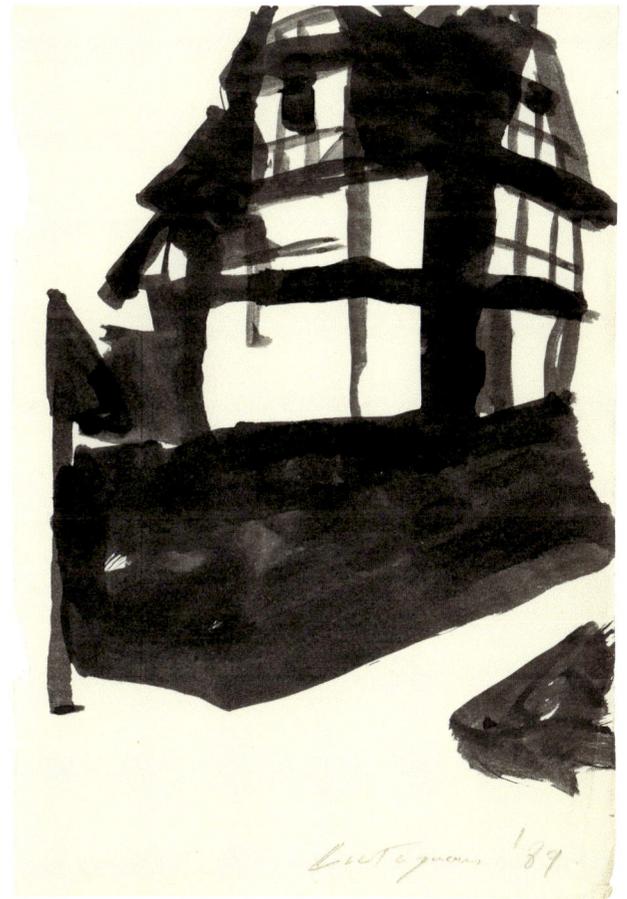

Luc Tuymans, Untitled, 1989

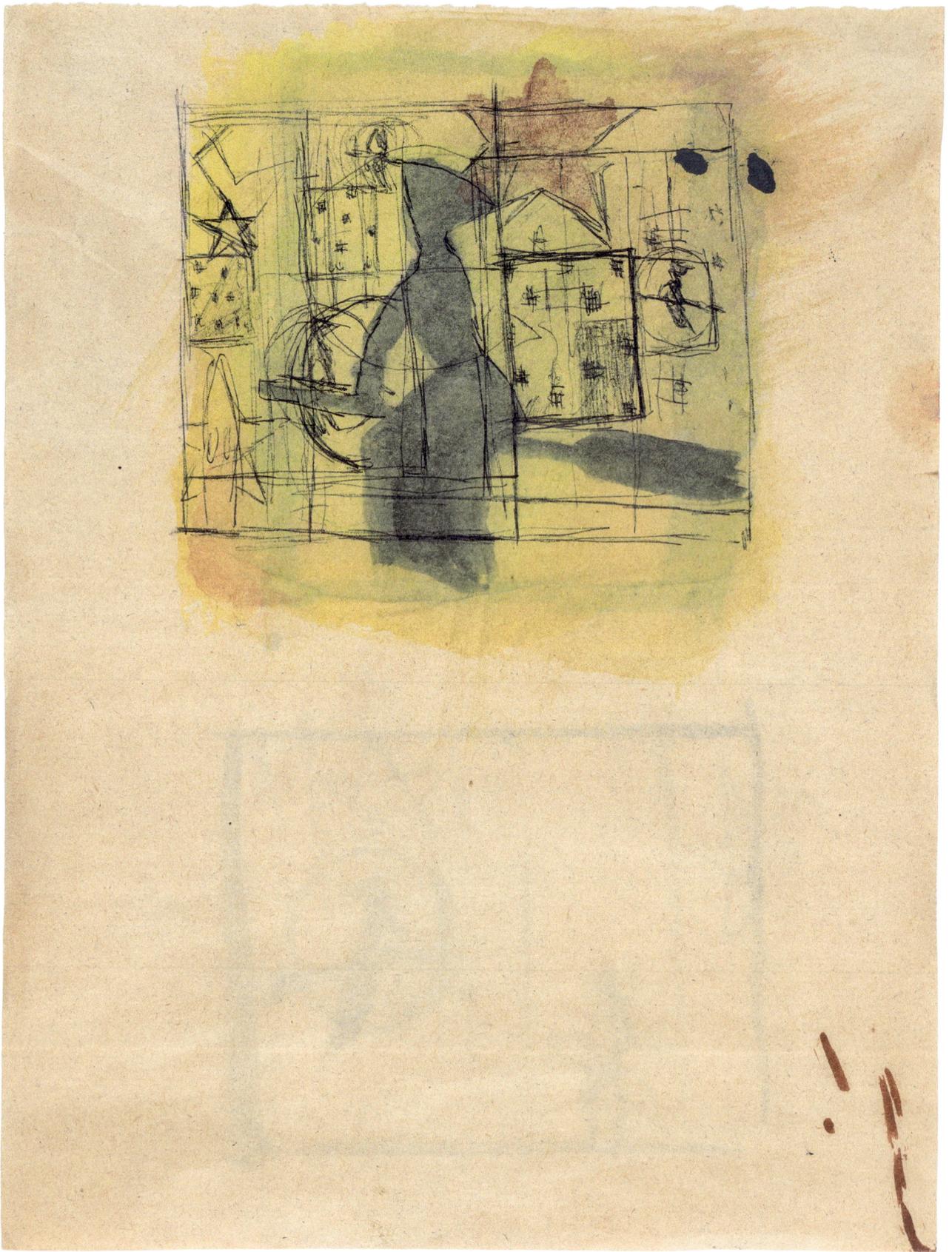

Luc Tuymans, *Halloween*, 1986

In a watercolor from 1987 Tuymans painted the arm of a chair from his parental home with a hand resting on it. *Toys* (1991) recalls a tin figure he saw as a child. He was fascinated by the thin metal form painted in a way that reminded him of carnival masks. *Halloween* (1986) is also based on a memory. As a child Tuymans cut out witches and stars, which were hung up at home as Halloween decorations. The childhood memories that Tuymans captures in these unpretentious little paintings are always steeped in fear.

In the two untitled watercolors from 1986 and 1987 the focus is on spatial perceptions; in the first they are connected with memories of visits to the subterranean aquarium at Antwerp Zoo. Tuymans was fascinated "by [the] arches and barriers, and by the aquarium itself."[2] His spatial drawings call to mind the memory palaces that have been used since antiquity as mnemonic devices, with key terms from a complex context being associated with an architectural structure.

The watercolor done in 1989 that conjures up a timber-frame house with a few deft brushstrokes refers to a widespread notion of German-ness, and thus also to three oil paintings from the same year that Tuymans grouped together with the collective title *Recherches*. The subjects of these paintings are a lampshade made from human skin, a tooth that looks like a skull, and a display case with fabrics made from human hair in Auschwitz. For Tuymans the crux is that the misdeeds perpetrated by monsters come in the guise of mundane philistinism and banality. The romantic exterior of a traditional building conceals the reality of abominations; there is a similar relationship between the innocuous appearance of toys and fathomless fear.

Ulrich Loock

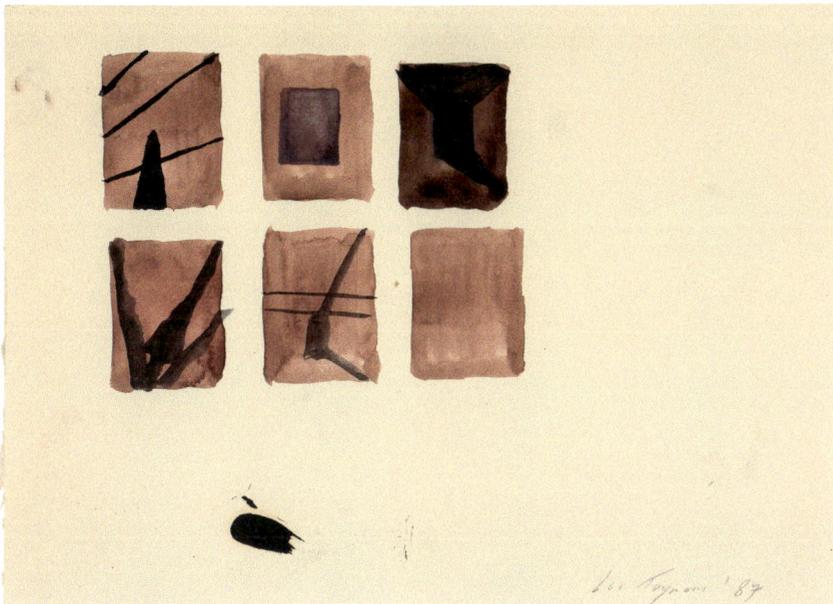

Luc Tuymans, Untitled, 1987

Luc Tuymans, Untitled, 1986

Luc Tuymans, *Toys*, 1991

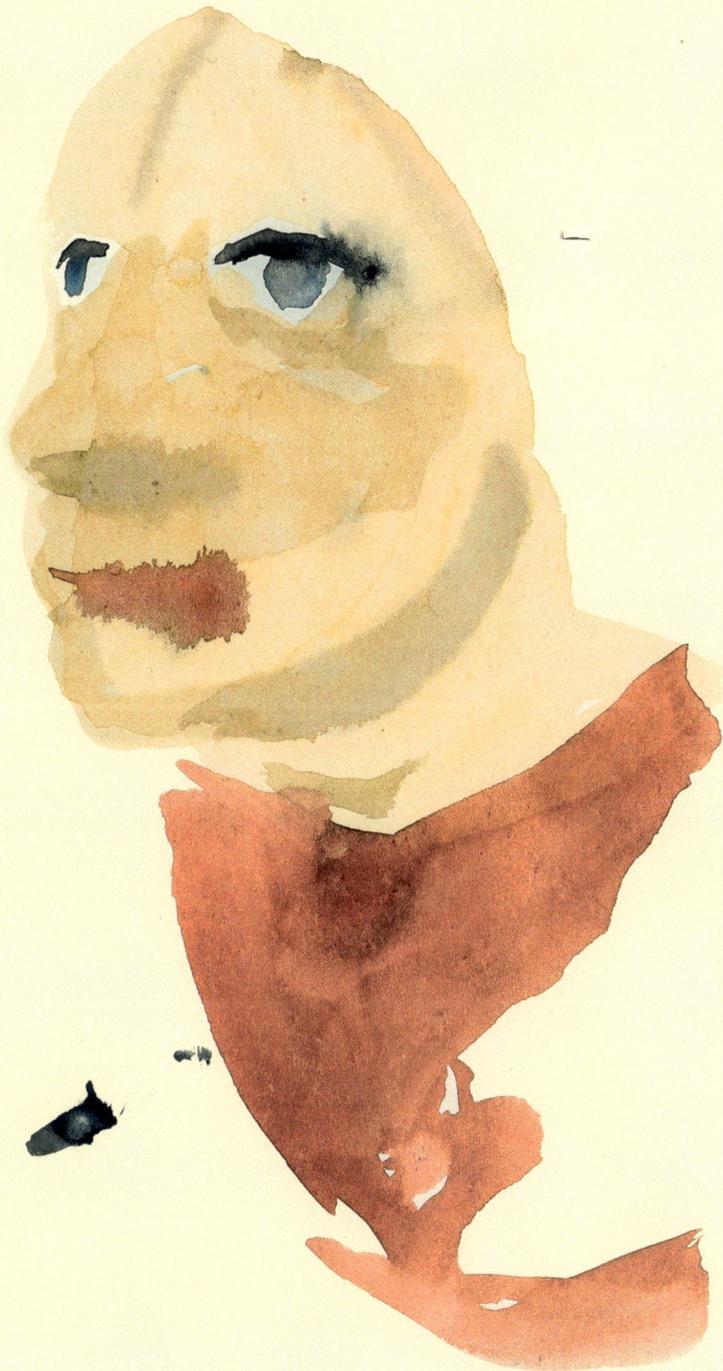

Marcel van Eeden

Born 1965 in The Hague, lives in Zurich, Karlsruhe, and The Hague

Dutch artist Marcel van Eeden, who has for many years lived sporadically on the shores of Lake Zurich, has produced at least one drawing every day, mostly with Nero pencil on handmade paper, since the beginning of his artistic career. These predominantly small-format works were all framed identically. In this way, he has built up an oeuvre encompassing thousands of images reflecting a disparate visual cosmos ranging from rural idyll to 20th-century war zones, from scenes of crime to modernist architecture, and from nocturnal urban scenes to iconic foods, taking in cartoons and textual fragments on the way. For each of his images, the artist has a model, be it a book, a magazine, an advertising leaflet, or the like. These models all stem from the period prior to his birthdate of November 22, 1965.

In addition to single-sheet works on paper, van Eeden also creates multi-part series of drawings that are based primarily on episodes from the lives of four characters imagined by the artist: K. M. Wiegand, Celia Coplestone, Matheus Boryna, and Oswald Sollmann. These pulp-fiction characters all experience bizarre and mysterious adventures that seem quite perplexing and ultimately impenetrable to outsiders. The dark-hued drawings illustrating the adventures of these imaginary individuals constantly oscillate between sensory overload and meaninglessness.

In his 2010 work *The Sollmann Collection*, the central figure is a cosmopolitan archaeologist by the name of Oswald Sollmann, who studied medicine and archaeology in the Netherlands, went on to work at the Pergamon Museum in Berlin, and traveled to India, Somalia, Marrakesh, Istanbul, and Zurich. The series of drawings gives an initial insight into the history of Oswald Sollman's wide-ranging art collection based on his predilection for 17th-century Dutch painting. Most of the works—portrayals of interior spaces, buildings, landscapes, and reproductions of paintings—include strange and at times almost indecipherable signs, writing, and symbols. These include, for example, a rendering of the planetary constellation on November 22, 1948, or the railway timetable for the Zurich suburb of Thalwil from the same year; some can be interpreted as the logos of companies or commercial products. Thus, *The Sollmann Collection* represents yet another piece in the puzzle that is van Eeden's multifaceted and highly sophisticated play on the histories and myths of modernism.

Martin Schwander

THE Sollmann Collection

Behind this facade, designed by Horace Trumbauer of Philadelphia, Oswald Sollmann lives, and

Lynnewood Hall MAKES A PERFECT SETTING FOR THE GREAT Sollmann COLLECTION

KMW

The four great Dutch paintings on the four previous pages are a very small part of the great Sollmann Collection that is housed in Lynnewood Hall in the Elkins Park suburbs of Philadelphia. Peter Arrell Brown Sollmann, whose portrait hangs above the mantel in the picture below,

KMW

Marcel van Eeden, *The Sollmann Collection*, 2010

191

Marcel van Eeden, *The Sollmann Collection*, 2010

Inez van Lamsweerde

Born 1963 in Amsterdam, lives in Amsterdam

Ines van Lamsweerde has worked since the 1980s in the more experimental areas of imaging between fine art and fashion, and is noted for pushing boundaries in the photographic depiction of human bodies. In the early 1990s it was clear that digital imaging (especially Photoshop) had introduced new possibilities in the control and manipulation of photography. Both fashion and fine art were exploring how photographic realism establishes expectations in viewers that can be subverted or challenged. The artist Jeff Wall had made complex digital composite works such as *A Sudden Gust of Wind (after Hokusai)* (1991), and *Dead Troops Talk* (1993). Van Lamsweerde had staged an exhibition of her eponymous series *Vital Statistics*, commissioned by the city of Groningen, in 1991, with images of female models posed in urban landscapes with exaggerated colours. The models and backgrounds had been photographed separately and then digitally combined.

At that time, digital work in fashion was largely confined to retouching in the traditional sense: smoothing away imperfections, emphasizing and delineating features, and eliminating dust. But it was perfectly apparent that the digital was going to have much more profound implications for the understanding of photography, and, by extension, for the understanding of the subject matter that is being photographed.

Part of the realist effect of photography is its capacity to propose itself as a stand-in for an encounter with what or who was in front of the camera. Such realism has its conventions—think of the studio portrait with a plain background shot in even light. The visual rhetoric here is of simplicity and straightforwardness. This is the setting van Lamsweerde used for *The Forest* (1995), a suite of four images each with a figure reclining. The framing is on the face, arms, and upper body, and all four figures wear the same yellow short-sleeved shirt, an item of clothing conventionally worn by both men and women. However, the photographs subtly mix up the standard media codes of "masculinity" and "femininity." The question soon arises as to whether van Lamsweerde is photographing subjects that identify in a non-binary way, or whether the people have been styled to transgress binary norms, or whether the images have been digitally composed, perhaps combining features and body parts from different people. The emphasis falls slightly differently in each image, but all evoke a feeling of fascinated uncertainty or unease.

Today, such imagery is much more commonplace, in art and fashion, but also in everyday life. Social norms and gender identities have become more open and fluid. Part of what has enabled this fluidity is the Internet, with its capacity to allow images of self-presentation to be uploaded and shared rapidly. Mainstream media outlets no longer have such a tight grip on representational norms. Looking back on these images by van Lamsweerde, with 25 years of hindsight, what is notable is that they were made in that very small window of time between the advent of digital post-production and the advent of the Internet.

David Campany

Inez van Lamsweerde, *The Forest. Marcel*, 1995

Inez van Lamsweerde, *The Forest. Klaus*, 1995

195

Ulla von Brandenburg

Born 1974 in Karlsruhe, lives in Nogent-sur-Marne

For some 20 years now, Ulla von Brandenburg has been developing a body of work that is centered on filmed and sung performance and scene-like installations in which the artistic and societal revolutions of the turn of the 20th century that she stages become the reflection of contemporary questions. After a childhood stamped by the teachings of Rudolf Steiner and psychoanalysis, the artist initially studied theater and new media at Karlsruhe's Hochschule für Gestaltung, before being briefly involved in the world of theater.

Not as well-known as her films, more discreet than her installations, von Brandenburg's drawings nevertheless play a significant role in her approach. The themes and figures seen in the films appear in her graphic work as collages of monochrome silhouettes, and large drawings streaked with a rainbow of watercolors. In counterpoint to her black-and-white films, these watercolors are characterized by an absence of preliminary outlining or drawing. The elements of the composition emerge from the swaths of color alone, which the artist places side by side and mixes in a watery porosity. First, von Brandenburg fashions the support from recycled paper (old geographical maps, the blank pages of old books found in junk shops), which she assembles to form large yellowing patchworks. Sewn, folded, pasted, or tinted, the paper in this way takes on a strong material presence that, by itself, conveys a certain history. Von Brandenburg

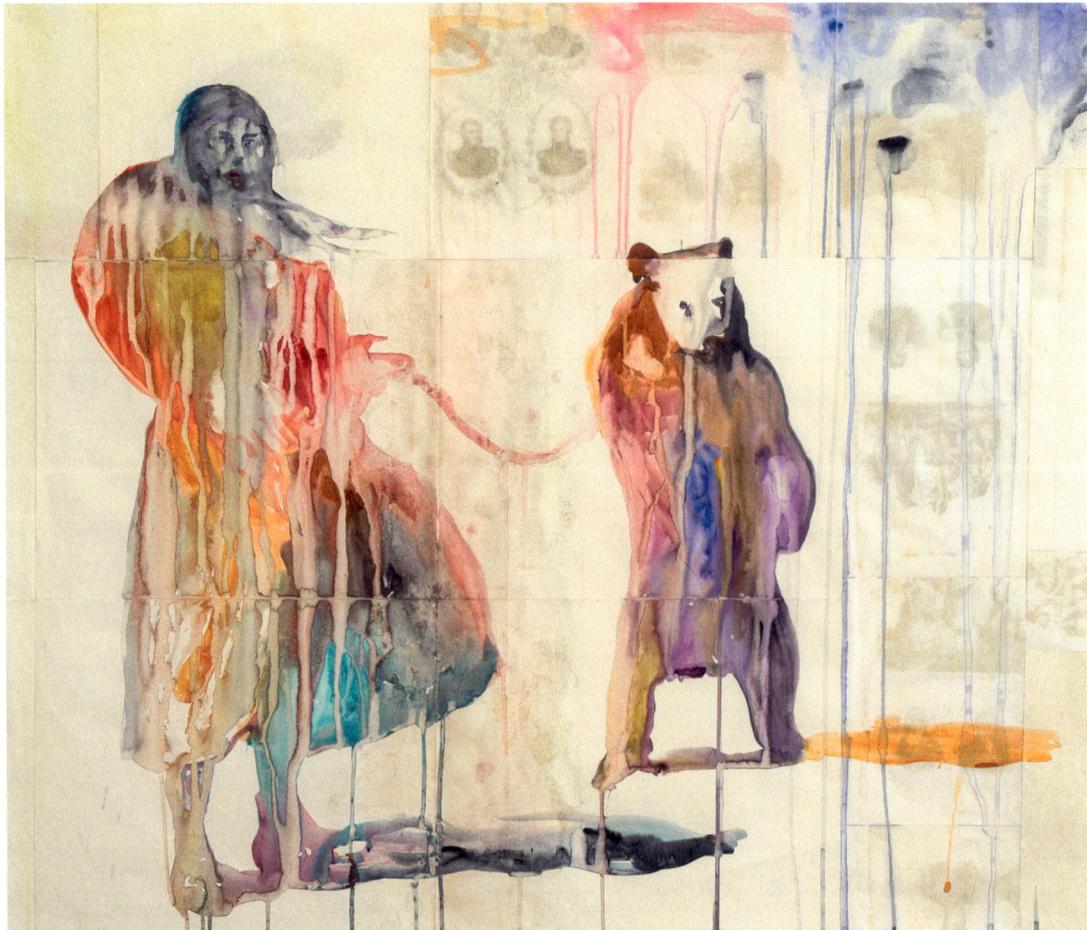

Ulla von Brandenburg, *Mädchen mit Bär*, 2016

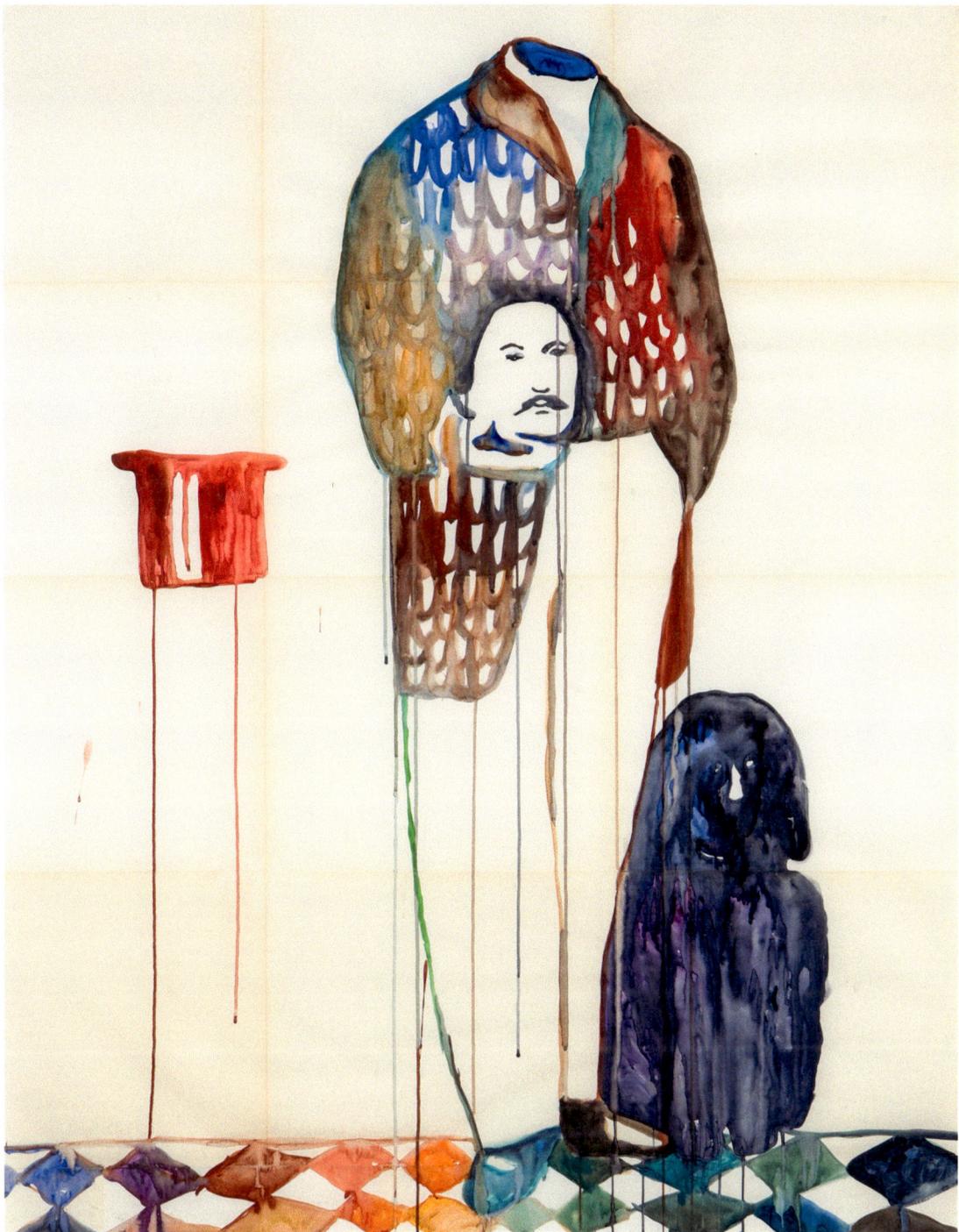

Ulla von Brandenburg, *Mann ohne Kopf*, 2015

then works the paper with a brush dripping with water. She chooses the colors of her palette without any prior plan, incorporating the runs and imperfections as clear signs of both a deliberate loss of control and a spontaneous gesture.

To create her stock of visual materials, the artist collects found images. Newspaper clippings, postcards, artworks, and scientific imagery—von Brandenburg's personal databank has taken shape around her favorite themes, including the carnival and the *Theatrum Mundi*, strong women, expressionist dance, spiritism and psychoanalysis, and popular culture. The artist transposes these black-and-white images into watercolors, and imbues them with a second life as if beings rising up from the past were suddenly witnesses to our contemporary world.

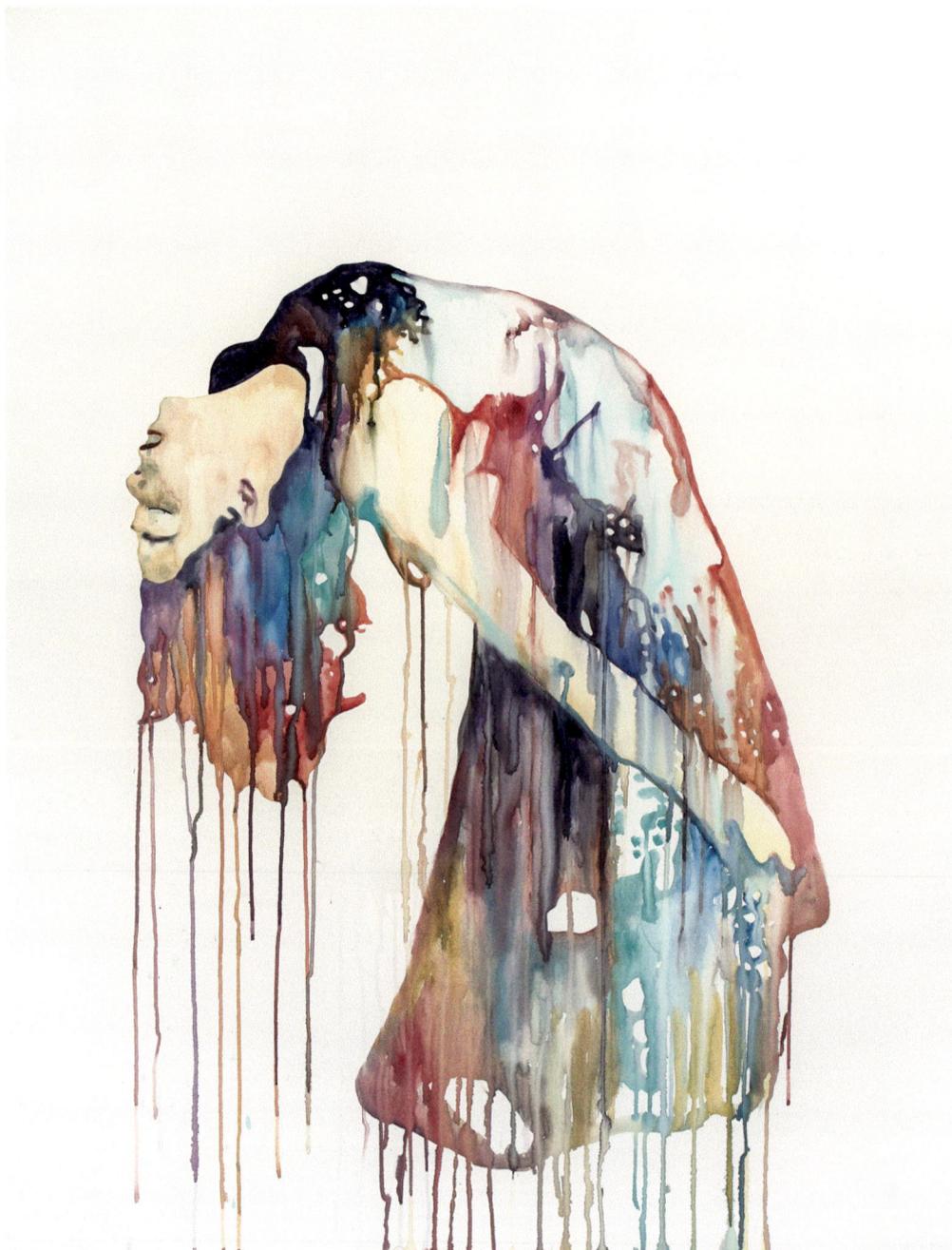

Ulla von Brandenburg, *Mary*, 2018

The large composition inspired by the German dancer Mary Wigman (1886–1973), makes clear the artist's interest in women whose lives took a special turn and left a mark on history. In this case, Wigman, who studied under Rudolf von Laban and created expressionist dance, embodies in the artist's eyes a tutelary figure who conveyed a new approach to body movements, which the dancer's greatly arched back can here attest. This free manner of experiencing artistic gesture echoes the approach championed by von Brandenburg, who, through her spontaneous drawing, is clearly working along the lines that Wigman pioneered in the first half of the 20th century. By appropriating this figure and breathing new life into her through the use of color, the artist turns the groundbreaking dancer into an unavoidable reference point in the genealogy of women artists, and finds a way of linking herself to her.

Julie Enckell Julliard

Amelie von Wulffen

Born 1966 in Breitenbrunn, Germany, lives in Berlin

Amelie von Wulffen has always engaged—in the widest sense—with realms of remembrance. When this German artist first made a name for herself with collages that marry two different systems of representation—photography and painting—her subjects were drawn from her own life and immediate surroundings. In these works, photographic fragments of Biedermeyer interiors are seamlessly combined with traumatic architectural scenarios: teenagers' idols are brought to life and reinvigorated by splashes of paint or gestural brushwork, thereby creating a mind-space that only memory can elicit.

In her works on paper and in her stylistically varied paintings von Wulffen turns her attention to her own life, without any hint of narcissism, and entirely without nostalgia. Her bourgeois background, her grandmother, family gatherings, and her own education loom into view both as fragments of factual and fictive memory and as an expression of her own critical self-observation. In her compositions, now with light-hearted, bright colors, now somber, von Wulffen demonstrates

Amelie von Wulffen, Untitled, 2010

199

how ineluctably our life stories are tied into our origins and how we are in thrall to our own particular constraints and circumstances—in the knowledge that we can never escape our own history.

In her series of strikingly agile vegetable-and-fruit watercolors (2010–2013), apple and pear dine together, a popsicle goes skiing, bananas debate with a strawberry, and a couple—two red-wine glasses—lie back watching TV. Von Wulffen's colorful fantasy world inevitably recalls illustrations in children's books, but it also serves as a reminder that many books read out loud to children in West Germany in the 1960s were just as ambiguous as her series of watercolors. In her work von Wulffen creates her own realms of remembrance, as if she were transposing books she has read back into her childhood world.

Von Wulffen's exhibition catalogue, *This Is How It Happened*[1]— the first publication that provides an overview of her watercolors— is dedicated to her grandmother Elisabeth von Wulffen, and right at the beginning seemingly presents the reader with a historic illustration from a subtly authoritarian-looking children's book; it is not stated whether the artist was also the illustrator. The catalogue's dedication allows Amelie von Wulffen to explicitly locate these playful watercolors in the realms of her own existence, the outcome of her own history and biography.

Philipp Kaiser

1 Amelie von Wulffen, *This Is How It Happened*, ed. Alex Zachary, exh. cat. Greene Naftali Gallery, New York 2011.

Amelie von Wulffen, Untitled, 2012

Amelie von Wulffen, Untitled, 2010

Amelie von Wulffen, Untitled, 2013

Kemang Wa Lehulere

Born 1984 in Cape Town, lives in Cape Town

Kemang Wa Lehulere, *Sketch for a Situation*, 2013

Kemang Wa Lehulere, who lives in his native city of Cape Town, is one
of the leading members of a younger generation of South African
artists who use a variety of mediums and genres to develop alternative
views and narrative methods to devise other forms of remembering.
His chalk drawings, videos, installations, and performances are all
preceded by detailed research. Kemang Wa Lehulere realizes these
either on his own or in artists' collectives, such as the Center for
Historical Reenactments in Johannesburg, and the now disbanded
Gugulective, which he cofounded in 2006.

Wa Lehulere frequently engages with the history of South Africa and how people deal with that history. His drawings combine found visual materials from myths, personal experience, and the era of apartheid. While he is interested in both collective memory and individual histories, his main focus is on processes of archiving and discovering, as well as on the repression and extinguishing of remembrance in words and images. Which things are forgotten, which events linger on in people's memories? Wa Lehulere's oeuvre makes its point through openness and process, through strategies of overwriting and reconstruction. It derives from the notion that all manifestations of art evolve by dint of collective processes, and it raises historical and social issues that are still relevant and important to us today.

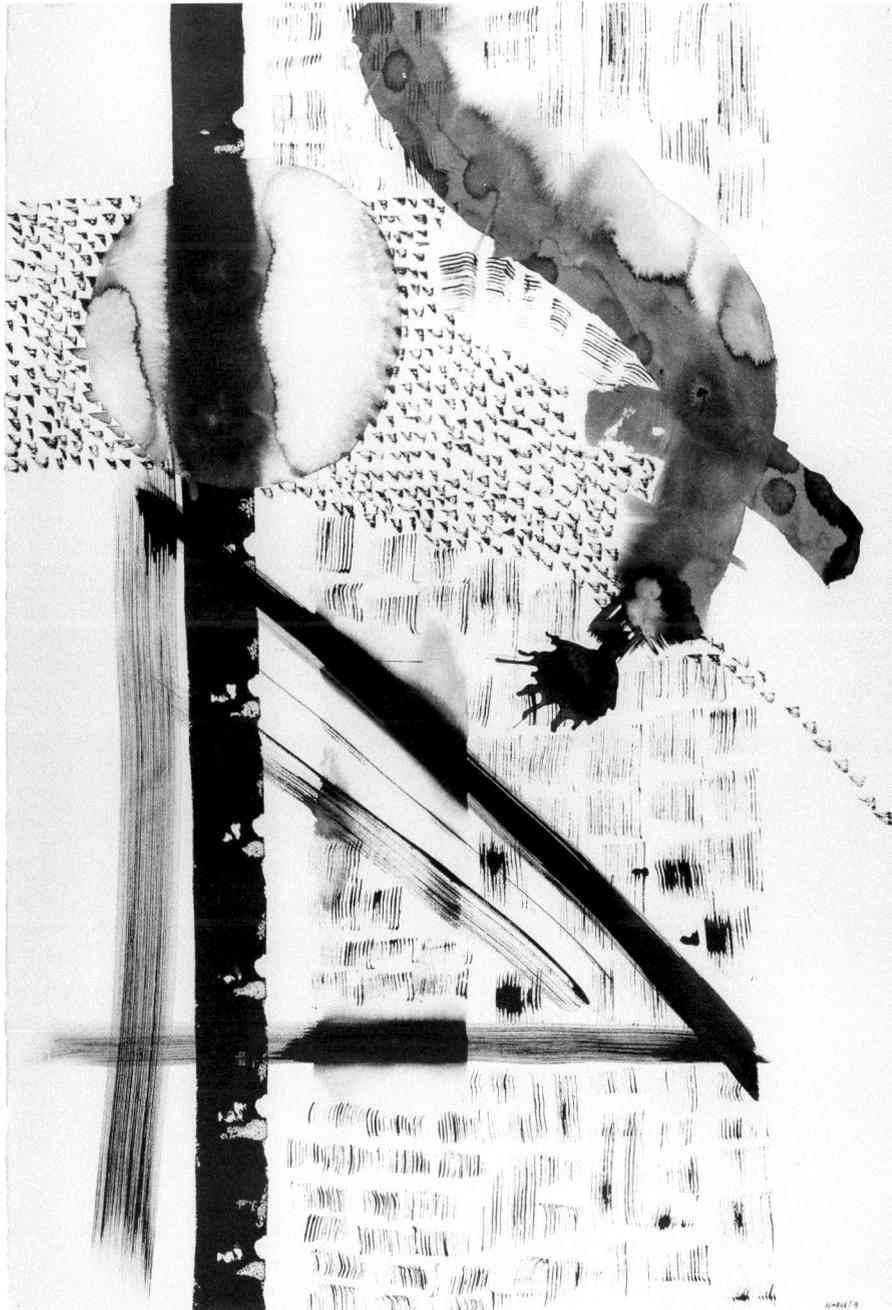

Kemang Wa Lehulere, *A Geometric Drop*, 2013

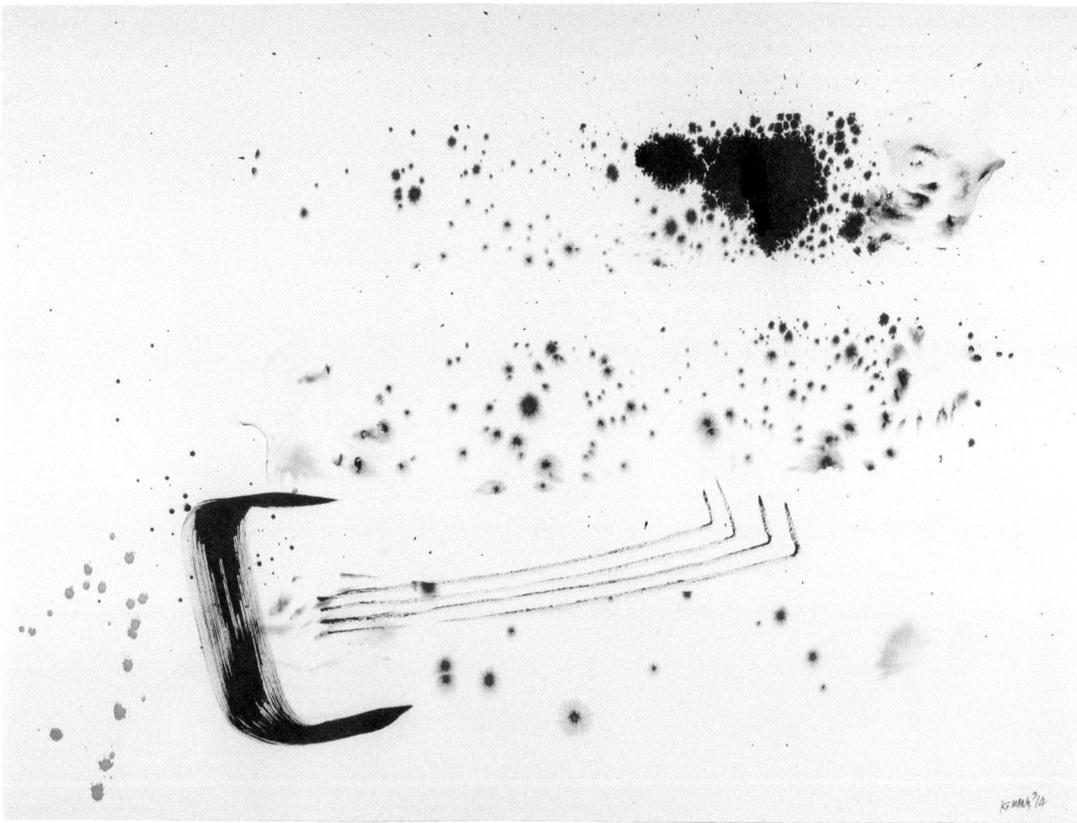

Kemang Wa Lehulere, *Negotiation 1.2*, 2014

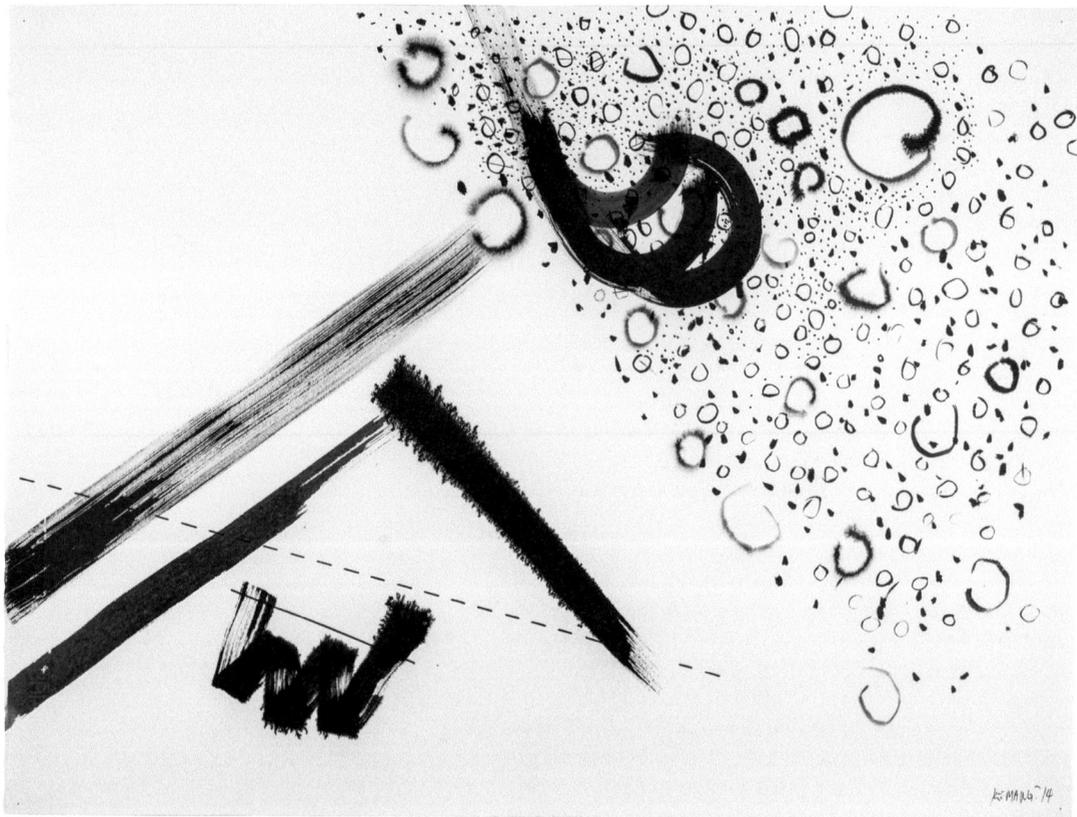

Kemang Wa Lehulere, *Negotiation 1.1*, 2014

The drawings by Wa Lehulere in the Baloise collection tell—in reduced, abstract forms—of motion and equilibrium, tension and potential configurations in space. They radiate meditative, even spiritual ease, and convey an impression of the artist's sensitive handling of his materials. Unlike the chalk drawings that generally fill entire rooms, which Wa Lehulere creates in public performances, these drawings are more delicate and in much smaller formats. Titles such as *Sketch for a Situation* and *Negotiation* indicate that these works address not only spiritual, but also social and political power plays and patterns. Although in these poetic, reserved works Wa Lehulere does not—as so often—directly confront South Africa's past and current social issues, he still communicates his own distinctive way of looking at things, and adeptly combines different pictorial traditions.

Brigitte Kölle

Stephen Waddell

Born 1968 in Vancouver, lives in Vancouver

In 2011, Canadian artist Stephen Waddell published *Hunt and Gather*, a collection of his observational photographs. The title was a reference to the idea of the wandering photographer, moving through the world speculatively, looking for opportunities to make pictures. Of course, no photographer is a blank page. The wandering is done with a mind full of experiences that shape and direct the looking, wishing for resonance, or affirmation, or surprise. This is the modus operandi of classic "street photography," perhaps the only pictorial genre that photography could claim as its own. All the other genres—landscape, townscape, portrait, still life—are inherited from a much longer history of picturing. And yet, street photography is also a way of coming into a relation to those other genres. A street photographer can be specific to their medium while also participating in, and extending, the long history of picturing.

Waddell has made himself intimately familiar with the history of the depiction of everyday life. This includes the history of street photography itself, as well as 19th-century French painting (Manet, Degas, Caillebotte, Morisot, Vuillard) along with other historical moments when the intimate observation of anonymous urban life gave rise to exceptional images.

Living in Vancouver, Waddell developed his approach in an artistic climate informed by the work of Jeff Wall, Rodney Graham, and Stan Douglas. But rather than making images through preparation and collaboration, Waddell remained light on his feet, trusting that the kinds of images he wanted to make could be chanced upon, noticed in their potential, and shaped into pictorial form. There is lightness in his observations, without overt reference to the history of art, and yet the strength of his pictures comes from an awareness of the artistic achievements of the past.

Very often Waddell is a lone observer photographing an isolated figure, involved in whatever they are doing. It could be work, or a moment of repose. Each figure is generally photographed from the side or back, at a distance that is intimate but unobtrusive. This means that the figure is not separated from their world, but is shown as a part of it, absorbed in it. The relation of figure to world might be pictorially and socially harmonious, or there might be signs of tension. But in the end, depiction is essentially an affectionate art. For all the gentle pictorial skill on display here, it is feelings of empathy, of joy taken in chance occurrence, and fascination with appearance as such that energize Waddell's photographs.

David Campany

Stephen Waddell, *Shopfront*, 2004

Stephen Waddell, *Man in Car, Powell Street*, 2012

Stephen Waddell, *Snail Seller*, 2009

Jeff Wall

Born 1946 in Vancouver, lives in Vancouver and Los Angeles

Jeff Wall, *Children*, 1988

209

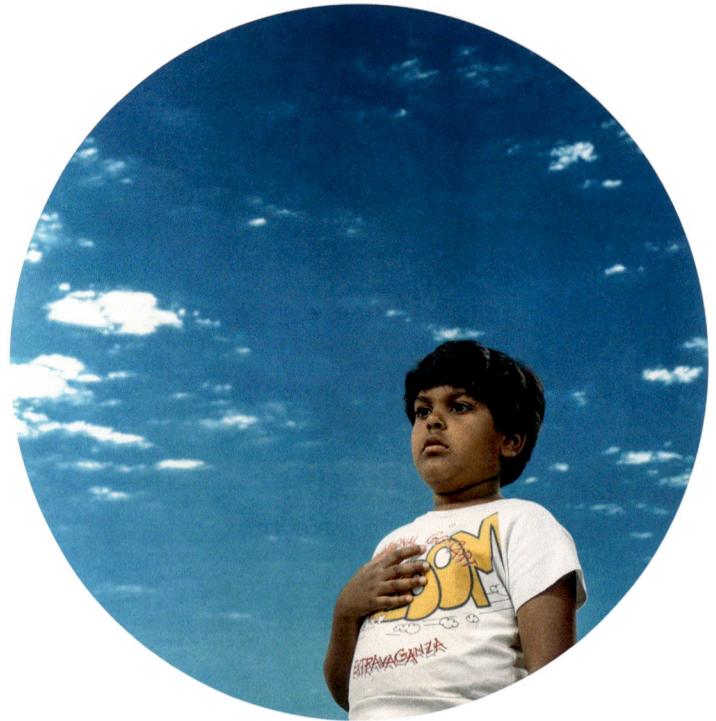

Jeff Wall, *Children*, 1988

Dan Graham and Jeff Wall are of roughly the same generation, although Graham is a little older and his art career began at a younger age. From an involvement in the Conceptual art of the second half of the 1960s, Graham's interests moved toward performance, architecture, and music, while Wall's moved toward the study of art history, and then a reimagining of photography along the lines of the Western tableau. Both artists maintain a deep interest in the social status of art and the conditions of spectatorship. Both have also written important essays, not least about each other's work. In 1980 Graham published "The *Destroyed Room* of Jeff Wall."[1] In 1981 Wall published "A Draft for *Dan Graham's Kammerspiel*"[2] (a text he later expanded). In 1989 the two artists collaborated on a proposal for a children's pavilion.

The proposal consists of a set of architectural plans, three-dimensional models, and nine circular photographic portraits of children. This was the third suite of portraits Wall had made, after *Young Workers* (1978; remade 1983), and *Movie Audience* (1979). All three were shot looking up at the subjects, a self-consciously "heroic" and "ennobling" angle reminiscent of Soviet portraiture of the 1920s and 30s.

With a circular interior and a domed roof, the pavilion was to be built into the ground on the top of a hill. It was to resemble a small amphitheater; the portraits were to be presented as backlit lightboxes, and placed high around the curved walls. The angle of view up to the portraits corresponds to the angle at which the portraits were shot.

At the apex of the domed roof, a hemispherical glass oculus was coated with two-way mirror. Those inside would look up and see an anamorphic reflection of the interior, including themselves. Those ascending the steps on the outside of the dome could look down through the oculus while also seeing themselves reflected against a background of domed sky. This view corresponded to the sky backdrops of the nine portraits.

1 Dan Graham, "The *Destroyed Room* of Jeff Wall," in *Real Life Magazine*, March 1980, p. 4–6.
2 Jeff Wall, "A Draft for *Dan Graham's Kammerspiel*," in Jeff Wall, *Selected Essays and Interviews*, New York 2007, p. 11–29.

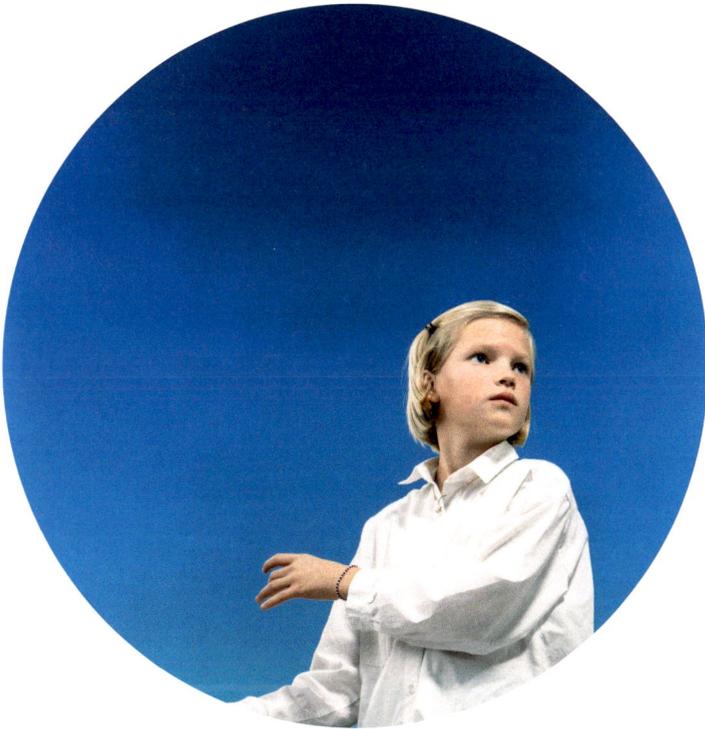

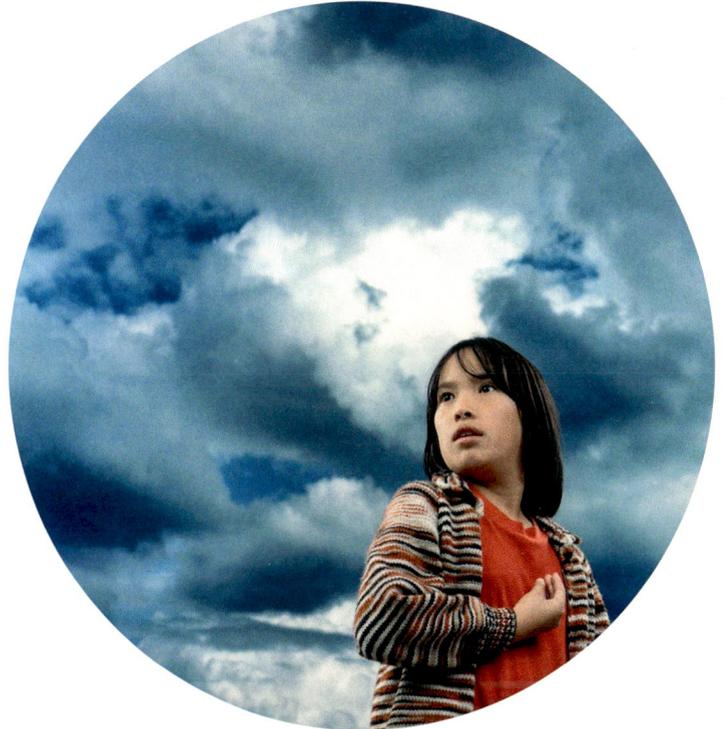

While no architecture can program its uses, the design of the pavilion was certainly informed by an interest in a kind of spatial theater of vision and play that each of the artists had been exploring in their solo work. *The Children's Pavilion* could provide a heightened and highly reflexive sense of space and spectacle, blurring the distinction between play and audience, watchers and watched.

Thirty years on, it seems unlikely that *The Children's Pavilion* will be realized. In the intervening years, Graham has gone on to make other kinds of steel and glass pavilion structures all over the world. Wall has stayed within the museum and gallery, exploring public space and social behavior at the level of depiction within his photographs (although he made a public sculpture, *Lost Luggage Depot*, 2001, installed on the quayside in Rotterdam).

Nevertheless, there is no reason why a proposal cannot be a work of art in itself. Indeed Dan Graham has made several "proposals as artworks" (notably *Alteration to a Suburban House*, 1978). Moreover, Wall has come to feel that his portraits of children function perfectly well in a gallery setting, and when exhibited together in the right configuration, they even suggest the idea of a pavilion.

David Campany

Franz Erhard Walther

Born 1939 in Fulda, Germany, lives in Fulda

The three-dimensional works by German artist Franz Erhard Walther
are characterized by ordinary, everyday materials (such as dyed cotton
fabrics) and by occasionally unexpected production techniques
(such as sewing). In this regard, they differ distinctly from the contem-
poraneous coolness of the industrially produced objects of American
minimal art. The way in which Walther presents his works suggests
that he does not aim for full disclosure, but instead deliberately
conceals some things, leaving open the possibility of revelation. This is
particularly evident in his key early work *1. Werksatz* (1963–69).
The 58 *Werkstücke* pieces that make up *1. Werksatz* have no autono-
mous aesthetic qualities. They are aimed at potential and actual
usability. Up until the mid-1970s, Walther's artistic work included the
"Aktivierung" (activation) of the individual Werkstücke pieces. These
"Handlungsformen" (forms of action) represented the transition from
potential to actual use and vice versa.

Franz Erhard Walther, *Werkzeichnung*, 1968–69

Franz Erhard Walther, *Werkzeichnung*, 1967–71

Franz Erhard Walther, *Werkzeichnung*, 1969

Franz Erhard Walther, *Werkzeichnung*, 1966–71

Of the 3,000 or so *Werkzeichnungen* that were produced at the same time as his *1. Werksatz*, a selection of 16 are held by the Baloise art collection. In these colorful works on paper, Walther distilled his insights and experiences of the "Aktivierung" (activation) of his 58 *Werkstücke* into a remarkably sensual visual language, containing elements of self-reflective discourse that are an integral part of Walther's praxis.

An artistic approach such as this harbors a wealth of possibilities that allow Walther to approach a new, or as he puts it "anderer Werkbegriff" (other concept of the artwork). The *Werkstücke* pieces in *1. Werksatz* and the *Werkzeichnungen* drawings have shifted away from the supposedly old-fashioned, traditional genres (painting, sculpture etc.). Walther's works explore the potential of a new concept of art in which the artwork itself is no longer fulfilled by the eye of the beholder, but which requires the beholder to engage several senses. The fact that such potential is far from exhausted is evident in the timeless relevance of Walther's oeuvre, which also appeals to a young generation of artists in search of answers to the question of what actually constitutes an artwork.

Martin Schwander

Cathy Wilkes

Born 1966 in Belfast, lives in Glasgow

Cathy Wilkes, *Cara Studies Votes for Women "Little Joe,"* 2004

Cathy Wilkes' interest is not in the new, the perfect, the immaculate. She is sooner drawn to fragile, ordinary things, to simple old items that may be damaged somehow, that show signs of use and have a story to tell. She incorporates these into installations made up of found objects, sculptures, and drawings. While each of the objects in her installations has its own story, en masse they create scenarios that combine dreamlike intensity with a sense of urgency.

When she is drawing, Wilkes does not necessarily always start with a new sheet of snow-white paper—as we see in the three works shown here, with their multiple strata, layers, and over-writings. These three sheets were in fact taken from the plates section of a catalogue essay on the English artist Francis Bacon. Wilkes has covered the reproductions of Bacon's images with drawings of her own, with the result that all that remains clearly visible of the original catalogue pages is the page number. Oil-paint marks and fine pencil lines coalesce at the center of these drawings into figures, as virtuosic as they are ambiguous. Is that a corpse lying on a stage? Is this a man standing in grass? Is that a human figure on a boat over there? In the last drawing, titled *"Little Joe,"* another frame has even been sketched in, creating a picture within a picture.

Cathy Wilkes, *Cara Studies Votes for Women "Valerie Lecturing on the Planets,"* 2004

Cathy Wilkes, *Cara Studies Votes for Women "Valerie's Lecture,"* 2004

215

And maybe a certain similarity to motifs in paintings by Bacon is not a matter of chance. Beside repeatedly painting figures—often in contorted poses—in interiors, in his famous portraits of the Pope Bacon also took works by past masters and painted over them or continued them; by this act, which was both respectful and aggressive, he claimed a place of his own in that genealogy.

In Wilkes' case there is no more than a subliminal hint that she may be continuing an artistic lineage. Instead she adds a different level: above the drawings Wilkes has "graffitied" slogans and titles such as *Votes for Women "Valerie Lecturing on the Planets"* and *"Little Joe."* "Votes for Women" harks back to the women's rights movement in the United Kingdom in the early 20th century, when women gathered in public and used posters and slogans to publicize their cause. There was also a magazine of that name, which was published from 1907 to 1918. Wilkes' allusions to the beginnings of women's liberation signal an important topic in her work, in which she consistently engages with the status of women, with the work done by women, and women's lives. These drawings point to art history and social themes, but they also have a private, personal character, which is open to interpretation.

Dora Imhof

Erwin Wurm
Born 1954 in Bruck an der Mur, Austria, lives in Vienna and Limberg

Since the late 1980s Austrian artist Erwin Wurm has been intent on widening the traditional notion of sculpture. He became internationally known in the early 1990s with his *One Minute Sculptures*. Behavioral instructions from the artist—some written, some illustrated—turn exhibition goers into ephemeral sculptures, as they briefly adopt strange bodily positions exactly as described by Wurm; his descriptions often involve the use of ordinary objects, such as chairs or knitted sweaters. The whole procedure is documented in photographs or videos.

Absurdity and comedy play an important part in Wurm's art, and the humor in his works is bizarre, often veering into satire. He himself uses humor as "a weapon." Even issues such as the transience of artistic activity, the roles ascribed to the artist and to the recipient / actor, the unity of work and action are raised with playful ease and nonchalant spontaneity.

There are eight works on paper by Wurm in the Baloise collection, all done on a standard writing-pad format using pencil and fineliner or ink. They are sketch-like images showing people interacting with objects, or human body parts interacting with mechanical components. In some cases written notes explain what is happening. Handwritten pointers such as "2 Vasen 20 Secunden" (2 vases 20 seconds) and "13 Pullover übereinander" (13 pullovers on top of each other) align these drawings with Wurm's *One Minute Sculptures*: a man wearing

Erwin Wurm, *13 Pullover übereinander (One Minute Sculpture)*, 1992

Erwin Wurm, *Helsinki (One Minute Sculpture)*, 2001

only a pair of shorts balances a flower-filled vase on each of his out-stretched arms. Another is seen pulling his pullover down. His bulky upper body seems strangely bloated and out of proportion with the rest of him—13 (!) pullovers on top of each other cannot go unnoticed. More broadly speaking, clothing as a second skin, as a protective shell, is a key topic in Wurm's multilayered work, which combines per-formance, video, photography, drawing, and sculpture. The process of a shape being filled out, weight gain, and growth also play a part in Wurm's so-called Fat sculptures, which show cars or single-family homes in a "fattened," distended state. At the same time, Wurm consistently counters interpretations of his work as socio-critical with comments such as, "my work is about the drama of the inconse-quentiality of existence. Whether one approaches it via philosophy or via a diet, ultimately one only ever draws the short straw." [1]

Brigitte Kölle

1 Erwin Wurm, in *Süddeutsche Zeitung Magazin, Erwin Wurm – Nudelskulpturen*, 46, November 18, 2016, p. 25.

Erwin Wurm, *Kugelschreiber, Hand (One Minute Sculpture)*, 1998

ERWIN WURM

2 Vasen 20 Secunden

Erwin Wurm, *2 Vasen 20 Secunden (One Minute Sculpture)*, 1996

Heimo Zobernig

Born 1958 in Mauthen, Austria, lives in Vienna

From the beginning of his artistic career Heimo Zobernig has grappled with conventions in the visual arts and with the question of the relationship between form and the creation of meaning. As the genre that, historically, has been uniquely coupled with artistic subjectivity, painting has been at the heart of Zobernig's investigations. For many years, starting in 1977, Zobernig produced gouaches on an almost daily basis—first postcard-sized and then on A4 paper—in which he explored every possible register of painting: casual paint application, expressive gesture, and, above all, color effects and the interplay of colors and shapes. In the early 1980s he delved deep into the language of geometric abstraction, as it was seen in works by the Zurich School of Concretists for instance: artists such as Max Bill, Richard Paul Lohse, and Verena Loewensberg, who explicitly sought to banish expression from art. Zobernig's subsequent gouaches show him deploying the formal vocabulary and design principles of Concrete art in a way that deliberately flirts with representation and narration.

Heimo Zobernig, Untitled, 1984

Heimo Zobernig, Untitled, 1984

Heimo Zobernig, Untitled, 1984

Heimo Zobernig, Untitled, 2013

In a work such as *Untitled* (1984), for instance, the tip-to-tip black triangles crowned with a cream-colored disc indubitably form a "figure," whose symbolically anthropomorphic shape casts doubt on the notion of "pure" geometric form. Other sheets from the same period seem to process impressions left on Zobernig by the works of art and architectural monuments that were important to him at that time—witness the arch with a view of a "green landscape" that could easily be found at a villa by Andrea Palladio, or the figure formed from layered planes, which calls to mind the segmented human figures by the Greek-Austrian sculptor Joannis Avramidis. The gouaches made by Zobernig in the 1980s also notably contain the discs, grids, and colored stripe-formations that recur throughout his entire oeuvre. They appear in videos, sculptures, and installations, reaffirming Zobernig's interest in a cross-genre engagement with pictorial forms and formats,

Heimo Zobernig, Untitled, 2012

that in turn casts a sharp light on the rules and conventions of medium-based categorization. Also of relevance in this context is Zobernig's active interest in the relationship of image and text, and, in a wider sense, of artistic work to its institutionalization. *Untitled* (2012), for instance, depicts a "tornado" of rub-on letters, numbers, and signs—question marks, ampersands, dollar signs, and so on—even sticky dots and shapes. Here and there words loom into view, for instance "Helvetica" (a font often used by Zobernig), "made," and "instant letter-ing." Entirely at odds with the rubbed-on demand for "order," artistic work, critique, and questions of economy form a chaotic round dance that once again marks out Zobernig's works on paper as a place of artistic assessment and positioning.

Manuela Ammer

221

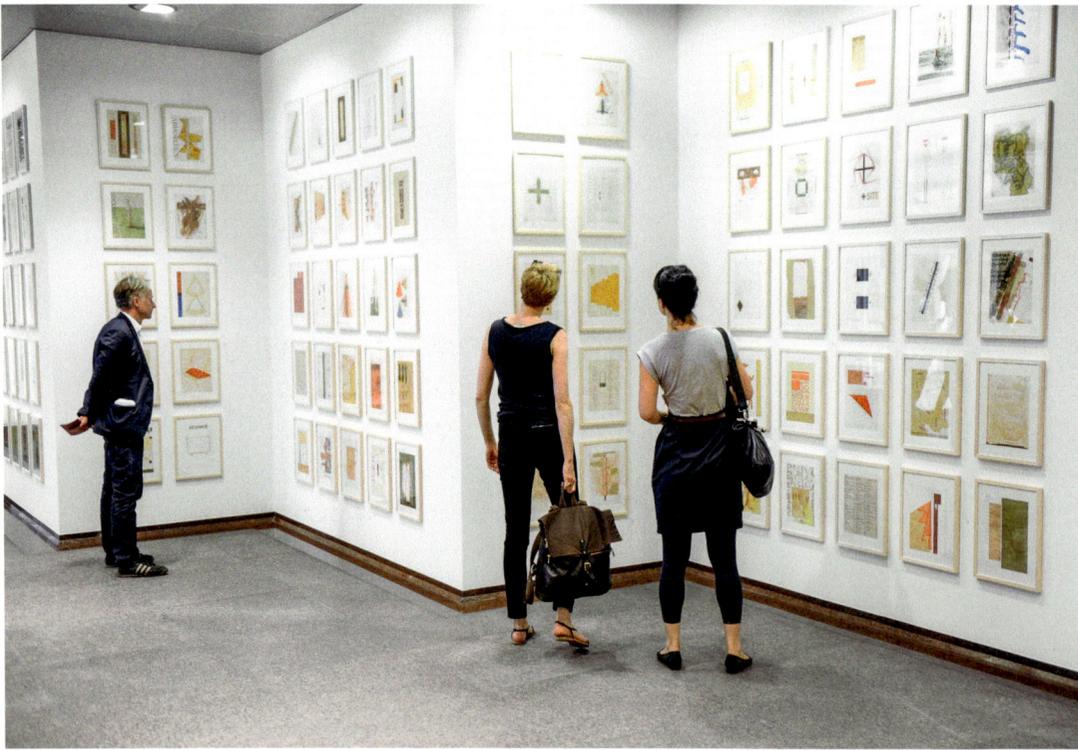

Franz Erhard Walther. Die Modellierung des Innenraums. Werkzeichnungen 1963–1974, Kunstforum Baloise, June 12 – November 1, 2013

Heimo Zobernig. Arbeiten auf Papier 1982–2013, Kunstforum Baloise, June 18 – October 31, 2014

222

Kunstforum Baloise

Martin Schwander

The Baloise art collection shares the fate of many corporate art collections. The rooms in which the artworks are presented are accessible to the public only on rare occasions. Even employees find it difficult to gain an overview of the collection, as it is distributed across a number of locations. The upshot of all this is that such unseen collections tend to remain a well-kept secret.

This less than satisfactory situation was one of the reasons for founding the Kunstforum Baloise in 1998. Over the course of more than two decades, the Kunstforum has offered employees, as well as an art-interested public, a significant insight into this wide-ranging collection twice each year. Its exhibitions, often enhanced by works on loan, are for the most part monographic.

From the very beginning, art mediation has played an important role. Each exhibition is accompanied by printed information outlining the theme of the show. This didactic approach is shored up with guided tours for employees and interested outside groups. What is more, there are also well-attended discussion sessions with the exhibiting artists. This direct personal exchange with the artists themselves opens up new and unforeseen pathways toward appreciating the works on display.

Often, the artists go beyond simply enhancing the existing Baloise art collection by providing works on loan. Indeed, some even take the opportunity to create a whole new group of works. Occasionally, this engagement has gone so far as to reflect, in the works, the involvement of the Baloise group as a patron, or references to Basel as the venue of the exhibition.

In March 2002, with a view to her forthcoming exhibition at the Kunstforum Baloise, German photographer Candida Höfer chose to visit nine public and semi-public places in Basel. For the exhibition, in early June 2002, she selected works from a group of 25 photographs featuring famous and less well known places in the city.[1]

In 2007, Baloise Art Prize winner Peter Piller showed a series of 60 color photographs, identical in format, under the title *nimmt Schaden.* He chose the photographs taken by insurance claims inspectors from thousands in the insurance company's archives. *Nimmt Schaden* is a rare example of close and meaningful cooperation between artist and company.[2]

The exhibitions at Kunstforum Baloise also provide a welcome opportunity to gain a deeper understanding of the oeuvre of each respective participating artist. For instance, as early as 1992, Baloise acquired a group of *Werkzeichnungen* by Franz Erhard Walther. This choice formed the basis for a 2013 exhibition for which the artist provided more than 200 examples of his *Werkzeichnungen* directly from his studio. The result was a presentation that gave a broad insight into, and understanding of, Walther's oeuvre. At the same time, the exhibition

1 See the essay on Candida Höfer in this publication, p. 111–113.
2 See the essay on Peter Piller in this publication, p. 150–153.

offered an opportunity to further enhance the Baloise collection through the acquisition of a substantial group of *Werkzeichnungen*.[3]

The shows at the Kunstforum Baloise can also open up new perspectives. In the course of preparing for the exhibition of works by Austrian artist Heimo Zobernig, it soon became clear that his considerable output of drawings had been under-appreciated. The 2014 exhibition at the Kunstforum Baloise thus became the first comprehensive presentation of his work in this field. The earliest drawings on display dated from 1982, when Zoberning was still a student at the University of Applied Arts in Vienna, while the most recent had been completed just shortly before the exhibition opened. This rich panoply ensured a broad insight into Zobernig's thought processes and working methods. Like so many of the exhibitions at the Kunstforum Baloise, this show provided another welcome opportunity to expand the existing collection by adding further carefully selected acquisitions.[4]

The renown that the Kunstforum Baloise had garnered in the course of more than two decades of exhibitions at Aeschengraben 21 was the driving force behind the idea of including an exhibition space in the plans for the new Baloise Park company headquarters. Opening in 2020, the glass building designed by Diener & Diener Architekten incorporates a new and freely accessible Kunstforum Baloise space for staff and visitors alike in the entrance area. Amid the hustle and bustle of Baloise Park, with its constant stream of passersby, the Kunstforum Baloise is an oasis of tranquility—the ideal setting for undisturbed contemplation of the artworks on display. The generously proportioned, column-free exhibition space of approximately 150m^2 can accommodate a wide variety of different art forms. Precision lighting and modular partition walls, dimming technology and digital networking are all essential to the aesthetic and practical requirements for art exhibitions of our time. By ensuring that these are met, we are on track to writing further chapters in the history of the Kunstforum Baloise.

3 See the essay on Franz Erhard Walther in this publication, p. 212–213.
4 See the essay on Heimo Zobernig in this publication, p. 219–221.

Kunstforum Baloise
Aeschengraben 21, Basel
(1998–2019)
Baloise Park, Basel
(from 2020)

January – June 1998
*Menschenbilder. Silvia Bächli,
Stephan Balkenhol, Jonathan
Borofsky, Marlene Dumas,
Josef Felix Müller, Luc
Tuymans, Rolf Winnewisser*

September – December 1998
*Martin Disler. Arbeiten auf
Papier 1973–1995 aus
der Sammlung der Basler
Versicherungs-Gruppe*

February 18 – June 25, 1999
*Teresa Hubbard und
Alexander Birchler.
Scene – Fotografien*

August 9, 1999 – January 14, 2000
*Walter Kurt Wiemken.
Werke 1928–1938*

February 4 – Juni 2, 2000
*Christoph Draeger.
Going All The Way*

June 19, 2000 – January 19, 2001
Katharina Fritsch. Multiples

January 29 – May 25, 2001
Tracey Moffatt

June 5 – November 2, 2001
*Jeff Wall. Still Lifes &
Interiors*

November 15, 2001 – May 17, 2002
*Stephan Balkenhol.
Zeichnungen und Skulpturen*

June 3 – November 1, 2002
Candida Höfer. Basel

November 29 – May 23, 2003
*Zwischenbilanz. Neuerwer-
bungen aus der Sammlung
der Baloise-Gruppe. Marcel
Dzama, Helmut Federle,
Katharina Fritsch, Annika
Larsson, Tracey Moffatt,
Claudia & Julia Müller, Laura
Owens, Thomas Schütte*

June 2 – October 31, 2003
Silvia Bächli

November 28, 2003 – May 28, 2004
*Basler Meister. Hommage an
Hans Göhner*

June 14 – October 29, 2004
*StadtRäume. Nobuyoshi
Araki, Christoph Draeger,
Naoya Hatakeyama, Candida
Höfer, Theresa Hubbard/
Alexander Birchler, Thomas
Ruff, Jeff Wall*

November 5, 2004 – May 27, 2005
*Baloise Kunstpreis. Die
ersten fünf Jahre 1999–2003.
Annika Larsson, Laura
Owens, John Pilson, Navin
Rawanchaikul, Jeroen de
Rijke/Willem de Rooij,
Matthew Ritchie, Ross
Sinclair, Monika Sosnowska,
Cathy Wilkes, Saskia Olde
Wolbers*

June 13 – November 4, 2005
*Monica Studer/Christoph
van den Berg: Rocks,
Flowers and a Touch of
Dizziness*

November 18, 2005 – May 19, 2006
Thomas Huber. Aquarelle

June 12 – October 27, 2006
*Stephen Waddell. Mostly
Unforseen Encounters*

November 3, 2006 – May 25, 2007
*Aleksandra Mir. The Big
Umbrella*

June 11 – November 16, 2007
Peter Piller. Nimmt Schaden

November 23, 2007 – May 16, 2008
*Zwischenbildanz II. Neuer-
werbungen aus der Sammlung
der Baloise-Gruppe.
Annelise Coste, Keren Cytter,
Slawomir Elsner, Zilla
Leutenegger, Mrzyk &
Moriceau, Claudia & Julia
Müller, Simone Shubuk,
Lucy Skaer*

June 2 – October 31, 2008
Keren Cytter. Drawings

November 28, 2008 – May 22, 2009
*Spoiler Alert. Joanne
Greenbaum. Works on Paper*

June 10 – October 30, 2009
Pia Fries. Spanraum

November 27, 2009 – May 28, 2010
Geert Goiris. Confabulation

June 16 – October 29, 2010
*Marcel van Eeden.
The Sollmann Collection*

November 26, 2010 – May 27, 2011
Alain Huck. Déposition

June 15 – October 28, 2011
*Elger Esser. Arc, Lys et
Douville. Neue Heliogravuren*

November 25, 2011 – May 25, 2012
*Monica Studer/
Christoph van den Berg.
Primordial Matter*

June 13 – October 26, 2012
Stephen Waddell. Einwohner

November 28, 2012 – May 24, 2013
*Walter Kurt Wiemken.
Werke aus der Sammlung
Baloise Group*

June 12 – November 1, 2013
*Franz Erhard Walther. Die
Modellierung des Innen-
raums. Werkzeichnungen
1963–1974*

November 27, 2013 – May 3, 2014
Karsten Födinger. Struttin'

June 18 – October 31, 2014
*Heimo Zobernig. Arbeiten
auf Papier 1982–2013*

November 27, 2014 – June 5, 2015
*Amelie von Wulffen.
This Is How It Happened*

June 17 – October 30, 2015
Andreas Eriksson. Erosion

November 26, 2015 – June 3, 2016
John Skoog. Palace

June 15 – October 28, 2016
Jenni Tischer. Meeting Point

November 24, 2016 – May 26, 2017
Luke Fowler

June 14 – October 27, 2017
*Susanne Kriemann. Dyeing
till the Water Runs Clean*

November 30, 2017 – May 25, 2018
*Kemang Wa Lehulere.
Arbeiten auf Papier*

June 13 – October 26, 2018
*Mathieu Kleyebe Abonnenc.
Vieux-Wacapou*

November 28, 2018 – May 31, 2019
20 Jahre Baloise Kunst-Preis

June 12 – October 25, 2019
Karsten Födinger. Trestles

September 16, 2020 – Spring 2021
Thomas Schütte

Board Chairman Andreas Burckhardt presents the 2013 Baloise Art Prize
to Jenni Tischer and Kemang Wa Lehulere

Jenni Tischer, installation view, 2013
Art Basel, Statements, Galerie Krobath, Vienna

Sam Pulitzer, installation view, 2017
Art Basel, Statements, Real Fine Arts, Brooklyn

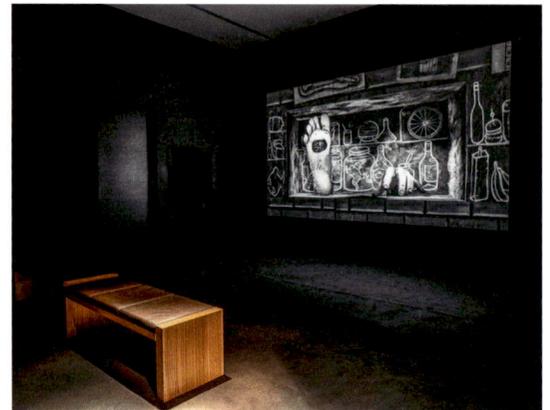
Mary Reid Kelley with Patrick Kelley, *This Is Offal*, installation view
Mudam Luxembourg – Musée d'Art Moderne Grand-Duc Jean, Luxembourg,
June 17 – September 10, 2017

Monika Sosnowska, installation view, 2003
Art Basel, Statements, Fundacja Galerii Foksal,
Warsaw

Aleksandra Mir, Baloise Art Prize winner 2004, at Art Basel, under her umbrella
with Martin Schwander, Board Chairman Rolf Schäuble, and Jürgen Sieger
on the left, and Martin Strobel, Rudolf Joller, Verena Joller, and Astrid Sieger
on the right

Haegue Yang, installation view, 2007
Art Basel, Statements, Galerie Barbara Wien, Berlin

Baloise Art Prize

The initiative for launching the Baloise Art Prize in 1999 chimed with the view of the then Board Chairman Dr. Rolf Schäuble, who believed that successful business enterprises should take on greater social and cultural responsibilities within a changing social environment. Based on this premise, Baloise weighed up several options in the late 1990s. The idea that ultimately won through was that the longstanding commitment to art by the Baloise Group should be substantially expanded by the introduction of an international art prize.

The concept of the Baloise Art Prize has barely changed since its inception. The first and most prominent partner in this endeavor is the Art Basel fair, which attracts thousands of art collectors and art lovers from all over the world each year in June. Baloise is involved in the successful Statements sector, a platform that promotes emerging artists; the subsidy with which Baloise supports this sector allows less established galleries to participate in the Statements framework.

The Statements sector presents some 20 projects chosen by the Selection Committee of Art Basel from a large number of candidates in the course of a multi-stage process of elimination. Just before the fair begins, the Baloise jury, made up of a panel of international specialists, considers the short list drawn up by Art Basel. In the early years of the Baloise Art Prize, emerging European and North American artists were put forward by predominantly young European and North American galleries. The globalization of the art market in the 2000s has resulted in galleries all over the world applying for a Statements booth.

The Baloise jury, in its annually changing constellation, selects two artists every year to receive a monetary award of 30,000 Swiss Francs each. In addition, Baloise purchases works by the prizewinners for donation to two leading European art museums. The first two long-term partners in this collaborative effort were the S.M.A.K. – Stedelijk Museum voor Actuele Kunst, in Ghent, and the Hamburger Kunsthalle. Currently, works by Baloise laureates enter the collections of the Hamburger Bahnhof (Museum für Gegenwart) in Berlin and the Mudam (Musée d'Art Moderne Grand-Duc Jean) in Luxembourg. These partner institutions treat the repeated gifts of such artworks as an occasion to present them, often accompanied by a publication. The exhibition openings usually involve a reception for art lovers and business partners personally invited by Baloise subsidiaries in each respective location. This allows most of the prizewinners to gain their first important experience of dealing with both the ideal and the practical aspects relating to museums and institutions. For the young artists this adds an incalculably precious non-material dimension to the actual Baloise Art Prize itself.

Over the course of the past two decades, the Baloise Art Prize has garnered widespread recognition as an important and established international award. One crucial factor in this regard has been the profile of the Baloise laureates themselves, many of whom have gone on to find a firm foothold on the art world's international stage. Moreover, several prizewinners have become official representatives of their respective countries at the Venice Biennale.

The Baloise Art Prize has also proved an immense asset to the Baloise art collection. A considerable number of laureates have had large groups of works accepted into the collection. Often it has been possible to acquire key works by these artists at a relatively early stage in their careers. For many of the prizewinners, this recognition does not stop with the acquisition of their works for the collection: exhibition projects for the Kunstforum Baloise have been undertaken in dialogue with the artists, while others have gone on to develop works relating to the architecture and business activities of the Baloise Group.

Baloise Art Prize

1999
Laura Owens (b. 1970)
　Gavin Brown's enterprise,
　New York
　Donation to S.M.A.K. –
　Stedelijk Museum voor
　Actuele Kunst, Ghent

Matthew Ritchie (b. 1964)
　c/o Atle Gerhardsen, Oslo
　Donation to Hamburger
　Kunsthalle, Hamburg

2000
Jeroen de Rijke (1970–2006) and
　Willem de Rooij (b. 1969)
　Galerie Daniel Buchholz,
　Cologne
　Donation to Hamburger
　Kunsthalle, Hamburg

Navin Rawanchaikul (b. 1971)
　Shugoarts, Tokyo
　Donation to S.M.A.K. –
　Stedelijk Museum voor
　Actuele Kunst, Ghent

2001
Annika Larsson (b. 1972)
　Andréhn-Schiptjenko,
　Stockholm
　Donation to S.M.A.K. –
　Stedelijk Museum voor
　Actuele Kunst, Ghent

Ross Sinclair (b. 1966)
　The Agency, London
　Donation to Hamburger
　Kunsthalle, Hamburg

2002
John Pilson (b. 1968)
　Nicole Klagsbrun, New York
　Donation to Hamburger
　Kunsthalle, Hamburg

Cathy Wilkes (b. 1966)
　The Modern Institute,
　Glasgow
　Donation to S.M.A.K. –
　Stedelijk Museum voor
　Actuele Kunst, Ghent

2003
Saskia Olde Wolbers (b. 1971)
　Galerie Diana Stigter,
　Amsterdam
　Donation to S.M.A.K. –
　Stedelijk Museum voor
　Actuele Kunst, Ghent

Monika Sosnowska (b. 1972)
　Fundacja Galerii Foksal,
　Warsaw
　Donation to Hamburger
　Kunsthalle, Hamburg

2004
Aleksandra Mir (b. 1967)
　Jousse entreprise, Paris
　Donation to S.M.A.K. –
　Stedelijk Museum voor
　Actuele Kunst, Ghent

Tino Sehgal (b. 1976)
　Jan Mot, Brussels, in
　collaboration with Johnen +
　Schöttle, Cologne
　Donation to Hamburger
　Kunsthalle, Hamburg

2005
Jim Drain (b. 1975)
Greene Naftali, New York
Donation to Hamburger
Kunsthalle, Hamburg

Ryan Gander (b. 1976)
Annet Gelink, Amsterdam
Donation to mumok –
Museum moderner Kunst
Stiftung Ludwig Wien,
Vienna

2006
Keren Cytter (b. 1977)
Elisabeth Kaufmann, Zurich
Donation to mumok –
Museum moderner Kunst
Stiftung Ludwig Wien,
Vienna

Peter Piller (b. 1968)
Frehrking Wiesehöfer,
Cologne
Donation to Hamburger
Kunsthalle, Hamburg

2007
Andreas Eriksson (b. 1975)
Galleri Riis, Oslo
Donation to mumok –
Museum moderner Kunst
Stiftung Ludwig Wien,
Vienna

Haegue Yang (b. 1971)
Galerie Barbara Wien, Berlin
Donation to Hamburger
Kunsthalle, Hamburg

2008
Duncan Campbell (b. 1972)
Hotel, London
Donation to mumok –
Museum moderner Kunst
Stiftung Ludwig Wien,
Vienna

Tris Vonna-Michell (b. 1982)
T293, Naples
Donation to Hamburger
Kunsthalle, Hamburg

2009
Nina Canell (b. 1979)
Mother's Tankstation, Dublin
Donation to mumok –
Museum moderner Kunst
Stiftung Ludwig Wien,
Vienna

Geert Goiris (b. 1971)
Art : Concept, Paris
Donation to Hamburger
Kunsthalle, Hamburg

2010
Simon Fujiwara (b. 1982)
Neue Alte Brücke,
Frankfurt am Main
Donation to Hamburger
Kunsthalle, Hamburg

Claire Hooper (b. 1978)
Hollybush Gardens, London
Donation to mumok –
Museum moderner Kunst
Stiftung Ludwig Wien,
Vienna

2011
Alejandro Cesarco (b. 1975)
Murray Guy, New York
Donation to mumok –
Museum moderner Kunst
Stiftung Ludwig Wien,
Vienna

Ben Rivers (b. 1972)
Kate MacGarry, London
Donation to Hamburger
Kunsthalle, Hamburg

2012
Simon Denny (b. 1982)
Michael Lett, Auckland
Donation to mumok –
Museum moderner Kunst
Stiftung Ludwig Wien,
Vienna

Karsten Födinger (b. 1978)
RaebervonStenglin, Zurich
Donation to Hamburger
Kunsthalle, Hamburg

2013
Jenni Tischer (b. 1979)
Krobath, Vienna
Donation to mumok –
Museum moderner Kunst
Stiftung Ludwig Wien,
Vienna

Kemang Wa Lehulere (b. 1984)
Stevenson, Cape Town
Donation to Hamburger
Kunsthalle, Hamburg

2014
John Skoog (b. 1985)
Pilar Corrias, London
Donation to mumok –
Museum moderner Kunst
Stiftung Ludwig Wien,
Vienna, and Museum MMK
für Moderne Kunst,
Frankfurt am Main

2015
Mathieu Kleyebe Abonnenc
(b. 1977)
Marcelle Alix Galerie, Paris
Donation to Museum MMK
für Moderne Kunst,
Frankfurt am Main

Beatrice Gibson (b. 1978)
Laura Bartlett Gallery,
London
Donation to Mudam
Luxembourg – Musée d'Art
Moderne Grand-Duc Jean,
Luxembourg

2016
Sara Cwynar (b. 1985)
Foxy Production, New York
Donation to Museum MMK
für Moderne Kunst,
Frankfurt am Main

Mary Reid Kelley (b. 1979)
Arratia Beer, Berlin
Donation to Mudam
Luxembourg – Musée d'Art
Moderne Grand-Duc Jean,
Luxembourg

2017
Martha Atienza (b. 1981)
Silverlens Galleries,
Makati City, Philippines
Donation to Mudam
Luxembourg – Musée d'Art
Moderne Grand-Duc Jean,
Luxembourg

Sam Pulitzer (b. 1984)
Real Fine Arts, Brooklyn
Donation to Hamburger
Bahnhof – Museum für
Gegenwart – Berlin, Staatli-
che Museen zu Berlin,
Stiftung Preussischer
Kulturbesitz

2018
Lawrence Abu Hamdan (b. 1985)
mor charpentier, Paris
Donation to Hamburger
Bahnhof – Museum für
Gegenwart – Berlin, Staatli-
che Museen zu Berlin,
Stiftung Preussischer
Kulturbesitz

Suki Seokyeong Kang (b. 1977)
One and J. Gallery, Seoul
Donation to Mudam
Luxembourg – Musée d'Art
Moderne Grand-Duc Jean,
Luxembourg

2019
Giulia Cenci (b. 1988)
SpazioA, Pistoia
Donation to Mudam
Luxembourg – Musée d'Art
Moderne Grand-Duc Jean,
Luxembourg

Xinyi Cheng (b. 1989)
Galerie Balice Hertling, Paris
Donation to Hamburger
Bahnhof – Museum für
Gegenwart – Berlin, Staatli-
che Museen zu Berlin,
Stiftung Preussischer
Kulturbesitz

Baloise Park, aerial view, rendering by Nightnurse Images GmbH, 2018

Baloise Park
The New Gateway to the City

Philippe Fürstenberger

2013 saw public announcement of Baloise Group's construction plans for Baloise Park, close to the train station Basel SBB. The construction project between Nauenstrasse, Aeschengraben, and Parkweg has now been completed, and the site—with its three striking new buildings—is teeming with life. Companies occupy the offices, the new Mövenpick Hotel has guests from all over the world, and the new, public Baloise Platz invites locals to linger.

Basel architects Miller & Maranta designed the high-rise in Baloise Park West, which—with a height of 89 meters—is currently the tallest building in the district. It is now home to the 5-star Mövenpick Hotel with 264 rooms. The top seven floors of office space (there are 24 floors in total) are leased out by Baloise. The neighboring building, an eight-story block by Basel architects Diener & Diener, is the new headquarters of the Baloise Group. The concrete-and-glass facade of the headquarters is notable for its eight-meter tall, convex windows on the side facing the square. Passersby can glimpse the pairs of floors behind these extra tall windows. The third new building on this site is an office block by Grisons architect Valerio Olgiati, which contains the Baloise training center, and units leased out to tenants.

The creation of this Baloise Park is not the first time that the Baloise Group has played its part in setting the tone of the city. Their tradition of pioneering construction projects goes right back to the 19th century and the Baloise "tower house" built on the corner of St. Jakobs-Strasse in 1928/29, that still defines Aeschenplatz today. Aeschenplatz also boasts another architectural jewel: the grand, Belle Époque palace was the head office of Basler Leben (as the company was then known) from 1912 to 1983. In the years up until 1989, Baloise acquired several lots between Aeschengraben, Parkweg, and Nauenstrasse, where it then constructed a new office block for itself. A Hilton Hotel, built at the same location in 1975, was acquired by Baloise in 1987.

A few decades later the Hilton Hotel was in need of refurbishment, which led to a feasibility study for the whole site being conducted in 2011, along the lines suggested by the Basel architectural practice Miller & Maranta; this then became the basis for the new development plan. During the feasibility study it soon became clear that a wholesale redevelopment of this area could be a unique opportunity, and could help to redefine this part of the city. It would also enhance the status of the Baloise complex in the life of the city. Looking back in a subsequent interview, architect Quintus Miller commented that, "our work developing a master plan showed that a group of three buildings would work best."[1]

The development project was divided into separate zones: the West Site— high-rise with new hotel; the South Site—Baloise headquarters; the East Site— office block containing the Baloise training center and commercial lets. From the outset it was clear that the high-rise on the West Site would be designed by

1 *Baloise Park Baumagazin*, May 9, 2019, p. 7.

architects Miller & Maranta, who had drawn up the development plan. The interior design of the new Hotel Mövenpick in the high-rise was in the hands of Matteo Thun & Partners, who operate internationally in the hospitality business.

In 2014 the Baloise ran two concurrent, anonymous competitions for proposals for the South Site and the East Site. In each case they invited entries from five Swiss architectural practices based in different parts of the country. The competing architects were faced with a considerable challenge: the buildings should be distinctive yet in harmony with each other. The jury, led by Austrian architect Adolf Krischanitz, comprised representatives from the Baloise, from the Canton of Basel-Stadt, and other professionals in the field of architecture.[2]

The jury's main concern was that new development as a whole should be innately coherent. They unanimously recommended the "Baloiseforum" by Diener & Diener Architekten in Basel for the South Site. In their final report the jury summed up their thinking: "This project seems eye-catchingly simple, but on closer examination it turns out to be instilled with an intrinsic, efficacious complexity, which nevertheless does not undermine the self-referential auto-nomy of the building. It takes the most rigorous account of the building's future use as the Baloise headquarters. This building operates on its own terms, making a distinct contribution to this prominent location, yet it still fits into the overall development plan. The paired floors—this extra tall, colossal order with a heightened lucidity—create something akin to 'small monumentalism,' which in turn ensures that, in the company of the structures on the East Site and the West Site, this building is both autonomous and their equal."[3] Moreover, the report states that "in keeping with the Baloise's own mission, the role art can play is also taken seriously, and effectively deployed externally in the form of a 'frieze' on the facade, and internally in the Kunstforum on the ground floor and in the étagères (open shelves)."[4] In the end, the frieze mentioned here was not realized.

As to the architects of the Baloiseforum, Roger Diener recalled their main concerns: "In this competition our aim was to achieve ambivalence and subtlety, to react both as architects and planners in this highly urbanized location to the ensemble at Baloise Park and to provide the basis for interaction with the neighboring high-rise at Aeschengraben. With the monumental articulation of the facade, the eight stories look like four tall stories, elongated in a way that we still associate with elegance in our view of architecture."[5] Roger Diener also made another point: "The windows facing the square remind us of bowfronts. Their curved glass provides a lightsome outer wall both for the café and the art forum on the ground floor and for the workstations on the upper floors. These new workstations are a modern addition to the workstations in the existing, neighboring buildings, and intrinsic to a building in which different departments are very visible and readily accessible."[6]

2 Competition jury: Baloise: Renato Piffaretti, Head of Real Estate; Philippe Fürstenberger, Head of Real Estate Services; Marlis Lübcke, Head of Buildings Management; Canton Basel-Stadt: Fritz Schumacher, Cantonal Architect, Department of Building and Traffic, represented during the judging process by Jürg Degen, Head of Site and Zoning Planning, Department of Building and Traffic; Professionals and Experts: Adolf Krischanitz, Architect, Vienna and Zurich, Chairperson; Quintus Miller, Architect, Basel, Partner at Miller & Maranta, Project Site A, Masterplan coordination; Christine Binswanger, Architect, Basel, Partner at Herzog & de Meuron; Jörg Koch, Architect, Zurich, CEO at Pensimo Management AG.
3 Final report by the competition jury, November 18, 2014, p. 21.
4 Ibid.
5 Written interview with Roger Diener, conducted by the Baloise, May 2019.
6 Ibid.

The Baloise art collection played a key part in the design of the group's new headquarters. Diener & Diener Architekten already had very considerable experience in the field of art-related building projects. On the ground floor of the Baloise headquarters the new Kunstforum will mount a program of exhibitions with works by artists who are represented in the Baloise collection. Roger Diener spoke about this aspect of the project: "With the Kunstforum specifically designed as an independent, communicative part of the Baloiseforum in the new square, the works of art are immediately next to the main entrance for the Baloise workforce, in the same spirit as renowned independent or company-owned galleries that are now seen in office blocks in European, Asian, and American cities. Baloise Park now takes its place as one of a very visible group of open spaces in the city center, alongside the De-Wette Park and the Central-bahnplatz outside the main train station. With its collection and its activities, the Baloise thus now occupies a very prominent position in the cityscape."[7]

In their design for the Kunstforum, Diener & Diener Architekten—working together with the Baloise group and the Baloise art collection team—attached particular importance to creating a space that could hold large numbers of visitors, yet still afford individuals viewing works of art on their own the necessary peace and quiet. At the same time they also wanted to design a space that felt generous and welcoming. The Kunstforum is a place of communication, it is not a place of transit. The architects specifically wanted to avoid it being seen as a museum, as Roger Diener explained: "This open space, free of supporting columns, is not defined by any rigid form. The proportions generated by the paintable walls, the floor, and the ceiling take on a different scale depending on the works shown here and the way they are hung. In this building the internal room-height is prescribed by building regulations, and the services require a suspended ceiling. Together the walls, the lighting fixtures, the floor, and the ceiling create an effect that distinguishes the Kunstforum from the rest of the ground floor, both subtly and more obviously; at the same time it is also a multi-use space. In architectural terms we see the Kunstforum as, in some senses, a temporary structure, in that it is more of a flexible, elastic installation than a fixture. The spatial contact with art here suggests maneuverability and longevity, fragility and stability on both sides: the art and the space itself."[8]

In addition to the Kunstforum, Diener & Diener Architekten were keen to devise another physical means to ensure that the Baloise art collection would in fact take center stage on every floor of the building. They came up with an "étagère" as they term it, having never before encountered a name for this special presentation method, which pervades an entire building. Works from the art collection are displayed in a vertical sequence in the étagères, and the "shelf levels" are connected from one story to the next by a stairwell and elevators. The spaces between the étagères are the height of one, sometimes two stories. "During the working day individuals cross through these spaces consciously or not as they move around on one level, or they may pass through a series of these

7 Ibid.
8 Ibid.

spaces as they head for the exit or seek out colleagues on other floors," Roger Diener explains.[9] These étagère spaces can accommodate much of the Baloise art collection, and they allow the workforce to come into contact with professionally curated displays on an almost daily basis. The generous sliding doors to the offices, which are more often than not open, are closed when guests are being taken on a tour of the collection. These tours take place on weekdays and are always guided, since safety considerations mean that visitors cannot be allowed to roam freely through the building.

The jury's selection for the East Site was not as straightforward as for the Baloise headquarters on the South Site. Since none of the competition entries seemed entirely suitable to the jury, its members decided unanimously not to recommend any of these proposals for further development. Instead, for the East Site the jury selected "Vers" by Valerio Ogiati's architectural practice in Flims, which had originally been submitted as a proposal for the South Site. The jury took the view that this design, with its striking individuality, had all the makings of an innovative, future-proofed office block. Moreover the jury was in no doubt that this concept could work for the East Site. In its final report the jury summed up its conclusion: "As an architectural body this project, with its precisely proportioned structure, is a natural fit for the new ensemble of Baloise buildings at the corner of Aeschengraben and Nauenstrasse. At the same time, its iconographically striking facade design, with pointed tips to its uprights, gives it a strong identity, which is further reinforced by its materialization in red concrete."[10] The jury made particular mention of the innovative typology of this building. Valerio Olgiati described his design as follows: "With its earth-toned concrete and expansive glass facades, the building is both transparent and stable. The red-brown concrete—or engineered stone—harmonizes with the mineral facade of the high-rise hotel."[11]

In November 2015 work started on the removal of the existing buildings. At the time the Baloise art collection owned a unique glass window, made by artist Paul Stöckli in 1955, which filled the foyer of 25 Aeschengraben with colored light. On August 28, 2018, after the window's removal prior to the demolition of the building, it was gifted to the Nidwaldner Museum in Stans, the artist's native town.

Preparations for the construction of the high-rise at Baloise Park started in April 2016; at the foundation-stone ceremony in June 2017, celebrations marked the commencement of construction work. The special three-part "foundation stone" was commissioned by the Baloise from German artist Karsten Födinger, winner of the 2012 Baloise Art Prize. Födinger was the natural choice for this task as an artist whose work strikes a fine balance between architecture and sculpture. He created a separate work for each of the three buildings, and in so doing engaged directly with the early stages of each construction process. The first foundation stone, for the high-rise, is not hidden from sight; on the contrary, it is an integral part of the architecture. As in classical sculptures of

9 Ibid.
10 Final report by the competition jury, November 18, 2014, p. 43.
11 *Baloise Park Baumagazin*, 7, April 2018, p. 3.

Atlas, the building stands directly on the foundation stone—a copper column. Normally copper is used in buildings for water and electricity conduits; in this context it thus calls to mind its function as part of a building's services. The column fulfills a similar function to a tree trunk, anchoring the structure in the ground. In a communal action, the guests at the foundation-stone ceremony added their own handwritten dedications to the column, in effect turning it into a time capsule.

The second foundation stone was laid on the occasion of the topping-out ceremony for Diener & Diener's new headquarters for the Baloise group. The copper pillar on the building's facade on Nauenstrasse is immediately visible to passersby. Baloise staff members had the opportunity to inscribe their signatures and dedications or hopes for the future into this approximately seven-meter-long foundation stone—making their mark on the history of the Baloise Group.

Coinciding with the completion of construction work on the Olgiati building, the third foundation stone—another time capsule—was integrated into the final construction project. In this case it took the form of a sealed copper cylinder that was fitted into the shuttering for the last pile. Thus the capsule connected with the making of the last vertical component in the building and would still be visible, but no longer accessible, once the concrete had set. This third capsule contains rolls of analog film, shot by Födinger, but not developed. The photographs capture moments in the construction of the buildings, from the planning stages to the finishing by craftsmen. The artist set out his thinking in his proposal: "The cylinder is an allusion to the idea of a time capsule, of the kind used at the Barbarastollen in Oberried. This is the main site where the Federal Republic of Germany stores microfilms of documents of outstanding national or cultural importance."[12]

Baloise Park has now been completed. It is an inviting place of work and a meeting point for the Baloise workforce, for leaseholders, and for the population at large. These three buildings contain around 1,300 new workstations, with the Baloise occupying about 700 of these. Baloise Park has become a gateway to the city and is now intrinsic to the urban concentration in the vicinity of the station, at the heart of a major travel hub. These three striking buildings significantly contribute to the image of the city, and reflect the Baloise Group's commitment to Basel.

12 Karsten Födinger, Proposal for Baloise Park, Foundation Stone III.

List of Illustrations

Andreas Eriksson
Erosion 24, 2015
Watercolor on paper
19 × 14 cm
Ill. p. 71, bottom, center

Andreas Eriksson
Erosion 34, 2015
Watercolor on paper
19 × 14 cm
Ill. p. 71, bottom, right

Elger Esser
*Combray (Douville-sur-Andelle),
Frankreich (Haute-Normandie,
27 Eure)*, 2010
Heliogravure on handmade paper,
ed. 6/12
107.5 × 124.5 cm
Ill. p. 73

Elger Esser
*Combray (Echaney II), Frankreich
(Bourgogne, 21 Côte-d'Or)*, 2008
Heliogravure on handmade paper,
ed. 11/12
108 × 124 cm
Ill. p. 74

Elger Esser
*Combray (Fontaines-en-Duesmois),
Frankreich (Bourgogne,
21 Côte-d'Or)*, 2008
Heliogravure on handmade paper,
ed. 7/12
108.5 × 124.5 cm
Ill. p. 75

Luciano Fabro
Giardino all'italiana, 1994
55 steles, 4 benches, granite
pavement (Nero Zimbabwe
and Bianco Berrocal), and
170 lighting gears
Picassoplatz, Basel
Ill. pp. 76–77

Luciano Fabro
Basilea: il cielo sotto la pioggia, 1992
Pencil and colored pencil on paper
39 × 53.9 cm
Private collection, Basel
Ill. p. 79

Helmut Federle
*Relation of All Possibilities. Cold
Nov. NY*, 1980
Pencil, colored pencil, and ballpoint
pen on paper
19.7 × 27.5 cm
Ill. p. 80

Helmut Federle
*Disaster Drawing mit untergehender
Sonne for V.*, 1979
Pencil, ballpoint pen, and
transparent adhesive tape on paper
28 × 21.5 cm
Ill. p. 81, left

Helmut Federle
Familienbaum 19. Aug. 1980, NYC,
1980
Pencil and oil crayon on paper
27.9 × 21.4 cm
Ill. p. 81, right

Karsten Födinger
Untitled, 2018
Fine art print on Baryta paper, ed. 5
AP 2/2
11.7 × 11.7 cm
Ill. p. 83, top

Karsten Födinger
Untitled, 2009
Fine art print on Baryta paper, ed. 5
AP 2/2
15.3 × 12.6 cm
Ill. p. 83, bottom, left

Karsten Födinger
Untitled, 2010
Fine art print on Baryta paper, ed. 5
AP 2/2
18.2 × 12.7 cm
Ill. p. 83, bottom, right

Karsten Födinger
Untitled, 2016
Fine art print on Baryta paper, ed. 5
AP 2/2
17.7 × 12.7 cm
Ill. p. 84, top, left

Karsten Födinger
Untitled, 2016
Fine art print on Baryta paper, ed. 5
AP 2/2
19.2 × 12.7 cm
Ill. p. 84, top, right

Karsten Födinger
Untitled, 2017
Fine art print on Baryta paper, ed. 5
AP 2/2
16.7 × 12.6 cm
Ill. p. 84, bottom, left

Karsten Födinger
Untitled, 2017
Fine art print on Baryta paper, ed. 5
AP 2/2
14.5 × 12.9 cm
Ill. p. 84, bottom, right

Luke Fowler
Perfect Lives, 2015
20 C-prints on paper, ed. 2/3
133 × 204 cm overall
Ill. pp. 86–87

Luke Fowler
Perfect Lives, 2015
Sheet 8 of 20
C-print on paper, ed. 2/3
26 × 36 cm
Ill. p. 88, top

Luke Fowler
Perfect Lives, 2015
Sheet 18 of 20
C-print on paper, ed. 2/3
26 × 36 cm
Ill. p. 88, bottom

Pia Fries
Untitled (No. 53), 2000
Oil on offset on paper
46.5 × 60.5 cm
Ill. p. 89

Pia Fries
Untitled (No. 8), 2001–02
Oil on screen print on paper
71.8 × 102.5 cm
Ill. p. 90

Katharina Fritsch
*Lexikonzeichnungen, 4. Serie.
Aberglaube, Geisselerzug*, 1996
Screen print on paper, ed. 1/3
74 × 52 cm
Ill. p. 91, left

Katharina Fritsch
*Lexikonzeichnungen, 4. Serie.
Aberglaube, Geisterbeschwörung*,
1996
Screen print on paper, ed. 1/3
74 × 52 cm
Ill. p. 91, right

Katharina Fritsch
*Lexikonzeichnungen, 4. Serie.
Aberglaube, Hexentanz*, 1996
Screen print on paper, ed. 1/3
74 × 52 cm
Ill. p. 92, left

Katharina Fritsch
*Lexikonzeichnungen, 4. Serie.
Aberglaube, Wahrsagerin*, 1996
Screen print on paper, ed. 1/3
74 × 52 cm
Ill. p. 92, right

Simon Fujiwara
Letters from Mexico (Triptych), 2011
Hand-typed letters, envelopes,
ephemera, colored backgrounds,
framed behind Plexiglas in
dark-stained maple wood
3 parts, each 68 × 48 × 3.5 cm
Ill. pp. 94–95

Ryan Gander
*Portrait of Spencer Anthony
Somewhere Between 1970 and
1973*, 2003
Black and white photograph, ed. 5/5
15 × 20 cm
Ill. p. 96

Ryan Gander
Portrait of Mary Aurory 1972, 2003
Black and white photograph, ed. 4/5
20 × 15 cm
Ill. p. 97

Geert Goiris
Whiteout 1–3, 2008–09
Lambda print on Endura paper, ed. 1/5
3 parts, each 50 × 60 cm
Ill. pp. 99–101

Geert Goiris
Lion, 2005
Lambda print on Endura paper, ed. 1/5
125.1 × 164.1 cm
Ill. p. 102

Joanne Greenbaum
Untitled, 2001
Watercolor and gouache on paper
36 × 37.3 cm
Ill. p. 103, left

Joanne Greenbaum
Untitled, 2001
Watercolor and gouache on paper
35.6 × 36.8 cm
Ill. p. 103, right

Joanne Greenbaum
Untitled, 2003
Watercolor on paper
76.2 × 56 cm
Ill. p. 104

Joanne Greenbaum
Untitled, 2008
Watercolor on paper
41.3 × 29.8 cm
Ill. p. 105, left

Joanne Greenbaum
Untitled, 2008
Watercolor on paper
42 × 30 cm
Ill. p. 105, right

Naoya Hatakeyama
Still Life, 2001
C-print on paper, ed. 4/5
19.2 × 38.8 cm
Ill. pp. 106–107

Naoya Hatakeyama
Still Life, 2001
C-print on paper, ed. 4/5
18.6 × 38.1 cm
Ill. p. 108

Naoya Hatakeyama
Still Life, 2001
C-print on paper, ed. 4/5
18.5 × 38 cm
Ill. p. 109, top

Naoya Hatakeyama
Still Life, 2001
C-print on paper, ed. 4/5
18.5 × 38 cm
Ill. p. 109, bottom

Naoya Hatakeyama
Still Life, 2001
C-print on paper, ed. 4/5
18.5 × 38 cm
Ill. p. 110

Candida Höfer
*Allgemeine Lesegesellschaft
Basel III*, 1999
C-print on paper, ed. 2/6
85 × 85 cm
Ill. p. 111

Candida Höfer
*Anatomisches Institut der
Universität Basel I*, 2002
C-print on paper, ed. 2/6
152 × 152 cm
Ill. p. 112

Candida Höfer
Baloise Basel II, 2002
C-print on paper, ed. 2/6
85 × 85 cm
Ill. p. 113

Teresa Hubbard/Alexander Birchler
Falling Down, 1996
Chromogenic print on Dibond,
ed. 1/5
60 × 90 cm
Ill. p. 115, top

Teresa Hubbard/Alexander Birchler
Falling Down, 1996
Chromogenic print on Dibond,
ed. 1/5
60 × 90 cm
Ill. p. 115, bottom

Teresa Hubbard/Alexander Birchler
Filmstills. Tinseltown South, 2002
Lightjet print on Fujicolor archive
paper on Dibond, ed. 3/10
59 × 99.5 cm
Ill. p. 116, top

Teresa Hubbard/Alexander Birchler
Filmstills. Tinseltown Twenty, 2002
Lightjet print on Fujicolor archive
paper on Dibond, ed. 3/10
59 × 99.5 cm
Ill. p. 116, bottom

Thomas Huber
Bildreservoir, 2002
Watercolor on paper
30 × 39.7 cm
Ill. p. 117

Thomas Huber
Réservoir, 2002
Watercolor on paper
40 × 30 cm
Ill. p. 118

Thomas Huber
Bilderlager 1, 2002
Watercolor on paper
40 × 30 cm
Ill. p. 119

Alain Huck
Affection, 2010
Charcoal on paper
151 × 225 cm
Ill. pp. 120–121

Alain Huck
Le souffle, 2010
Charcoal on paper
151 × 225 cm
Ill. p. 122

Max Kämpf
Bube mit Ballon, 1941–42
Oil on canvas
209.5 × 74.3 cm
Ill. p. 19, left

Lenz Klotz
Struppig, 1958
Oil on canvas
100 × 80.5 cm
Ill. p. 20, bottom

Susanne Kriemann
*Bitterkraut aus: Falsche
Kamille, Wilde Möhre,
Bitterkraut (Zyklus 2)*, 2017
Heliogravure with ox-tongue
pigment, 0.4 g soot on paper,
Unicum
84.8 × 64.7 cm
Ill. p. 123

Susanne Kriemann
*Bitterkraut aus: Falsche
Kamille, Wilde Möhre,
Bitterkraut (Zyklus 2)*, 2017
Heliogravure with ox-tongue
pigment, 0.6 g soot on paper,
Unicum
84.8 × 64.7 cm
Ill. p. 124

Susanne Kriemann
*Bitterkraut aus: Falsche
Kamille, Wilde Möhre,
Bitterkraut (Zyklus 2)*, 2017
Heliogravure with ox-tongue
pigment, 0.8 g soot on paper,
Unicum
84.8 × 64.7 cm
Ill. p. 125

René Küng
Steinerne Landschaft, 1982–83
Baveno granite
525 × 570 × 540 cm
Ill. p. 24, bottom

Annika Larsson
Untitled (*Bend II*), 2002
Lambda print on paper, ed. 1/3
120 × 160 cm
Ill. p. 126

Annika Larsson
Untitled (*Bend II*), 2002
Lambda print on paper, ed. 1/3
120 × 160 cm
Ill. p. 127

List of Illustrations

Annika Larsson
Untitled (Bend II), 2002
Lambda print on paper, ed. 1/3
120 × 160 cm
Ill. p. 128

Zilla Leutenegger
New York, 2010
Pencil and colored pencil on paper
45.7 × 60.5 cm
Ill. p. 129

Zilla Leutenegger
Zahnweh, 2005
Pencil and acrylic on paper
104 × 70 cm
Ill. p. 130

Zilla Leutenegger
Telefon (Mia Farrow), 2005
Pencil and acrylic on paper
104 × 70 cm
Ill. p. 131

Sol LeWitt
Drawing for Four Pages, 1974
Pencil and India ink on card
65 × 50 cm
Ill. p. 133

Jean-Jacques Lüscher
Der Trommler (Waisenbube), 1911
Oil on canvas
149.1 × 116.5 cm
Ill. p. 12, bottom

Rudolf Maeglin
Skelettbau, 1938
Oil on canvas
116.8 × 167.5 cm
Ill. p. 16, center

Aleksandra Mir
The Big Umbrella. Copenhagen, 2004
C-print on paper, ed. 1/5
78.2 × 98.2 cm
Ill. p. 134

Aleksandra Mir
The Big Umbrella. London, 2004
C-print on paper, ed. 3/5
35.3 × 48.5 cm
Ill. p. 135

Aleksandra Mir
The Big Umbrella. London, 2004
C-print on paper, ed. 1/5
72.2 × 98.2 cm
Ill. p. 136

Tracey Moffatt
Scarred for Life II. Homemade
Hand-Knit, 1958, 1999
Offset print on paper, ed. 57/60
80 × 60 cm
Ill. p. 137

Tracey Moffatt
Scarred for Life II. Scissor Cut, 1980,
1999
Offset print on paper, ed. 57/60
80 × 60 cm
Ill. p. 138

Tracey Moffatt
Scarred for Life II. Piss Bags, 1978,
1999
Offset print on paper, ed. 57/60
80 × 60 cm
Ill. p. 139, left

Tracey Moffatt
Scarred for Life II. Always the
Sheep, 1987, 1999
Offset print on paper, ed. 57/60
80 × 60 cm
Ill. p. 139, right

Mrzyk & Moriceau
Untitled, 2001
India ink on paper
21 × 29.6 cm
Cover, ill. p. 140

Mrzyk & Moriceau
Untitled, 2003
India ink on paper
21 × 29.7 cm
Ill. p. 141

Mrzyk & Moriceau
Untitled, 2001
India ink on paper
21 × 29.8 cm
Ill. p. 142, top, left

Mrzyk & Moriceau
Untitled, 2003
India ink on paper
21 × 29.6 cm
Ill. p. 142, top, right

Mrzyk & Moriceau
Untitled, 2004
India ink on paper
21 × 29.7 cm
Ill. p. 142, bottom, left

Mrzyk & Moriceau
Untitled, 2004
India ink on paper
21 × 29.7 cm
Ill. p. 142, bottom, right

Claudia & Julia Müller
Groups and Spots (Apes), 2003
Acrylic on paper
45 × 60 cm
Ill. p. 143

Claudia & Julia Müller
Groups and Spots (Warriors), 2003
Acrylic on paper
45 × 60 cm
Ill. p. 144, top

Claudia & Julia Müller
Groups and Spots (Children), 2003
Acrylic on paper
45 × 60 cm
Ill. p. 144, bottom

Claudia & Julia Müller
Groups and Spots (Tibetanian
Beauty Queens), 2003
Acrylic on paper
45 × 60 cm
Ill. p. 145

Bruce Nauman
Human Need Drain, 1983
Pencil, charcoal, and watercolor on
paper
217.8 × 202.6 cm
Ill. p. 147

Saskia Olde Wolbers
Placebo, 2002 (video still)
C-Print on Kodak photographic
paper, ed. 2/7
63.1 × 60.1 cm
Ill. p. 149

Peter Piller
nimmt Schaden, 2007
Pigment print on archival paper, ed. 1/6
57.5 × 75 cm
Ill. p. 150, top, left

Peter Piller
nimmt Schaden, 2007
Pigment print on archival paper, ed. 1/6
57.5 × 75 cm
Ill. p. 150, top, right

Peter Piller
nimmt Schaden, 2007
Pigment print on archival paper, ed. 1/6
57.5 × 75 cm
Ill. p. 150, bottom, left

Peter Piller
nimmt Schaden, 2007
Pigment print on archival paper, ed. 1/6
57.5 × 75 cm
Ill. p. 150, bottom, right

Peter Piller
nimmt Schaden, 2007
Pigment print on archival paper, ed. 1/6
57.5 × 75 cm
Ill. p. 151, top, left

Peter Piller
nimmt Schaden, 2007
Pigment print on archival paper, ed. 1/6
57.5 × 75 cm
Dust jacket, back; ill. p. 151, top, right

Peter Piller
nimmt Schaden, 2007
Pigment print on archival paper, ed. 1/6
57.5 × 75 cm
Ill. p. 151, bottom, left

Peter Piller
nimmt Schaden, 2007
Pigment print on archival paper, ed. 1/6
57.5 × 75 cm
Ill. p. 151, bottom, right

Peter Piller
nimmt Schaden, 2007
Pigment print on archival paper, ed. 1/6
57.5 × 75 cm
Ill. p. 152, top, left

Peter Piller
nimmt Schaden, 2007
Pigment print on archival paper, ed. 1/6
57.5 × 75 cm
Ill. p. 152, top, right

Peter Piller
nimmt Schaden, 2007
Pigment print on archival paper, ed. 1/6
57.5 × 75 cm
Ill. p. 152, bottom, left

Peter Piller
nimmt Schaden, 2007
Pigment print on archival paper, ed. 1/6
57.5 × 75 cm
Ill. p. 152, bottom, right

Peter Piller
nimmt Schaden, 2007
Pigment print on archival paper, ed. 1/6
57.5 × 75 cm
Ill. p. 153, top, left

Peter Piller
nimmt Schaden, 2007
Pigment print on archival paper, ed. 1/6
57.5 × 75 cm
Ill. p. 153, top, right

Peter Piller
nimmt Schaden, 2007
Pigment print on archival paper, ed. 1/6
57.5 × 75 cm
Ill. p. 153, bottom, left

Peter Piller
nimmt Schaden, 2007
Pigment print on archival paper, ed. 1/6
57.5 × 75 cm
Ill. p. 153, bottom, right

Mary Reid Kelley
Lil' Kim, 2015
Pigment ink print on paper, ed. 3/3
55.1 × 36.5 cm
Ill. p. 155

Mary Reid Kelley
Mary Shelley, 2015
Pigment ink print on paper, ed. 3/3
54.9 × 36.5 cm
Ill. p. 156

Mary Reid Kelley
Edgar Allan Poe (Stella), 2015
Pigment ink print on paper, ed. 3/3
54.9 × 38.1 cm
Ill. p. 157

Thomas Ruff
Portrait, 1987
C-print on paper, ed. 3/3
210 × 166 cm
Ill. p. 158, left

Thomas Ruff
Portrait, 1987
C-print on paper, ed. 1/4
210 × 166 cm
Ill. p. 158, right

Thomas Ruff
Stellwerk Basel, 1994
C-print on paper, ed. of 4
228 × 187.6 cm
Ill. p. 159

Thomas Ruff
Nacht 12 I, 1992
C-print on paper, ed. 1/2
185.2 × 185.1 cm
Ill. p. 160

Marcel Schaffner
Maschine, 1958
Oil on canvas
159 × 110 cm
Ill. p. 24, top

Hermann Scherer
Bergwald bei Davos, 1924
Oil on canvas
85.2 × 70.3 cm
Ill. p. 15, center

Thomas Schütte
Drittes Tier, 2017
Patinated bronze and
water pump
350 × 410 × 215 cm
Ill. p. 27

Thomas Schütte
Flucht, 1997
Watercolor, India ink, and
chalk on paper
Ten-part, each 28.6 × 16.5–17 cm
Ill. p. 162–163

Richard Serra
Robeson, 1984
Paintstick on screen print
on paper, ed. 12/15
257.4 × 167.5 cm
Ill. p. 165

Ross Sinclair
Decline and Fall, No. 7, 1998
C-print on paper, ed. 1/1
52.1 × 64.3 cm
Ill. p. 166

Ross Sinclair
Glasgow II, No. 5, 2001
C-print on paper, ed. 1/3
75 × 92.7 cm
Ill. p. 167

Ross Sinclair
Real Life. Geography, 2001
Screen print on paper, ed. 1/5
171.4 × 110.0 cm
Ill. p. 168

Lucy Skaer
Solid Ground. Tarsal, 2006
Pencil and gold leaf on Fabriano paper
140.5 × 200 cm
Ill. p. 170

Lucy Skaer
Solid Ground. Carpal, 2006
Pencil, felt-tip pen, and gold leaf
on Fabriano paper
140 × 200 cm
Ill. p. 171

John Skoog
Movie Palaces Series. Community
Theater, the Grand, Milwaukee, WI,
2010–15
Pigment print on paper, ed. 3/3
57 × 37.5 cm
Ill. p. 172, left

John Skoog
Movie Palaces Series. Streamers,
Westlake, Los Angeles, CA, 2010–15
Pigment print on paper, ed. 3/3
57.1 × 37.4 cm
Ill. p. 172, right

John Skoog
Movie Palaces Series. Toile, Al
Ringling, Baraboo, WI, 2010–15
Pigment print on paper, ed. 3/3
57.1 × 37.4 cm
Ill. p. 173, left

John Skoog
Movie Palaces Series. Women, the
Orpheum, Madison, WI, 2010–15
Pigment print on paper, ed. 3/3
57.6 × 37.9 cm
Ill. p. 173, right

John Skoog
Movie Palaces Series. Catedral de
la Fe, the State, Los Angeles, CA,
2010–15
Pigment print on paper, ed. 3/3
37.4 × 57 cm
Ill. p. 174, top

John Skoog
Movie Palaces Series. Red Carpet,
the Lake, Oak Park, IL (with Nicholas
Vargelis), 2010–15
Pigment print on paper, ed. 3/3
37.3 × 57 cm
Ill. p. 174, center

John Skoog
Movie Palaces Series. Lobby
Orpheus, the Orpheum, Madison,
WI, 2010–15
Pigment print on paper, ed. 3/3
37.3 × 57 cm
Ill. p. 174, bottom

Monika Sosnowska
Untitled, 2003
Pencil on paper
18 × 25.7 cm
Ill. p. 175, top, left

Monika Sosnowska
Untitled, 2003
Pencil on paper
18 × 25.7 cm
Ill. p. 175, top, right

Monika Sosnowska
Untitled, 2003
Pencil on paper
18 × 25.7 cm
Ill. p. 175, bottom, left

Monika Sosnowska
Untitled, 2003
Pencil on paper
18 × 25.7 cm
Ill. p. 175, bottom, right

Anselm Stalder
Untitled, 1980
Gouache on paper
34.8 × 49.4 cm
Ill. p. 177

Anselm Stalder
Untitled, 1982
Gouache on paper
35 × 50 cm
Ill. p. 178, top

Anselm Stalder
Untitled, 1982
Gouache on paper
35 × 50 cm
Ill. p. 178, bottom

Niklaus Stoecklin
Meine Schwester Franziska, 1919
Oil on canvas
75.5 × 57.2 cm
Ill. p. 15, top

Monica Studer/
Christoph van den Berg
Hotel Vue des Alpes. Nr. 4
Speisesaal, 2003
Laminated inkjet print on
photographic paper on aluminum,
ed. 1/7
79 × 87 cm
Ill. p. 179, left

Monica Studer/
Christoph van den Berg
Hotel Vue des Alpes. Nr. 3 Zimmer,
2003
Laminated inkjet print on
photographic paper on aluminum,
ed. 1/7
79 × 87 cm
Ill. p. 179, right

Monica Studer/
Christoph van den Berg
Hotel Vue des Alpes. Terrasse 4,
2003
Laminated inkjet print on
photographic paper on aluminum,
ed. 2/5
219 × 148 cm
Ill. p. 180

Monica Studer/
Christoph van den Berg
Hotel Vue des Alpes. Alpenrose,
2005
Laminated inkjet print on
photographic paper on aluminum,
ed. 2/5
140 × 140 cm
Ill. p. 181

Jenni Tischer
Pattern Recognition (Color) I, 2016
India ink on paper
36.1 × 51 cm
Ill. p. 182

Jenni Tischer
Mood, 2016
India ink and pastel crayon
on paper, collage
36 × 51.7 cm
Ill. p. 183, top

Jenni Tischer
Untitled (Pattern Fragments), 2016
Watercolor on paper
36 × 51 cm
Ill. p. 183, bottom

Jenni Tischer
Pattern Recognition (sw) II, 2016
India ink and pencil on paper
41.7 × 28.2 cm
Ill. p. 184, right

Luc Tuymans
Untitled, 1987
Watercolor on paper
24.5 × 14.9 cm
Ill. p. 185, left

Luc Tuymans
Untitled, 1989
Watercolor on paper
20.9 × 14.2 cm
Ill. p. 185, right

Luc Tuymans
Halloween, 1986
Watercolor on paper
27 × 21 cm
Ill. p. 186

Luc Tuymans
Untitled, 1987
Watercolor on paper
21 × 29.8 cm
Ill. p. 187, left

Luc Tuymans
Untitled, 1986
Watercolor on paper
26.9 × 21 cm
Ill. p. 187, right

Luc Tuymans
Toys, 1991
Watercolor on paper
20.6 × 29.6 cm
Ill. pp. 188–189

Marcel van Eeden
The Sollmann Collection, 2010
Nero pencil and color pencil
on paper
19 × 28 cm
Ill. p. 191, top, left

Marcel van Eeden
The Sollmann Collection, 2010
Nero pencil on paper
19 × 28 cm
Ill. p. 191, top, right

Marcel van Eeden
The Sollmann Collection, 2010
Nero pencil on paper
19 × 28 cm
Ill. p. 191, center, left

Marcel van Eeden
The Sollmann Collection, 2010
Nero pencil on paper
19 × 28 cm
Ill. p. 191, center, right

Marcel van Eeden
The Sollmann Collection, 2010
Nero pencil on paper
19 × 28 cm
Ill. p. 191, bottom

Marcel van Eeden
The Sollmann Collection, 2010
Nero pencil and color pencil
on paper
28 × 38 cm
Ill. p. 192, top

Marcel van Eeden
The Sollmann Collection, 2010
Nero pencil on paper
28 × 38 cm
Ill. p. 192, bottom

Inez van Lamsweerde
The Forest. Marcel, 1995
Chromogenic print mounted on
Dibond and Plexiglas, ed. 1/4
135 × 180 cm
Ill. p. 194

Inez van Lamsweerde
The Forest. Klaus, 1995
Chromogenic print mounted on
Dibond and Plexiglas, ed. 1/4
135 × 180 cm
Ill. p. 195

Ulla von Brandenburg
Mädchen mit Bär, 2016
Watercolor on assembled paper
73 × 88 cm
Ill. p. 196

Ulla von Brandenburg
Mann ohne Kopf, 2015
Watercolor on assembled paper
140 × 110 cm
Ill. p. 197

Ulla von Brandenburg
Mary, 2018
Watercolor on gesso on wood
139.8 × 110 cm
Ill. p. 198

Amelie von Wulffen
Untitled, 2010
Watercolor and India ink on paper
29.5 × 21 cm
Ill. p. 199

Amelie von Wulffen
Untitled, 2012
Watercolor and India ink on paper
21 × 29.5 cm
Ill. p. 200

Amelie von Wulffen
Untitled, 2010
Watercolor and India ink on paper
29.5 × 21 cm
Ill. p. 201, left

Amelie von Wulffen
Untitled, 2010
Watercolor and India ink on paper
29.5 × 21 cm
Ill. p. 201, right

Kemang Wa Lehulere
Sketch for a Situation, 2013
Ink on paper
100 × 70.5 cm
Ill. p. 202

Kemang Wa Lehulere
A Geometric Drop, 2013
Ink on paper
100 × 70.3 cm
Ill. p. 203

Kemang Wa Lehulere
Negotiation 1.2, 2014
Ink on paper
51.6 × 76.4 cm
Ill. p. 204, top

Kemang Wa Lehulere
Negotiation 1.1, 2014
Ink on paper
56 × 76.5 cm
Ill. p. 204, bottom

Stephen Waddell
Shopfront, 2004
C-print on paper, ed. 3/7
145 × 97 cm
Ill. p. 206

Stephen Waddell
Man in Car, Powell Street, 2012
Inkjet print mounted on Dibond,
ed. 2/5
99.9 × 125.3 cm
Ill. p. 207, top

Stephen Waddell
Snail Seller, 2009
Inkjet print mounted with Diasec,
ed. 1/3
63.5 × 96.5 cm
Ill. p. 207, bottom

Jeff Wall
Children, 1988
Transparencies in lightboxes, ed. 2/3
9 parts, diameter 119 cm each
Ill. pp. 208–211

Franz Erhard Walther
Werkzeichnung, 1968–69
Pencil and watercolor on paper
29.5 × 20.8 cm
Ill. p. 212, left

Franz Erhard Walther
Werkzeichnung, 1967–71
Pencil and watercolor on paper
29.6 × 20.8 cm
Ill. p. 212, right

Franz Erhard Walther
Werkzeichnung, 1969
Pencil and watercolor on paper
29.5 × 21 cm
Ill. p. 213, left

Franz Erhard Walther
Werkzeichnung, 1966–71
Pencil and watercolor on paper
29.6 × 21 cm
Ill. p. 213, right

Walter Kurt Wiemken
Artistenzimmer, 1932
Oil on canvas
81.2 × 54.1 cm
Ill. p. 15, bottom

Cathy Wilkes
Cara Studies Votes for Women
"Little Joe," 2004
Oil on catalogue plate
27 × 20.3 cm
Ill. p. 214

Cathy Wilkes
Cara Studies Votes for Women
"Valerie Lecturing on the Planets,"
2004
Oil on catalogue plate
27 × 20.8 cm
Ill. p. 215, left

Cathy Wilkes
Cara Studies Votes for Women
"Valerie's Lecture," 2004
Oil on catalogue plate
27 × 20.8 cm
Ill. p. 215, right

Erwin Wurm
13 Pullover übereinander
(One Minute Sculpture), 1992
India ink on paper
29.6 × 21 cm
Ill. p. 217, left

Erwin Wurm
Helsinki (One Minute Sculpture),
2001
Pencil and fineliner on paper
29.5 × 21 cm
Ill. p. 217, right

Erwin Wurm
Kugelschreiber, Hand
(One Minute Sculpture), 1998
India ink on paper
30 × 20 cm
Ill. p. 218, left

Erwin Wurm
2 Vasen 20 Secunden
(One Minute Sculpture), 1996
India ink on paper
28 × 21 cm
Ill. p. 218, right

Heimo Zobernig
Untitled, 1984
Gouache on paper
29.6 × 20.7 cm
Ill. p. 219, left

Heimo Zobernig
Untitled, 1984
Gouache on paper
30.3 × 20.4 cm
Ill. p. 219, right

Heimo Zobernig
Untitled, 1984
Gouache on paper
29.5 × 20.8 cm
Ill. p. 220, left

Heimo Zobernig
Untitled, 2013
Acrylic on paper
29.7 × 20.7 cm
Ill. p. 220, right

Heimo Zobernig
Untitled, 2012
Adhesive dots, adhesive film,
and Letraset on paper
29.6 × 20.9 cm
Ill. p. 221

Authors

Manuela Ammer	Curator, mumok—Museum moderner Kunst Stiftung Ludwig, Vienna
Julika Bosch	Curator, Kestner Gesellschaft, Hannover
Kathleen Bühler	Curator, Gegenwartskunst, Kunstmuseum Bern
Andreas Burckhardt	President of the Board, Bâloise Holding AG, Basel
David Campany	Author and curator, London
Marianne Dobner	Curator, mumok—Museum moderner Kunst Stiftung Ludwig, Vienna
Julie Enckell Julliard	Head of Cultural Development, HEAD—Geneva University of Art and Design
Marie-Noëlle Farcy	Curator and Head of Collection—Mudam Luxembourg, Musée d'Art Moderne Grand-Duc Jean, Luxembourg
Philippe Fürstenberger	Overall Project Leader Baloise Park, Head of Construction & Development, Baloise, Basel
Roberto Gargiani	Professor, EPFL—Swiss Federal Institute of Technology Lausanne
Isabelle Guggenheim	Arts and Culture Management, Bâloise Holding AG, Basel
Sharon Hecker	Art historian, curator, author, and lecturer, Milan
Dora Imhof	Art historian and lecturer at the Institute for the History and Theory of Architecture (gta), ETH Zurich
Philipp Kaiser	Curator and Chief Executive Director of Artists and Programs, Marian Goodman Gallery, New York, London, Paris
Brigitte Kölle	Head of the Contemporary Art Collection, Hamburger Kunsthalle, Hamburg
Ulrich Loock	Author and curator, Berlin
Letizia Ragaglia	Director, Museion, Bolzano
Anna Rosellini	Associate Professor, University of Bologna
Carla Schulz-Hoffmann	Deputy Director General (rtd.) Bavarian State Collections, Curator for Modern and Contemporary Art, Munich
Martin Schwander	Curator and artistic advisor to Baloise, Basel
Dieter Schwarz	Author and curator, Zurich
Beat Wismer	Art historian, museum director (rtd.), author, and curator, Zurich

Mathieu Kleyebe Abonnenc, Courtesy the artist and Marcelle Alix, Paris: pp. 30–31; Baloise Archive: p. 226 bottom, center; Christian Baur, Basel: pp. 12, 15, 16, 19, 20, 24 above, 35, 48, 80, 81; Tom Bisig, Basel: p. 24 bottom; Hans Brändli: pp. 89, 90; Keren Cytter, Courtesy the artist and Pilar Corrias, London: pp. 52, 53, 54–55; Sara Cwynar, Courtesy the artist and Foxy Production, New York: dust jacket front, pp. 50, 51; Andreas Eriksson: p. 71; Elger Esser: pp. 73, 74, 75; Fiorini, Schweizerische Nationalbibliothek, Eidgenössisches Archiv für Denkmalpflege, Archiv Photoglob-Wehrli: p. 11 top; Karsten Födinger: pp. 83, 84; Luke Fowler: p. 88; Katharina Fritsch: pp. 91, 92; David Gagnebin-de Bons: pp. 120–121, 122; Ryan Gander: pp. 96, 97; Geert Goiris: pp. 99, 100, 101, 102; Joanne Greenbaum, Courtesy the artist and Nicolas Krupp, Basel: pp. 103, 104, 105; Julien Gremaud: pp. 76–77; gta Archiv / ETH Zürich, Hermann and Hans Peter Baur: p. 11 bottom, 184 left; Naoya Hatakeyama, Courtesy the artist, L. A. Galerie Lothar Albrecht and Taka Ishii Gallery: pp. 106–107, 108, 109, 110; Candida Höfer: pp. 111, 112, 113; Teresa Hubbard / Alexander Birchler: pp. 115, 116; Thomas Huber, Courtesy the artist and SKOPIA Art contemporain, Geneva: pp. 117, 118, 119; Keystone: p. 23; Susanne Kriemann: pp. 123, 124, 125; Annika Larsson, Courtesy the artist and Andréhn-Schiptjenko, Stockholm: pp. 126, 127, 128; Brigitt Lattmann: p. 32; Gunter Lepkowski: p. 201 right; Zilla Leutenegger, Courtesy the artist and Galerie Peter Kilchmann, Zurich: p. 131; Zilla Leutenegger, Courtesy the artist and Galerie Stampa: p. 129; max-color, Berlin: pp. 199, 201 left; Aleksandra Mir: pp. 134, 135, 136; Tracey Moffatt, Courtesy the artist and L. A. Galerie Lothar Albrecht: pp. 137, 138, 139; Mrzyk & Moriceau, Courtesy the artists and Air de Paris: cover, pp. 140, 141, 142; Börje Müller, Basel: p. 27; Claudia & Julia Müller, Courtesy the artists and Galerie Peter Kilchmann, Zurich: pp. 143, 144, 145; Maria Netter, SIK-ISEA, Courtesy Fotostiftung Schweiz: p. 8 bottom; Nightnurse Images GmbH: p. 230; Alex North: pp. 58, 59; Saskia Olde Wolbers, Courtesy the artist and Stigter van Doesburg: p. 149; Photographic Services, Basel: p. 226 bottom, right; Peter Piller, Courtesy the artist and Capitain Petzel, Berlin: dust jacket back, pp. 150, 151, 152, 153; Raccolte d'Arte Antica del Castello Sforzesco, Milan, Copyright Comune di Milano, all rights reserved: p. 78; André-Marc Räubig: pp. 2, 33, 34, 36, 37, 38, 39, 40–41, 42, 43, 45, 46, 47, 49, 56, 57, 60, 61, 62, 64, 65, 66, 67, 68, 69, 70, 79, 94–95, 130, 133, 155, 156, 157, 162–163, 166, 168, 170, 171, 175, 177, 178, 182, 183, 184 right, 185, 186, 187, 188–189, 191, 192, 202, 203, 204, 212, 213, 214, 215, 217, 218, 219, 220, 221; Thomas Ruff: pp. 158, 159, 160; Peter Schnetz: pp. 222, 226 top, left, 226 top, right, 226 center, left, 226 bottom, left; Richard Serra, Courtesy the artist and Galerie M, Bochum: p. 165; Ross Sinclair: p. 167; John Skoog: p. 172, 173, 174; Julia Spicker: p. 200; Monica Studer / Christoph van den Berg: pp. 179, 180, 181; Inez van Lamsweerde, © **Inez & Vinoodh. Courtesy Gagosian**: pp. 194, 195; Rémi Villaggi, Courtesy Mudam Luxembourg: p. 226 center, right; Andreas F. Voegelin: p. 147; Simon Vogel: pp. 86–87; Jules Vogt, Keystone: p. 8 top; Ulla von Brandenburg, Courtesy the artist and Pilar Corrias, London: pp. 196, 197, 198; Stephen Waddell: pp. 206, 207; Jeff Wall: pp. 208, 209, 210, 211; Ursula Wirz-Göhner: p. 8 center

Colophon

Editor
Martin Schwander on behalf of Baloise

Project Manager
Salome Schnetz

Baloise Collaborators
Ben Silberschmidt (Art Handling),
Noah Senn (Trainee)

Copy Editing and Proof Reading
Clare Manchester

Translation
Fiona Elliott (Architecture, Bächli, Balkenhol, Cahn, Cytter, Dahn, Denny, Disler, Dumas, Eriksson, Federle, Födinger, Fritsch, Fujiwara, Gander, Greenbaum, Hubbard/Birchler, Huber, Larsson, Leutenegger, Moffatt, Müller, Olde Wolbers, Sinclair, Skaer, Sosnowska, Stalder, Tischer, Tuymans, von Wulffen, Wa Lehulere, Wilkes, Wurm, Zobernig)

Ishbel Flett (Introduction, History, Kunstforum, Art Prize, Foreword, Abonnenc, Clemente, Cucchi, Draeger, Esser, Fowler, Fries, Goiris, Höfer, Huck, Kriemann, LeWitt, Mir, Nauman, Piller; Schütte, Serra, Skoog, Studer/van den Berg, van Eeden, Walther)

John O'Toole (Borofsky, Dzama, Mrzyk & Moriceau, Reid Kelley, von Brandenburg)

Graphic Design and Typesetting
Teo Schifferli, Zurich, with Fabian Fretz

Typeface
Basel Book

Project Coordination
Richard Viktor Hagemann, Hatje Cantz

Production Manager
Thomas Lemaître, Hatje Cantz

Color Separation
Repromayer Medienproduktion GmbH, Reutlingen

Paper
Munken Arctic Volume White 150g

Printing and Binding
GCC – Grafisches Centrum Cuno

A publication of
Baloise Group
Aeschengraben 21
4002 Basel
Switzerland

Published by
Hatje Cantz Verlag GmbH
Mommsenstrasse 27
10629 Berlin
Germany
www.hatjecantz.com
A Ganske Publishing Group Company

ISBN 978-3-7757-4672-4 (English)
ISBN 978-3-7757-4641-0 (German)

Printed in Germany

Dust Jacket, front: Sara Cwynar,
Tracy (Cézanne), 2017
Dust jacket, back: Peter Piller,
nimmt Schaden, 2007
Cover: Mrzyk & Moriceau, Untitled, 2001